The New Earthwork

For more than 40 years, sculptors have been at the
forefront of environmental and ecological/social inno-
vation, making works that treat the earth as creative
partner rather than resource and raw material. The
new earthwork, which is currently at the leading edge
of sculptural practice, means art for the future of
humanity and the planet; it means a new approach to
aesthetics and the role of art in our lives; it means
a sustainable and vital artistic practice that not only
solves problems but dares to ask questions and seek
answers across disciplinary boundaries. Working
in the land to solve agricultural, habitat, and water
problems; using new materials and technologies;
employing, and sometimes generating, alternative
energy sources; taking action and educating about
recycling, frontier biology, and genetic engineering,
these artists demonstrate how art can open people's
eyes, drive change, and envision more than one
possible future.

Sculpture magazine and ISC Press are programs of the International Sculpture
Center, a 501(c)3 nonprofit corporation.

isc Press

19 Fairgrounds Rd. Suite B
Hamilton, NJ 08619, USA
www.sculpture.org

Distributed by
University of Washington Press
P.O. Box 50096
Seattle, WA 98145-5096, USA
www.washington.edu/uwpress

Library of Congress Cataloging-in-Publication Data
The new earthwork : art action agency / edited by Twylene Moyer and Glenn Harper.
— 1st ed.
 p. cm.
ISBN 978-0-295-99164-1 (pbk. : alk. paper)
1. Ecology in art. 2. Art and social action.
I. Moyer, Twylene. II. Harper, Glenn. III. Sculpture magazine. IV. Title: Art action agency.
N8217.E28N49 2011
701'.08 — dc23 2011043475

The New Earthwork: Art Action Agency
Edited by Twylene Moyer and Glenn Harper: with an introduction by Lucy R.Lippard

ISBN 978-0-295-99164-1

Cover images: see page 312

NATIONAL
ENDOWMENT
FOR THE ARTS

The New Earthwork

Art Action Agency

Edited by Twylene Moyer
and Glenn Harper

Perspectives on Contemporary Sculpture: Volume 4

From the Publisher

In 2006, *Sculpture* magazine celebrated its 25th anniversary. To mark the occasion, the International Sculpture Center (ISC), the publisher of *Sculpture*, inaugurated ISC Press with *A Sculpture Reader: Contemporary Sculpture Since 1980* (a compendium of more than 40 articles that first appeared in *Sculpture*). That first book has since grown into the "Perspectives on Contemporary Sculpture" series. These books, which provide essential documentation of developments in the field (including installation, new media, and public art) serve as tools for educators, students, and those interested in contemporary sculpture. Already required reading for many sculpture programs in universities and art schools around the world, the contents of these volumes provide a much needed resource and are an important ISC educational program. In addition to *A Sculpture Reader*, the series features *Conversations on Sculpture* (interviews with contemporary artists), and *Landscapes for Art: Contemporary Sculpture Parks* (an anthology of articles on sculpture parks and gardens around the world that focus on contemporary art), and now, *The New Earthwork: Art, Action, Agency*.

The ISC, a member-supported, nonprofit organization, was founded in 1960 as a conference at the University of Kansas presenting new technologies to sculptors from across the U.S. Subsequent conferences expanded to encompass a wide range of aesthetic and professional interests and attracted attendees from around the world; today, the ISC's biennial conferences continue under the title International Sculpture Conference and alternate with smaller, subject-focused symposia. The ISC also supports sculpture and sculptors with a variety of other programs, including *Sculpture* and ISC Press, <www.sculpture.org>, the annual Lifetime Achievement in Contemporary Sculpture Award, the Outstanding Sculpture Educator Award, the Outstanding Student Achievement in Contemporary Sculpture Awards, and the Patron's Recognition Award.

On the occasion of the fourth book from ISC Press, *The New Earthwork: Art, Action, Agency*, we want to thank *Sculpture* magazine's editor, Glenn Harper, and managing editor, Twylene Moyer, for their work on this and the other ISC Press publications. We also want to thank the ISC Board of Trustees, for their continued support of the organization's publication program, as well as the University of Washington Press (our distribution partner for the project). We also owe a debt of gratitude to the National Endowment for the Arts, for their generous support of *The New Earthwork* and the ISC.

—*Johannah Hutchison*
Executive Director, the International Sculpture Center

Table of Contents

Foreword

by Twylene Moyer

As *The New Earthwork* began to wrap up in August of 2011, a single week brought an earthquake, tornadoes, and torrential downpours spawned by Hurricane Irene to the U.S. Mid-Atlantic—all this after a summer of unrelenting heat that broke records set only the year before. And that was just local. From heat waves and droughts to floods, tsunamis, and blizzards, "weather panic" aberrations have become the new norm around the world. At the same time, we watched as government officials played politics with the future, holding environmental policy hostage to short-term economics and partisan enmity, while scientists and activists issued increasingly dire updates on glacial melting, species endangerment, and crop yields.

It didn't have to be like this. We knew. More than 50 years ago, scientists had already identified the dangers of unfettered development and the effects of climate change on the planet's balance, along with the consequences for life (human and otherwise). Responding to the trials of the '60s—fossil fuel limits, acid rain, famine, and the effects of phosphates, pesticides, and industrial chemistry on a wide variety of causally networked systems, a vanguard of artists, landscape architects, and urban planners took change seriously. They countered perceived constraints with a sense of possibility, open-endedness, and an experimentalist ethos. But humans are a stubborn species, fearful of change unless it is absolutely necessary, happy to forget, unless life and livelihood are immediately endangered. Once the crisis had passed, such forward-looking, creative calls to action and visions for new modes of life fell victim to the siren call of the market economy, with its easy illusions of store-bought well-being.

So, we're back where we started, with the critical difference that we seem to have lost our spirit. That sense of promise with which an earlier generation faced crisis—as Mario Merz asked, "What is to be done?"—has been replaced with an overwhelming concern to preserve the lifestyle to which we've become accustomed, with the fewest changes, while still averting doomsday. But we are past technological band-aids and reactive, piecemeal fixes. It's time to throw off the illusions of a substitute life of consumption and rediscover the possibilities of adaptive, radical, and revolutionary vision. The foundation is already there. As Rem Koolhaas, the force behind Roadmap 2050's vision of an E.U.-wide decarbonized power grid has pointed out, the achievements of the decade between 1965 and 1975 are a "buried asset" waiting to be rediscovered.

Perhaps the most incisive call to action produced during that Golden Age—*Limits to Growth: A Report to the Club of Rome* (1972/89)—still stands as a blueprint for putting our house in order. In a tour de force of holistic, integrative thinking, the authors outlined a trans-disciplinary, collaborative approach that acknowledged the true meaning of ecology, drawing together the social, cultural, economic, political, and environmental spheres in a concerted effort to drive change—in values, behavior, policy, and definitions of progress. Their idea of sustainable, creative economies realized through local effort was ahead of its time, as was their advocacy of culture.

For this is the key question: How can you convince people to change their values? How can you redefine the quality of life? In the West, quality of life has been synonymous with gain, accumulation, and waste for so long that merely suggesting otherwise raises the specter of sacrifice, falling standards, and deprivation. Club of Rome founder Aurelio

Peccei wasn't wrong when he identified the defense of the environment as a powerful rallying point capable of uniting a plethora of small groups and interests, but we have not yet succeeded in creating the higher level of commitment that unites separate, small-scale efforts (from rescuing an endangered species to preserving a park, improving conditions in a rural area, or feeding the hungry). Culture supplies the missing piece of the puzzle. As scientist Tim Flannery remarks in his recent book, *Here on Earth: A Natural History of the Planet*, "It is not so much our technology, but what we believe, that will change our fate."

If art is looking for a larger purpose beyond commodity and investment vehicle, beyond entertainment and urban decoration, then this is it. There is no other issue so universal, no meaning more intrinsic than survival. If critics and artists alike bemoan art's lack of relevance in the contemporary world—and they do—then this is the chance to make a real contribution, to enter people's daily lives and perhaps make them better. For artists, galleries, and museums, this is an opportunity to weave culture into a fabric of new connections joining environment, social relations, and human subjectivity (to borrow Félix Guattari's three registers of ecosophy): there can be no more false dichotomy between nature and culture—environmental health, social justice, and cultural achievement are not mutually exclusive.

The New Earthwork re-issues Guattari's invitation, calling on creative individuals of every discipline and background to use culture as a wedge to inspire a change in values, to produce interruptions in the everyday that jar us out of rote complacency and open our minds to new ways of feeling, perceiving, and conceiving. The work of culture, though sidetracked during the "lost" years, has never stopped. Far from forgetting our "buried assets," artists and other cultural innovators have safeguarded them, stubbornly persevering in their efforts to jumpstart our thinking and re-envision our relationships with each other and with the planet. And a new generation is now rising to the challenge.

This book begins with the premise that artists are relevant, and indeed vital, to a new formulation of possible futures. Although it does not attempt a history as such, it does trace a certain trajectory based in the shared legacy of

The Yes Men with Tom Foster, promotional materials for *SurvivaBall*, 2006–ongoing.

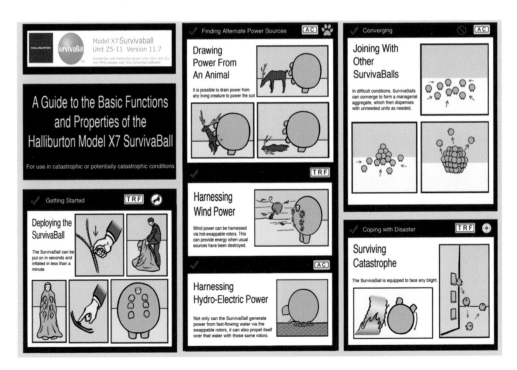

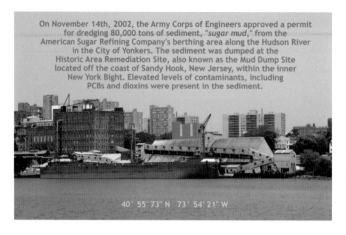

On November 14th, 2002, the Army Corps of Engineers approved a permit for dredging 80,000 tons of sediment, "sugar mud," from the American Sugar Refining Company's berthing area along the Hudson River in the City of Yonkers. The sediment was dumped at the Historic Area Remediation Site, also known as the Mud Dump Site located off the coast of Sandy Hook, New Jersey, within the inner New York Bight. Elevated levels of contaminants, including PCBs and dioxins were present in the sediment.

40° 55' 73" N 73° 54' 21" W

Eve Andrée Laramée, *Sugar Mud: Sugar Factory*, 2003. Digital print of American Sugar and Syrup Factory with superimposed text.

Arte Povera, Zero, body and performance art, British Land Art, and social sculpture. Art as life and life as art naturally segue into experimental, participatory, activist, grassroots, and people-to-people approaches to ecological change. We are not advocating any single artistic strategy—the time for insular debate and preaching to the choir (of art world peers) is past—instead, we offer a variety of approaches, each one appropriate to its particular context and audience. The artists featured here open our eyes to the natural world, teaching us to experience it as more than a backdrop. They forge new models of cooperation with scientists, government entities, and activists to solve problems of water, land, and air pollution. They create habitats for flora and fauna. They serve as critical watchdogs, questioning the side effects and outcomes of our practices and technologies. They offer practical solutions to waste stream logistics, energy needs, and air quality. They step in to improve health and welfare conditions when official entities drop the ball and bring countless environmental/human rights abuses to the attention of a larger public. Most importantly, they realize outside-the-box, innovative visions for transforming, sustainable, and pleasurable ways of life. Thanks to the return of a familiar cast of villains—food contamination, pollution, climate disasters, and of course, oil—general consciousness may once again be primed to receive, and act on, their ideas. (The essays in the second section of the book capture the recurring start-stop cycles of fashionable concern and willful apathy as they have recurred from the 1980s to the present.) But this time around, artists have a wealth of possible approaches at their disposal—not to mention new technologies. Powerful communications media allow remote projects to break through their isolation and reach audiences around the world, while establishing new kinds of public interaction and new cooperative strategies that get the word out and whip up support.

Though it is always dangerous to signal a crossroads moment—most come to nothing—the human race has managed to squander the last 50 years in complacency and denial. We may not have that luxury again. Regardless of the timetable and scope of predicted disaster, we have a choice: to continue on a path of self-imposed destruction or take the steps that should have been taken long ago, to live more enriching lives in tune with the organic functioning of our environment. We can fall back into the industrial/ecological dark age that started in the 1980s, losing hard-won insights and gains so that our brief awakening becomes nothing more than a passing renascence. Or we can revitalize culture and the planet with a new vision that sustains an equal opportunity of life for all. The only thing holding us back is fear, coupled with a simple lack of imagination. But artists can guide us through the inertia, teaching us to welcome change as much as the title character in Robert Musil's *The Man Without Qualities*: "Every generation treats the life into which it is born as firmly established, except for those few things it is interested in changing. This is practical, but it is wrong. The world can be changed in all directions at any moment…it's in the world's nature. Wouldn't it be more original to try to live, not as a definite person in a definite world where only a few buttons need adjusting—what we call evolution— but rather to behave from the start as someone born to change surrounded by a world created by change?" In the current climate, we all need to think and act like artists.

Introduction: Down and Dirty

by Lucy R. Lippard

One place understood helps us understand all other places better. — Eudora Welty

We have come a long way since Renaissance painters tentatively introduced landscapes as backgrounds for more serious subjects and the 19th century positioned "man" on the edge of the natural abyss, staring out at sea or forest. Or, to track a different ancestral line, we have come a long way since traditional farms and formal gardens (and cemeteries) led to public and national parks as the nation closed in on its wildernesses. This book offers a panoply of ways in which contemporary artists get down and dirty, addressing universal concerns about what we now call the environment — by which we usually mean the natural environment, though we often forget that humans and our constructions are equally part of nature, even as we dominate, exploit, and patronize our natural resources.

I promised myself when I started writing this introduction that I wouldn't drop names, because it could become nothing but a list of all the impressive contributors or a list of my personal favorites. So instead of singling out individuals, I've looked at the book's general content and what it reveals about how artists have been working over the last, very important, two decades. The variety is stunning. The inclusion of interviews allows us to hear the artists' voices directly. Many of the projects were new to me. I suspect that every reader is in for some pleasant surprises. Yet it is also sad to realize that so much forward-looking art, from the 1960s on, has not been incorporated into art canons as a model for expanding concerns. Time has been lost, wheels have been reinvented.

Most of the works covered here can be categorized as "sculpture" — even those that seem submerged in life itself, which is, of course, three-dimensional until it is banished to TV and computer screens, joining the more general category of "imagery." In Michael Shellenberger and Ted Nordhaus's now famous announcement of the "death of environmentalism," they wrote, "With their coffee table books, wall calendars, and postcards, environmentalists have long been image obsessed. Images of disappearing glaciers, dead penguins, and drowning polar bears aren't going to solve the political obstacles to wider action on global warming." Needless to say, while I agree with much of their thesis, I strongly disagree about the power of images. Despite my presumed art world sophistication, I can be deeply moved by a strong image of a polar bear poised on the edge of a tiny shrinking ice island. Nobody claims that artists alone can solve social problems or change the world. But in collaboration with social movements, scientists, governments, and communities, the sky's the limit. One artist in this book compares environmental art to a magnifying glass, revealing details and depths we don't see or don't think about. It is not a matter of imitating nature, but of paying homage to its extraordinary mechanisms and manifestations.

My personal bias is toward those projects that confront social issues, offering depth and alternatives to our current co-existence with our environments, toward those artists who are not afraid to criticize governmental neglect and corporate control of nature, who consider more than the moment, more than their visual or economic success. Many are actively contributing to the reinvention of infrastructures, working (when they can get a foot in the door) on water purification, smog/emissions control, solar and wind generation, shelter and nurture of wildlife, waste disposal, and

even grand schemes to transform whole regions. With more holistic views now popular, artists can illuminate sites without altering them, and alter sites that need restoration. They can transform brownfields into green fields, restore damaged habitats with the cooperation of communities, and resurrect ecological values that were once taken for granted. This book demonstrates how artists imaginatively use materials ranging from those that naturally disintegrate and decay in the process of a project to those that are recycled from the wastes of a consumer society. Sometimes these works involve information and even didacticism—eye-catching and entertaining signs or one-liner visuals in any medium. Sometimes what is called for is immersion in local issues and local politics. Sometimes a monument or large-scale restoration and transformation project is possible. And sometimes the best art interventions are almost totally invisible, doing their jobs subtly in collaboration with nature itself.

It is clear now that many of the monumental earthworks of the 1960s and '70s—dependent on distance, photography, and major funding—cannot be said to be "environmental" in today's context. While they were created as tourist destinations for city folks, today's younger artists and collectives are reversing the direction, bringing rural and agricultural sites to the cities, reminding urbanites of the hidden hills and streams beneath their feet, mapping migrations, extinctions, and survivals. We have moved from perceiving the environmental artwork's location as a *site* to expanding it into a *place*, which includes history and ecosystems, as well as popular access. Indoor installations can incorporate fine-tuned messages and enter into dialogues with contemporary mainstream art. Outdoor projects can illuminate our everyday lives. There has been a transition from objects and institutions to ideas and actions, leading to interventions in the inhabited landscape. Eco/environmental arts are becoming less focused on sculptural structures, creating liminal spaces between the natural and the built—spaces that mediate between humans and their surroundings.

The works featured here open up new questions about how, when, and where we experience and "appreciate" art.

Beauty is taken for granted when the word "nature" is raised. From "New Topographics" to "Altered Landscapes," photographers hoping to raise consciousness of polluted air and waters, of lands destroyed by mining or by the evils of suburban sprawl, have often been criticized for their concentration on the beauty of ugliness. The other visual arts have more frequently focused on rescuing beauty from ugliness, juxtaposing varieties of beauty, or creating oases of beauty in surrounding ugliness. Here, they often meet and overlap with landscape architecture, a field that has long thirsted for some of art's freedom and iconoclasm, while art itself gains substance after a taste of functionalism.

Futurefarmers, *Soil Kitchen*, 2011. Mixed media, detail of installation in Philadelphia.

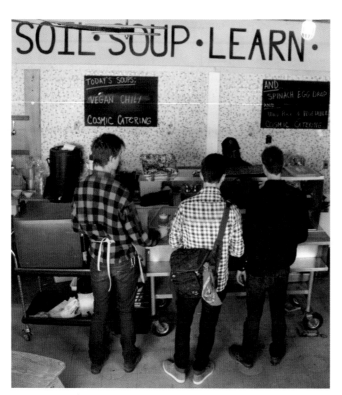

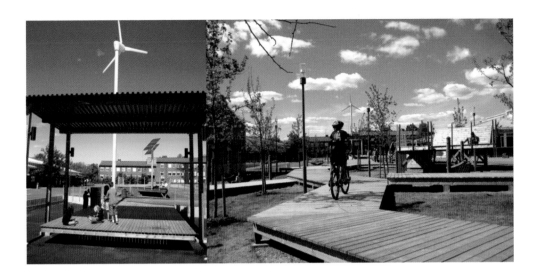

Marjetica Potrč, *A Schoolyard in Knivsta: Fruit and Energy Farms*, 2008. Energy infrastructure and fruit trees, dimensions variable. View of project in Knivsta, Sweden.

All of these endeavors demand a sense of place, familiarity with local geography, and a high degree of ecological sensitivity. Walking and looking, becoming "a tourist at home," encourage a familiarity with topography and geography as well as with changing seasons, changing lights, changing demographics. The issue of climate change is another effective wedge into the interconnections that lie at the heart of environmental art, blurring the boundaries between rural, suburban, and urban—all of which are equally affected by current changes and those lurking in the future. Particularly valuable are new alliances with environmental movements, with scientists, farmers, gardeners, foresters, green builders, and others who spend their lives on the details that artists will probably generalize as they come up with unexpected angles of vision. Collaborations between artists and scientists, constantly increasing in number, are often fruitful precisely because of the differences between their disciplines. With some scientific knowledge under their belt, artists are better able to deal with the fluid, organic nature of ideas, working freely between the questions and the answers.

Some of the pioneers in the field of environmental art brought together natural and cultural histories, offering aids to read ever-changing landscapes. For most of human history, nature constructed us; now we are constructing nature, with cloned bodies and genetically modified foods. At the same time, we are increasingly aware of the need to protect watershed and food webs, as well as the emotionally and physically remediatory power of trees. A crucial element is understanding the distinctions between short- and long-term thinking—the linear restrictions of human time and the vaster cycles of natural time.

There is only a fine line between eco-art and activism. Some readers may be surprised to see how many artists have plunged into the fray, confronting environmental issues rather than obliquely citing or picturing them. The vast scope of the themes undertaken in this book, microcosmic to macrocosmic, offers insights into the ways in which we navigate the spaces and meanings of daily life. As I write, as the book goes to press, more artists are confronting the possibilities of reflecting, remediating, and re-envisioning their environments.

Richard Long's *Line*: Dissolving Aesthetics into Ethics

by Dieter Roelstraete

What a strange word, or notion, carbon footprint is—"the total set of greenhouse gas emissions caused by an organization, event, product or person," as an authoritative Web site on the subject puts it. Most of us, i.e., most of us in the art world, have a basic guilty (and basically guilty) knowledge of the concept: our carbon footprint is that which continuously expands as we fly around the world in pursuit of art—either to make art, in the artist's case (which is bad enough), or to look at art and think and talk about it, in the critic's and curator's case (which is even worse). This is the first thing that came to my mind when I was invited to retrace those momentous steps taken by Richard Long back in 1967, when he first conceived his seminal *A Line Made By Walking*, within the context of a publication devoted to the ecological horizon of contemporary sculptural practice.

In a monograph dedicated to this single work, one of the earliest known examples of Land and/or Environmental Art in the narrow sense of the term, I dwelled quite extensively on the circumstances of its emergence within the larger framework of postwar ecological activism and increased environmental awareness (a context, it must be added here, which Long himself, like so many of his peers and traveling companions, was hardly aware of at the time). *A Line Made By Walking* was made in the summer of 1967, just a couple of months after the Torrey Canyon supertanker was shipwrecked off the coast of Cornwall—not very far from the countryside outside Bristol where Long grew up, essayed his first forays into outdoor sculpture, and continues to live to this day—causing the worst environmental disaster of its kind to date, a pivotal moment in the history of eco-politics.[1] Less than two years later, a similar disaster struck U.S. waters when an estimated 100,000 barrels of crude oil spilled onto a beach in Southern California. These events, along with a rising tide of pacifist-inspired, anti-nuclear protests, would prove crucial for the founding, in the early 1970s, of Greenpeace in the western Canadian city of Vancouver (which, incidentally, quickly established itself as an important hub for the burgeoning conceptual art movement with which many early Land or Earth artists were affiliated), and soon thereafter, everywhere around the (Western) world, grassroots environmentalist movements and green parties of all stripes would see the light of day.

Although Earth Art and/or Land Art, like so many other offshoots of the mid-'60s revolution in art-making, never directly reflected, let alone commented on, these major shifts in culture and society, it is clear that many of the artistic practices associated with these "movements" would have been impossible, unthinkable even, without the tidal wave of social, economic, political, cultural, and ideological changes that washed over Western society (or, more precisely still, the "first world") in the 1960s. One key factor uniting these two spheres—infrastructure and suprastructure, in old-fashioned Marxist terms—concerned the critique of production, which, born from the growing dissatisfaction with boom-era materialist lifestyles, quickly became one of the basic tenets of conceptual art. Insofar as environmental disasters were seen as the immediate consequences of a productivist regime gone haywire—the evil twin of a consumerism that, in the early years of Pop Art, had still been the subject, however ambiguous, of artistic celebration—the appropriate critical response on the part of the art world (which increasingly came to view itself as a stronghold of critical practice) was to refrain from production altogether. "The artist may construct the piece—the piece may be

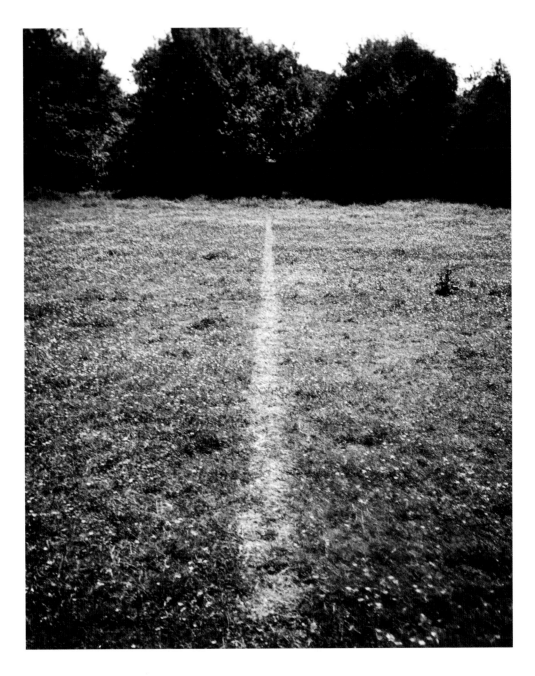

A Line Made By Walking, England, 1967.

fabricated—the piece need not be built," in Lawrence Weiner's justly famous words. Or, as Douglas Huebler said, "The world is full of objects, more or less interesting; I do not wish to add any more." Long exhibited with both artists on a telling number of occasions. His *Line* "made" by merely walking up and down the same narrow strip of grass in a field somewhere in Somerset, a gesture memorialized with a minimum amount of fuss (using a very basic camera, yielding just one image), is an emblematic work in this respect. The understated drama of Long's refusal of production, of

"making" as such, is here set in something resembling the natural world itself—a world seemingly devoid of dubious human impositions, enjoining us to "take only photographs, leave only footprints."

The meadow in Somerset where art and production part ways is also the site where, symbolically at least, art acquired a new degree of mobility—and here too, certain economic developments that defined much of the 1960s first made their impact felt. If Bruce Nauman still clung to the belief that "art is what an artist does, just sitting around in the studio," Long's work showed that even the studio need no longer be part of the equation—a shift facilitated, in part, by the democratization of (air) travel on the one hand and by rapid developments in photographic technology on the other hand. Indeed, Long's work from the late '60s and early '70s—soon after Somerset, he would set off to the far ends of the earth, from the Andes to Alaska and Texas to Malawi—is also paradigmatic in that it heralds the advent of the artist as the quintessential contemporary nomad. No longer weighed down by an oeuvre made up of burdensome inanimate objects, no longer chained to a fixed studio address, and freed, at long last, from the stifling duties of production, the first generation of conceptual artists to which the likes of Huebler, Long, and Weiner belonged did much to shape both the infrastructure and mindset of the art world as we know it today—a world that requires extensive air travel, to biennials and art fairs scattered across the six continents, and a mind and body both flexible and mobile enough to meet the challenge of even the most casually made invitation. And here, of course, lies one of the greatest ironies in recent art history: what began, back in the late '60s, as an earnest call for the critique of production and its concomitant materialist ethic—cue the "dematerialization of the art object" as chronicled by Lucy Lippard—contributed in no small way to the creation of those conditions of dramatically increased mobility which we now know to constitute one of the main causes of the global greenhouse effect—the art world's ever-growing carbon footprint.

A wild, wide-open question in conclusion: If *A Line Made By Walking* continues to stand as a monument of dematerialization, could it also be said to presage, in some way or other, the digital revolutions of the 1990s and 2000s which have done so much to accelerate the dematerialization of so many key aspects of the world economy? In Long's work, transience and ephemerality are no longer accidental features of a certain type of art-making but have come to occupy its very core, and this too makes *A Line Made By Walking* undyingly contemporary (walking is now big business in art, by the way).[2] It took the artist less than 20 minutes to make the work, and it probably took the grass even less time to rise up again after its trampling; all that ever remained of Long's moment was a fleeting record, itself subject to the merciless onslaught of time—everything in this work is always about to disappear. If the piece ever had any relationship to writing, that relationship derived from its survival as a photo-

A Snowball Track, Bristol, 1964.

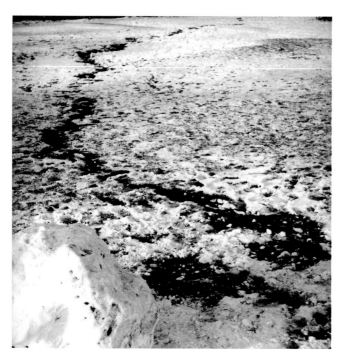

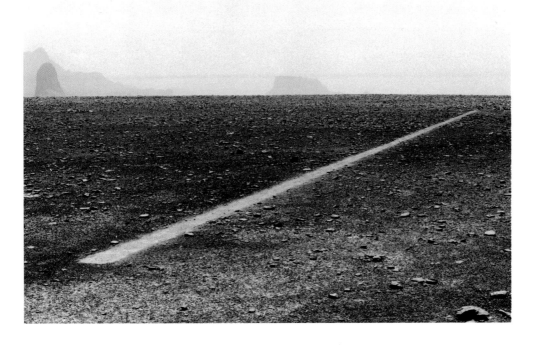

Dusty Boots Line, the Sahara, 1988.

graph: something written with *light*, another transitory "material." It could now be said to resemble an e-mail, *avant la lettre*—something that exists only as immaterial code, up in the air. Indeed, there is an element of gestural immediacy to the work that, four decades later, seems to resonate rather well with the very structure of electronic communication and its overpowering suggestion of an absolute (and absolutely shared) presence. *A Line Made By Walking* really only existed for a very brief moment in the summer of 1967, yet it continues to cast its long shadow—and this is something that could now be said to be characteristic of many a cyberian event (the quintessentially post-material language of the event is another cultural complex first mapped or touched on by the pioneers of 1960s conceptual art). The Web is yet another non-space built on the precondition of the erasure of every step ever taken in it, yet its memory for traces is theoretically inexhaustible. Is this the reason why Richard Long does not have an e-mail address and chooses to avoid digital existence? Because *one* line made by walking, one sentence written in mid-air more than 40 years ago, will suffice?

Notes

1 See Dieter Roelstraete, *Richard Long: A Line Made By Walking* (London: Afterall Books, 2010), pp. 39–46, for a full discussion of contemporary environmental milestones and pp. 43–45 for an examination of how Long's work fits a particularly English paradigm of art in the land.

2 Ibid., pp. 9–19, for a historical and theoretical discussion of the politics of walking.

Forms Behaving in Time:
A Conversation with David Nash

by Ina Cole

Immersed in the sensibilities of wood, David Nash has a highly developed understanding of the complexities underlying tree growth. His longstanding base, the aptly named Cae'n-y-Coed (Field of Trees) in the slate-mining region of Blaenau Ffestiniog in North Wales, serves as inspiration, laboratory, and studio, launching projects that take him around the globe. Since the mid-1970s, this woodland has become home to more than a dozen planted tree sculptures, living "weavings of earth, light, and water" that embody "time and space in their most active forms." *Ash Dome*, the first and most demanding, consists of 22 ash trees rigorously wedged, bent, and pruned to curve inward, an effort that they have stubbornly resisted. Nash decided that this was too much manipulation, and later living works, like *Ash Bowl*, channel the trees' light-seeking inclinations to direct growth. Other works at Cae'n-y-Coed include a serpentine row and braided hedge of sycamores, a wedge of ash, and a neat circle of mown grass—the surviving portion of *Sod Swap*, a 1983 turf-exchange between Wales and England that was originally installed at London's Serpentine Gallery. (The environmental group Common Ground rescued the Welsh half after the show and set its native "weeds" within a manicured London lawn, but it was later destroyed.)

Always mindful of the course of time, Nash makes long-term commitments to many works: for instance, he has spent years following the progress of a wooden "boulder" that he dropped into a stream in 1978. It finally reached the sea in a tidal basin, where it moves slightly with the tides. Eventually it will move out to sea, vanish from view, and return to nature.

Like Nash's outdoor works around the world, his gallery sculptures (made from fallen trees) also live out a destiny, drying, warping, and cracking as they exert organic will against artist-determined form. He is intrigued by nature's relationship to geometry: "Geometry lies behind everything as a living force, not as a dead, abstract, intellectual invention, but as a reality in motion." When Nash started down this path, in the midst of Cold War tensions, economic recession, and nuclear proliferation, planting trees seemed the proper response, and he senses that once again the time may be right for a "bit of homeopathic medicine" that offers something for the future.

Ina Cole: *You call yourself a researcher into the science and anthropology of trees, and there's certainly a distinct progression from the rawness of the first cut shapes to the poise of the recent sculptures. How has your work evolved since you started using wood in the 1970s?*

David Nash: It has evolved, but I'm not that conscious of it because it's just an accumulation of knowledge and experience. As the possibilities become greater, you need better equipment, and that brings new possibilities. I now like working with cast iron because it has a similar quality to wood: it has behavior, it changes, and I like the rawness of that. I've made experimental works by pouring molten bronze onto wood so that it meshes around the charred form. Metal is a mineral when cold—it's an earth element. You apply the heat element to make it molten, and it changes into a water element while fluid. You can then pour it into a space—the air element—and it goes back to being an earth element. I'm interested in these elemental forces being amalgamated and worked at by a human mind.

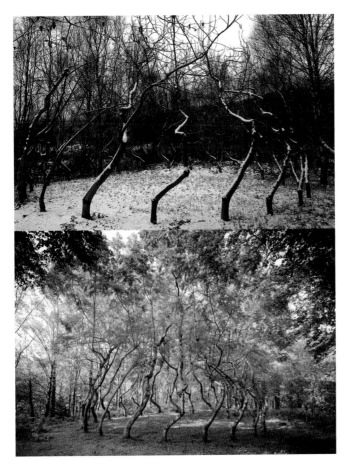

DN: The knowledge is so deep within me, I just deal with it. If the wood is red, I make the most of it being red; if it's a yew, which doesn't split, I make something that doesn't split; if it's a certain size, I do something with that size. Although my material is wood, the tools I use are steel, with edges that hit or spin as in a chain saw, with lots of sharp little chisels going round. I cut as little as possible to get the form and leave the mark of the tool on the wood, so that a sense of the original shape remains in order to build a continuum in the viewer's mind. Some people criticize me for not doing much. Quite right—these are quick sleights of hand, but I've transformed a recognizable piece of a tree into a step-

Top: *Ash Dome*, 1977, matured 1998. Above: *Ash Dome*, 1977, matured 2009. Work created from 22 living trees planted by Nash, located near his home in Wales.

ping-stone linking the human mind, the wood, and the earth.

IC: *You give human characteristics to trees and have described redwoods as benign and calm.* Red Column *has an affinity with Brancusi's* Endless Column, *but you've accentuated its organic vertical growth.*

DN: Brancusi was making a column of breathing, which pushes out into space then comes in. It's very different from my column, which is a pile of lumps. Trees are columns; a tree has its root and its leaf, and it is building a column throughout its life. That's its capital, and the leaf is its revenue, with the root pulling it all up. *Red Column* won't stay red; it will start to go gray after nine months, after which I may char it.

IC: *In* Black Sphere, Husk, Two Sliced Cedars, *the charred, carbonized forms left after controlled burning become ghosts of their former selves.*

DN: Yes, that's what carbon does. The blackened works are about mineral, darkness, absorption. The experience of carbon is of a deeper time. Wood is closer to our own mortality, but if you blacken it, you're into another time zone altogether. I trial the work in a fire to get big texture and thick carbon, then scrape it off; I don't want people to look at the texture, I want them to look at the form. Then I burn it again with propane to get that ethereal quality. Years ago, I remember looking across a green field with black cows, and the cows appeared like holes in the landscape. In

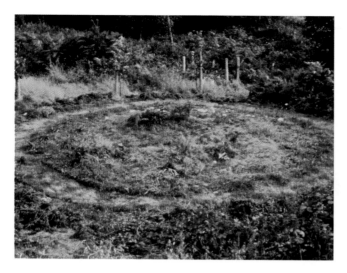

Sod Swap, 1983. View of work in North Wales.

a sense, these pieces aren't there—they've become like holes. When a work is black, you see the form first and the material second; with wood, you see the wood first, then the form.

IC: *Reviewing your 2010–11 show at Yorkshire Sculpture Park for the* Guardian, *Annie Proulx relates an imaginary scenario in which you are half-human, half-lignum, opening our eyes to the sentient forest. Her concern is that humans have lost their spiritual and aesthetic knowledge of the forest, seeing only exploitation and utility. Do you think this is true?*

DN: "Sentient forest" is a good term—like Grimm's fairy tales, which are ancient myths and deep, deep truths. I like to think that my work touches on these truths, and I don't stray from that. My work states an attitude of being, which is my avenue into our attitude toward the environment and toward other people. I hope that people see this interface between the living, elemental world—the environment on which we're all dependent and interdependent—and the human mind, which is in its infancy in terms of consciousness. Tree species are far older than us; there's a level of deep wisdom in these ancient things because of the longevity of their truth.

Human beings need wood—it's about fundamental survival in our environment—and this commonality of experience makes my work accessible, which is partly why I choose wood as a material. It's also about beginnings. I'm working with the four elements, time, and space, and I put forms into time for them to behave in time.

IC: Ash Dome *is a good example of a work that's been launched into time and space. When you planted this ring of trees in 1977, it was an act of optimism during a time of economic gloom. Isn't it ironic that it has reached full maturity in another era of political uncertainty?*

DN: I hadn't actually thought of it like that. It's an artist-attached work, so I needed to be near it, but its concept was longevity, as opposed to quickly changing governments and short-term policies. At the time, people were saying that we wouldn't see the end of the century, so with *Ash Dome*, I thought I'd throw a grappling iron into the 21st century. It had no interest in the millennium itself, but that was its graduation time. It's continuously spontaneous and genuinely of its place, not made somewhere else and brought in like a UFO. Most Land artists at the time did an event, documented it, and moved on, but I was interested in taking responsibility. This was the first piece, and it needed more interference than I'm comfortable with, but I learned a lot from it.

IC: *You have a longstanding interest in the pyramid, the sphere, and the cube. What is it about this combination of forms that continues to inspire your work?*

DN: When Richard Long was asked why he creates straight lines and circles, he replied, "Because they don't belong to anybody." That's a brilliant thing to say, and I realized it's because the forms are universals, not inventions. The footprint of the pyramid is a triangle, the footprint of the sphere is a circle, and the footprint of the cube is a square.

We understand the three-dimensional world through our body size, and we read pictures two-dimensionally—they're two different perception systems. In *Pyramid Sphere Cube*, I've put them together, which people find very satis-

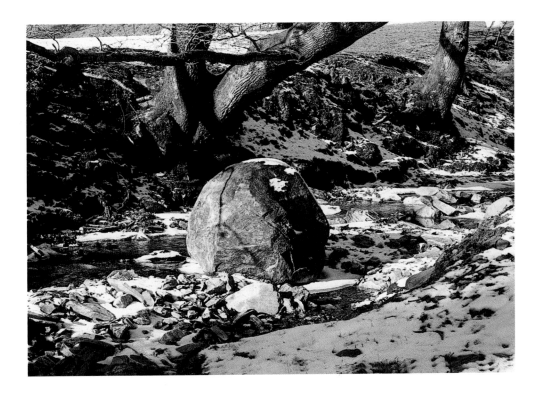

Wooden Boulder, 1978–present; photograph taken in 1990. 400-kilogram chunk of oak left to travel along a river in Wales.

fying. The physical world is a threshold to the spirit world, and people relate to these forms because they speak recognizable truths. They're not highly complex, philosophical truths, they're fundamental: the vertical is awake, the horizontal passive, and the diagonal hugely dynamic. The whole experience is geometric, yet emotional, and everybody identifies with these forms, even children. Of course, we miss a lot now, because there's so much on screen. It makes everything seem the same—everything's virtual. There isn't any "body learning" anymore, and it's terrible for children because they should be playing with objects. It makes them very bad drivers because they haven't got that play experience of body, weight, and speed.

IC: *The relationship between your works in a studio or gallery setting must present a different challenge to the decisions you make when creating work in the landscape. How do you resolve this dichotomy?*

DN: I'm not trying to work consciously with the landscape—it is as it is, outside, inside. Galleries are like little temples to me. I can create an experience that I can't create outside; there are no stops outside. Ninety percent of what I do is indoors. People think it's mainly outdoors, but it's not, because wood is a material that you can borrow from its cycle of growth and decay to bring inside, and then put back into the cycle for it to go into reintegration.

IC: *It's been said that* Millennium Book, *which emits a powerful message, has echoes of Rodin's* Gates of Hell, *which was inspired by Dante's* Inferno. *How does this narrative remain relevant today?*

DN: This century is appalling, with capitalism, greed, and the atrocities that people perpetrate. They always have, of course, but it just goes on and on; they don't learn anything. *Millennium Book* just pitches something to viewers, and where their thoughts go is where their thoughts go—I'm not controlling that, I'm just making a theatrical gesture.

Alfio Bonanno: One With Nature

by Twylene Moyer

In 1979, Alfio Bonanno recorded a performance on video that serves as a manifesto of his approach to environmental art. In this untitled ritual, he cuts a fresh branch from a tree, amputates the lateral growth, and peels away the bark. Then, just as resolutely, he cuts his own thumb with the same knife. His blood oozes onto the branch, mingling with the sap, sap mixing with blood. Dramatic and deeply important to an understanding of Bonanno's subsequent work and philosophy, this action gives concrete expression to his belief that we as humans are one with nature, sharing the same destiny.

Bonanno's approach to environmental art is open, engaged, and pragmatic. It draws on his early roots in Arte Povera's non-conformist use of materials and the heritage of '60s Body Art and protest movements. An ecological and political activist, as well as the founder of TICKON, an international center for art and nature in Denmark that fosters collaborations among artists and specialists (from farmers and artisans to biologists, zoologists, and botanists), he does not romanticize nature or overly aestheticize it with a benign view of its beauty. Rather, he underscores its inherent power, its force and violence, its contrasts and contradictions. He gives us nature as a whole and places us within it. For all their attention to site and materials, his works are visceral in their effect, drawing the elements together as in *East Sea Ring*, a 20-meter ring built out of two-meter sections of pine that bridged land and sea. Setting it on fire added the element of air to the already present earth and water, the ring becoming a fitting symbol of unity. Created in 2000, *East Sea Ring* has since been claimed by the sea. Even when Bonanno's works appear strong and resilient, they are inherently and intentionally vulnerable to time, weather, and natural cycles of decay.

Untitled, 1979. Still from video documentation of performance.

Whether working with trees, bamboo, straw, stone, or garbage, Bonanno's goal is to move beyond concerns specific to the world of art, toward a vernacular language, common to all species, that expresses our interlinked habitation on this planet. He does not so much make finished objects in the land, as uncover the hidden stories of twigs, stones, fossils, plants, and animals. In many ways, he is like a tracker, following signs and symbols to trace the natural history of all that moves

and grows, then creating a dynamic new narrative in which the rest of us can participate. Viewers who pass through his works undergo a kind of initiation in which knowledge is gained through close participation both in the works themselves and in the surrounding environs.

Sometimes the history of a site is written on its surface, found in the patterns of twigs and growth. Other times, it must be pried forth. Bonanno has been particularly fascinated with the fossil life trapped inside stone. For him, rock is never only a rock: it speaks, its history active within it. In *Granite Environment*, he split a huge glacial boulder in two, forcing it apart and leaving his drill marks like wounds across the surface—a new layer in the long interaction between man and stone. The boulder now acts as a passage, a gateway into the past, set atop a block from a demolished tumulus, another fossil trace, this time of ancient human civilization. Standing between the stone halves, surrounded by the primeval foundation of granite, we have entered the strength, resistance, and weight that is stone.

Granite Environment under-

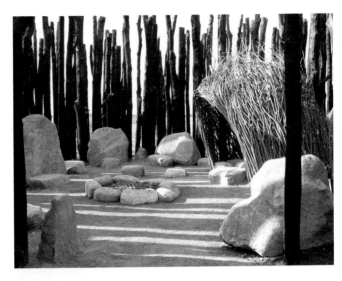

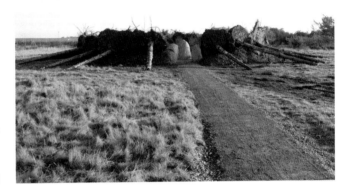

Himmelhøj, 2004. Oak tree trunks, wood, plants, poles, granite boulders, uprooted pine trees, vegetation, and earth, entire site 35,000 sq. meters.

scores a guilty paradox at the heart of human creation that applies especially to work in the land. In order to make, the artist must first unmake; something, whether tree, stone, or microhabitat, must be destroyed in order to create art in a natural setting. Bonanno makes every effort to correct the balance, constructing projects that give back to the ecosystem in which they are introduced. He sees artists as consummate problem-solvers, willing to enter a situation when others have given up and to find creative solutions. For instance, to provide habitat for waterfowl and abandoned pet turtles at the Copenhagen Botanical Gardens, he built island structures framed from fresh willow and sycamore branches and filled them with plant material mixed with earth. Birds, insects, and the wind did the rest, sowing seeds that grew into shade-producing plants, which provided nesting areas for birds and shelter for sunbathing turtles. As the willow grew roots, it attracted fish, frogs, and insects. For Bonanno, the point was to construct the forms in a simple and practical way for use and growth—not to create an artificial sculpture that we, as humans, would find attractive or artistic.

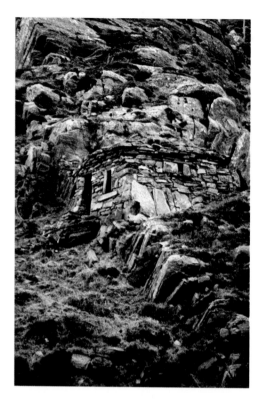

When working in nature, Bonanno feels it almost irrelevant to talk about art. The more he gets inside the structure of a landscape, working with and within its web of materials and changes, the less he feels a need for the theories and conventions of art. Beginning in the mid-'90s, he became increasingly interested in the twin notions of structure and shelter—some suitable for human use, some not. His simple forms are curious conflations of pods, cocoons, nests, beaver dams, and familiar architectural prototypes such as huts and bridges. Regardless of the form, these interactive works alter our perceptions of the world around us; they frame new vistas, draw attention to almost invisible minutiae, and speak the instinctual language of survival, as in *Natural Dialogue*, which acts as a shelter, a food chamber for animals feeding from the grape arbor, and a private meditation space.

Self-contained and closed to human bodies, the two densely woven, pod-like thickets of trees in *Where Trees Grow on Stone* offer a variety of hiding places and nesting areas for spiders, scorpions, and snakes—a gift to creatures that may have been displaced during the construction. A similar principle applies in *Where Lizards Lose their Tail*, a work created in a Japanese bamboo forest. Inspired by a fallen tree supported by standing cedars, Bonanno constructed two bamboo pods and raised them into the canopy. During the process, he discovered an

Alfio Bonanno and Chris Drury, *Wilderness Shelter*, 1995. View of site-specific work at the Wilderness Sanctuary in County Cork, Ireland.

abandoned insect nest, carefully preserved it, and extended its pitted mud surface to the pods, whose tiny holes give free play to the song of the wind and provide cover for the lizards that live there, one of which, surprised by Bonanno, shed its tail—hence the name of the work.

In *Fallen Tree*, a protective web of saplings spun around a dead tree leads to an inner chamber, akin to a child's cozy hideaway. Its sheltering hollow and the open space just outside capture the basic polarities of life: shadow and light, safety and adventure, restful ease and alert action. Within its enclosure, time almost comes to a stop. Past and future cease to exist, replaced by a transcendent, calm present of pure experience, yielding to the concreteness of things as opposed to a world of abstract and ideal images. Bonanno's structures are marginal spaces, in the sense that they are neither nature nor culture, but a synthesis of both. They allow us to experience life as directly lived; "make believe" becomes real because it is made.

At the Louisiana Museum in Denmark, Bonanno has constructed a multi-part menagerie of landscape structures and experiences, a type of trail that continually alters its materials, scale, and relation to the surrounding land. The split-tree *Bridge at Humlebaekken* leads through the stony trough of *Fox Hill Passage* to *Snail Tunnel*, which transforms the concept of the web sanctuary into a long, covered processional through the forest. The culminating intervention, *Eel Box Labyrinth*, consists of approximately 30 recycled wooden tanks (used to keep fish and eels alive during transport) climbing up a slope. Arranged in a funhouse maze of open and closed spaces, the labyrinth offers passages and rooms to be explored in themselves and as part of the environment. Investigating the various

stops along this ecological journey slows human speed to a natural pace, prolonging time and awakening observation and pleasure in the earth.

Bonanno's recent large-scale projects such as *Målselv Varde (Målselv Cairn)* (northern Norway, 2005), *From Earth to Sky* (Sculpture in the Parklands, Lough Boora, Ireland, 2010), and *Seven Steps* (Ii, Finland, 2008) shift perspective from individual to collective experience. Expanding on the concept of shelter as instinctual necessity, they fuse nature and community to create protective spaces tied to the traditional life of small towns and villages. Collaboration and cooperation are key to these undertakings, which mark a return to Bonanno's activist roots. Local input, labor, expertise, and materials instill a sense of ownership and give these gathering places a life beyond art. By sustaining local history and accommodating beloved customs, they become focal points of community activity.

Not all of Bonanno's projects are set in the wilderness or in remote locations. He takes an equal interest in the urban environment, particularly when it comes to works designed to increase environmental awareness. In 1992, he

CO2 Cube, 2009. 12 containers on floating steel platform and LED lighting system, 27 x 27 x 27 ft.

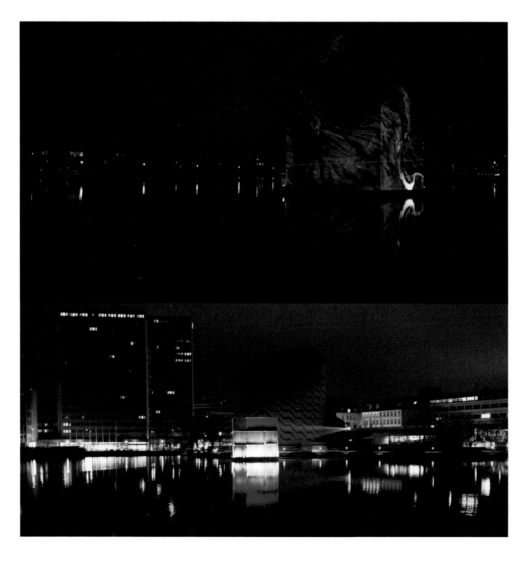

occupied the Danish Parliament Building Square in Copenhagen with a ziggurat built of straw blocks, initiating a dialogue on alternative energy—a few bales of hay can produce the same amount of energy as 200 liters of heating oil. In 1995, working with the Centre for Landscape, Environment and Culture in the 21st Century at Dense, he attempted to reclaim an abandoned garbage dump with a project emphasizing recycling, redevelopment, and interdisciplinary co-operation in which disinterred garbage was re-envisioned as a precious commodity. Bonanno and his collaborators, including local residents, planned to cut a huge trench through the dump, revealing all manner of detritus and transforming it into the narrator of a pointed story. After four years of work, bureaucratic red tape killed the idea.

CO2 Cube (2009), which was shown in conjunction with a United Nations Climate Change Conference in Copenhagen, took Bonanno's activism in a radical new direction. As tall as a three-story building, the 27-foot cube, which was co-designed by Christophe Cornubert, floated on the waters of Saint Jørgen Lake, in front of the Copenhagen Planetarium. The 8.2-square-meter interior measured a space equivalent to one ton of CO_2—the amount emitted each month by the average person in an industrialized country (or two weeks in the case of the U.S.). To underscore the significance (and ramifications) of its dimensions, the cube harnessed an array of multimedia elements, including video footage, real-time data and statistics gathering, and interpretative imagery, all presented via an innovative digital projection system developed by Obscura Digital that allows images to wrap around corners. Two sides of the cube were projected from the roof of the planetarium; the other two sides were generated on the containers themselves by LEDs. Bonanno originally intended to place cubes in different capitals of the world, but the cost was prohibitive and additional funding unavailable. He was "happy with the final location, though, because I really wanted the cube to be on the water since one of the issues with CO_2 is melting ice and rising water levels."[1]

The mediagenic technology behind *CO2 Cube* enabled Bonanno to reach new and wider audiences, with other media picking up and re-broadcasting the climate change message: "It was very visible and generated quite a response. The Climate Conference newspaper gave it front-page coverage. The U.N. secretary general pointed out how important *CO2 Cube* was in communicating the problems of carbon dioxide emissions to a broader public. Google and YouTube collaborated in bringing a broader audience, something quite new for me." For the two weeks of the Climate Change conference, *CO2 Cube* was constantly visible on the Internet via a live feed. Ever adaptable, Bonanno recognizes that "if you want to communicate with a larger public, this is the way to do it now. I could have made the most beautiful nature sculpture, and it would not have had any effect or impact."[2]

Neither a subscriber to aesthetic avant-gardism nor a "nature fascist," Bonanno continues to operate within an ethical avant-garde, one whose vision opens new perspectives on existence and seeks solutions to dilemmas, whether spiritual or ecological. Recently he has received invitations to bring his community-based model of collaboration to earthquake zones. These projects, too, are about more than art; they are about hope and energy for the future. "It is fascinating, Bonanno says, that we can simultaneously discuss the ozone hole and its consequences while considering the possibility of space tourism. We humans are, and always will be, the most complex, destructive, and unpredictable species."

Notes

1 Alfio Bonanno in conversation with John Grande, from an unpublished interview, 2010.

2 Ibid.

Ice in the Whirlwind: Chris Drury's Desert Journey from Antarctica to Nevada

by Oliver Lowenstein

When the British Antarctic Survey publicized its Artists and Writers residency in 2006, Chris Drury, who had been looking for a way to visit one of the earth's most remote and extreme places, applied and was selected. Arriving at Rothera, he joined the scientists and technicians who make up the British base's semi-permanent community: from here, he could fly deep into the continent, as far as the Ellsworth Mountains at 78 degrees south. It proved to be a valuable journey for Drury, who is closely identified with the ecological end of the art world, and, by extension, with the environmental movement.

Over the last few years, politicians, the public, the media, and the art world have become transfixed by climate change and its possible consequences. Drury's residency was well timed in terms of public interest in the environment; he was also well placed at Sky Blu, a small tented base deep inland on the icecap, sharing meals and conversation with glaciologists. Over the previous decade, Drury, who has been identified as one Britain's most important Land artists, alongside Andy Goldsworthy, Richard Long, and David Nash, had become increasingly preoccupied with the modern scientific outlook. His explorations of flow, chaos, and complexity in the natural world first surfaced in *Edge Of Chaos* (2000), which led to a series of works linking the land to the body (*Heart of Stone, Rhythms of the Heart*), some with a medical overlay.

As part of his research at Conquest Hospital (in Sussex, Southern England), Drury observed images of a beating heart—an inner landscape corresponding to landscapes in the outer world. The resulting series, "Heart Waves," uses digital prints from echocardiograms. In *Rhythms of the Heart*, he hand-wrote a series of lines radiating out to a circumference, recording the names of every medicinal plant used to treat heart ailments and interspersing them with a nurse's diary from a 12-hour shift on a cardiac ward. He also began applying inner/outer connections to various outdoor commissions.

The most ambitious of these works, at least in terms of physical scale, is *Heart of Reeds* (2005) for his hometown of Lewes, Sussex. Seven years in the making, this art site/reed bed is designed to increase biodiversity on the borderlands where water meets earth. Drury says that *Heart of Reeds* is "something very sane in a crazy world where art, science, ecology, medicine, a wildlife trust, a district council, a county council, an arts council, schools and colleges, a waste management company, a brewery, a water company, and a large construction company can all work together to produce this extraordinary thing." Here, on a three-acre site within the Railway Land Nature Reserve, Drury's work, which provides refuge for various at-risk species, is landscaped into a cross-section of the heart's apex—an ecologically practical and conceptually rich approach to an outdoor artwork. It was no easy task to make a reed bed into a sculpture while keeping in mind that the design would have to be harvested and cleared every few years without disturbing the wildlife (the heart's ventricles offer a division, and the work is cleared one half at a time). Since the project's completion, the swirling channel and island forms have been taken over by the reed beds at the water's edge, and aquatic creatures, birds, and insects have settled in. *Heart of Reeds* takes the merger of ecology and medicine as its reference point. As Drury says, "Science is here, and art is here, in completely different places—divided. But when you talk to sci-

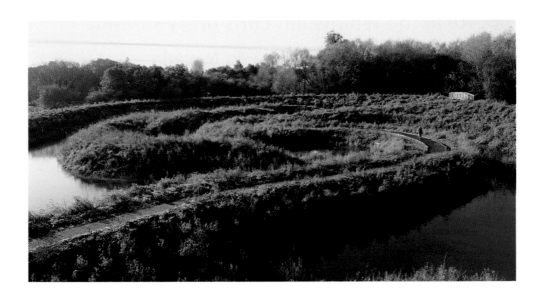

Heart of Reeds, 2005. Earth, water, and plants, 3-acre site, approximately 8 x 210 x 110 meters at the mound.

entists, they often think like we artists do. The breakthroughs all come through in the same, intuitive space, whether in art or science."

The promise and threat of science continue to be primary sources of inspiration in Drury's work. His 2008 exhibition at the Nevada Museum of Art, "Mushrooms | Clouds," showed him moving ever further from his Land Art roots and taking on aspects of the nuclear question. The works in "Mushrooms | Clouds" were closely related to Drury's experience of Antarctica, and to its life at the edge of death — a place of absolute nothingness that contains the essence of everything.

If Drury had ideas for what he might work on before he left for Antarctica, once there, his expectations were completely blown away, the singularity of the experience defying rational perspective: "When you're there, you don't know what you're doing, frankly, because it is so extraordinary. All I was doing was experiencing the place, and these few works I made on the ice were just bits and pieces along the way. It is totally and utterly empty. It has that feeling of nothingness. The only life we saw was a storm petrel, a small bird which had got blown off course, which was suddenly there. Otherwise it's lifeless. You don't get ill because no germs, viruses, or mold can survive there. But at the same time, it's incredibly exhilarating. The light's intense. There are crystals in the air, like gold-dust in the sunshine. And there's all this information in the ice, which is what the scientists are there for."

Gradually ideas did come. Drury began to feel the immensity of the ice both in time and space. The ice core, reaching four kilometers down into the earth, is also temporal, built up over 900,000 years. He realized that this time span could be compared to the period during which the human species has been on the planet: "It's relatively short in terms of the earth, but it's the generator of life on the planet. A lot of the climate is generated by Antarctica because it's a land mass, and the circulating current affects and drives the climate throughout the earth."

Drury learned that scientists working in the remote and lifeless Ellsworth Mountains had found proto-bacteria in the soil. This is the first building block of soil nutrients and therefore a kind of life-in-waiting. In *Life in the Presence of Death*, Drury stenciled the 700-gene sequence for this primitive organism on paper, using Antarctic soil. Later, in Nevada, he took the piece a step further. Scientists working for the Desert Research Institute at the Nevada Test Site provided him with a magnified image of the sino-bacteria Microcoleus vaginata (found in the soil of Frenchman's Flat,

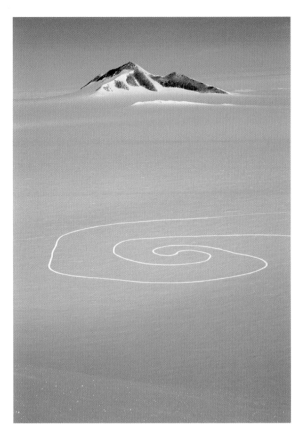

Wind Vortex, 2007–08. Photograph documenting part of a double vortex pre-plotted on computer and transferred via GPS to a several-acre site near Lanzarotti Nunatak, Antarctica.

where 100 atmospheric tests were carried out) and an image of the test site from space. By coincidence, the one looked like a microcosm of the other, which spawned two further works: *Life in the Field of Death II*, a 559-partial-gene sequence stenciled onto a 60-foot wall of the Nevada Art Museum in Nevada Test Site soil, and *559 Shelter Stones*, a primitive shelter of partially scattered stones that evokes vulnerability in the face of huge explosive forces. Just like the gene sequence from the Ellsworth Mountains, which seemed so extraordinary in a place "so utterly dead," this bacteria and its regeneration at the atomic test site spoke a language of everything and nothing.

"A Heartbeat of the Earth," Drury's Antarctica exhibition at the Beaux Arts gallery in London, was divided between documentation of work done at Sky Blu and work inspired by the stay but completed back in his Lewes studio. One photo essay documents a fingerprint (a familiar Drury motif), drawn onto the ice with a dustpan and brush after a fresh fall of snow. *Wind Vortex*, another drawing spanning several acres, was planned and downloaded onto a GPS and made with the device strapped to a ski-doo after a fresh fall of snow at Sky Blu. Drury also transposed a formalized version of this vortex, found in the designs of Native American coil baskets, onto an alkali lake bed in northern Nevada on the boundary of the Paiute Indian Reservation. *Winnemucca Whirlwind* referenced the devastating storm of environmental and cultural change that the Paiute people have faced from the mid-1800s to the present day.

The second strand of Antarctic works adds to an already familiar theme—the marriage of digital imaging with the handmade, principally in the guise of handwriting. Drury uncovered beautiful ice imagery sourced from echogram radar imaging. The echograms are made by bouncing a radar beam from the undersides of the wings of a Twin Otter plane, down through the ice to the bedrock, and back into a computer, recording the forms, movement, and structure of the frozen water below. Using the echogram's scientific data, Drury created a series of visually meditative, though abstracted, records of the ice, reiterating his earlier medical prints. Many of the post-Antarctic pieces that Drury worked on in his studio use data sourced from echograms, ice-core analogues to medical echocardiograms.

Explorers at the Edge of the Void, for instance, resulted from a visit to the European Nuclear Research Centre, CERN, soon after Drury returned from Sky Blu. He was enthusiastic about CERN's Genesis Project, which mimics in small scale certain conditions of the Big Bang in the hope of finding the "theory of everything." As Drury explains, "I thought about…how physics is about the smallest things and the largest things, but also how man cannot be taken out of the equation. Over the last century, there have been giants of physics like Einstein and Planck, who were

contemporaries of the South Pole explorers, Amundsen, Scott, and Shackleton. On the one hand, there are explorers [reaching] the extremities of the earth, and on the other, this metaphysical exploration. I found that really interesting, as it seems to be coming to a head now." *Explorers at the Edge of the Void*, a large-scale canvas of inky words, plays out the patterns over an Antarctic echogram. The names drawn from both physics and South Pole exploration gradually morph into theories, and finally into the equations that guide CERN's collider experiment. If Drury describes the CERN visit as amazing, its implicit inversion—a theory of nothing—remains unspoken, its traces silently embodied in his many Zen-inspired works.

For his first large-scale exhibition in the U.S., at the Nevada Museum of Art, in collaboration with California's For-Site Foundation, Drury worked with scientists at the Desert Research Institute, an environmental science center based at the Nevada Test Site and in Reno. He also read *Savage Dreams*, by West Coast eco-activist Rebecca Solnit, which testifies to the fate of Native Americans as they were removed by the powers of the Atomic Age. This research, together with information on Paiute land and water rights struggles at Pyramid Lake and ancient Maidu hunter-gatherer practices in the Sierra around the For-Site land, informed the Reno exhibition.

Drury has long been interested in Native American world views. *Destroying Angel*, a work in three progressively dimmer parts, is based on the poisonous destroying angel mushroom, *Amanita virosa*. Mushrooms, as much as peyote, are part of Native American culture in the Southwest. For the Nevada exhibition, Drury overlaid these connotations with the death-pall that rises from nuclear explosions, piecing together a mushroom cloud from approximately 1,670 small bundles of sage brush, strung floor to ceiling on nylon thread. This new form was accompanied by a short video loop of sage brush smoke, which returns to Drury's enduring fascination with the chaotic flow-forms of the natural world.

Winnemucca Whirlwind, 2008. Raked alkali flat, 300 ft. diameter. Created in collaboration with the Pyramid Lake Paiute Tribe, Nixon, Nevada.

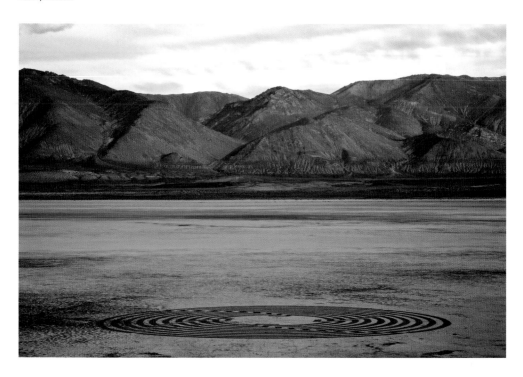

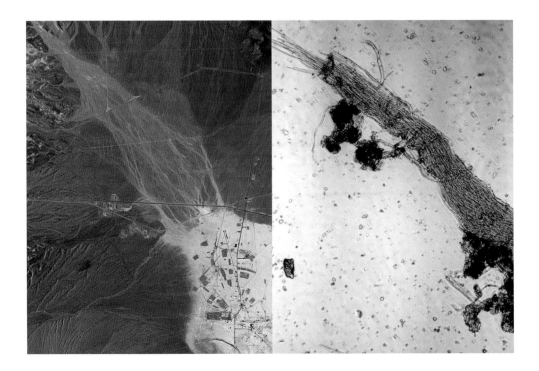

Life in the Field of Death I, 2008. (Left) satellite image of Nevada Test Site where 100 atmospheric nuclear bombs were exploded; (right) microscopic image of Microcoleus vaginata, a soil microbe at the test site.

These works, Drury acknowledges, give a wide reflection on "the state of the world." Part of the '60s generation, he is edging toward a more fully crafted consideration of these scary times than others from his Land Art generation. And yet his work from the '80s and '90s, even though it questioned the continuum between culture and nature, betrays scant sense that 10 or 15 years later, he'd be addressing such first and last things. Whereas Drury's earlier work, like much ecological art, focused on the living world, his new explorations, beginning with *Destroying Angel*, introduce death into the equation. The emergence of these polarities in his recent work—the absolutes of life and death, of everything and nothing—indicates his capacity to grow creatively and to respond to increasingly anxious cultural circumstances.

The simple "Land Art" tag, long interpreted as a romantic gesture against the scientific mindset, no longer makes much sense for Drury. Since the publication of his book *Silent Spaces* in 1997, his journey can be read as indicative of a rapidly changing world and his curiosity to engage beyond traditional Land Art horizons. Referring to this journey into science, he says, "it has opened the whole thing up. What's complicated for me is that I'm dealing with different people and different ideas, and it gets more and more complicated as life goes on, but also richer. It's so complex, as there's so much of it, but there's also something simple running through it."

Andy Goldsworthy: Restoring the Senses

by Twylene Moyer

If we understand "environment" as the sum total of our surroundings, a fusion of the natural world and the present, as well as past, dimensions of human culture, then Andy Goldsworthy is the consummate environmental artist. His work holds within itself a balance of nature and culture, of past time, immediate lived experience, and future possibilities. Through his actions of making sculpture in the land and through the final works themselves, no matter how short-lived they may be, he points the way to a recuperation of the incarnate, sensorial dimension of experience and offers a viable alternative to the all-consuming manmade reality that limits our contact with the outside world and cuts us off from the earth of which we are a part. His lyrical interplays with trees, leaves, water, stone, and snow restore a kind of forgotten vision, opening our eyes to the particulars of the natural world in all their infinite variety and detail. Seldom do we see, hear, and feel what is, in fact, a vast interwoven web of perceptions and sensations formed by countless other bodies—icy streams tumbling down granite slopes, lichen, leaves, invisible breaths of wind. Such minutiae simply do not register when landscape is reduced to an inert backdrop for human dramatics, a drive-through panorama projected on the windshield.

Though Goldsworthy has never been considered a pioneer, his acute sensitivity to the accidental poetics of natural elements—their minutest material properties and processes—distinguishes his work from that of Richard Long, David Nash, and Alfio Bonanno. Approaching the found materials of nature with a craftsman's eye for shifting nuances and cyclical transformation, Goldsworthy creates from almost nothing: red pigment powder tossed in the air disperses in

Ash throw / and shadow / midday sun / on the edge of storm clouds, Galisteo, New Mexico, July 24, 1999.

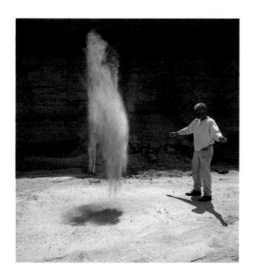 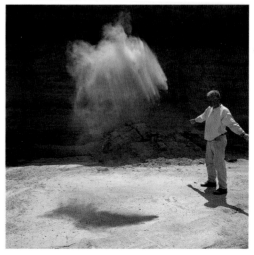

Dandelions / newly flowered / none as yet turned to seed / undamaged by wind or rain / a grass verge between dual carriageways, near West Bretton, Yorkshire, April 28, 1987.

wind-drawn formations; a woven cloth of leaves, hung on a tree trunk, picks out the deeply furrowed patterns of chestnut bark. Like the elements from which they are made, Goldsworthy's sculptures consist of repetitive arrangements and juxtapositions that never exactly repeat themselves. Winding serpentine lines, a favorite found figure that captures flow, movement, and the arrow of time, take on new dimensions with each iteration: excavating channels in a mound of sand, unfurling as autumn-colored, thorn-stitched leaves against a field of green grass, emerging from within the craquelure of dried clay, and even rising as stone walls wandering through trees. Every work is unique, each set of circumstances, feelings, and interactions resulting in a new creation. His process of making—from the most ephemeral, momentary action to semi-permanent constructions based on pre-industrial forms such as cairns, arches, walls, and sheepfolds—mirrors the growth of nature. The duplication of individual cells extends into patterns, which coalesce into form and mass.

Preliminary Sketch for *Snow House*, 2010. Graphite on paper, 8.25 x 11.25 in.

Living nature acts as an essential partner for Goldsworthy. Characterized by reciprocity, exchange, and interplay, his sculpture reintegrates the human individual into the seasonal rhythms of the land. (This integration is key to his many works that draw on the agricultural past.) Environmental architect James Cutler makes an important distinction between those makers who approach a prospective setting as a "site" and those who talk about the "land." Site betrays an attitude of intervention or domination—something to be reshaped and altered to enhance an imposed creation— while land indicates an openness to collaborative dialogue. Goldsworthy obviously belongs to the latter group, and for this reason, his work is genuinely land-specific and contextual—an intuitive response to the conditions and elements found in one particular spot at one particular time, a cooperative effort between intention and accident. There is no need to reshape "inert materials," to alter them into an external form that represents something else or that refers to an abstract concept. The work and the material are one and the same. Goldsworthy's sculptures do not stifle the non-human, independent character of his collaborators; instead, he allows their intrinsic properties to live and breathe, respecting their dynamism and power. His touch is feather light, a shadow passing over the land: there and then gone—a fleeting presence in the palimpsest of entities and forces that together form the earth's surface.

For this reason, his work seems to be of the land. It belongs. To come across one of his insertions is to encounter the completely unexpected, but not out of place. There is something intuitively possible about snowballs lining up along horizontal tree limbs, icicle stalagmites rising out of rock, and hieroglyphic trails routing through chalky cliffs. Almost not made, they could be artifacts left by animals or shaped by chance events, any traces of the human hand and intellect so slight as to defy attribution and intention. These apparitions partake of the same marvelous hybridity that characterizes such accidental wonders of ambiguous creation as bridges artfully sculpted by elemental engineers

or ancient monoliths whose ghostly features have faded back into matter. No line of demarcation identifies where art ends and nature begins, a deliberate fusion that Goldsworthy emphasizes when he says that his works have "to feel as if [they have] fallen there." When one of his creations makes its unforeseen appearance, it re-stages its surroundings, bringing "scenery" to the fore. It makes us stop and reconsider what we may have missed before our senses were alerted. (Perhaps ironically, photographs—an essential element in Goldsworthy's work—further concentrate this power, as do his indoor installations.) By creating an intimate focal space within the "undifferentiated" vastness of the "landscape," Goldsworthy directs and concentrates experience. In this respect, he acts as a translator for the natural world, a mediator who brings his engagement to the rest of us. Through his work, we learn to immerse ourselves in the larger whole, to reinsert the ego into the fabric of life.

Drawing on found beauty, Goldsworthy makes sculpture that is intensely personal and yet communal. The wondrous quality so evident in his sculptures—their rightness and simplicity—stems from this conjunction of personal response and shared communication. His work is immediately accessible. There is nothing to decipher. He renders visible what we all see without knowing it, restoring a sense of wonder in natural phenomena that we have learned to take for granted. There is a sense of joy, mirth, of sheer reveling. Goldsworthy exemplifies curiosity and fascination, making art from free and engaged play. (The liberating aspect of his influence is clear along any trail in any park around the world, where visitors leave small tokens in crooks of trees, along streams, and in rock crevices.)

A fascination with geometry, ritual, labor, and time unites Goldsworthy's immense body of work, drawing together the actual, the experiential, the seasonal, the historical, and the cosmological. *Snow House*, his ambitious proposal for the DeCordova Sculpture Park and Museum, conjoins all of these interests while adding a purposeful commitment to community. Set deeply into a slope along the side of Flint's Pond (where farmers once cut ice), the granite structure (based on the design of early ice houses), will house a single nine-foot-diameter ball of snow. Each winter, after the first significant snowfall, local residents will build the snowball and then entomb it within the shelter; come summer, the chamber will be opened once again to reveal the last relic of winter as it melts away. For Goldsworthy, *Snow House* is "a container—a forum for change, memory, replenishment, season—in which construction and care...along with interaction...are integral." Marking the seasonal cycle in perpetuity, the work will also act as a monitoring system for changing weather patterns, charting precipitation and temperature variations through experience: When is the ball built, and how long does it take to melt?

Once again, Goldsworthy teaches us to observe and notice, but this new work shifts emphasis. It is no longer enough to see and experience the natural world—as the environmental movement has discovered, appreciation of pristine beauty has not slowed destruction or modified human behavior. Goldsworthy, who has been so instrumental in raising our awareness of the larger world and who has always understood that the environment is inseparable from us and our creations, is now directing our eyes beyond natural wonders to a future as potentially ephemeral and fragile as a snowball.

Eco-Logic *(1990)*

by Eleanor Heartney

After remaining dormant for most of the '80s, ecological awareness is suddenly all the rage, subject of a best-selling book (*The End of Nature* by William McKibben), object of a celebrity benefit sponsored by Madonna and Kenny Scharf, and theme of any number of recent art exhibitions. For an art world lately content to accept Baudrillardian assurances that nature is nothing more than an arbitrary cultural code, such recent occurrences as the Alaskan oil spill, the widening of the ozone hole, and the depletion of the Amazon rainforests have rather forcibly brought home the point that nature may be real after all.

However, as reflected through the prism of art, ecological awareness too often has remained enmeshed in a romanticized notion of nature as Other. The myths of arcadia, the sublime, and the conquest of nature by technology all tend to oppose nature to mankind and culture and to glorify or dramatize the conflict between them. This is certainly the underlying text of the Romantic landscapes of Church, Ryder, and Turner as well as their latter-day descendents like Mark Innerst and April Gornik, for whom the archetypal landscape image is that of a tiny figure reduced to insignificance before the fury or magnificence of nature. One may also trace this attitude in the work of many Earth artists of the late '60s and '70s, whose grandiose land projects and transformations at times suggested the aftermath of skirmishes in the war between the forces of nature and development.

What has been largely missing in art that deals with nature—and from the larger world it reflects—is a sense of genuine connection between the processes of nature and those of human life, culture, urbanization, and industrialization. It also lacks an awareness that to speak of nature is to speak of ourselves as well. Only now that some of the earth's essential regenerative systems may have been irreparably damaged is it becoming clear that the mere conquest of nature may be a Pyrrhic victory. To mend the rift between nature and culture, it will be necessary to balance their respective claims, rather than play the game of winner take all.

Recent works by three artists suggest different systematic ways of thinking about nature and culture. The most problematic is Ashley Bickerton, who has turned from a celebration of consumerism to an exploration of environmentalism. His New York show at Sonnabend Gallery featured a variety of elaborate storage cases containing seed pods, dried grasses, industrial rubbish, and trash. Designed to suggest time capsules that could theoretically be floated out to sea or hung from mountain cliffs (though it is unlikely any owner of these pricey items would be persuaded to set them free), these works embody a rather pessimistic notion of nature as relic. In a conversation with Mark Dion published in *Galleries Magazine*, Bickerton described his intent: "Most often, for Western culture, nature's place has been that of property or resources. This view now seems to be changing or shifting. This body of work implies that no view of nature is innocent, without interest; whether that view be nature as product or nature as museum. In the U.S., we no longer engage in a dialogue of how nature constructs us, but rather how we construct nature. What can be considered nature in the days of genetic alteration, waste management, desertification, all-natural frozen fruit drinks?"

Nature, Bickerton suggests, is inextricably entwined with the forces of development. In keeping with this philosophy, the cases are constructed of environmentally hazardous materials. *Composition in Red and Yellow*, for instance, is

Mierle Laderman Ukeles, *Flow City*, 1983–90. Public art/video environment at 59th Street Marine Transfer Station, New York.

Mierle Laderman Ukeles, *Freshkills Park*, 2001. Aerial view of 2200-acre site.

a kind of homage to Minimalism and consists of two protruding boxes, one featuring a painted square of cadmium red, the other cadmium yellow. On the side of the boxes, Bickerton lists the toxic qualities of cadmium.

Another theme of these works is the futility of our romantic longings to return to a state of undefiled nature. That this cannot be is the message of *Stratified Landscape #1*, which looks like a cross between a museum display and a piece of farm equipment. A row of boxes with glass windows and a canvas basket are stacked on top of each other. They contain samples of materials—dried seaweed, bits of coral, quartz, beans—as if they were putting nature on the examining table.

Like Bickerton's forays into commodity critique, these works are deliberately complicit—actually drawing support from the system they rhetorically condemn. While they effectively demonstrate the intermingling of nature and culture, they offer no way out of the destructive cycles that they chronicle and prefer instead to luxuriate in the certainty of environmental disaster.

Neither as trendily apocalyptic nor as flatly didactic as Bickerton's seed-filled reliquaries, David Nyzio's process-oriented assemblages mix the natural and the industrial as if their interdependence were never in question. "Form," an exhibition of his works at Postmasters Gallery in New York, underlined his fascination with the structures and systems of nature. In a manner that recalls the work of Alan Sonfist and Gilberto Zorio, or Hans Haacke in his pre-political days, Nyzio frequently creates environments that change organically over time. At the Anchorage in Brooklyn, he ran water over a huge shower curtain, allowing a film of algae and organic matter to grow over it. Another work, *Perfect Progression of Random Spacing*, which has been exhibited in several shows since it was first constructed in early 1988, features a column of clear plastic filled with water-immersed golf balls whose slimy green coating grows thicker with each appearance.

While Nyzio's works have something of a science-project ambiance, there is generally an edge that lifts them out of the realm of gee-whiz experimentation and into a more philosophical plane. For instance, *Form*—an iridescent tapestry composed of thousands of small squares cut from butterfly wings pinned to the wall—is astonishingly lovely, rippling with shades of rose, blue, and violet that shift as the viewer crosses in front of it. At the same time, and in a way far more effective than Bickerton's bald description of cadmium's toxicity, all those little wing fragments remind us that there is often a link between beauty and cruelty and between art (or culture) and ecological destruction. *Morphology* makes a similar point. Here, a miniature mountain has been created from a mound of milkweed bugs— used in experiments by college biology students—that Nyzio raised himself. Despite these hints at a political stance, Nyzio's works are more poetic than polemical. They unify the forces and materials of nature with those of the industrial world, implicating both sides in the organic world's cycles of dissolution and degeneration.

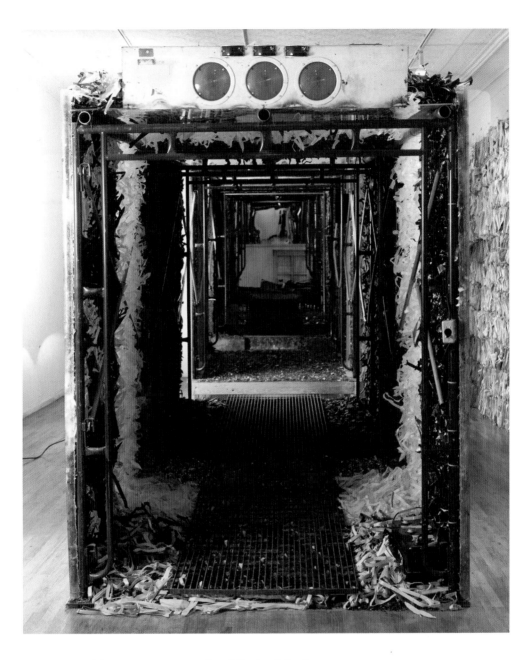

Mierle Laderman Ukeles, *RE-ENTRY*, 1987. 20 tons of recyclables, installation view.

Bickerton's neatly encapsulated rubbish and Nyzio's disintegrating golf balls and shower curtains touch on the problem of waste management. No artist, however, has considered this issue as thoroughly as Mierle Laderman Ukeles. For the last 10 years, she has been the unsalaried artist-in-residence at the New York Department of Sanitation (her interest in the subject goes back to 1969). Ukeles uses a variety of media to drive home the social and global implications of waste management. Much of her work has attempted to make the despised and normally ignored sanitation system visible. To this end, she has choreographed street "dances" for garbage trucks, created multimedia

installations within waste facilities, built architectural structures out of waste materials, and even undertaken to shake the hand of every sanitation worker in New York.

For the last five years, she has been working with the sanitation department to open the city's new marine transfer station on West 59th Street to public view. This station is the site at which thousands of tons of garbage are transferred each day from trucks to barges on their way to a landfill on Staten Island. When completed, *Flow City*, as Ukeles has named her project, will have three parts. It will consist of a passage ramp built of crushed waste materials that will provide a view of the collection trucks, an observation deck looking out over the barge-launching area, and a wall of video screens that will monitor the facility's other activities and provide information on waste management and other environmental issues.

Set against a particularly lovely view of the Hudson River, *Flow City* is a graphic demonstration of the city as organism, in which the flow of garbage operates as a kind of circulatory system. Waste maintenance becomes a metaphor for the maintenance of life on the planet, and Ukeles reminds us that the earth is an ecosystem in which garbage, toxic waste, and chemical and nuclear byproducts only seem to disappear.

The re-emergence of environmental concerns at the end of a decade that seemed largely devoted to private gain is a hopeful sign. The new prominence of artists like Carol Hepper, Petah Coyne, Meg Webster, and others (many of whom have long been concerned with environmental themes) seems to suggest that the art world has turned away from the self-aggrandizing individualism of the 1980s toward a more socially and ecologically minded consciousness. Of course, as the much-publicized but probably not particularly remunerative Madonna/Kenny Scharf rainforest bash suggests, even the environment can become fodder for fashion disguised as politics. If eco-awareness is to be anything more than another art theme-for-a-day, it will be thanks to artists like Ukeles, Nyzio and, much more problematically, Bickerton, who suggest ways of thinking ourselves back into the overall scheme of nature.

Breaking Ground: Alan Sonfist, Helen Mayer and Newton Harrison, Mel Chin, Michele Oka Doner, Jody Pinto, and Aviva Rahmani *(1991)*

by Jude Schwendenwien

As the 1990s begin to take shape, the art world has shifted noticeably away from the rampant commercialism and ego-tism of the '80s to a more heightened awareness of social and environmental problems. Ironically, many artists whose work appears to be socially engaged have simply jumped on the latest fashionable bandwagon (not unlike McDonald's becoming environmentally conscious by getting rid of Styrofoam containers). As with any fad in the art world, only time will separate the wheat from the chaff, the genuine from the phony. The trendiness of environmental art may actually prove to be beneficial if it serves to increase public awareness of urgent problems.

The most compelling environmental artists today developed out of such '60s and '70s traditions as Earth Art and temporary site sculpture. However, unlike the earthworks of this period by Heizer, Smithson, and others, this newer work does not treat the earth as raw material for formal transformation. Instead, it takes its formal cues from nature's historical or virginal condition. Nature becomes the end, not the means, of the artistic process. Artists like Alan Sonfist, Helen and Newton Harrison, Mel Chin, Michele Oka Doner, and Jody Pinto use art as a tool for environmental healing and land reclamation. Working closely with architects, environmentalists, public officials, scientists, and local commu-nities, they seek to initiate beneficial change and reverse the damages from mankind's battle with nature.

One of the leading figures, perhaps even the forefather, of this kind of environmental art is New York-based Alan Sonfist. In 1965—when urban land restoration did not yet exist—Sonfist oversaw the planting of his Illinois *Time Landscape*, the precursor to his famous New York *Time Landscape*. This site-specific project on the corner of La Guardia and Houston streets was fully realized in 1977, though it was initiated in the mid '60s. Years later, Sonfist is still devel-oping this idea of narrative landscape in his 10-mile-long *Natural/Cultural Landscape of Paris*, which begins preliminary construction this fall.

Like other artists who practice healing and reclamation, Sonfist strives to return the land to a prior historical condition. He goes as far back as ancient cultures or the Renaissance to find the basis for future solutions. New York's *Time Landscape* was modeled after a colonial forest, with indigenous plant species that would have originally grown on the site in the 15th century. The reintroduced historical spe-cies give the project an extra charge; although it is based on scientific

Alan Sonfist, *Time Landscape of New York*, 1965. Trees and earth, 45 x 200 ft.

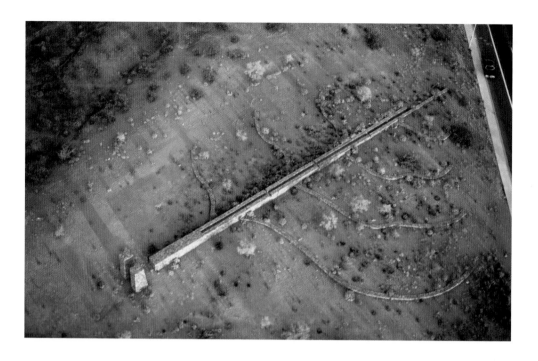

Jody Pinto with Steve Martino, *Papago Park/City Boundary Project (Tree of Life)*, 1992. Stone markers, dry-stacked fieldstone terraces, and plant materials, 2 acres.

research and planning, the work has a magical quality, as if Sonfist reconnects us with the vast historical continuum that is the earth's environment.

Providing the viewer with an opportunity to get reacquainted with the land is essential to Sonfist's work. As he states, "I'm trying to provoke people to think about the environment, to focus on the poetry of the forest, not to present a science exhibit. Art is a form of dialogue, a continuous richness you go back to again and again because there's something there that you don't comprehend right away. It's not an end in itself, but a growing entity."

Sonfist is intrigued by how art can extend the findings of science, enlisting the imagination to push scientific ideas (in the tradition of Leonardo da Vinci) to the furthest degree of speculation. Sonfist asks himself how he can stretch these premises to create a clearer interpretation of the environment. His projects of the last 25 years establish a radical precedent by which other environmental art projects can be measured. This radicalness derives in part from his awareness of the implications of removing art from an institutional context and siting it in the natural world.

Sonfist and other artists of his ilk view their large-scale projects as living museums that provide natural markers for human existence. They work to counter the ignorance resulting from our gradual disconnection from natural history. A key strategy for promoting the healing and reclamation of the land is to provide actual examples of what once existed before mankind's intervention.

Aviva Rahmani, who in the past has dealt with personal healing, has now extended that concept to embrace the ecology on a group of remote islands off the coast of Maine. She has initiated a long-term project (1991–2000) titled *Ghost Nets*, referring to the invisible monofilament fishing nets that get lost and strip-mine the ocean, which she sees as a metaphor for the "trap of the familiar." Rahmani has purchased land on one of these islands to create the first section of the project, a Medicine Wheel Garden based on a Native American ritual that heals the earth. She is gathering boulders and placing them on a 100-year-old manmade promontory. Since the promontory hosts an established

ecosystem, destroying it would result in another kind of damage. Rahmani's solution is to use it as a foundation to reintroduce the island's pre-inhabited state, 200 years ago. Since much of the indigenous hardwood has been stripped, causing extensive erosion, she is introducing pin oak, Norway maple, Chinese chestnut, and Siberian elm at specific points of the Medicine Wheel. The ultimate goal is to make the promontory more hospitable and to reintegrate 10 microclimates and micro-ecologies to reinforce the existing ecology, which includes freshwater ponds. The land will ideally become self-sustaining, bearing seeds, fruits, and nuts beneficial to birds and insects.

Jody Pinto also creates works that integrate seamlessly into the natural environment. In projects such as *Papago Park/City Boundary Project* (1990–present), she investigates local environmental damage perpetrated by past and recent civilization. The goal of *Papago Park/City Boundary*—a collaboration with Arizona landscape architect Steve Martino, sponsored by the Phoenix Arts Commission and the Scottsdale Cultural Council—is to re-create the plant and animal life that originally thrived on the land. The park's entire ecological system was damaged in the 1930s, '40s, and '50s when workers clearing the land removed the bursage cactus, which is integral to the life cycle of the saguaro cactus (sheltering its seedlings, among other functions). Pinto and Martino plan to revitalize the park through a natural system of water harvesting that will make the land hospitable to indigenous plant and animal species. The landscape design refers to the Tree of Life—a universal symbol with particular potency for local Native Americans who view life as coming into the world through a channel or stem. This Tree of Life has seven branches constructed of stacked fieldstone,

Helen and Newton Harrison, *Pollution from the fertilizer factory mixed with sewage from the town of Kutina*, 1989. Photography and oil, 54 x 70 in.

forming farming terraces used for water harvesting, a method practiced by the Hohokam Indians, who were remarkable engineers. The work is also closely linked to the summer solstice (the longest farming day of the year), revolving around the concept of alignment, emphasized by the placement of "verticals," or land markers.

Pinto and Martino's monumental construction will have a lasting effect thanks to water harvesting and planting, as well as to the relocation of an unruly rabbit population and the introduction of natural predators. It will also demonstrate that the desert is not barren, as commonly perceived, but full of extraordinary growth. Such generative art excites Pinto, who believes that "working in this manner is a way of having an effect on the environment in which I live. It has to do with the idea of artist as citizen. It's living art, art that's animate—it changes, expands, contracts with use."

Papago Park Project, with its inception of a transformative ecology that changes over time, has a parallel in the projects of Newton and Helen Mayer Harrison. Since 1970, this collaborative husband-and-wife team has initiated environments across the U.S. and the world. Their art-making program involves visiting places and discussing ecological problems and possibilities with local communities. Their work manifests itself not only in reclamation, but also in elaborate and imaginative documentation—in photography, drawings, mapmaking, poetic dialogues, and installations. In all of their projects, they strive to uncover the belief systems that lie at the root of environmental problems and to come to terms with the increasing manipulation of the natural world. Of all the

Michele Oka Doner, armature suspended in salt water, from the *Venice Accretion Project*, 1989.

environmental artists discussed here, the Harrisons are certainly the most eccentric, coming up with ideas such as crab farming (a 1973 Sea Grants project) and an orchard that can be placed in a museum (from their *Survival Series*).

A very human element comes into play in such works as *Brazil—Breathing Cubatão* (1987), created during the São Paulo Biennial. The Harrisons learned of a nearby community where infants were being born with parts of their brains missing as a result of gas and water pollutants from local factories. (The pollution was so extensive, the water caught fire.) In response, they assembled a commentary on the problem consisting of photographs of the damaged environment, drawings, and a descriptive text. Due to a lack of funding, they were not able to create a proposal for a solution, but they feel that their interest was part of a larger discourse, which has ultimately led to efforts to clean up the inlet and the harbor.

While some might not consider this Brazilian commentary as art, other projects are too poetic to be anything but art. *Breathing Space for the Sava River, Yugoslavia* is a current proposal for the Sava River, which runs through Slovenia, Croatia, and ultimately flows through Serbia into the Lower Danube. In contrast to the financial problems of *Brazil—*

Breathing Cubatão, the World Bank has given its backing to the purification of the Sava river, in part due to the Harrisons' project. Their work goes further than just purifying the river, however, aiming to prevent the problem of "island isolation," where small parcels of undamaged land are surrounded by industrial or agricultural pollution. The Harrisons plan to alleviate the problem by using the present earth dam flood-control system as a new ecological form to create a corridor of unpolluted land through which animals can migrate and natural systems can function. To achieve this, they will have to address the imminent dangers of chemical and sewage pollution from neighboring towns and farms. (In 1991, civil conflicts in Yugoslavia interrupted the work, which was later resumed.)

In contrast to the cynicism of much '80s art, the Harrisons' works are optimistic, and they have seen incredible results from their creations. The fundamental goal of these artistic projects is to facilitate and document a dual transformation of the environment *and* human consciousness.

Michele Oka Doner, a New York-based artist, has targeted the aquatic realm for her restorative projects. She creates sculptures through the scientific process of accretion—the underwater depositing and calcification of minerals—by using electrical processes similar to those found in the structural mechanisms of living organisms. Used in on-site applications, Oka Doner's process can imitate the methods of sea animals, building up a bony substance of calcium carbonate as in reef creation. Through these means, she has created sculptural objects of aesthetic quality that also maintain a beneficial function. In *Venice Accretion Project*, conceived in collaboration with Valerio Scarpa, Oka Doner inserted five metal armatures into the Adriatic. This two-year process, set near the island of Lazzaretto Nuovo at the north end of the Venetian lagoon, added mass to the sculptures through accretion, simulating the formation of coral by drawing calcium carbonate from the water via an electrical current flowing through the mesh. As the shell-like material (as hard and sturdy as concrete) accumulates, the "artificial" reefs also begin to attract fish and encourage thriving underwater ecosystems. Scientists originally developed the technology for underwater construction projects, including toxic waste containers, but Oka Doner hopes that it can eventually be used to end the decay that threatens

Mel Chin, *Revival Field*, 1993. Replicated field test in St. Paul, Minnesota.

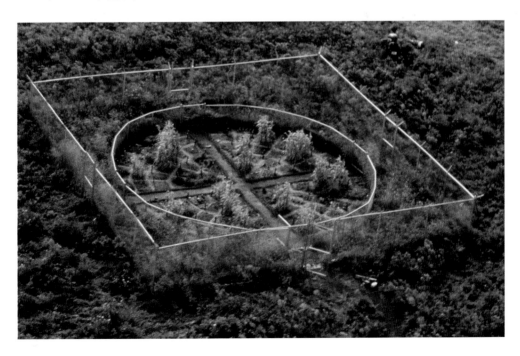

Venice's foundations. With support from the Samuel H. Kress Foundation and the L.J. Skaggs and Mary C. Skaggs Foundation, she has been exploring how accretion can produce an impermeable shield to fortify the Grand Canal against erosion and save the wooden pilings of the city's iconic buildings from rot by "petrifying" them.

Mel Chin's *Revival Field* is another educational, aesthetic, and ecologically sound project. It received media attention earlier this year when it became the first National Endowment for the Arts grant vetoed (and subsequently reinstated) by chairman John Frohnmayer. In spite of the controversy and economic constraints, Chin is pursuing this conceptual project at a Minnesota Superfund site. *Revival Field* aims to transform a hazardous waste dump into a revitalized landscape by using metal-leaching plants called "hyperaccumulators."

In order to detoxify the ground (which has been proven viable by USDA senior research scientist Rufus Chaney), Chin is growing plants that act as "toxic sponges." The plants extract poisons from the tainted soil and store them in their vascular structure. The layout for this garden experiment is both formal and functional. The plan consists of a circle within a square, with the dirt in the square left unplanted as a control for the detoxifying weeds in the central circle. Two intersecting crosswalks run through the configuration, creating a cross-hair target when seen from above, suggesting the metaphor of aiming or targeting the troubled site. Chin, who until this project worked in a more traditional sculptural format, perceives *Revival Field* as a form of "constructive activism." He hopes that similar revival fields could be implemented throughout the world, to "alter the earth from within, to heal and return its potential to sustain life."

Revival Field is not a commentary on artistic ego, but an example of an artist relinquishing ultimate control to the huge entity known as Nature. Like most sculptors working in this mode, Chin works in alliance with nature, allowing a natural progression to take over once he has laid down the aesthetic groundwork.

Confronting the magnificence and supremacy of nature allows us to see our mortal lives in a proper perspective. Rapid advances in technology have changed the fabric of our existence, but at what price? Issues such as the greenhouse effect have forced most people to reconsider their connection to the land and sky, but few know how to counteract the damage that has already been done. Sonfist, the Harrisons, Pinto, Oka Doner, and Chin propose solutions with scientific validity that also embrace a strong visual component and the poetic elements of conjecture and metaphor. While much of the "hot" art of the '80s was media-oriented and intellectually deconstructive, this environmental art is essentially reconstructive. The optimism of these works, which will have a lasting impact for future generations, is hopefully infectious, reaffirming mankind's best instincts.

Environment, Audience, and Public Art in the New World (Order) *(2000)*

by Mara Adamitz Scrupe

Environmental conditions inform the creative work of many contemporary artists. Some undertake the effort as a means of suggesting solutions or, at the very least, approaches to the pressing problems making up what we refer to as "issues of the environment."[1] Others make no claim to world-altering ambitions; instead, they seek to describe and illustrate the issues, informing viewers about them and predicting what certain behaviors might yield in terms of future environmental degradation.

Stacy Levy's work addresses the essence of time and the relentless unfolding of biotic processes in nature. As critic Penny Balkin Bach writes: "Levy's studies in sculpture, forestry, environmental science, and landscape architecture, her interest in cartography and geography, as well as her professional involvement in the landscape restoration firm that she founded, conspire to integrate her thinking about the relationship of science, art, and life. She is, indeed, an artist for the 21st century, expanding and often ignoring the boundaries that tend to classify and compartmentalize our thinking as we grapple with the ineffable and try to name it."[2]

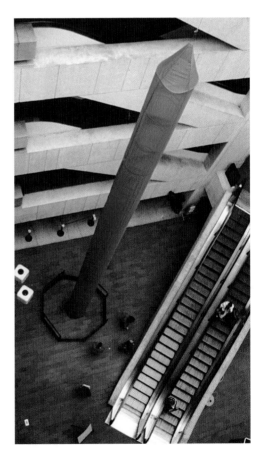

Stacy Levy, *A Month of Tides* (high tide), 1993. Polyester, steel, plastic, timing devices, and motor, 720 x 36 in. (high tide); 4 x 36 in. (low tide).

A Month of Tides, which Levy created in 1993, approached the immensity of natural systems, using a conjunction of technology and nature to further visual presentation. The 60-foot-tall, pulley- and cable-driven tubular indicator (fabricated from plastic and steel-reinforced sea-blue polyester) hung in a six-story atrium on the campus of Miami-Dade Community College. The arrow-like indicator responded to an electronic timer, which raised and lowered the mechanism in correspondence with the rising and falling of nearby Atlantic tides. This simple, visually arresting device exposed and re-created the relentless movement of the sea during a month-long exhibition.

A Month of Tides required patience and prolonged attention, reminding viewers of the physical and metaphysical relationships that we share with other life forms

and processes. Who among us doesn't involuntarily respond to the shifting of the tides, the aural experience of the waves corresponding to our breathing as we inhale and exhale? Just as Levy reminds us of our participation in the cycles of nature, she prods us to revive our ancient memories as animals *within* nature's systems. Elegantly incorporating modern technology and craftsmanship with sensory and intellectual references to our animal past, Levy exhorts us to reconsider our attitudes in the hope that we might be brought to understand our rightful place in nature's community.

Jackie Brookner is a sculptor, teacher, and writer whose installation *Of Earth and Cotton* traveled to regional museums and public sites across the South. Exhibition curator Susan Harris Edwards writes: "*Of Earth and Cotton*... invite[s] people from all walks of life to consider their relationship to the source of their survival...The historical photographs of cotton workers [projected as part of the installation] capture the dawn-to-dusk drudgery of planting, chopping, and picking cotton by hand. *Of Earth and Cotton*...provides an opportunity to feel and reflect upon the connection each of us has with the earth and each other. At each exhibition site, [the artist] locates former cotton workers and invites them to participate as models and speak about their memories and experiences of working the land."[3]

Brookner's installation explicitly portrays the arduous existence of the rural worker, while implicitly reminding viewers of the ecological impoverishment of urban life, which offers no real physical experience of, or kinship with, the rhythms of nature. As city dwellers, we are removed from concerns of daily subsistence: we don't grow our own food or raise animals on land that we care for, nor do we keep generational memories of a particular farm or home. Our overwhelmingly urbanized society has distanced us from the requirements of our animal bodies and therefore from the cycles of nature. Missing the workings of our sensuous selves in nature, we've filled the breach with manmade material possessions.

Of Earth and Cotton is a reminder that artists can foster a keener sense of the physical and psychological links between people and nature. Brookner also reminds us that that we are obliged to deal with the materiality of nature

Jackie Brookner, *Of Earth and Cotton*, 1994–98. Cotton, soil, video, and slides, dimensions variable.

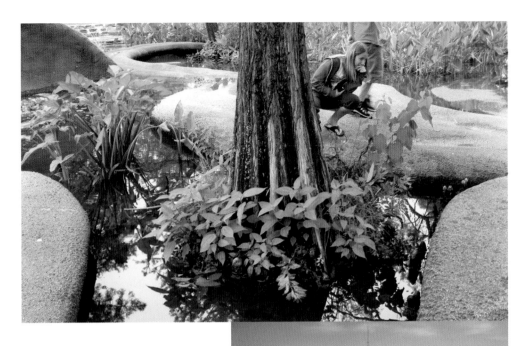

Patricia Johanson, *Fair Park Lagoon*, 1981–86. Gunite, plants, water, and animals, 12 x 225 x 112 ft. Two views of project installed in Dallas.

and the power of our own natural physicality to move us in confusing and frightening ways, noting, "I really want people to understand the installation with their bodies—the smell and weight of the cotton, the density of the dirt, the physical presence of the feet. Matter is so much the issue here, and what we make of it...This is what sculpture can do. We can feel the materials so actively, and they can carry layers of meaning through association."[4] Brookner's work connects with viewers from all social strata, in part because she brings the work to them, through physical and sensory experience. She is not averse to meeting viewers on their own terms, acknowledging that not everyone has experience with the often arcane forms and languages of contemporary art.

According to Wendell Berry, conservationist, philosopher, and farmer, "The most characteristically modern behavior, or misbehavior, was made possible by a redefinition of humanity which allowed it to claim, not the sovereignty of its place, neither godly nor beastly, in the order of things, but rather an absolute sovereignty, placing the human in charge of itself and of the universe."[5] In tacit agreement, Brookner says, "We must control nature, control matter, show who is boss. We must dismiss its power as passive and inert—mere matter, something for us to use or, better yet, possess. In frantic glut we have lost our senses, in fury fled our bodies. Fled into the arms of a consuming capitalism where what grows is money."[6]

In the preface to *Art and Survival*, a monograph on the work of environmental artist Patricia Johanson, Caffyn Kelley comments: "Johanson's graceful designs for sewers, parks, and other functional projects not only speak to deep human needs for beauty, culture, and historical memory. She also answers to the needs of birds, bugs, fish, animals,

and micro-organisms. Her art reclaims degraded ecologies and creates conditions that permit endangered species to thrive in the middle of urban centers." Johanson responds, "To me, it's all equally important, the microscopic bacteria and the man who contributes a million dollars to build the project."[7]

Johanson's design for *Fair Park Lagoon* in Dallas transformed an ecologically degraded shoreline containing almost no living creatures into "a raw functioning ecology." Her sculpture allows visitors to physically access this reinvigorated waterscape, discovering "a marvelous new world."[8] The lagoon's sculptural elements, which provide walkways among the natural features, are based on two plants native to the area, the Delta duck potato and the Texas fern, which play an important role in providing microhabitats for plants, fish, turtles, and birds. To complement the sculpture's practical function, other vegetation was planted along the shoreline: some affording habitat, some providing food and shelter for visiting birds and other wildlife. Fish were also introduced into the microhabitats best suited to their needs.

In the 13 years since its completion, *Fair Park Lagoon* has, by all accounts, been a success, both for people, who find it a friendly and entertaining place to visit, and for insects, reptiles, birds, and mammals, who thrive in its environment. The lagoon's food chain, once utterly destroyed, has been re-established over time and now represents a richness and diversity of biotic life, which has not been seen or experienced in that location in recent memory.

Steven Siegel's site-specific sculptures comment on the plethora of consumer materials produced and discarded at an alarming rate in our capitalist society. He constructs huge, organically shaped forms from stacked and compressed recycled newspaper, rubbish, and nature's detritus. Through these public works, he makes a small, but worthwhile dent in the complacent attitude with which our culture has, until relatively recently, regarded its trash. The sculptures, which are physically and conceptually integrated with their chosen sites, eventually break down (in anywhere from two to 15 years), disappearing into and nourishing the earth from which they originally emerged.

Siegel seems to say that art can "make a difference" in the wider world, whether or not art world cognoscenti take it seriously. His installations are almost always built with the assistance of people from the communities in which they are sited, and they often appear in places open to public interaction. Beautifully crafted from humble and easily obtainable materials, they attract admiration for the quality of their workmanship and engineering, while they question what makes a thing beautiful and why. He is a moral artist, delivering a message based on a fully developed ethic. His site works explain the processes of nature, while reminding us that the products of economic and scientific progress come with a price. Unafraid of being taken for a naif, he asks that viewers care as much as he does about these issues. He places his sculptures in handsome natural settings to remind us, all the more poignantly, of our destructive ethic of accumulation and disposal. The ephemeral quality of Siegel's work also serves to underscore the fact that the products of human ingenuity, and indeed the

Steven Siegel, *Ursula*, 1998. Wood and paper, 10 x 8 x 7 ft. View of work in 2008.

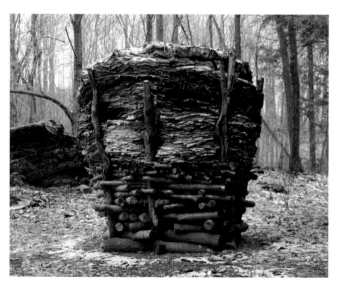

very existence of human beings on earth, will ultimately prove to be a relatively brief and inconsequential evolutionary event.

Like Levy, Brookner, and Johanson, Siegel conjoins natural and human time as a central conceptual and formal element. Yet, in their efforts to create works that effectively reveal, explain, or otherwise treat critical issues in the natural environment, which have been millennia in the making, they find themselves addressing a modern world in which there is little time to foster the breadth of understanding necessary for people to fully experience either nature or art.

Pulitzer Prize-winning scientist and environmentalist Edward O. Wilson once wrote, "If a price can be put on something, that something can be devalued, sold, and discarded."[9] Although he is referring to the dilemmas of living in a technologized and biologically impoverished world, he might also be offering a critique of contemporary artists who willingly devalue their work and potential for service by an easy acceptance of the capitalist paradigm. Focusing their efforts on appealing to a very small group of connoisseurs, they prohibit themselves from developing work that conscientiously and responsibly speaks to a more inclusive audience, wherever that audience might be found.

Given the surfeit of factors alienating people from new art, perhaps those of us engaged in creating an earth-based, physical, and sensual form of public art are presented with a singular opportunity. It seems obvious that in order to present artwork viewed seriously by the art-consuming public, as well as the uninitiated, artists must make their work essential to the world in new ways. Continuing to create in a cultural vacuum is a terrible mistake and the reason why we are so often dismissed from important, broad-based dialogues regarding the environment and other pressing issues. In view of larger planetary concerns, ego-gratification and self-indulgence as artistic strategies are not only self-serving, but small and petty, bespeaking a convenient and distressing amorality.

As early as 1949, acclaimed teacher and conservationist Aldo Leopold wrote, "No important change in ethics was ever accomplished without an internal change in our intellectual emphasis, loyalties, affections, and convictions."[10] Addressing the need for a change in the philosophical values that determine our sense of conscience and duty with respect to nature, he might also have been speaking directly to contemporary artists. Artists who make work that participates in the environmental discourse, especially public artists, must understand that this engagement requires a level of participation akin to community service. Because so few of us lead lives that put us in daily contact with nature or with the places where our artwork will eventually reside, we must recognize that we enter into an implied contract with these communities and audiences. This contract demands that we respect the people, traditions, rituals, and evidences of nature that already exist there. Perhaps equally important to the success of our proposed projects is the acknowledgment that artists must come as students of the community and the biosphere first, and teachers later.

Notes

1 Rachel Carson correctly identified the consequences of our easy acceptance of the pollution of our air, water, and soil, pointing out that the damage will probably not be repaired with scores or even centuries of concerned human effort. See *Silent Spring* (New York: Houghton Muffin Company, 1994), pp. 4–13.

2 Penny Balkin Bach, *Watercourse, A site-specific installation mapping the rivers and streams of the Delaware River*, exhibition brochure, (Philadelphia: Rosenwald-Wolf Gallery, The University of the Arts, 1996).

3 Susan Harris Edwards, *Of Earth and Cotton*, exhibition brochure, (Columbia, South Carolina: McKissick Museum, University of South Carolina, 1994).

4 Jackie Brookner, *Natural Reality: Artistic Positions Between Nature and Culture*, exhibition catalogue, (Aachen, Germany: Ludwig Museum, 1999).

5 Wendell Berry, *The Unsettling of America: Culture & Agriculture* (San Francisco: Sierra Club Books, 1986), pp. 55–56.

6 Brookner, op. cit.

7 See Caffyn Kelley, *Art and Survival: Creative Solutions to Environmental Problems* (Gallerie Women Artists' Monographs, 1992). A new edition, *Art and Survival: Patricia Johanson's Environmental Projects*, with an introduction by Lucy Lippard, was published in 2006.

8 Johanson, quoted in *Art and Survival*, op. cit.

9 Edward O. Wilson, *The Diversity of Life* (New York: W.W. Norton, 1993), p. 348.

10 Aldo Leopold, *A Sand Country Almanac* (Oxford: Oxford University Press, 1949), pp. 209–10.

Public Art Ecology: From Restoration To Social Intervention *(2011)*

by Amy Lipton and Patricia Watts

In the half-century since the Earth and Land Art movements, artists have evolved various approaches to the earth's ecological systems, seeking to revive damaged landscapes and modify destructive human behavior. Embodying what Joseph Beuys termed "social sculpture" in the 1970s to illustrate art's potential to shape society and the environment, this genre of art has never been more relevant.

Shelley Sacks, a former Beuys student/collaborator and founder of the Social Sculpture Research Unit at Oxford Brookes University in England, expanded on the term in 1998, making the distinction that art has the potential to "shap[e] a humane and ecologically viable society."[1] Out of this revival of Beuysian ideology has come a new generation of artists in the U.S. who are shaping or "sculpting" the public sphere. Simplifying and re-orienting the large-scale reclamation and revisioning projects of their immediate predecessors (while circumventing bureaucratic constraints and funding fluctuations), these artists are taking their activist work to the streets, engaging the public as individuals who directly affect the landscape.

Mierle Laderman Ukeles could be considered the standard bearer of the ecological art movement. Her questioning of collective values and desires in a consumerist society has led to a rethinking about what we keep and what we throw away. She has held the title of artist-in-residence with the New York City Department of Sanitation since 1976, and her large-scale public works continue to set a precedent for similarly minded projects. In 1992, Ukeles was awarded a Percent for Art commission by the New York City Department of Cultural Affairs as the Artist of the Fresh Kills Landfill, the largest landfill in the world, with 150 million tons of garbage dumped over a 50-year period. Since 1995, she has been working with the architectural firm Field Operations to create a design master plan for the landfill, which is projected to become a park and nature preserve by 2025–2050. Ukeles is now in her third phase of proposals on this tediously slow-moving project, which involves cooperation and decision-making from several New York City agencies, including Sanitation, Parks, and Cultural Affairs.

Although her larger vision for *Freshkills Park* may never be fully implemented, Ukeles feels that the site is the ultimate embodiment of social sculpture: it cannot be truly transformed unless its renewal actively and personally engages a large number of those who contributed to its creation.[2] One of Ukeles's many proposals for the 2,200-acre park is *Public Offering*, an invitation to more than one million members of the public to contribute a small item of personal value. These offerings will be embedded in transparent recycled glass blocks and permanently placed along miles of pathways and retaining walls. The intent is to transform the former landfill into a site of renewal, created out of community actions that give individuals the opportunity to expand their ideas and relationships to materials and their value. The offerings will not be "rejects." They will be artifacts voluntarily released, their value staying with them to be shared by the community.

Patricia Johanson is another pioneer who has been working to shape and redefine the landscape. Since her first work of Land Art in 1968, she has created many large-scale restoration projects, including the ground-breaking *Fair Park Lagoon* (1981–86) in Dallas. This project was one of the earliest of its kind—transforming and reframing an engineered

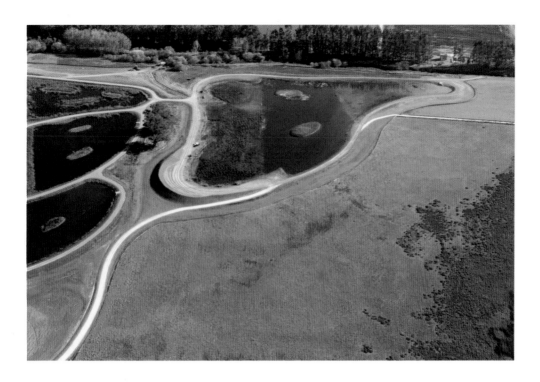

Patricia Johanson, *Ellis Creek Water Recycling Facility: Mouse Ponds*, 2000–09. Earth, plants, and water, 45 acres. Partial view of project in Petaluma, California.

landscape into a public artwork and functioning ecosystem to be experienced and explored by visitors. Always beginning with drawings based on natural forms, Johanson's multi-disciplinary projects refer to the history of place, ecological systems, native vegetation and wildlife, and human interaction.

Initiated in 2000 and still in various states of completion in 2010, Johanson's 45-acre public landscape for the Ellis Creek Water Recycling Facility in Petaluma, California, cleans and returns eight million gallons of wastewater a day to the river, the city, and outlying farms. It also provides three miles of trails that meander through a polishing wetland habitat. Johanson worked with Carollo Engineers to design the wetlands in the shape of the endangered salt marsh harvest mouse; the mouse's tail encloses a Water Conservation Garden in a morning glory design. Ponds outlining the scalloped edges of a butterfly's wing form beaches for wildlife, while islands provide nesting for birds and direct the flow of water as part of the treatment sequence. At the flower's center, a garden containing plants that conserve water surrounds a reservoir for recycled water. The wetlands' primary function is to remove traces of organic pollutants and dissolved metals as the final step in the treatment process.

Johanson's most recent project, *Mary's Garden*, is currently underway at Marywood University in Scranton, Pennsylvania. Incorporating art, engineering, wildlife habitat, water purification, energy concerns, education, and watershed restoration, it occupies an eight-acre site that was continuously mined for almost 90 years. Its two flower-form areas, *Madonna Lily* and *Mary's Rose*, will serve as sculptures and outdoor classrooms while also reclaiming land and water destroyed by coal mining. As in all of Johanson's work, there are many overlapping layers of narrative to discover.

Since the late 1980s, Bay Area artist Mark Brest van Kempen has produced art that connects people with plant and animal habitats, architecture, and infrastructure. He is interested in revealing the social, ecological, and historical

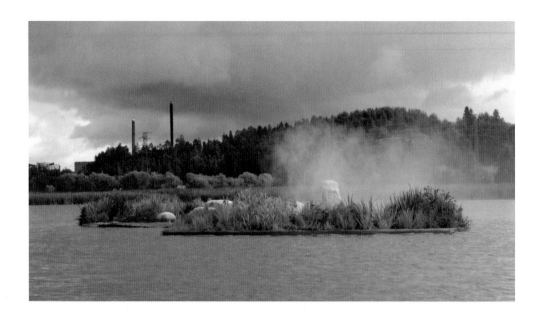

Jackie Brookner, *Veden Taika (The Magic of Water)*, 2007–09. HDPE pipe, geotextile, rubber-coated mesh, gravel, leca, flax mat, peat, native wetland plants, misting system, and subsurface aerator, 3 islands: 7.45 x 28 meters; 11.45 x 6 meters; 11.45 x 6 meters.

layers that encompass a given "place" and committed to educating people about ecological systems—after 20 years, he has only recently begun to see the real potential of his labor. In the last decade, he has created sculptural infrastructure for three public art projects, including viewing stations that daylight Ravenna Creek in Seattle; viewing devices and interpretive signage for the Rockridge-Temescal Greenbelt, Temescal Creek, in Oakland; and a recently awarded project for interpretive tours at the San Jose/Santa Clara Water Pollution Control Plant, also in California.

In the early 1980s, watershed groups in Seattle rallied to redirect the naturally fed Ravenna Creek, which had been diverted to a sewer line and water treatment plant. This shortsighted decision, made 50 years ago, unnecessarily treated the creek water, and by 2002, the county stepped up to return Ravenna Creek to where it had flowed historically—though it would now mostly be underground. After a national request for qualifications, Brest van Kempen was invited to trace the historic and present-day Ravenna streambed down a one-mile corridor to Lake Washington, which flows into Union Bay. The elements that he created for the Ravenna Creek Project include an outfall structure and viewing station where the creek enters the pipeline underground from the park; interventions along the sidewalks to the lake, including three daylighting vaults; and embedded plaques with inset capsules of native seed. To memorialize the flow of the creek, he worked hand-in-hand with the City of Seattle Parks and Recreation and Metro/King County Drainage and Wastewater departments.

Since the mid-1990s, Jackie Brookner has created public art projects that address water pollution using both artistic and scientific methods. Like Ukeles, Johanson, and Brest van Kempen, she partners with botanists, ecologists, engineers, and landscape architects. Brookner's work aims to effect positive change in individual behavior, which she feels requires a deep level of transformation that can be inspired aesthetically. Her Biosculptures™ are functioning ecosystems incorporating concrete, moss, and ferns to collect, filter, and cleanse water through a bio-geochemical process known as phytoremediation.[3]

Brookner's ambitious *Veden Taika (The Magic of Water)* (2007–09) in Salo, Finland, consists of three constructed islands floating in the Halikonlahti Bird Pools. These lagoons were once part of the Salo Municipal Sewage Treatment

Facility, but the area was designated an official E.U. conservation site for migrating and nesting birds. The largest island provides nesting sites, while the two smaller islands support vegetation specifically chosen to remove pollutants from the water and sediments. During warm months, a wind-powered mist rises up over the islands several times a day. Wind-powered aerators beneath the islands oxygenate the water and stimulate microbial processes on the plant roots.

With the help of a dedicated project partner, Finnish artist Tuula Nikulainen, Brookner was able to proceed quickly with funding from local art foundations, rather than waiting on slower, government-based programs. Significant help was also provided by students from a nearby vocational high school. Local ecologists and volunteers helped with the planting and remain involved in the maintenance of the work, including water monitoring. Brookner has learned through prior projects that ground-level community support is essential to the success of truly sustainable works of art.

Visionary ecological public art projects such as these can take years to complete, and may never be realized as the artists intend, so over the last 10 years, emerging artists have been developing ways to address questions of sustainability on a smaller, more immediate scale. Out of a desire to create more immediately responsive work, and tapping into the funding now available for temporary public artworks, many artists are working in more performative ways that often include direct dialogue between artist and public.

Inspired by Al Gore's *An Inconvenient Truth*, Eve Mosher began research for *HighWaterLine* in 2006. This self-initiated, temporary intervention helped people to understand the effects of climate change in their own neighborhoods, visualizing sea-level rise along the shorelines of New York City. Mosher used the streets and sidewalks to "draw" a continuous chalk line marking the worst-case-scenario, 10-foot rise predicted by scientific data along the Brooklyn and Lower Manhattan waterfronts.[4] Her model project could be replicated in any coastal community.

Eve Mosher, *HighWaterLine*, 2007. Blue chalk line and illuminated, water-filled markers tracing the 10-ft.-above sea level line.

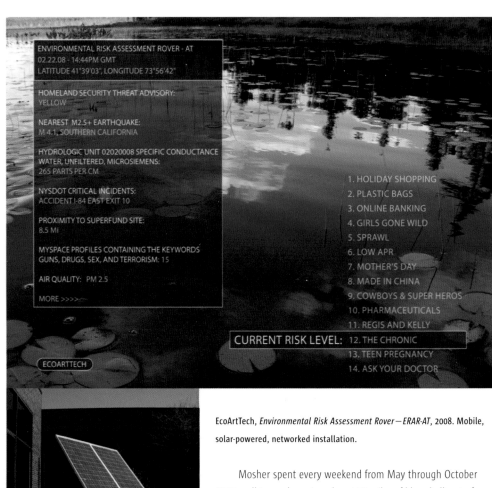

ENVIRONMENTAL RISK ASSESSMENT ROVER - AT
02.22.08 - 14:44PM GMT
LATITUDE 41°39'03", LONGITUDE 73°56'42"

HOMELAND SECURITY THREAT ADVISORY:
YELLOW

NEAREST M2.5+ EARTHQUAKE:
M 4.1, SOUTHERN CALIFORNIA

HYDROLOGIC UNIT 02020008 SPECIFIC CONDUCTANCE
WATER, UNFILTERED, MICROSIEMENS:
265 PARTS PER CM

NYSDOT CRITICAL INCIDENTS:
ACCIDENT I-84 EAST EXIT 10

PROXIMITY TO SUPERFUND SITE:
8.5 Mi

MYSPACE PROFILES CONTAINING THE KEYWORDS
GUNS, DRUGS, SEX, AND TERRORISM: 15

AIR QUALITY: PM 2.5

MORE >>>>

ECOARTTECH

1. HOLIDAY SHOPPING
2. PLASTIC BAGS
3. ONLINE BANKING
4. GIRLS GONE WILD
5. SPRAWL
6. LOW APR
7. MOTHER'S DAY
8. MADE IN CHINA
9. COWBOYS & SUPER HEROS
10. PHARMACEUTICALS
11. REGIS AND KELLY
CURRENT RISK LEVEL: 12. THE CHRONIC
13. TEEN PREGNANCY
14. ASK YOUR DOCTOR

EcoArtTech, *Environmental Risk Assessment Rover—ERAR-AT*, 2008. Mobile, solar-powered, networked installation.

Mosher spent every weekend from May through October 2007, walking and pouring almost 70 miles of blue chalk out of a mobile aluminum dispenser, the kind used to draw lines for baseball diamonds. Being in the public eye during this prolonged performance enabled her to talk to people of all ages in different neighborhoods about high CO_2 levels and their potential impact if nothing is done to re-direct human behavior. In this way, she was able to break down the barriers separating art and real life, recalling *Touch Sanitation* (1978–84), in which Ukeles shook hands with each of the 8,500 New York City Sanitation Department workers over the course of one year.[5]

Mosher maintained a detailed blog account of her conversations with the citizens who would be most affected by this potential flooding. In these densely populated sections of New York City, large numbers of residents, as well as private property and infrastructure, are at risk. Mosher's experiences led her to develop *Seeding The City*, a new project that uses social networking tools to assist in siting green roof modules in New York. On-line resources that map the modules and provide tools for tracking the urban heat island effect are important components of the project <http://seedingthecity.org>.

Like Mosher, EcoArtTech collaborators Cary Peppermint and Leila Nadir use visualization of scientific data to focus their social sculpture practice. The team creates functional objects by developing digital applications that monitor and provide feedback on current physical states in the environment. Since 2005, they have been designing a series of solar-

powered mobile platforms, including the sound art transmission *Wilderness Information Network* (2006), the outdoor video and live FM-radio installation *Frontier Mythology* (2007), and the almost-robotic *Environmental Risk Assessment Rover* (2008).

Known as *ERAR-AT*, the rover is an all-terrain mobile sculpture or "station" that uses GPS networks and solar power to project real-time data based on local coordinates. Site-specific environmental threats and risks are assessed through an on-line data-scrape that accesses information on traffic accidents, earthquakes, air pollution, and possible violence. The data are then listed in a 14-tier threat level embedded live within a video projection of local natural and architectural images. By answering such questions as "How far is the closest Superfund site or nuclear power plant or agribusiness?" *ERAR-AT* examines how scientific research can help us understand the "riskiness" of contemporary life. It is designed to travel anywhere there is Wi-Fi or mobile network coverage.

Eclipse (2009), a Web-based artwork/application, alters images of U.S. national and state parks based on the air quality of the nearest city within a 65-mile radius. Visitors to <www.turbulence.org/Works/eclipse> choose a park from a pull-down menu, and *Eclipse* overlays images of the site with real-time particle pollution data from airnow.gov, which tracks air-quality conditions in more than 300 locations across the country. The higher the Air Quality Index (AQI) or pollution level for the selected location, the more the park image is corrupted through a set of algorithms that affect color, saturations, and contrast while imposing intermittent monitoring, deletion, and cropping. The distortions provide a visual rendering of the invisible damage wrought by particulates (including acids such as nitrates and sulfates, organic chemicals, and metals) on "pristine" wilderness areas.

In *Indeterminate Hike* or *IH* (2010), EcoArtTech has developed a downloadable Android phone application that acts as a personal guide through New York City's urban wilderness. It includes a selection of GPS-directed, inner-city "hiking trails" directing participants to indiscriminate locations or "opportunities" for identifying new scenic vistas. Participants are prompted to "look for flying creatures" or "consider car alarms as bird calls." They are also invited

EcoArtTech, *Eclipse*, 2009. On-line application.

to take photos of the urban "wild" with their phones and upload the images to an on-line public database.

Bay Area-based Amy Franceschini and Futurefarmers have been challenging unsustainable systems since 1995. Many of their public projects have brought agricultural issues to an international audience. Their most widely known work, *F.R.U.I.T. Network* (2005–ongoing), is an indoor installation consisting of a large fruit stand, a computer station that links to an on-line interactive protest forum, and a series of graphic wall maps with international distribution patterns that educate about food miles.

Amy Franceschini, *Victory Gardens*, 2007–10. 2 views of mixed-media project.

Victory Gardens began as a utopian proposal and later evolved into a two-year pilot project funded by the City of San Francisco. Inspired by the nationwide program of World War I and II food gardens, the concept supports the transformation of back and front yards, window boxes, rooftops, and unused plots of land into food production areas. The goal is to create a "citywide network of urban farming by (1) growing, distributing, and supporting home gardens, (2) educating through lessons, exhibitions, and Web sites and, (3) planting demonstration gardens in highly visible public lands such as city halls, schools, and parks."[6]

As part of the summer 2008 pilot project, Franceschini collaborated with several community groups, including Slow Food Nation, to create an updated version of the Victory Garden sited on the Civic Center Plaza in 1943. Displayed in front of San Francisco's City Hall, the new garden was both a work of art and a community project. Unlike its

Amy Franceschini, Myriel Milicevic, and Corinne Matesich, *F.R.U.I.T. Network*, 2005–ongoing. Mixed media, dimensions variable.

wartime predecessor, however, this intervention did not address a lack of available labor for growing food; instead, it offered the potential of a truly local urban agriculture practice. The quarter-acre edible landscape was harvested and the produce donated to city food service programs. The real victory is an ongoing series of Backyard Victory Gardens, workshops, and a small demonstration garden. A planned City Farm Program will eventually implement a Community Supported Agriculture (CSA) model to enhance food security and emergency preparedness.

Tattfoo Tan is a New York artist originally from Malaysia who started out as a graphic designer. Over the last 10 years, he has developed an arts practice involving a persona that is part boy scout, part ecological super hero, and part artist. *Green Stewardship*, which he began in 2008, explores how the public can acquire knowledge and master the

Tattfoo Tan, *S.O.S. Mobile Garden*, ongoing. Mixed media, dimensions variable.

skills necessary to take care of the planet. For this project, Tan enrolls in various "green" training courses and receives certification, which he proudly flaunts in the form of custom merit badges that he designs for his coveralls. For his Master Composter badge, he redesigned the Caduceus symbol of divine providence and the embryo of life, changing it from a serpent to intertwined red worms and placing an icon of the earth in the background to represent how composting can save the planet. Tan has also become a certified Citizen Pruner, which legally allows him to prune street trees in New York City. In 2010, he began teaching public workshops from his *S.O.S. Mobile Classroom*, a cargo bicycle featuring tools, a garden, and composting bin.

Tan recently completed *S.O.S. (Sustainable Organic Stewardship) Pledge* at P.S. 971, a primary school in Brooklyn serving children pre-K through second grade. A Green Schools Alliance initiative, this engraved wall sculpture was commissioned by the NYC Department of Cultural Affairs Percent for Art Program and the NYC School Construction Authority Public Art for Public Schools Program. The work consists of a 10-foot-high Carrara marble mural etched with gold-painted text. The pledge itself adapts the Pledge of Allegiance and the Scout Promise, amending them with a green mission. Every day, it reminds passing students to be green stewards, calling attention to their personal responsibility for contributing to a healthy community and world. Tan feels that by understanding what we can do and change in our own lives—even if our individual actions might be small—our collective impact will be big. His *S.O.S. Pledge* is simple to enact: "I hereby pledge to make the following changes in my life. My actions will be small, but their collective impact will be great. I promise to consume fresh and local produce. I promise to reduce, reuse, recycle, compost, and conserve

Tattfoo Tan, *S.O.S. Steward*, ongoing. Custom merit badge designed as part of *Green Stewardship*.

energy. I will walk, bike, or ride public transportation as much as I can. I will set an example for others as a sustainable organic steward (S.O.S.)."

These artists, and many others, are applying their skills as citizens and creative individuals to today's challenging environmental issues. They share an ability to take their concerns into the public sphere, using diverse and critical artistic methodologies within the context of activism, without losing sight of aesthetic form. They wish to engage the public on multiple levels and are making the most of both low-tech and high-tech means. Employing current scientific research and trans-disciplinary collaboration, they are exploring new ways to implement their works in the real world by disrupting or subverting traditional arts practices. Realizing radical change, via individual action, demands deep changes in consciousness.

Ecologically minded artists seek to inform, challenge, inspire, and thereby activate audiences without being self-righteous or pedantic. At the same time, the urgency behind this calling demands a certain type of self-initiated, energized action, as well as a willingness to mobilize quickly for the sake of future generations.

Notes

1 Shelley Sacks's mission statement for the Social Sculpture Research Unit (SSRU) can be found at <http://www.social-sculpture.org>.

2 Interview with Mierle Laderman Ukeles conducted by Amy Lipton, November 11, 2010.

3 Interview with Jackie Brookner conducted by Amy Lipton, October 27, 2010.

4 According to Mosher's research, the 10-foot line marks the flood zone brought on by stronger and more frequent storms that would occur every 19 years on average by 2050. See Vivian Gornitz, Stephen Couch, and Ellen K. Hartig, "Impacts of sea level rise in the New York City metropolitan area," *Global Planet. Change* 2001 (32), pp. 61–88.

5 Robert C. Morgan, "Touch Sanitation: Mierle Laderman Ukeles," *High Performance*, Fall 1982; reprinted in *The Citizen Artist: 20 Years of Art in the Public Arena. An Anthology from High Performance Magazine 1978-1998* (Gardiner, New York: Community Arts Network and Critical Press, 1998).

6 More information on the *Victory Gardens* can be found at <www.futurefarmers.com>.

Reinvigorating Nature and Public Art:
A Conversation with Alan Sonfist

by John K. Grande

Alan Sonfist has bridged the gap between humanity and nature for four decades. His works from the 1960s presaged what we now see as environmental art — artists working in the land and in our cities, solving community and ecological problems while raising issues of bioregionalism, site-specificity, and ephemerality. When Sonfist began, however, these notions of "living history" were not part of art's popular vernacular. His early *Time Landscape* (1965) still occupies a permanent site in New York City, integrating indigenous plants and trees into the urban fabric. The same year, he advocated the building of monuments dedicated to unpolluted air and suggested that bird migrations should be reported as public events. In his 1968 essay "Natural Phenomena as Public Monuments," Sonfist emancipated public art from human history, stating: "As in war monuments that record the life and death of soldiers, the life and death of natural phenomena such as rivers, springs, and natural outcroppings need to be remembered. Public art can be a reminder that the city was once a forest or a marsh." Sonfist continues to advocate projects that heighten our awareness of the geology, terrain, and flora of a place, as well as their interactions with human history.

John K. Grande: *There was nothing ecological at all about early Land Art. It was basically "after Minimalism," getting out of the galleries. What drew you to a different approach?*
Alan Sonfist: The essence of my work began in my childhood, when I witnessed the destruction of the Bronx forest. I was, and still am, captivated by the magic of the ancient forest. When people in the community set fires and destroyed the woods, I realized that my life would be dedicated to educating people about the value of natural areas within urban environments. My art consistently calls attention to natural events that occur in urban and suburban environments. I see my art as a social discourse. We have to make a decision about how we create public art. Is it going to be just a decoration with very little meaning for the community, or will it engage in a dialogue with that community? That is the important difference between my projects and those of the early Land artists. I once said, "We have landmark buildings, we should create landmark nature within urban and suburban areas." Since we are actively destroying the world's natural heritage, I propose that public art be created to celebrate the lost natural environments of our communities.
JG: *What inspiration did you draw from the art world? Were there certain artists or teachers who drew you in the direction you wanted?*
AS: To a certain extent, I was self-directed. I was always tuned to collecting and gathering fragments of the forest. Labeling it as art or not art was never an issue. It was more the preciousness of these elements. When I went to school in the Midwest, I brought some seedlings of my young forest with me.
JG: *You continued that love of trees in your early bronze sculptures, which were assembled from various trees spliced together to form new species. And recently, in* The Disappearing Forest of Germany *(2009), three monumental aluminum leaves serve as arks that shelter seeds from three iconic and disappearing denizens of the northern European forest — German oak, beech, and service trees. As the aluminum degrades, each leaf has the potential to begin repopulation of the shrinking forests.*

Trail of Gold #2, 1975. Gold leaf within the natural landscape, photograph, 16 x 20 in.

AS: For me, trees are the heroes of our world. We should treat them as monuments. The early bronze sculptures were made of tree relics that I collaged together. They are exact replicas of fallen limbs. At the Ludwig Museum in Aachen, I created a series juxtaposing natural limbs and the bronzed copies. The original natural limb or branch was worth $3,000 and the bronze was worth $3. We must place more value on our natural heritage.

JG: *Lightning (1965) involved living growth in art. You reintroduced indigenous animals into an urban setting.*

AS: As with *Time Landscape* in Greenwich Village, where I brought trees such as beech, oak, and maple and plant species native to New York, there was an idea of going back into my childhood forest. Besides experiencing the indigenous trees of New York City, *Lightning* allowed me to interact with foxes, deer, snakes, and eagles.

JG: *In the sense of public art restoring nature, you were ahead of landscape architecture.*

AS: Yes, in the early '70s, I was invited to MIT as a research fellow with the architectural program to set up a dialogue on how nature could be brought into architecture. I found an enthusiastic forum of scientists and architects who all wanted to work with me to create large-scale civic projects. We worked on an ecological project for the Charles River.

JG: *Disciplinary crossover is very important at this stage, isn't it?*

AS: Over the years, I have collaborated with experts throughout the world. I am currently working with scientists and architects in Florence, Italy, to create a large environmental sculpture that will bring back the ancient vegetation of Tuscany. The park, which will visualize the ancient olive tree, will be surrounded by the evolution of the city's human history. The collaboration will bridge contemporary buildings with their ancient past.

JG: *How did you begin the process for* Time Landscape *near Washington Square in New York?*

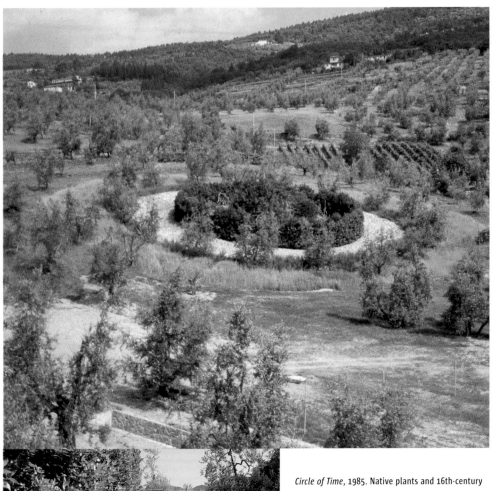

Circle of Time, 1985. Native plants and 16th-century stone walkway.

AS: I approached the community and said that I had an idea to create a historical landscape within the historic boundaries of Greenwich Village, which is one of the earlier settlements in New York City. Within that community, there were two very strong advocates of creating green spaces—Jane Jacobs and Ruth Wittenborn. They had not thought about the idea of history, but they wanted to create more green spaces. To me, both were pioneers. They stopped Robert Moses's massive highway system from going through Greenwich Village, and they substituted *Time Landscape* for what would have been the Moses Highway. *Time Landscape* is a historical natural landscape showing the juxtaposition of indigenous and colonial peoples—how they interacted in the land using the context of natural flora. Dutch and English colonial diaries gave me insight into the native vegetation on the island in the earliest period of European settlement.

JG: *Other projects, such as* Florida Natural/Cultural Landscape *in Tampa, create living landscapes that reference different eras by planting various living species from those eras. They become multi-layered natural histories spanning centuries that also reflect changes from human intervention.*

AS: The city of Tampa invited me to collaborate with a landscape architect and architect to develop a public waterfront area. We had numerous meetings with the community and the government about how the area could be made into a unique public space. My contribution was to create an environmental sculpture that included a sidewalk relief reflecting the historical evolution of the city. I juxtaposed the original natural landscape with contemporary skyscrapers. The crucial element is that each one is self-sustaining.

JG: *Why did you integrate four classical columns?*

AS: The columns represent the Spanish, the first Europeans to enter Florida. They built colonnaded buildings that still survive in one section of Tampa. The columns are accurate in scale, but they incorporate a veining structure that encourages different kinds of vegetation to grow. Each column has a different plant form growing within it, from the earliest prehistoric species to contemporary plants. They are living systems, living testaments to natural history.

JG: *You designed non-linear pathways through the grassy landscape.*

AS: There were certain parameters for the park. Unfortunately, and this is true of most urban parks due to safety concerns, they wanted open space. I didn't want that to be a compromise or monotonous, so I found a way to incorporate openness. I ultimately decided to use metaphors for the different ecological niches that existed in this region. Again, it deals with a layering of time. I created a prehistoric landscape by the edge of the river, and then taking one of the plants—an oak leaf—from that landscape, I made a walkway in that shape. Each section of the walkway is a leaf form that surrounds a little oasis, and each oasis marks an ecology that once existed in the region. It starts with prehistoric time and ends with a contemporary landscape, with reliefs of buildings built into the stonework.

I also tried to reference the region's place as a major railroad center at the turn of the century. Imprints of railroad tracks were inscribed into the sidewalks. At the entranceway is a more contemporary section, where the shadows of the facing buildings are reflected in the concrete, and underneath, the actual topography appears in green. Walking through the park echoes our understanding of the community's history, from the land to the warehouses to the skyscrapers.

JG: *Is there a link to the shoreline?*

AS: The walkway connects directly to the shoreline so that people can walk from the street to the water.

JG: *Many of your gallery pieces, like* Rock Monument of Manhattan *(1975–2000), uncover hidden geological landscapes that we do not see.*

AS: Over the years, I have created core-sample works throughout the world, predominantly in Europe and North America. For the opening of the new Ludwig Museum, for instance, I was commissioned to uncover the geological history of the city. By drilling in four strategic locations, I was able to expose a living geological history normally covered by concrete. I laid the cores out like a tablet, revealing the geologic secrets of the city.

JG: Circle of Time *(1985), in Italy, is one of your most innovative and fascinating projects. In addition to referencing natural features and topography, it builds a narrative out of the intertwining of natural and human history.*

AS: *Circle of Time* echoes the rings of a tree. It is a metaphor to show the ages of the earth, each ring representing a different time frame. It starts out at the central core with the original Tuscan forest, moves to the Etruscan use of the land, and then continues through subsequent eras of the place. Each stone was laid as if this were a geological history of the area, and the layout mimics the hills of Tuscany. The last ring covered an agricultural area, with olive trees and wheat fields. The local farmers collect the harvest, so it becomes a truly public sculpture. This is the crucial element for all of my projects—they do not disconnect from or impose on the community. I was pleased that the workers and community on the Italian project had a picnic afterwards to celebrate the work, as they did after my project in Denmark.

Circles of Life, 1985. Bronze, trees, and earth, 28 x 50 x 50 ft.

JG: *Yes, tell me about your work at TICKON.*

AS: I spent several months studying the topography and ancient burial grounds that contained stone ships. I thought, "Why don't I create a stone ship and instead of paying homage to the humans again, pay homage to the oaks that created the ships?" Like many other peoples around the world, the Danes over-cut their timber, so the particular oak used in Viking ships became almost extinct, the lands deforested. And here I am, within this stone ship, planting more than 1,000 saplings from this endangered species. Instead of protecting a burial, the stone ship now becomes a life force, a protector of the forest of the future.

JG: *For the La Quinta, California, nature trail (1992), you reintroduced indigenous species and designed paths through the landscape.*

AS: The waterworks department had dug a 100-year trench intended to prevent flooding. The excess material was simply dumped on the desert, and the community was up in arms because they could see it from their windows and demanded that it be removed. The waterworks people said that it would cost over $20 million to remove the rubble. I was invited to work with both groups and come up with a solution. I proposed using indigenous plants, which need minimal care. It cost less and created a beautiful nature walk. Public schools, as well as nature groups, now use the park.

JG: Pool of Virgin Earth *at Artpark in Lewiston, New York, regenerated a part of what was, and still is, a chemical wasteland.*

AS: That was done in the early 1970s, before they understood how to seal toxic areas. It was a desert of toxicity. I worked with scientists to create a six-foot-deep pool of virgin soil that would show the rebirth of the dump. Plants were selected to help heal the earth. The idea was that seeds would also come from the wind, as well as birds and animals. More plants would grow and generate a pure environment in this chemical wasteland. It has since been expanded and has become a whole landscape. They grew a forest on the land.

JG: *You created a new landscape topography in a flooded open pit mine for Expo 2000 in Dessau, Germany. Again, the emphasis was on purifying the environment with a living artwork.*

AS: In collaboration with engineers, I re-created living ecosystems on a series of islands in the open pit mine. The islands reflected ecosystems dating from prehistoric to contemporary times. The ecologies we brought to the site acted as purifiers for the polluted environment and water system.

JG: *As the landscape is becoming increasingly transformed and imposed on by human intervention—highways and auto-mobiles, for instance—do you believe that the role of the artist could be to reinvigorate an idea of nature, as much as nature itself, through public art projects?*

AS: There are many social and ecological concerns that need to be addressed by artists. Nature is constantly changing—it's in transformation, existing in a continuum. We are going into global warming now, just as we had various ice ages. Walking and observing are crucial elements in my work. My original proposal for New York City in 1965 was to create a series of integrated historical landscapes in every community throughout the city, and they would be connected by a path representing the ancient pathways of pre-European Manhattan.

JG: *There is a strong link between performance art and art that embraces ecology, between artists like yourself and Allan Kaprow, for instance. When you worked on the nature theater as early as 1971, the interactions were real, involving nature and sound orchestration in the forest.*

AS: I agree. Kaprow was very important because he tried to integrate art back into the community through perform-ance. The nature theater involves creating a physical construct, a fragment of a forest, and then allowing nature itself to create the sounds, as opposed to constructing the noises of a forest. The animals themselves become the perform-ers—the migration of the birds becomes a special event. I have done several of these, one on the campus of Ohio University in the 1970s and, more recently, for Gerta Park at the Bauhaus in Dessau, Germany (1998).

JG: *You strongly believe in a social context for art.*

AS: There has to be social commitment. People have lost the idea that public art means public. For my projects to be successful, they have to involve the enjoyment of the public, not just the art community. One of the most important comments made about work came from a local baker who walked over to see *Time Landscape*. He said, "I don't know if this is art, but I like it." For art to function in the 21st century, it has to be involved in the community.

JG: *I have been thinking about the decline and end of civilizations as Jared Diamond describes in* Collapse. *When will we start to consider the relation between nature and society in the way we build, invent, and design our lives?*

AS: Ephesus, one of the eight wonders of the world, offers a classic example. They had a choice whether to build more and create more religious icons or to clean their harbor. They didn't clean their harbor, and the city had to be aban-doned. It is now 20 miles from the ocean. This example also offers considerations for environmental public artworks, which is why my recent projects have taken global warming into account. Water becomes a crucial factor, as well as climate change and its effects. I am currently working on a global warming sculpture in Cologne, that captures the past, present, and future rhythms of our planet.

Though I've mainly worked with land, I've been interested in water for a long time. In New York, I proposed a park where the city's original water source would be flowing. The sculpture would filter the ancient water and allow the public to engage in the historic streams of the city. I first proposed to expose the natural springs of New York in 1971 for Earth Day.

JG: *Can you tell me about your recent project at the Centre for Contemporary Art and the Natural World in Devon? You are using ancient microbes to rebuild the region's soil in order to re-create an ancient English forest. Changes at a chemical level will create the artwork—a self-sustaining forest.*

AS: For *Serpent Mound*, I worked with the head forester, as well as the cultural committee. Haldon Forest is a contem-porary exotic forest, but they want to bring back the indigenous forest, which cannot survive in today's soil. Because my art is about integration, I collaborated with a local architect and historian to create an island connecting the ancient human population to the vegetation that existed in that time. The serpentine mound, which is a Celtic icon,

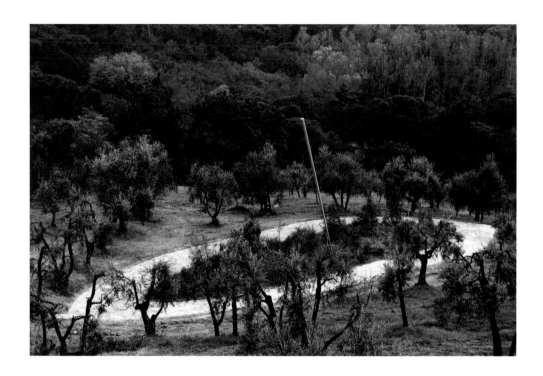

Birth by Spear, 2010. Reintroduction of original olive trees to a functioning agricultural olive grove, 5 acres.

will protect the microbes and provide space to regenerate the indigenous forest. The chief forester is so enthusiastic about the proposal that he wants to integrate it into other forest areas and involve community schools.

JG: *Can public nature/public art projects move us in a positive direction? What strategies would you recommend for young ecological artists working in the public sphere?*

AS: All of my work involves a clear understanding of environmental issues and their unique relationship with local communities. Swedish sociologists once did a study on urban nature, and they asked the citizens what they liked. An overwhelming percentage of respondents said, "We want more trees." This became the essence of my planning projects for Sweden. In the 21st century, we have to redefine the role of the artist as an individual who is actively seeking solutions to improve our world.

Agnes Denes: Sculptural and Environmental Conceptualism

by Ricardo D. Barreto

Although the traditional description of Agnes Denes as a conceptual/environmental artist does not capture the full breadth of her innovative and expanded aesthetic vocabulary, it does reflect many of her core concerns. Eluding easy categorization, her work springs from a complex foundation of disciplines, encompassing not only art and the history of art, but also the humanities and the sciences. Denes's oeuvre includes everything from conceptual works with text to drawings, graphs, photographs, x-rays, prints, and major public and environmental projects, as well as works that come close in appearance and concept to traditional sculpture.

Even today, Denes remains a difficult figure to classify. For those who have taken the time to examine her work, however, the experience is both exhilarating and enlightening—her influence and importance are clear, her eloquent articulation of the crisis in the interaction of humanity and nature touchingly apparent. For Robert Hobbs, Denes is "an artists' artist," one of those "individuals who have emphasized in their work the raising of provocative questions and who have also tested the limits of art by taking it into new, unforeseen areas and by using it for distinctly new functions."[1]

For me, the essence of Denes's unique contribution is sculptural. This can be seen in the majority of her works, not only those realized in three dimensions. I have come to understand that every major insight, concept, or far-ranging vision that she has evolved during her career has volumetric consequences. Even more interesting, her concern with multi-dimensional possibilities moves beyond the three-dimensional to include the shaping of time. Indeed, she has found a vocabulary of tools to sculpt time and history in order to integrate their philosophical implications into her environmental works.

Denes's work is created by shaping knowledge and concepts into form and making connections where none existed before. Through her studies in the sciences, technology, philosophy, linguistics, theology, art history, music, and ecology, she has constructed a hybrid methodology that allows her to give form to philosophical concepts rooted in the human condition itself and in the environmental condition of the planet. Just as the masters of Gothic art gave physical form to mysticism, so Denes makes tangible the implications and paradoxes inherent in humanity's accumulated knowledge. Throughout her career, she has endeavored to bring intellectual content into the landscape in order to elucidate the complexities of human society, the natural world in which we live, and the effects of the one on the other.

While many of Denes's works are realizable, there are those that are not. This seems to be especially true of her works from the late '60s and early to mid-'70s. A little-known proposal called *Chaining Giant Sequoias in the California Redwoods* (1972) belongs to this category. By suggesting that the tree's growth be curtailed or halted by chaining its branches to its roots, Denes asks us to consider which is stronger—nature or human thought. She also examines the "thoughts" and experiences of a 1,000-year-old tree grown to 300 feet, with a trunk diameter of some 30 feet. In *Underwater Project* (1972), "the earth's surface terrain, our present landscape, is replaced with the jagged spikes of mountain tops and hollowed valleys of the ocean floor, lending our world the eerie look of science fiction."[2] In both

examples, space and volume are key elements of the works and central to their complete understanding. The intention was never to chain giant sequoias or pull up the ocean floor and sink the mountains, but to contemplate the magnitude and implications of these propositions.

Throughout her career, Denes has spent a great deal of time drawing. While this is an efficient way to explore her ideas, it is also a consequence of the difficulty that she faces in bringing to fruition her monumental public and environmental works, which are the logical final results of her creative process. One very clear example is a series of luscious two-dimensional works that consider the mutation of volume and space. *Isometric Systems in Isotropic Space — Map Projections*, first conceived in 1973, takes our planet and systematically distorts it into a variety of forms, including *The Snail*, *The Cube*, *The Doughnut*, *The Hot Dog*, *The Lemon*, and *The Pyramid*. Throughout these transformations, the outlines of the continents are made to correspond to the exact longitudinal and latitudinal location each would occupy if the metamorphosis were to occur.

The *Map Projections* also demonstrate Denes's evolved use of mathematics as a building element in the service of art, a conceptual methodology perhaps best illustrated by the *Pyramid Series*. Donald Kuspit calls the pyramid works, "the ultimate distillation of [Denes's] scientific interests and philosophy of life.[3] The early drawings lead to monumental visualizations such as *Citadel for the Inner City — The Glass Wall* (1976), as well as to the highly abstract series *The Restless Pyramids* (begun in 1983). Designs for sculptures in motion, these last include some of Denes's most compelling images: "Realizing they are organic forms, the pyramids lose their rigidity and stillness, begin to break loose from the tyranny of being built...Thus freed, they become flexible and take on dynamic forms of their own choosing, begin to fend for themselves and create their own destiny."[4] Denes envisions these works as models for future self-contained and self-supporting habitats on earth and in space.

Rice/Tree/Burial, 1969–79. Detail of project at Artpark, Lewiston, New York.

The same vision of an optimistic future unfolding over time characterizes those works that have become realities. These include Denes's first major environmental piece, *Rice/Tree/Burial* (1969–79), in which a planted rice field symbolizing life, a chained group of trees signifying humanity's interference in nature, and a buried poem implied a cyclical transformation from chaos to order and back, as well as her signature *Wheatfield — A Confrontation* (1982), two acres of wheat planted on a landfill in downtown Manhattan in what is now Battery Park City, and *Hot/Cold Earth Ship with Heartbeat* (1992), a structure combining

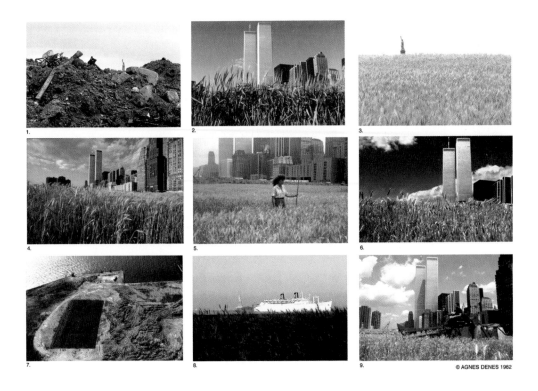

Above: *Wheatfield—A Confrontation, Battery Park Landfill*, 1982. 2 acres of wheat planted and harvested by Denes on a landfill in Lower Manhattan. Below: *A Forest for Australia*, 1998. 6000 trees planted in 5 spirals to create step pyramids, 400 x 80 meters. Project located in Melbourne, Australia.

ancient boat-building techniques and 20th-century electrical devices such as a refrigeration unit, heater, and sound system to produce frozen earth on one side and a warm heartbeat on the other. But there is perhaps no better example of a monumental work that incorporates both time and history as building blocks than *Tree Mountain—A Living Time Capsule*. Originally conceived in 1992 and planted in 1996, *Tree Mountain* was commissioned by the Finnish government and funded by the U.N. Perhaps a better way to describe this project would be to say that its birth was commissioned and realized. Distinguished by evolution through natural growth and the passage of time, *Tree Mountain* undertakes nothing less than a gradual rebuilding of the environment and the eventual creation of a "virgin" forest. Like so many of Denes's works, this grand environmental project found its first incarnation in a drawing, *Proposal for a Forest*.

What is now taking place in the reclaimed gravel fields of Ylöjärvi, Finland, is the physical

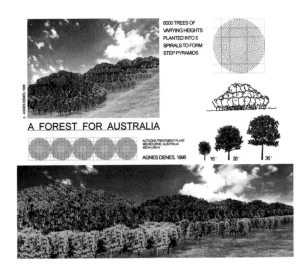

manifestation of a vast environmental construct whose meaning deliberately stretches from the deep past to 400 years into the future—the expected life span of the 11,000 trees planted in an intricate mathematical pattern of interlocking spirals by people from all over the world on a manmade elliptical mountain measuring 420 meters in length, 270 meters in width, and 28 meters in height. Visible from space, *Tree Mountain* has been called the first monument on earth that does not serve the human ego. As Hobbs points out, it is, instead, "a monument to endurance, to transcendence and survival, to collaboration, and to differentiating nature from human beings."[5]

Now that the mountain is there and the trees planted, the project's ultimate meaning will be enhanced by its survival into the future. Unlike the original drawing, *Proposal for a Forest*, which made a complete, unchanging statement on its own, *Tree Mountain* must survive real-world conditions. As an actual monument, its physicality makes it a considerably more fragile proposition—at the mercy of the environment, history, and 20 generations of people.[6] In a related 1998 work in Melbourne, Australia, Denes planted 6,000 trees in five spirals to form step pyramids depending on the height of the trees.

Even more ambitious and far-reaching than *Tree Mountain*, Denes's 25-year master plan for the Nieuwe Hollandse Waterlinie in the Netherlands made some progress before it died of ministry neglect. This water-based series of defenses, first conceived in the early 17th century, joined with natural bodies of water to surround and protect the economic heartland of the Dutch Republic as an isolated island. Altered and renamed the New Dutch Waterline in the 19th century after the formation of the United Kingdom of the Netherlands, the system was further fortified during World War II and later redesigned to counter possible Soviet invasion. When the line was retired in 1960, many of the forts remained more or less intact, and the Dutch government began to consider how to recover and make use of the area's

Tree Mountain—A Living Time Capsule—11,000 Trees, 11,000 People, 400 Years, 1992–96. Project located in Ylöjärvi, Finland, 28 x 270 x 420 meters.

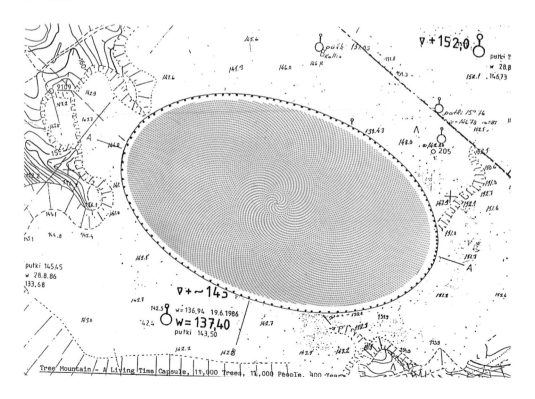

Tree Mountain—A Living Time Capsule—11,000 Trees, 11,000 People, 400 Years (detail), 1992–96.

historical significance and natural beauty. Hiking and biking paths were gradually installed, and some of the forts became camping sites and cabins, while others were adapted to a variety of functions—for example, Utrecht University houses its botanical garden in Fort Hoofddijlk. But before Denes entered the discussions in the late 1990s, these developments lacked coherence. Her vision for the 85-kilometer area (a UNESCO World Heritage Site) unites and environmentally stabilizes the 100-kilometer-long string of 16th- to 19th-century forts, incorporating increased flood and water management, transportation, rehabilitation of marshlands, wildlife areas, and watershed buffer zones, wind-power generation, and tourism. Combining conceptual rigor with multi-use functionality, this complex planning tour de force bears all the hallmarks of Denes's approach—her earliest proposals, such as the striking *Crystal Fort— Masterplan: Nieuwe Hollandse Waterlinie* (2000), a full-size futuristic glass fortress designed as a tourist attraction to raise revenue for the reclamation plans, already demonstrate an integrated approach to the site and its realities.

Elusive and transparent, Denes's work is as solid as sculpture. Her objects of transcendent beauty are realized through her integration of poetry, mathematics, and philosophy. If we recognize Denes as an environmental artist, as we should, then we must also recognize her as a consummate exponent of sculptural conceptualism, a paradox very much of her own making.

Notes

1 Robert Hobbs, "Agnes Denes's Environmental Projects and Installations: Sowing New Concepts," in *Agnes Denes*, exhibition catalogue, (Ithaca: Herbert F. Johnson Museum of Arts, Cornell University, 1992), p. 169.

2 Agnes Denes, proposal for *Underwater Project: Ocean Floor vs. Continent—A Conceptual Work*, 1972.

3 Donald Kuspit, "Paradox Perfected: Agnes Denes's *Pyramids*," in *Agnes Denes*, op. cit., p. 171.

4 Denes, description of *The Restless Pyramids*, 1984.

5 Hobbs, op. cit., p. 166.

6 Each one of the 11,000 people who planted a tree received a certificate of custodianship that reaches 400 years into the future, with each generation inheriting the tree as one might a precious legacy.

Nature Redux: Nancy Holt and the '90s Reclamation Revival

by Joan Marter

The mid-1990s saw a renaissance in land reclamation art, with many projects completed and others entering the planning stages. A few triumphs were even celebrated, including the official acceptance of Long Island City's Socrates Sculpture Park—formerly a garbage-strewn landfill—into the New York City Department of Parks and Recreation. Meanwhile more than a few exhibitions documented urban and industrial clean-up projects. "Urban Paradise: Gardens in the City" showcased proposals by Alison and Betye Saar, Meg Webster, and Haim Steinbach, among others, to transform inner-city sites, including a Brooklyn wastewater plant, into gardens.[1] "Fragile Ecologies: Contemporary Artists' Interpretations and Solutions," which traveled to seven states, featured reclamation projects by Patricia Johanson, Mierle Laderman Ukeles, and Mel Chin, among others.[2] "Creative Solutions to Ecological Issues" included an excerpt from Al Gore's *Earth in the Balance* in its catalogue and presented artists involved in water and land reclamation, reforestation, and waste management.[3]

Sky Mound, 1991. View of garbage pile dug up when excavating for the methane collection system. Project site in the Hackensack Meadowlands, New Jersey.

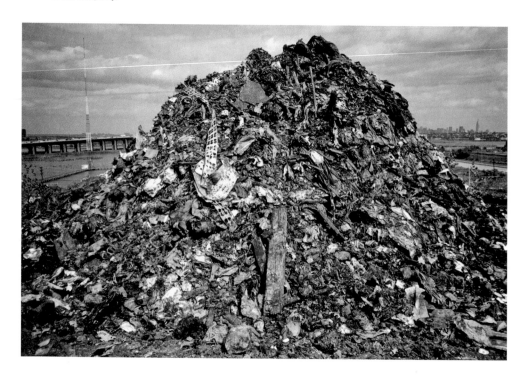

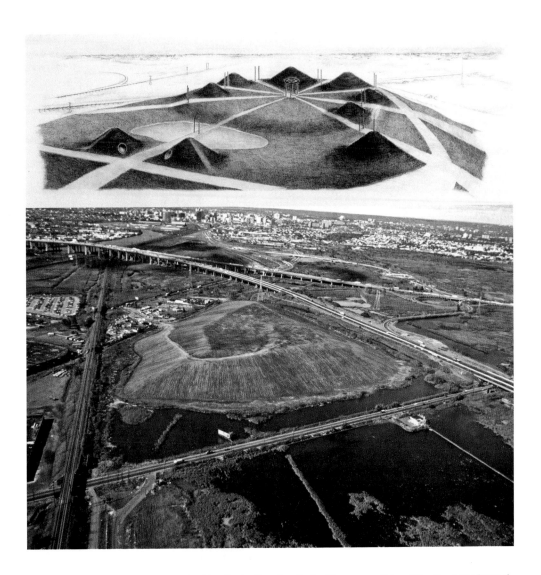

Top: *Sky Mound: Sun Viewing Area with Pond and Star Viewing Mounds*, 1985. Graphite on paper, 23.5 x 47.5 in. Above: Aerial view of the original *Sky Mound* site, 1984.

Why all of this renewed interest in reclamation art? After Gore became Vice President and Bruce Babbitt became Secretary of the Interior, environmental protection issues attracted wider attention. During the Clinton/Gore administration, reclamation efforts began to flourish once again, as long-ignored legislation to reclaim polluted or ravaged sites—including the National Environmental Policy Act (1970) and the Federal Land Policy and Management Act (1977)—was once again enforced.

Despite government inaction during the Reagan and Bush administrations, artists like Nancy Holt never stopped working to reclaim neglected refuse sites, landfills, and murky waterways. Holt is exemplary in her efforts to restore ravaged sites to health, producing works that not only rehabilitate nature, but also contribute to human enjoyment and welfare. She practices true reclamation, making permanent changes in damaged habitats, while continuing the imagery and conceptual interests of her more formal projects.

Beginning with *Dark Star Park* (1979–84), Holt has developed a succession of site-related works that combine environmental concerns with an awareness of time and space. *Sky Mound*, a project conceived in the mid-'80s, was among the earliest examples of waste-dump regeneration initiatives. (*Byxbee Park* [1988–92], built on a landfill in Palo Alto by Hargreaves Associates in collaboration with sculptors Peter Richards and Michael Oppenheimer, is another early example.) Sited in the New Jersey Meadowlands, where 10 million tons of garbage have been dumped over many decades, this ambitious two-part project has met with partial success. The first phase (1984–91) included sealing the landfill at a cost of nearly $11 million. An invisible slurry wall contains the decomposing garbage, which is covered by plastic liners made from recycled bottles and topped with 18 inches of soil. Methane gas, a product of decomposing organic matter, is isolated in a recovery system and made available as an alternative energy source. Holt sees the 57-acre landfill as "a place where sky and ground meet, where you can track the sun, moon, and stars with the naked eye, and where you have 360-degree panoramic views of Manhattan, Newark, and the Pulaski Skyway, networks of highways and train tracks, old steel turn bridges, and here and there decaying remnants of the Industrial Revolution. As soon as I saw the site, I knew that I wanted to transform the landfill into a 'park/artwork.'"[4]

Holt acknowledges that *Sky Mound*, which includes a 100-square-foot, central solar area that doubles as a haven for people and wildlife, resembles a prehistoric Native American mound (she consulted with an archaeo-astonomer to do the astronomical calculations). A visit reveals an astonishing array of plants and wildflowers, while geese and ducks inhabit the completed pond on the capped landfill. As in *Sun Tunnels* (1973–76), *Sky Mound* registers the summer and winter solstices, but here, large earth mounds and steel posts frame the sunrises and sunsets during both solstices and equinoxes.

The second stage of *Sky Mound*, which includes the non-functional sculptural sections, has been delayed since 1991 for an evaluation of the closure technology. [Further construction, already funded by the National Endowment for the Arts and the New Jersey State Council on the Arts, remains postponed.]

Up and Under, 1987–98. Earth gathered from sites all over Finland and buried in the center where 5 tunnels converge, 235 ft. long. View of installation at the Pinsio Sand Quarry in Nokia, Finland.

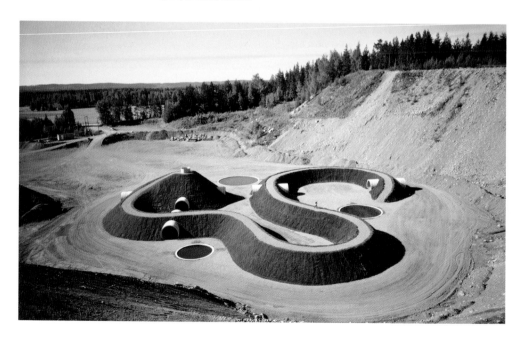

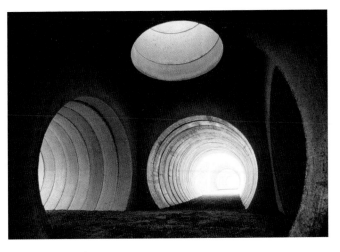

Up and Under, 1987–98. Detail of installation at the Pinsio Sand Quarry in Nokia, Finland.

During the delay, Holt turned to *Up and Under*, a reclamation project in Nokia, Finland, completed in 1998. Government and local arts organizations joined together to commission the work for an abandoned sand quarry, one of several in the region. Holt was fascinated by the variations in elevation left by the quarrying operations and was determined to make effective use of these height changes in an otherwise flat terrain. Her innovative solution responds to the site while conceptually relating to her previous projects and encouraging visitor participation. The full effect of *Up and Under* can only be discovered by walking through the entire site—along the elevated perimeter (the only place where the entire configuration of the work becomes visible), on the ground below, and within the work itself. Each changing visual experience relates to the dynamics of perception—near and far, whole and detail, aerial and ground.

Up and Under is 235 feet long (the entire length of the curving mound being 620 feet), 26 feet high, and 203 feet wide. The tunnels are all aligned north-south and east-west. Their crossing suggests the center of the world, the convergence of the four directions of the globe, with the addition of a fifth vertical direction. Looking up through the vertical tunnel, one sees a circle of sky and stars; looking down into the three pools, the sky is encircled at one's feet. The tunnels can provide shelter from rain or offer refuge from the sun. The work can also be used as a performance site, as requested by the local community, its natural curve serving as an amphitheater and the side tunnels providing entry to a performance area.

While Holt is certainly not alone in her efforts to counter environmental devastation, these projects are remarkable for their ambition and consistent application of developed aesthetic aims. In his 1972 book, *Arts of the Environment*, Gyorgy Kepes observed that artists had begun to question their role in relation to society and the environment: "Missing from 20th-century art was the cohesion, completeness, the link between art and life, man and environment, which was the source of all great art in the past."[5] For decades, reclamation concerns have been missing from public consciousness. Artists' interventions in blighted sites have called attention to the ecosystems essential to the planet, and it is possible that even more spectacular reclamation successes will be driven by sculptors working in the land to renew natural habitats.

Notes

1 "Urban Paradise: Gardens in the City" was organized by the Public Art Fund and shown at the PaineWebber (now UBS) Art Gallery, New York, April 15–July 1, 1994.

2 Barbara C. Matilsky, *Fragile Ecologies: Contemporary Artists' Interpretation and Solutions* (New York, Rizzoli, 1992). This exhibition originated at the Queens Museum of Art and was shown in Washington, California, Wisconsin, Massachusetts, and Florida.

3 Gail Enid Gelburd, *Creative Solutions to Ecological Issues* (New York: Council for Creative Projects, 1993). This exhibition was shown in Dallas, Saint Louis, Philadelphia, and Farmville, Virginia.

4 From an unpublished statement by Nancy Holt. My thanks to the artist for several interviews conducted in 1994.

5 Gyorgy Kepes, ed., *Arts of the Environment* (New York: Aidan Ellis Publishing, 1972), p. 5.

Herman Prigann and the Unfinished Ecology of Sculpture

by Paula Llull

Herman Prigann, a German artist who spent the latter part of his career in Spain (where he died in 2008), not only reshaped devastated landscapes through his visionary work, he also created a sense of positive identification with individual sites. Recognizing early on that "all assertions about nature are assertions about the nature of man" and that art is a reflection of this dialectic, he carried out an in-depth analysis of the human attitude toward the environment, using his work to foster new relationships and new forms of dialogue between man and landscape that sought to re-forge forgotten links connecting local nature and the history of place. He dedicated his work to reconciling site restoration and the past, present, and future of humanity and nature. His projects paired aesthetics with a strong social component, and they were accompanied by texts detailing a comprehensive conceptual and theoretical background. Prigann called his new philosophical concept of art and nature, "Ecological Aesthetics."

From the beginning, Prigann was a politically committed social artist who advocated for an integrated perspective. His early happenings and actions of the 1960s already incorporated the basic traits that would characterize his major works two decades later: the relevance of the artistic process in the metamorphosis of the art object; a multidisciplinary, cooperative approach involving the knowledge of experts in other disciplines and the labor of the unemployed

Photograph of existing landscape, lignite opencast mine near Cottbus, Germany, 1990s.

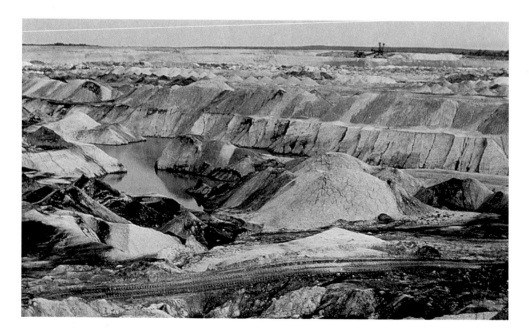

Terra Nova Wetlands, design for *Terra Nova landscape,* 1990–2000. Ink on paper.

and recovering addicts; and a constant, evolving commitment to raising awareness of the environment's intrinsic value. These three concepts — materialization, multi-disciplinarity, and environmental awareness — came to the fore in Prigann's work of the early 1980s.

Prigann's concerns aligned his work with a distinctly European approach to art and environment, dubbed "Art in Nature" by critics Vittorio Fagone and Dieter Rönte. While American Land Art used nature as a scenario, promoting the contemplation of natural processes as part of the artwork, Art in Nature took a different approach, advocating for site interventions in which the artist's action is incorporated into the intervention itself, so that the viewer turns from watching the spectacle of nature to an active move into ecology. *Ring der Erinnerung (Circle of Remembrance)* (1989–92), situated between Braunlage and Blankenburg on the former East/West German border, demonstrates how the concept functions within the scope of a memorial. A dam of piled tree trunks and limbs surrounds nine concrete fence posts from the "death strip," collapsing and rotting over time in a cyclical promotion of new growth. In this and other projects, Prigann opted for an art practice that functions as a sign language materializing both our inner/symbolic perception of nature (we are part of universal existence) and our outer/objective understanding (we are part of the process of energy/matter exchange). This new conception requires a different form of representation, one that conceives of nature as fundamental entity and not a mere transmission tool of dialogue.

Once we understand that we are part of a perpetual process of metamorphosis, we will also accept that works of art can never be completed. They evolve as time goes by, and through their contemplation, we may simultaneously experience past, present, and future. Prigann's Metamorphic Objects/Sculptural Places reach their full meaning after being placed in a specific site, where they begin their process of transformation either by rapid, fire-induced destruction or slow alteration through the passage of time and human activity.[1] The Metamorphic Objects use such conditions as motors of change, palpably embodying their effects in shifts of shape, color, and size. Rather than creating barriers

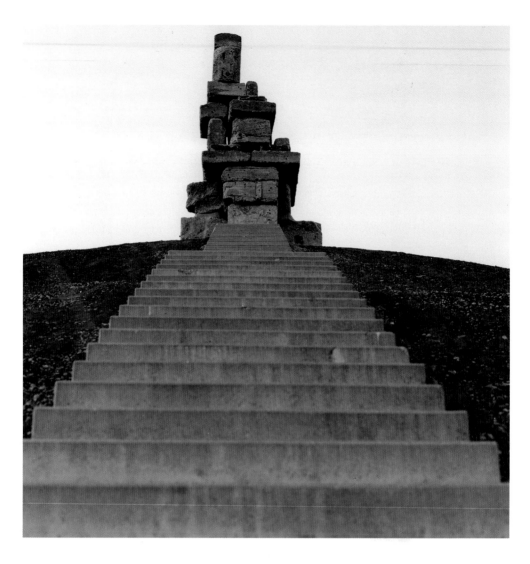

Himmelstreppe (Skystairs), 1998–99. Concrete foundation, 26 meters high.

between artwork and environment, Prigann placed his materials in specific natural contexts where alteration could take place. Time, enhanced by the growth and death of indigenous plants and the effects of climate, reveals the ephemeral and immanent aspects of the artwork in a continuous process that reflects changes in our own existence and in life itself, leading to an open ending.

In his papers and lectures, Prigann stated that art is the means to re-establish a dialogue across culture (or intellect), technology, and nature to restore damaged land and replace what industrialization stripped away. In order to produce a balanced dialogue, it is important that the intervention not modify or imitate nature, but build a bridge between nature and the social and industrial history of the site.

In the 1990s, Prigann began a series of ambitious interventions known as the Terra Nova project. This monumental undertaking attempted to apply a systems intervention concept to sites devastated by industrial contamination and resource extraction, including open pit mines, slag heaps, and slag fields. Prigann cooperated with scientists, technicians,

and artisans in developing what he called "Interactive Landscape Art." Interdisciplinarity and trans-disciplinarity became essential components in the redesign of these post-industrial landscapes.[2] In order to carry out an in-depth study of the setting, its past and recent history, and the involvement of society in the process of change, these highly complex interventions needed the experience and participation of individuals with different cultural and technical backgrounds, as well as the input and participation of lay citizens. The reconstruction process of a degraded landscape cannot be fulfilled without an initial and ongoing social process in which teams are put together, meetings are held, and debate and consensus drive an increasingly creative ecological consciousness.

The artist plays a determining role in the transformation process, both as a knowledge broker among the different experts and groups and as the catalyst driving different efforts toward a single outcome that integrates artistic and social meaning. This is a critical difference between Prigann's Integrative Landscape Art and Land Art, which, when it was interested in reclamation at all, advocated for a purely aesthetic approach to devastated landscapes, arguing that any reparatory intervention should be prevented due to the "intrinsic beauty" of these degraded places. *Large Stone Field* (Mont Cenis, Herne, Ruhr Valley, Germany, 1999), *Water levels* (Marl, Germany, 1998–2005), and *Rheinelbe Sculpture Wood* (Gelsenkirchen, Germany, 1997–2000) are perhaps the best known of the Terra Nova works.

In a to-the-point mission statement, Prigann wrote about Terra Nova: "It is a fact that we have to devise and develop an aesthetic awareness of beauty in nature for our times that approaches design ecologically and humanistically. Without this awareness we will not succeed in solving cultural and ecological problems."[3] Assuming that the landscape is the result of a cultural construction, projects developed under the principles of Ecological Aesthetics present the artist as the ideal mediator, able to identify new signs in a landscape no longer tied to domination while also discovering new places that do not turn away from the site's historical and natural background. This aesthetic restructuring entails a new perception of the land, characterized by a higher ecological consciousness and a new dialogue with nature that disrupts old-fashioned dualism. Prigann defended an exchange with nature guided by self-criticism, as opposed to

Wasserstände (Water levels), 1998–2005. Pump station, construction materials, earth, plants, and water, installation view.

exploitative human action, and art was the best-suited vehicle for this non-dominating dialogue. He developed a consistent and solid theoretical background for the approach behind the Terra Nova project, describing it as a "concept for an aesthetic and ecological program for re-cultivating landscapes that have been destroyed, with suggested solutions in the following areas: 1. Establishing new jobs in the environmental field. 2. Co-operation with universities in the ecological sphere. 3. Setting up a "campus" in areas currently receiving attention for education and training in cultural ecology. 4. Extraction of organic raw materials and establishing industries for processing them."[4] In summary, he envisioned Terra Nova as a collective project bringing together the efforts of biologists, ecologists, experts in aesthetics, students in environmental sciences, and the unemployed under the guidance of the artist. During the 10 years that Prigann devoted to this project, he showed how it was possible to re-integrate a devastated landscape by putting its former industrial use into the cultural context of a region. It could become a leisure space reintroducing nature while preserving its recent past. The construction of pools and the introduction of local vegetation and purifying plants could clean out toxic agents. In some places, crops could be grown, and small manufacturing industries could be established to create jobs.

Terra Nova closes the circle of Prigann's work; it incorporates elements from all of his previous projects, beginning with *Release* in the 1970s. Despite extensive planning and preparation, and the partial completion of work in Cottbus and the Ruhr Valley, Terra Nova never fully materialized due to its complexity and the lack of agreement across different institutions and public agencies.

Prigann also tried to put forward projects in Spain, where he settled in 1986. He regretted not having been able to implement several proposals such as an intervention in the Tormes River area, near Salamanca, which was part of the E.U.-funded Parque fluvial de cultura y ecología (River Park for Culture and Ecology) aimed at regenerating this deprived area. But he did direct a workshop in the province of Salamanca together with artist and curator Bodo Rau, who is planning to resume the intervention in line with Prigann's spirit and ideas. Rau is working with the local municipality and trying to overcome the same bureaucratic complexities that Prigann faced so many times.

Prigann spent his last 20 years in Majorca, continuing to develop projects and conduct workshops throughout Europe. Today visitors can experience and enjoy his many site-specific interventions, mainly in Germany, but also in Italy, France, Denmark, Austria, and Japan. His intensive dissemination of ideas through essays, workshops, and lectures was not in vain. Interest in Prigann's work is steadily growing as the practices behind his Integrative Landscape Art spread, passed from workshop attendees to other artists, and ecologists and other scientists embrace his holistic approach to sustaining humanity and nature.

Notes

1 Examples of the Metamorphic Objects include *Der duftende Meiler (The fragrant pile)*, a five-meter-high charcoal pile that smoked in central Vienna for five weeks; *Die brennende Pyramide (The burning pyramid)*, which was burned in Danube Island, Vienna; and *Adam im Feuer (Adam in fire)* in Mürz (all dating from 1985). His works related to the duration of time include *Two trunks — Three stones* (1995, Krakamarken, Art in Nature Park, Denmark); *Hanging stones and Stone table* (1994, Arte Sella, Valsugana, Italy); and *Tower of the roots* (1999, Tosa Cho forest, Sameura Park, Shikoku, Japan).

2 "Transdisciplinarity is seen here as a research approach that defines problems independently of any discipline. It is a further development of interdisciplinarity. This is seen in the first place as embracing other disciplines, as co-operation between them." See Prigann, "A dialogue with ongoing processes," in Heike Strelow, ed., *Ecological Aesthetics*, (Basel: Birkhäuser, 2004).

3 Herman Prigann, "Project Terra Nova," in *Ring der Erinnerung/Circle of Remembrance* (Berlin: Nishen, 1993), p. 75.

4 Ibid., p. 69.

Acid Mine Drainage and Art: Art, History, and Science in Rural Pennsylvania

by Virginia Maksymowicz

Introduce yourself to T. Allan Comp, who works for the Office of Surface Mining in Washington, DC, and he'll give you an earful. He calls it "the art thing." As founding director of an organization with the curious name of AMD&Art—Acid Mine Drainage and Art—he became obsessed with the idea that art could somehow play a part in environmental reclamation. For artists, the notion that art can address ecological issues is taken for granted. But usually artists approach the non-artists, insisting that they have a contribution to make. This time, it worked the other way around. Comp, who holds a PhD in the history of technology, actively sought out the artists.

As his idea developed, an unlikely mix of historians, hydrogeologists, landscape designers, artists, retired miners, community activists, AmeriCorps volunteers, Navy Seabees, politicians, schoolteachers, and students came together in an extraordinary effort involving three sites in Pennsylvania—the Dark Shade Watershed in Somerset County, the Hughes Bore Hole, and the town of Vintondale in Cambria County—areas ravaged by acidic runoff from abandoned mines.

"Every region that mined coal in the 19th and first half of the 20th century is afflicted at one level or another by acid mine drainage," Comp explained in a television spot for CNN. "AMD&Art is a project that is trying very hard to engage rural, usually impoverished communities in fixing up what has been left behind by this coal-mining legacy." Comp's vision engaged a new paradigm, one in which the problem could be seen as an opportunity "to create an economic—even a spiritual—asset, a chance for transformation." Sounding more like a philosopher than a government official, he set out to build a coalition that would, in his words, ask "new questions" and find "new answers."

The first of these endeavors to come to fruition was Vintondale Park, a 35-acre coal field that has been transformed into a recreation area. On July 8, 2005, a public symposium involving scientists, historians, and artists was held at the church that housed the project's education center. The next day, townspeople held a gala celebration, complete with a parade down Main Street. At the dedication, the park was formally turned over to residents, with its endowment to be managed by the nonprofit Community Foundation of the Alleghenies. Ten years in the making, the Vintondale reclamation looks, at first glance, like any other park; it includes a hiking/bicycling trail, a stream and ponds, wildflowers, baseball and soccer fields, and a pavilion. But it soon becomes apparent that the history of the land and the process by which it is being healed are included as well, and this is where the art comes in.

The Great Map is a large ceramic mosaic originally designed by North Carolina artist Peter Richards and executed by Philadelphia artist Jessica Gorlin Liddell and former AmeriCorps member Dana Serovy. Based on an old fire insurance map, a schematic of the town is juxtaposed with reproductions of historical photographs and newspaper articles sand-blasted into black granite. The map is framed by the word "hope" translated into the 26 languages spoken by the immigrant miners. Visitors can walk on and around the work, imagining the layout of the town and its mines as they were while viewing the panorama of the area as it is now. The work serves as a practical point of orientation for geographic understanding of the park, a symbolic means of preserving public memory, and an artistic way to visualize both the past and the future of the Vintondale community.

Anita Lucero, *Mine No. 6 Portal*. Granite, installation view.

The Great Map is located directly across from the entrance to the old Mine No. 6 shaft, facing the town on the pathway that once led to the bridge connecting to the company houses. The mine's portal now frames a granite mural by Vermont artist Anita Lucero. The polished black stone is etched with ghostly images of miners, inspired by a 1938 home movie filmed by Vintondale resident Julius Morey. A crowd of almost 100 attended the dedication, three of whom had once worked in Mine No. 6.

Clean Slate situates two large pieces of Pennsylvania slate as platforms where "visitors can gather and reflect on the processes they witness in the park." Designed by Claire Fellman and Emily Neye, graduate students in landscape architecture at the University of Pennsylvania, it was selected in a national competition. Clean water flows over one of the slabs as it returns to Blacklick Creek; the other piece acts as an overlook to a descent of 10 steps leading down through a carboniferous garden to the creek.

Stacy Levy's *Testing the Waters* sculpts the environment itself. Along with landscape architect Julie Bargmann and hydrogeologist Robert Deason, she created a passive treatment system that de-acidifies the water while making its gradual purification visible. "One of the most amazing things about this cleaning process of the water is the different colors that it turns," Levy explained to CNN. "It's an extraordinary transition from a sort of scary orange to a kind of pea-soup green, and then it blues out in the end. That movement from orange to blue is the color of healing the waters, and we're going to play that up in this project by reiterating and enlarging those colors by the vegetation that we're using in what we call our Litmus Garden. It's showing the changing water quality through the vegetation that's designed to be around each of the pools." Once purified, the water settles into an area of wetlands that allows it to seep back into Blacklick Creek.

AMD&Art, which is headquartered in Johnstown, Pennsylvania, is slowly but surely continuing its work at the Dark Shade Watershed and the Hughes Bore Hole. Forming the necessary alliances of funders, politicians, scientists,

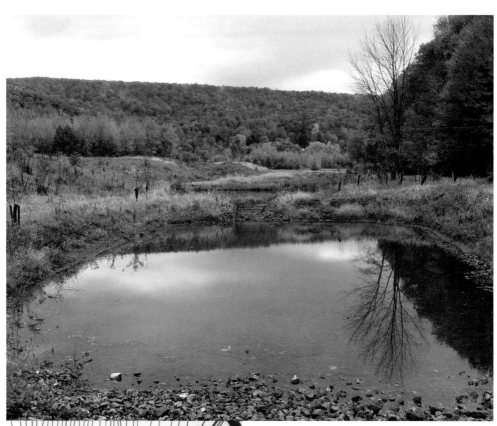

Above: Stacy Levy, in collaboration with Julie Bargmann, Robert Deason, and T. Allan Comp, *Testing the Waters: Acid Mine Drainage and Art Project for Vintondale, PA*. 1995–2007. Approximately 40 acres. Left: Stacy Levy, plan detail of *Testing the Waters*.

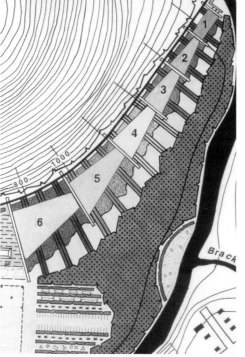

artists, and local residents takes time and tenacity. Its charismatic founder (San Francisco artist Jo Hanson once described T. Allan Comp as "a relaxed blend of John Muir, John Dewey, and John the Baptist") has moved on (he now leads the OSM/VISTA Team and Brownfields Initiatives at the Office of Surface Mining in the U.S. Department of the Interior). However, with the inclusion of artists like Lily Yeh, well known as the founder of Philadelphia's Village of Arts and Humanities, the list of those committed to the mission remains impressive.

Stacy Levy: Understanding Nature As It Happens

by Kathy Bruce

Stacy Levy transforms the invisible aspects of nature into visually seductive forms by acquainting us with the underlying structures of the natural world. Guided by her dual background in forestry and sculpture (she is a founding partner of Sere, Ltd., a collaborative venture dedicated to restoring forests, oldfields, and woodlands), Levy comments on nature in a way that is not just about gesture, information, ecology, or the landscape. At its best, her work redefines the categories of science, landscape art, and sculpture.

While in art school, Levy was intrigued by the structure of seedpods and sculpted dozens of variations on them in varying sizes and materials. As a result of this early work and her forestry experience at Yale, she gradually came to realize that she was more interested in the natural progression of life than in static objects. She also found that sculpture allowed her to deviate from the ecological constraints of forestry. The daily progression of seasons influenced her desire to make art about the processes of nature rather than in imitation of it.

Levy's work has been linked to Process Art, Earth Art, conceptual art, and performance art, though she considers herself principally a sculptor. Sculpture, she feels, "is a medium or field open to any form." Ironically, she has discovered that it is useless for her to use nature to establish a dialogue on nature. Rather than using living materials, she prefers to find manmade materials that contrast with nature to provide an altogether new vision. Unlike sculptors such as Ursula von Rydingsvard (for whom Levy was a studio assistant in 1980–81) who constantly work and rework ideas in one medium, Levy's work typically begins with the site, followed by the idea, and finally the materials. She intuitively allows the specifics of each project to dictate the materials required, and like a designer, she scopes out objects with the appropriate emotional intensity for each installation, thus achieving ever-fresh visual results.

In *Watercourse* (1996), she used more than 8,000 plastic cups (later recycled) to map the Delaware River and its tributaries on the gallery floor. In *Hidden River* (1990), she installed a pump that circulated running water through galvanized pipes connecting four wall-mounted porcelain sinks. Each sink represented a map (to scale) of the cities of northeast Pennsylvania that receive their drinking water from the Schuylkill River. In *Blue Lake* (2005),

Hidden River, 1990. Galvanized pipe, porcelain sinks, running water, and sandblasted glass, 10 x 22 x 2 ft.

River Eyelash, 2005. 3000 painted buoys, steel washers, and pink rope, 400-ft. span.

Levy installed a room full of waist-high steel rods supporting blue plastic disks to re-create the essence of an undulating pond environment. Consistently cross-referencing manmade and natural materials, she creates a magical overlay between the two. Influenced by Eva Hesse's use of multiples, Levy often employs clusters in her installations to explain the accrual of simple acts or processes in nature. Such is the case in *Tideflowers* (2004–08), in which Levy re-creates a vast field of flowers by attaching multiple red vinyl "petals" to approximately 40 pylons in the Hudson River. The petals open and close based on the ebb and flow of the tides.

Temporary works act as prototypes, testing materials that may or may not work in long-term projects such as fountains, waterworks, and drainages. Levy uses manmade objects such as spigots or faucets as metaphors for natural processes. Metaphor, she says, is one way to understand how something functions. Domestic hardware, for example the bathroom imagery of *Hidden River*, is a common language that can be used to create understanding and raise awareness. It also adds humor and lyricism, which is apparent in all of Levy's work and provides relief from the more scientific aspects. Levy's use of humor brings to mind *Hudson River Purge* (1991) by fellow land sculptor/ environmentalist and mentor, Buster Simpson. Simpson placed soft limestone disks in the Hudson River to dissolve and neutralize the water's acidity. Dubbed "River Rolaids," the result was visual, humorous, and environmentally restorative. Likewise Levy, as part-artist, part-scientist, reminds us that it is imperative to look at things from different perspectives in order to appreciate and understand fundamental processes in nature. She states that from her initial hypothesis (solving the problem and explaining it) to the final work (making it visual), she too experiences wonder and amazement at the outcome.

Levy also involves herself in the hands-on, physical side of making. It is crucial, she says, to relate to and learn from materials, assisting the fabricators to cut templates and trying out how pieces fit into the ground or how materials respond to air and water currents. A pivotal moment occurs when the elements get wet or rusty, which informs the next steps of the process. She tested pieces for *River Eyelash* (2005) in her pond before taking 15 strands to Pittsburgh to see how they responded to conditions there. In the final version, 3,000 Styrofoam buoys were painted and strung on 42 100-foot lengths of rope. The washers inserted between the buoys produced a clinking sound in the water. *River Eyelash* radiated from the bulkhead at Point State Park into the Allegheny, Monongahela, and Ohio Rivers. Its shape

Watermap, 2003. Sandblasted bluestone, brick paving, and rain, 30 ft. diameter.

at any given moment was subject to the prevailing winds, boat wakes, and changing currents of the three rivers.

In *Clerestories: Seeing The Path of the Wind* (2000), Levy installed a weather station on the roof of a gallery and filled the indoor space below with eight fans and 1,000 aqua and orange flags that changed speed and direction depending on the signals received from the weather vane above. She was present in the gallery to witness the wind direction and movements in her installation in advance of an approaching storm. In other instances, such as her water collection pieces, she is never certain where or how algae will grow.

Levy is also concerned with making art that performs a service for the environment. She explores the environmental possibilities of each project and spends more time in discussion with scientists, engineers, and architects than with other artists. Her recent works have brought her to research hydrology, tides, and zoology. She turns to scientists to find the facts of a site and thrives on those interactions. In *Testing the Waters* (Vintondale, Pennsylvania, 1995–2007), she collaborated with a landscape architect, a geologist, and a historian to demonstrate the effects of coalmines on the environment, while simultaneously restoring nature to its pre-industrial state.

Levy presents nature from the gigantic to the microscopic, reintroducing elements at both extremes on a human scale. In *Map Quest*, she zooms in and out with works either magnified or miniaturized to allow us to see the mechanical workings of nature at our own scale. In an initial proposal for her Hudson River project (later replaced by *Tideflowers*), she mapped the planets and stars through an ellipse situated in the landscape to help people find their place in the environment. Levy's installations and water maps create conceptual accessibility through physical, bodily understanding: they require participants to enter into their spaces. Shrinking giant bodies of water down to human scale allows viewers to trace waterways and find their own locations on the map, thus creating a relationship with the diagram. In *Watermap* (2003), rainwater runs across the tilted surface of a 30-foot stone circle flowing into the runnels of the tributaries blasted into the stone. The terrace functions as a watershed in miniature, as runoff flows from small streams to secondary tributaries and into the Delaware River.

Levy selects projects and sites that respond to the changing geographies, histories, and memories of an area. *Urban Oldfield: Diagram of a Vacant Lot* (1998) showed urbanites how to see the potential intricacy of places such as empty parking lots. In a gallery, she planted more than 13,000 artificial sculptural elements fabricated out of steel rods, Mylar, rubber, paper, copper tops, and other materials. These forms represented the plants—Queen Anne's lace, yarrow, chicory, and St. John's wort, to name a few—that might have grown on a nearby site had conditions been different. By reconfiguring an abandoned lot inside a gallery (complete with a sound recording from the site), this installation allowed visitors to consider disused urban spaces in a new light.

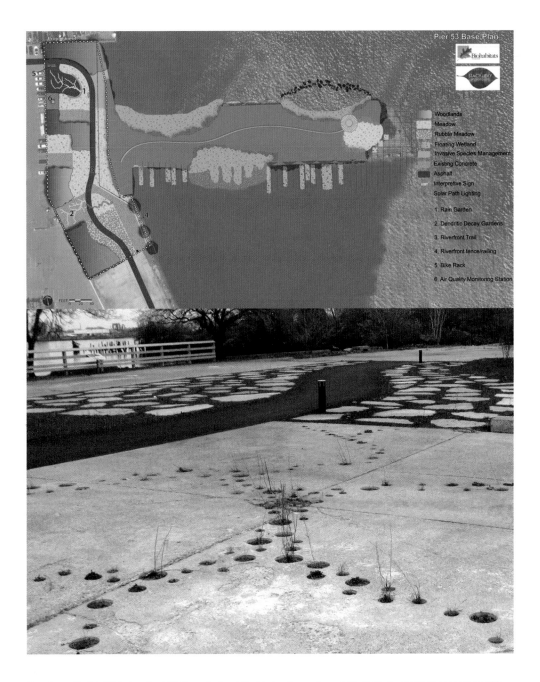

Stacy Levy with Biohabitats Inc., *Dendritic Decay Garden at Washington Avenue Green*, 2010. Removal of concrete and asphalt, addition of spoil and native plants, porous asphalt, recycled concrete, and glass, 1100 x 400 ft. Project in Philadelphia.

Based on simple concepts and clear execution, Levy's work is about inclusion, not exclusion or a hidden agenda. Her projects make for accessible and enjoyable experiences. Many of them, like *Calendar of Rain* (1992), which was installed in the window of the Larry Becker Gallery in Philadelphia, are interactive. Since this work was located next to a bus stop, people getting on and off the buses could observe it 24 hours a day for the duration of the show. With

a nod to Hans Haacke's *Biological Systems* (1962–64), in which Haacke placed water in boxes to register cycles of condensation and evaporation, every day Levy placed a glass bottle sandblasted with the date on a shelf located below a collection receptacle. When it rained, the water was channeled from funnels situated above the gallery entrance into clear plastic tubes, which drained into the receptacle and then into the dated bottle. Each bottle was placed on one of five glass shelves in the window. At the end of the show, the results were tallied on a bar graph. She repeated this under different circumstances for the exhibition "Drip, Blow, Burn: Forces of Nature in Contemporary Art" at the Hudson River Museum (1999), allowing viewers to look out on to a natural setting and observe the changes of the seasons while watching rainwater collection at work.

Experience and evolution over time continue to play an important part in Levy's *Dendritic Decay Garden*, which form the centerpiece of the Washington Avenue Green along the Delaware River waterfront in Philadelphia. This new park (construction was completed in 2010) began its life as Pier 53, an abandoned dock; in addition to the pier itself, the project encompasses a one-acre parcel at the end of Washington Avenue, where it connects with the riverfront recreational trail. The result of a collaborative effort involving Levy, the Delaware River Waterfront Corporation, and Biohabitats, Inc., the Green is designed to demonstrate the validity of regenerative design as a tool of ecological restoration and redevelopment. For the two decay gardens, Levy cut a watershed pattern into the existing concrete and asphalt of the pier. Holes bored through the impervious surface have become planters for native vegetation, and a new ecology of wet and dry areas is beginning to emerge. The natural mechanics of freeze/thaw will assist the plantings to break up the remaining hard surfaces as Levy's design becomes a conduit for stormwater treatment. In the future, the pier will flourish with regenerated native woodlands, meadows, and a living shoreline, in addition to air quality monitoring, invasive species management, and multiple recreation opportunities. In just several months, plants on the created wetlands are drawing nutrients from the river and providing habitat for water- and land-based wildlife while helping to improve water quality.

Levy cites medical books with transparent overlays and Victorian scientific diagrams as sources of inspiration for her immersion in art and science. In fact, many of her pieces use visual layers, maps, and charts as a means of communicating processes. She explains, "Before industrialization, people had a definite sense of the seasons and the impact of nature on their day-to-day existence. Life was connected to natural time, the seasons, light. [People in] the 19th century didn't need someone to describe or recondition their view of nature as they do in the 21st century." If the visual aspect of science was lost when the 21st century merged into the realm of the virtual and numerical, it may become the responsibility of artists to reconnect us with its visceral and practical foundations. Levy makes apparently difficult and obscure subject matter compelling, reconnecting viewers to the forces of the natural world. For instance, in *A Month of Tides* (1993), an immensely popular piece that visually explained tidal processes, an aqua-blue tidal register connected to mechanical gauges on the roof of a building slowly ascended and descended through a 60-foot-high atrium in sync with the ebb and flow of the ocean tides in nearby Biscayne Bay.

Levy believes that "the more knowledge you have, the more evocative an artwork becomes" and that if she can get people to relate to and understand nature, they will, in turn, protect and respect the environment. She is not satisfied with creating a lovely vision of the landscape; she is driven to look beyond appearances to explore and present us with invisible life as it is happening. Rather than capturing a single moment, she offers the entire process—the cause and effect of wind, water, and air, thereby bringing to our attention the ever-present movement of nature. Her work not only aspires to stand as a constant reminder of our relationship to the natural beauty of the world around us, it also seeks to restore and re-energize that beauty.

Artists Confronting Problems:
A Conversation with Michael Singer

by John K. Grande

Michael Singer's sculptural works from the 1970s and '80s opened up new approaches to site-specificity and the development of public space. His more recent works have been recognized for their original solutions to the integration of aesthetic, environmental, and social concerns in the context of public art and infrastructure. These projects exemplify how artistic practice can cross into and cooperate with other disciplines such as design, landscape architecture, engineering, and architecture. In 1993, the *New York Times* declared the Phoenix Recycling Center, co-produced by Singer and Linnea Glatt, to be one of the eight most significant American architectural projects of the year.

Among Singer's projects from the 1990s are a one-mile Waterfront Park restoration master plan in New Haven, Connecticut, and a large-scale indoor garden at the Denver airport that transforms the space into a habitat for small birds. He has also completed a multi-disciplinary revitalization project for the Troja Island River basin in Prague, an interpretive center for the Lower East Side Tenement Museum in New York, and an artists' environment for the Millay Colony for the Arts in Austerlitz, New York. His indoor and outdoor gardens (1999) for the Alterra Institute for Environmental Research in Wageningen, the Netherlands, function as the "lungs and kidneys" of this green building, cleaning air and gray water, as well as providing climate control without air conditioning. *West Palm Beach Living Docks* (2004–09) continues the idea of living infrastructure, with boat tie-ups and a promenade that double as habitat and a water-filtration system.

John K. Grande: *There has been a gradual evolution in your approach to outdoor sculpture. Your works from the 1970s go from drawing with trees, bamboo, and phragmites in natural settings to juxtapositions of cut and natural wood and stone. In the mid-'70s, you began working on indoor environments, such as the "Seven Moon Ritual Series" and the "Ritual Gates Series," which introduced a human element into environmental sculpture. They were not just about nature, but also about habitation, integration, and even fictional histories of habitation. It's interesting that you considered ritual as a complement to working in nature.*

Michael Singer: I saw my work in these environments and in my studio as daily rituals resulting, eventually, in a work of art. At the time, I felt that I could keep making outdoor installations in beautiful environments forever. It's seductive. I wanted to create works in which human activity would not be destructive and would interface with the natural environment. In the "Lily Pond Ritual Series" (1975), I sought to build a structure that captured light in different ways at different times. Eventually the question became: "What happens with a site that doesn't have reflection, illusion, changing atmospheres of light and space?" This led me to a dark site in an old hemlock forest. I took some limbs off the trees and built a mat to create a level place. I felt that this might be a human intervention in such an environment. It became a starting point.

JG: Ritual Series *(1980–81), at the Guggenheim is conceived for space, rather than a specific indoor or outdoor setting. This makes us reflect on art's fixation with object-making.*

MS: It's a question of what happens when you take an idea from a natural environment and work inside architecture.

Atria Gardens, 1986. View of project in Franklin Lakes, New Jersey.

The base of *Ritual Series* is the reconfigured wooden floor of a barn. I made walls similar to those in the hemlock forest pieces and built the structure within it. It's a kind of intervention that builds its meaning into an architectural setting.

JG: *The early pieces are fragile structures, everything hangs on everything else—the language of natural forms and pre-cut wood and stone. This interrelation of the manmade and the natural cast you as a neo-primitive back in the '70s, yet, as with the vast indoor garden at the Denver International Airport, the meaning of the place is determined by your work. You don't play off the structure; instead, you center it by adding another layer of meaning to the architecture.*

MS: I really respected Michael McConnell, the architect for my first permanent project, and he asked me to design two large atrium spaces in the building. When it was completed, he told me: "We designed the space, and you transformed it into a place." At the Denver airport, the garden is visible from the level above, where there's a McDonald's and all the airport junk stores. The garden is covered with vines, ferns, and all manner of growth—a living ecology and a complete contradiction to its surroundings.

JG: *Your language informs viewers about how we look at and perceive nature and the built environment in different contexts.*

MS: When I am involved in investigations at the intersection of the built and the natural environment, issues of geology, of time, and of layers enter into the subtext. Slate, granite, and natural stone inform the built realm, as well as the non-built. I am interested in how people move through a space and how architecture choreographs our movements, as well as in architecture's power to bring meaning to a site.

JG: Sangam Ritual Series *(1986), in Aspen, Colorado, uses a Hindu word that describes the place where two rivers join and features a miniature element within its walls and gates. It's like a micro-comment on the macro-scale of our landscape perception.*

MS: This was the first time that I worked on a site that I felt needed alteration. The river winds around almost at a right angle where I began. After working for 15 years in outdoor sites where I didn't touch anything, here I manipulated the site itself. It began to be about building a garden. I felt the need to establish a portal and boundary. As visitors enter through the portal, the sounds of the river become magnified. The small, shrunken element within is like a table of contents. And the archaeological-type layering of stone reflects the layering of the land.

JG: *Your work at the Phoenix Recycling Center is truly exceptional. Who would believe that artists created the building, the site, the layout, and the daily patterns for moving goods and vehicles? It draws crowds of tourists, residents, and school children, who come to recycle materials and see what's going on.*

MS: I worked on this project with Linnea Glatt from Dallas. An engineering firm had completed a preliminary plan that inadvertently defined this as a place that no one would ever want to visit. It was a box of a building that closed in on itself, 25 acres of pavement, with a nightmare traffic situation for the 500 tractor-trailer-sized trucks coming in every day, along with other users. People were supposed to bring their recycled materials into the back, which was hidden out of sight and therefore out of mind, not even related to the building. The planners thought that as invited artists we would do what most artists would do in a public art project of this sort—choose a color and paint a stripe around the building and make a little something. We said, "No way." There was a lot of money involved, a percentage of an $18 million construction budget.

If they had maintained the plan, nothing could have humanized this place. It would have been like every other off-the-shelf waste facility built around the world. But Phoenix had a very special public works official, Ron Jensen, who listened when we pointed out some of the problems of the site—for example, that all of the visitors and staff were placed on the east side of a two-acre structure filled with garbage, and the wind blew west to east. So, it took an artist to tell them that if they just moved visitors and administrators to the west side, upwind, they'd be way ahead of the game. In defense of the engineers, they never even went to the site. They just pushed a button on the computer and out came the design. There were other, similar problems that we were able to point out. So, Jensen said, "OK, we have a facility to build. It's on a schedule. We can give you two months to come back with a new site plan, and let's see what you artists can come up with." We assembled and led a team of professionals who worked with us to redesign the facility. It all happened in that brief time. We told them, "The plan is one thing, but we should also design the building, we should design every aspect of the site to give it meaning. If you really want people to understand, be open to, and

Concourse C, Denver International Airport, 1994. View of project in Denver, Colorado.

93

Michael Singer and Linnea Glatt, Solid Waste Transfer and Recycling Center, 1989–93. View of project in Phoenix, Arizona.

use this place, it needs the approach to every element in the site."
And Jensen said, "Go for it." We also increased the program, adding all kinds of community spaces. The project ended up costing 25 percent less than its original budget, coming in at $13 million.

JG: *So, this process involved a switch from environmental artist to environmental designer.*

MS: Not a switch but an inclusion, an addition. After 20 years of working in natural environments and questioning my role in a natural environment and what humans do there, I began to wonder how I could use that knowledge to address community issues, to look at problems in communities from an artist's point of view. I began to develop a sense that the creative process of artists is very special and different from that of other professionals. It's not that we have solutions, though sometimes we do, but we have observations, questions, and ideas, and we should be invited to the table to talk about the problems and to help with the problem-solving.

JG: *Working on percent-for-art projects is something of a dilemma for artists. You have to respond to designs that are already decided. There is seldom much communication between the landscaper, the architect, the artist, and the public works department.*

MS: Percent-for-art work tends to become decorative and tacked on rather than worked on in consultation with landscape designers and architects. People come to the Phoenix project and ask, "Well, where is the art?" It's within the design, it's within the questioning, it's in the raising of new issues.

JG: *That separatist attitude perpetuates a myth of art that doesn't include people directly as participants. We are fed so much encoded professional jargon that we can't see the forest for the trees.*

MS: It happens in every profession. It's a symptom of a culture that encourages specialization at every level. What interested me about Pierre E. Leclerc, Michel Archanbault, and their gallery (200m3) is that they encourage cross-disciplinary interest. It's much more fun. It's really stimulating for me to spend the same day looking at issues that deal with planning in Prague, considering an interpretative center for the Lower East Side Tenement Museum, and asking questions about a sculpture that has been slowly evolving in my studio in response to all this other input.

It's very important for me to acknowledge that it isn't me alone in my studio. I'm working in the community, putting people together, some of whom have never worked on projects before. I'm interested in a cultural historian's perspective on things, or an anthropologist's, an architect's, or an engineer's.

JG: *How does the garden as living infrastructure function? I'm thinking of your interior and exterior gardens at the Alterra Institute for Environmental Research.*

MS: Water is first diverted to an outdoor constructed wetland and pond. From that point, it is piped into the first atrium garden pool next to the building's library. This pool contains fish and plantings that absorb toxins. From the library pool, the water travels to the second atrium water feature for its final cleaning. This pool has a shallow-patterned concrete plate with water plants growing on the surface. The water drips into a deep cistern for storage and recycling in the building's irrigation system. The design also provides research and experimentation sites, within the garden, for some of the environmental scientists working at the institute.

JG: *Prototypes are always good in art, but it's the translation from prototype to real life that is the challenge.*

MS: Phoenix is a good example. Remember, in 1989, no architect would consider designing a waste facility. It took artists to change that. I think that this is an example of what artists do: an artist given a problem will come up with new ideas and questions. Some of them will be ridiculous, and some of them will offer unthought-of possibilities.

Alterra Institute for Environmental Research, 1999. View of project in Wageningen, the Netherlands.

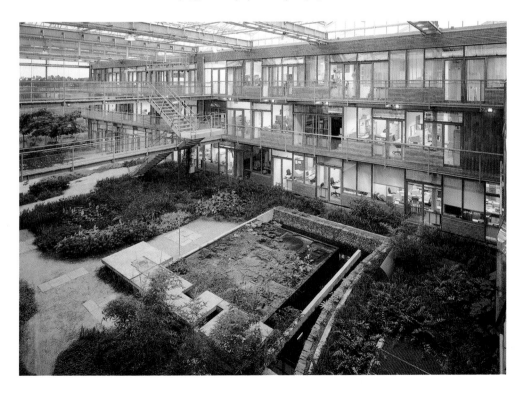

Buster Simpson: Greening Public Art

by Twylene Moyer

A "green" advocate long before that word became popular, Buster Simpson has helped define environmentally conscious public art since the 1970s. Combining an unconventional, make-do aesthetic with a commitment to social and ecological problem-solving, his highly original forms inject a provocative irreverence into daily life. As diverse as his endeavors have been over the years—from clandestine performances to official commissions—they all share an impish, prankster sensibility that drives home serious issues of vanished ecologies, displaced populations and values, and forgotten histories. Simpson does more than tease and taunt us into awareness, however; many of his witty urban interventions serve practical needs, inspiring and delighting while revealing through creative understanding.

Simpson first gained notoriety for rowdy grassroots projects and performances that tackled local matters in Seattle, where he settled in 1973. Today, he continues to instill at least an echo of his early improvisational, DIY style into even the most managed public commissions, a trick that turns them into replicable inspirations for smaller-scale, everyday action. Adapting his "artist-as-urban-guerrilla persona...into sidewalk, street, and building constructions" as accessible as they are challenging, Simpson re-envisions public art as a catalyst for community endeavor, with the potential to unite disparate individuals in shared urban environmentalist efforts that benefit everyone.[1]

Composting Commode, 1988. Plastic, metal, ceramics, compost (urine and feces), and tree, 10 x 3 x 3 ft.

For Simpson, art is a process that changes over time—nothing is permanent, or sacred. Adaptability and cooperation are key. The "anti-precious," opportunistic attitude that defines his approach to art-making and its materials—he recycles and reuses everything from water and felled trees to building materials, construction debris, and shards scavenged from the dumpsters of Seattle's famous glass studios—also recalibrates the relationship between art object and audience. From the time of his first utilitarian sculptures at Woodstock (1969), he has deliberately rejected the "gallery" experience of outdoor art as something removed from public use. When concertgoers harvested his wooden jungle gym to fuel fires, he embraced the evolution: "The lesson for me was that all of what we did was eventually used for basic survival needs...Public art gets re-appropriated by the public."[2]

In Seattle, he applied this insight to a responsive kind of urban art, one sensitized to its specific context in terms of audience and function and attuned to forgotten connections between city and natural world. *Myrtle Edwards Park Proposal* (1974), a plan to reclaim a section of waterfront near Elliott Bay, already revealed the hallmarks of the Simpson approach. Used as a dumping ground for highway construction debris, the site featured a stockpile of concrete slabs and footings and other materials, which Simpson proposed to use as readymade functional sculptures (they already served as ad hoc picnic/seating areas). His plan also incorporated natural features such as tide pools and sludge mounds to handle runoff and control erosion. Though the city rejected his idea, opting instead to clear the site and construct a generic park, he found another, much more fruitful outlet along First Avenue in his own neighborhood, the rapidly gentrifying Belltown.[3]

Designed to pay tribute to the area's colorful past, restore the ecological infrastructure, and improve a dilapidated neighborhood for its residents, the *First Avenue Streetscape Project* (1978–2000) began as a collaborative labor of love and evolved into a demonstration model for creative urban renewal freed from the trappings of commercialization. Simpson called it "a work in progress, a laboratory for untried approaches and solutions to urban design."[4] From readymade sandstone bus-stop benches (1982) selected from rejects found in a defunct historic quarry to a whimsical temporary clothesline (1978) designed to connect discordant groups, tree protection guards crafted from crutches and bed frames, and a community-driven urban arboretum that reintroduced native trees to the area, these interconnected works care for local spaces and their users (no matter their station in life), welcoming people who might not otherwise come together to build a joint community.[5]

Even as Simpson began to receive national recognition in the form of prominent temporary installations and numerous commissions, he continued to infiltrate the urban environment with a string of guerilla interventions aimed

When the Tide is Out, the Table is Set, 1978–present. Plates, 12 x 10 in. each.

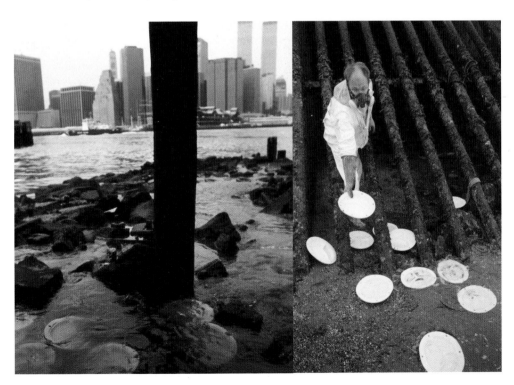

at provocative social and environmental action. Though designed to solve a two-fold problem back in Belltown—public toilets for the homeless and fertilizer for street trees in the urban arboretum—*Composting Commode* (1988) could be applied anywhere.[6] The portable plastic cabins (complete with aeration to expedite composting) were to be placed over the holes prepared for tree planting; once the pit was full, and the soil amended, the commode could be moved to the next location. Simpson tried for several years to get a permit; when he failed, he placed a prototype anyway. It remained for two weeks before it was removed, and a tree now thrives on the fertilized spot.[7] Another series of equally direct works examines problems of waste from another angle, drawing viscerally unappetizing conclusions. As part of the "I Love Canal" series (1978), Simpson placed eight cast concrete picnic plates near a sewage outfall that emptied directly into the Niagara River, allowing the polluted water to "paint" them. The effect became still more disturbing with the vitreous china used in *When the Tide is Out, the Table is Set*. This ongoing series was first realized at Kohler's Arts and Industry Program, where Simpson cast 300 picnic plates assembly line style while working next to Kohler employees fabricating toilets. After low-firing the plates, he steeped them in sewage effluent at outfalls in Puget Sound (Seattle), the Cuyahoga River (Cleveland), and the East River (New York City)—three notoriously polluted sites, poisoned with everything from pesticides to oil and other toxins, in addition to raw sewage. When the effluent plates were fired, the absorbed contaminants formed a glaze—the more colorful the glaze, the more toxic the ingredients. Simpson has also paired photographs of the pollution plates with images from slot machines, creating placemats that graphically re-create the real games of chance that we play with our water and food.

 Hudson River Purge (1991), perhaps Simpson's best-known piece of populist environmental agitprop, takes the digestive angle a step further. It works, as he says, "both metaphorically and pharmaceutically." In this dramatic example of localized bioremediation, Simpson dropped giant limestone "antacid tablets" into the headwaters of the Hudson

Hudson River Purge, 1991 (ongoing series dating to 1983). Soft limestone disks placed in the Hudson River, 24 x 3 in. each. View of project in Lake Placid, New York.

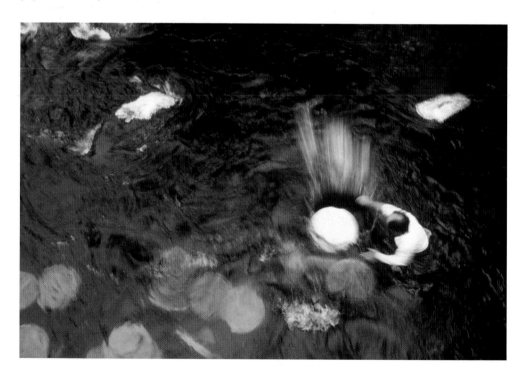

River (part of New York's water sup-
ply), making planet-wide crisis per-
sonal. The clever conceit — limestone
neutralizes or "sweetens" acidic
water and soil — was a hit with the
media; journalists loved the confla-
tion of acid indigestion and acid rain,
nicknaming the piece "River
Rolaids."[8] The humor makes an other-
wise tough issue digestible — images
of the pockmarked and cratered
disks, taken several years after their
placement, attest to the corrosive
effects of invisible toxicity. And yet,
as Simpson notes, limestone only
treats the symptoms and not the
underlying causes; combustion and
consumption continue unchecked,
and we remain resigned to stop-gap
solutions — "the bigger the problem,
the bigger the pill."

Just like the poetically evoca-
tive tree guard crutches, the "River
Rolaids" demonstrate Simpson's
ability to create iconic images and
objects that distill complex, intercon-
nected ideas into memorable and
resonant visual shorthand. His most
successful major commissions

Vertical Landscape/Downspout, 1999. Corrugated aluminum pipe, limestone, soil, and
vegetation, 5 x 4 x 1 ft. View of work installed at the Ellington Condominiums, Seattle.

become instantly recognizable logos for change. For instance, *Seattle George Monument* (1989) at the Washington State
Convention and Trade Center, a programmatically rich anti-monument to Chief Seattle (Chief Sealth) and George
Washington, plays off fears of assertion and assimilation, while deriding and harnessing the human predilection to manipu-
late nature. At the top of the structure, which doubles as a gazebo at ground level, 24 aluminum profiles of Chief Seattle
fan out to create an armature for English ivy growing out of a (salvaged) Boeing 707 nose cone planter. As the vines grew
over the head (which took about 10 years), Chief Seattle became a memory as a wind-activated blade rotated around his
portraits and trimmed the ivy overgrowth into a 360-degree evergreen bust of Washington — indigenous culture replaced
by the post-colonial American present. Ironically memorializing man's manipulation of nature, the sculpture relies on the
very actions that it critiques. And yet, the topiary shearing of Washington's bust is not assured. For Simpson, it doesn't
matter whether the transformation occurs; as he says, "nature inevitably does not do what we plan or predict." If this
manmade, artificially maintained landscape is interrupted by disease or neglect, Chief Seattle will re-emerge.[9]

Simpson's other projects over the years have included site-related aesthetic and architectural "appurtenances"
for new construction and renovated buildings in Seattle, many of them connected to *Growing Vine Street*, an ongoing
"green street" development/urban water garden that brings natural elements to the street while capturing, redirecting,

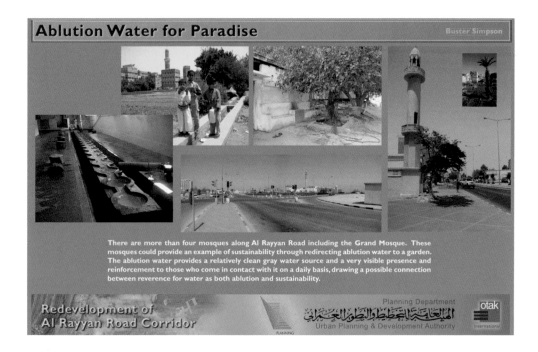

Rendering of the Al Rayyan Gardens and the Al Rayyan Road Corridor redesign, 2008–ongoing. Project in Doha, Qatar.

and reusing runoff. *Vertical Landscape/Downspout* (1999) channels runoff from the roof of 81 Vine Street through corrugated aluminum planters attached to the building's exterior. In the related *Water Glass/Water Table* (2001), a drinking straw doubles as a metal downspout, recycling water through a cistern beneath a planter and pumping it back into a green-tinted, faceted drinking glass. The 2003 *Beckoning Cistern* (an outstretched "hand" that collects water from the roof of a downtown building, aerates it, and directs it into a landscape of native plantings) continues Simpson's signature combination of concern for the environment and irreverent three-dimensional form.[10]

 Host Analog (1991), commissioned for the Portland, Oregon, Convention Center, provides a different kind of microcosmic solution to global environmental problems. This time, Simpson, who spent his childhood near the Michigan mill town of Saginaw, used natural processes to critique the timber industry and its decimation of Pacific Northwest old-growth forests. The foundation for this subtle outdoor work is a 90-foot-long Douglas fir log from a 500-year-old tree cut down 30 years before and never used. *Host Analog* allows the downed, decaying tree to function as it would on the forest floor, as a "nurse" that fosters new growth. With the future in mind, Simpson planted seeds of Western red cedar, Douglas fir, and hemlock directly into the sectioned log; a specially designed misting irrigation system optimizes growing conditions. Over the years, the log has also become home to opportunistic volunteers, including a pin oak, and it now supports a thriving mini-ecosystem of its own. This public display of regenerative decomposition brings natural processes into clear view, while promoting active custodianship of natural resources.[11]

 Like many of Simpson's works, *Host Analog* uses simple, low-tech parts (often detritus of one kind or another) that can be adapted by individuals in their own lives. What he offers are ways and means to get involved. His works serve as "idea kits" that make systems of storage, use, and recycling infinitely adaptable and creative. Simpson sees this aspect of his practice as "flow[ing] back into art, infusing poetic prototypes with pragmatics."

 In addition to the recently installed *Bio Boulevard Digester and Water Molecule* for the Brightwater Wastewater Treatment facility in Washington State, Simpson has several other projects scheduled for completion in the next few

years, including a 40-year art master plan for the San Jose/Santa Clara Water Pollution Control Plant (and its 300-square-mile "waste watershed") and a controversial bicycle rack for Portland, Oregon, that features stormwater management and a roof garden growing from the wreckage of a car.

Since 2008, he has also been working on a master plan for an eight-mile stretch of Al Rayyan Road in Qatar. This large-scale infrastructure overhaul of a principal ceremonial thoroughfare into Doha (with historical roots as a caravan route) is also intended as a showcase for sustainability. Simpson's Al Rayyan Gardens will host a variety of functions, including contemplative oases and food gardens, while reclaiming and redirecting domestic gray and brown water—an appropriate function since *rayyan* means "to irrigate." It will be fascinating to see how Simpson's approach translates to another culture: an important aspect of the project provides a strategy to encourage water reuse through prayer. Simpson noticed that most of the mosques in Doha do not recycle their ablution water or the water from their public drinking fountains. Simply redirecting lightly used water from the many mosques along the Al Rayyan corridor to nurture a garden "paradise" conveys a reverence for this increasingly scarce resource, and as with most of Simpson's projects, there is an implicit element of inspiring by example—such simple gray-water applications can easily be adapted at home. (This creative and culturally directed solution is also time-tested: the gardens of Old Sana'a in Yemen have been irrigated with ablution water for more than 500 years.)

Whether permanent or temporary, Simpson's wide-ranging works enhance and strengthen rather than just interpret the intersections between the natural and the manmade. His poetically practical works find solutions for whatever a situation demands, bringing an intimate, human-scale touch into the public arena and charging it with an atmosphere of community involvement.

Notes

1 Matthew Kangas, "Buster Simpson: Green Interventions," *Sculpture* (December 2003): pp. 39–43.

2 Simpson, quoted in Robin Updike, "Expanding the Canvas for Public Art—Agitator Buster Simpson's Works are Of the People, and For the People," *Seattle Times*, January 18, 1998, p. A2.

3 This was another important lesson: Simpson learned that such complex projects could not be undertaken alone. His next attempt, the *Viewland/Hoffman Substation Project* (1976–79) marked one of the first instances of an art design team working in tandem with an architect and developer. In addition to making sculptures from found and recycled objects, Simpson, Andrew Keating, and Sherry Markovitz planted trees to integrate the substation into the neighborhood and brought community members into the planning so that a structure opposed by many became a neighborhood focal point. Updike, op, cit., notes that Viewland/Hoffman is "still applauded as a successful example of how artists can make practical improvements to urban life."

4 Buster Simpson, "Perpendicular and Parallel Streetscape Stories," in Brett Bloom, Ava Bromberg, and Anthony Elms, eds., *Belltown Paradise* (Chicago: White Walls, 2004), p. 47.

5 For more detailed information on the various aspects of the *First Avenue Project*, see Anna Marie Heineman, "Nurturing Neighborhoods: Buster Simpson's Eco-Art," dissertation, University of Iowa, 2010.

6 Though created with particular places and circumstances in mind, many of Simpson's ideas have wider possiblities for application. He makes his rejected Art Master Plans freely available to anyone, anywhere, who might be able to use some or all of their components. Downloadable pdfs can be found at <www.bustersimpson.net>.

7 Seattle public health and public works officials labeled this innovative, cyclic approach to a lack of services "an offense to genteel sensibilities." A few years after its removal, the commode found a home in a community garden adjacent to an alternative public school, where it was used to teach children about recycling and waste management. See Heineman, op. cit., p. 81.

8 Simpson first explored limestone sweetening in *Antacid Rain Drip-a-Thon*, one of the works featured in his "90 Pine Show" back in Belltown (1982–83). Installed in Post Alley outside the Pine Tavern, this clear plastic downspout treated acid rain with limestone pebbles. For more on this neighborhood-appropriate recycling and environmental education center, see Kangas, op. cit., and Heineman, op. cit., p. 83.

9 Simpson's Web site quotes an apt statement from Chief Sealth: "At night when the streets of your cities and villages / will be silent / and you think them deserted, / they will throng with the returning hosts / that once filled and still / Love this beautiful land. / The white man will never be alone. / Let him be just / and deal kindly with my people / for the dead are not powerless. / Dead did I say? / There is no death. / Only the change of worlds."

10 Another urban water garden is located in Arlington, Virginia, where Simpson designed a community gathering place around a forgotten underground stream and reclaimed marsh. The marshlands filter runoff and other gray water into clean water, assisted by the addition of "Bromo Selzer" tablets.

11 Kangas notes that the process-oriented *Host Analog* owes its origin to Simpson's dust-collecting, time-released *Selective Disposal Project* (1973).

Working By Any Means Necessary:
A Conversation with Mel Chin

by Jeffry Cudlin

Mel Chin refuses to be pinned down, hemmed in, or otherwise restricted from pursuing whatever concept fires his imagination—in whatever medium seems appropriate. The Houston-born artist began his career making sculptures based on research into ancient cultures, social issues, and geopolitical subterfuges. But after a 1989 solo show at the Hirshhorn Museum and Sculpture Garden in Washington, DC, and a "living memorial" at New York's Central Park devoted to the non-existence of four extinct species (appearing as negative casts in their native habitats), he appeared to jump track, abandoning object-making for the less familiar territory of conceptual art based on botany, ecology, and hands-on collaboration with scientists and government officials. In *Revival Field* (1993), he attempted to reclaim 60 square feet of toxic soil in a St. Paul, Minnesota, landfill. To do this, Chin and his collaborator, Rufus Chaney, relied on plants called hyper-accumulators, which can draw heavy metals like zinc and cadmium out of the earth through their root systems.

Chin's current environmental/social reclamation effort, *Fundred Dollar Bill Project/Operation Paydirt*, consists of equal parts conceptual art gesture, school lesson plan, and exercise in magical thinking. Chin asked children across the country to draw fake $100 bills—*Fundreds*—and submit them to volunteer-led collection sites in public schools. Once three million of these *Fundreds* have been generated, an armored car equipped to run on recycled vegetable oil will visit each collection point, pick up the children's artwork, and eventually deliver all three million *Fundreds* to Congress. The goal is to make a one-to-one exchange with legislators, securing 300 million actual U.S. dollars to clean lead-contaminated soil in New Orleans following a protocol developed with Howard Mielke of the Tulane/Xavier Center for Bioenvironmental Research. Through the project, Chin hopes to highlight problems with lead poisoning that have plagued New Orleans's poorest neighborhoods since well before Hurricane Katrina.

Jeffry Cudlin: *Throughout your career, you've been in the process of putting down one medium and picking up another one.*
Mel Chin: Art, for me, is not about the medium. It really all comes down to the message. And the message must be communicated by my patented "Malcolm-Quattro-X" method: not just by any means, but also by any method, any action, or any material necessary. I'm not dropping or abandoning one medium in favor of another; I'm always striving to find the right material for capturing the specific weirdness of the present moment.
JC: *You've often cited your Hirshhorn show as a turning point, a catalyst that radically changed the kind of art you make. You realized that while you dearly loved making marvelous objects, you needed to let go of them. How did you reach that decision?*
MC: I didn't decide. I just heard a voice calling in my head and started walking that way. The voice led me to the process of thinking that brought me to *Revival Field*, a project about science, botany, and reclamation. There is a misunderstanding here, though. If we're still working in the world of ideas, concepts can lead you around to making a painting or a sculpture again—or a performance, or a photograph, or a film. The field has only expanded for me, it doesn't limit the type of work I can do at all.

JC: *A lot of your earlier work was research based, making cultural or art historical references that went back thousands of years. Now your work is engaged with at-risk communities, up-to-the minute political developments, and electronic media.*

MC: Life delivers things at various focal lengths. You zoom in, you pull out. I don't think that there's a specific preference or intention: it's whatever the present moment seems to call for in terms of perspective. Any distance from the subject can eventually lead you to thinking about the whole of human history—eternity, even.

JC: *Your way of working has to do with freedom, working, as you say, by any means necessary. Does that scare off people who could be in your corner—dealers, gallerists, collectors, institutions? Do you have to rethink who you can bring in to advocate for you?*

MC: Yeah, my corner man's not very good. I've been beaten up enough to know that. But I'm not beaten down by whatever distance I might seem to be imposing between my work and the art market. If you start expanding your worldview, immediately you exceed the art world, the galleries and institutions, and the whole spectrum of possibilities of engagement

Revival Field, 1993. Reclamation of a hazardous waste landfill in St. Paul, Minnesota, sculpting the site ecology by using plants to detoxify the soil.

gets larger. I think it's understood: with every liberation comes an entrapment. The creative process is sometimes based on breaking out of jail. You have to escape the prison that you've created for yourself. You can't make bail just through the support of dealers or galleries or museums. Sometimes there's a wall between different pieces, different phases. You have to find a way to escape the conditions that you've created. It's all my own fault, of course. I can't blame anybody else.

JC: *Modern art often looks like a series of refusals—refusal of heroic mastery, refusal of the seductive properties of a medium, even the refusal to lay things out easily for an audience. While your move from object-maker to conceptual artist seems like a kind of refusal of a particular way of working, it's ultimately made your work more populist, more open, maybe more accessible.*

MC: I don't think my work ever says no. It says maybe; there has to be some wiggle room. Once something becomes dogmatic, it's no longer interesting. Once you arrive at a formula, it's no longer useful.

As far as the notion of refusing, I understand Modernism as stemming from a deep belief in universal possibilities that were unrealized in the world and needed to be uncovered somehow. We know where that's led us. We can't just think about art anymore. We have to be engaged in the political world. Or at least I do—I shouldn't say that for anyone else except myself.

JC: *While your work seems approachable, humorous, and maybe even skeptical of trying to remake the way people live, it still aims for major transformations. In the case of the* Fundred/Paydirt *project, we're talking about $300 million possibly entering people's lives. How do you balance humor and skepticism with such ambitious expectations?*

MC: First off, the humor is there only because without it, life would be such a depressing reality that it would be difficult to stay and keep going. Second, my work has never been about anything but changing oneself. If you approach everything with a critical eye or mind, then the world will reveal itself as something that's quite impossible to change.

The human ecological track record is so horrific that I don't have much hope for it, really. But the moment that you're captured by some possibility, the moment when you discover art that's new to you, other philosophies, other music—those moments are very rare, but they transform you. Art can change who you are. I don't think about changing the world; I think about changing myself.

JC: *Still, you're talking about cleaning up the soil of New Orleans, a big action, a big change in the lives of thousands, and it looks like you might pull it off. That's not just personal transformation.*

MC: Well, I'm going to deliver, let's say that. I can't pull off *Operation Paydirt* alone, and that's the point. But we can pull it off. This project is less and less about me, and more about how I need to create this opportunity for engagement and need someone else to follow it. That's how it'll happen—with other people, it won't happen otherwise. Without the cash, the artistic currency that's being created nationwide, I will have very little chance of changing myself, much less anything else.

There is the possibility of changing the conditions in a place, conditions that compromise lives, close down possibilities. I'm not going to say that this project will definitely make everything better or worse, but it will give people more options than they had before. And that's where I find the art of it: I'm catalyzing possibilities that weren't actual before. That's what I'd do for myself. There will be necessary political wrangling, physical transformations, and economic

Operation Paydirt, 2006–ongoing. Soil sample collection in New Orleans' 8th Ward, part of an art/science project to clean up lead pollution in the city.

Top: Interior of the New Orleans *Safehouse* with *Fundreds*, 2006–ongoing. Above: *Safehouse*, 2006–ongoing. Existing house, stainless steel, steel, wood, plywood, 12,000 brass thumbtacks, 6000 hand-drawn *Fundreds*, and mixed media. Part of *Operation Paydirt*, located at 2461 North Villere St., New Orleans.

pragmatism layered into this. I persist only because I know that it will probably transform the world and make it better for myself as well. I hope it will, anyway.

JC: *So your art is entirely selfish.*

MC: Isn't that weird? If I look at myself critically, it probably always is. We're delusional if we try to say it's not. But maybe if we knew ourselves a little better, we could operate from a better place within that selfishness, right? I think

we need to be introspective: Why are we doing this? Why am I trying to work in this place? For me, the conditions in New Orleans compelled this project, spurred the problem-solving part of my brain, got me motivated. If I want to identify what's in it for me, what's selfish, maybe at the end of the day, it's the need to take on the puzzle. This is a real problem, and I feel compelled to get to work and solve it.

JC: *Are there moments in New Orleans when the immensity of what you're up against overwhelms you? Now that you've been interacting with the St. Roch neighborhood and know its rhythms, do the place, its poverty, and its violence continue to shock you?*

MC: Well, you're more comfortable with the people, you're familiar with the landscape, but a lot of the things that people warned me about in New Orleans—how slowly things move, how difficult it is to get any momentum going at all—are true and never cease to surprise me. At the same time, what really shocks me are all of the things that allow the project to go forward anyway. We're doing pretty well. And it's not just New Orleans. When I was touring the schools in Arlington, Virginia, I saw children, who I would've thought were too young, embrace the project and under-stand the intensity of the problem. Seeing them understand it completely was one of the more gratifying moments. There is a connection in this project between the beginning of one creative act and the beginning of another. Kids from everywhere, from Mongolia to Brooklyn, making these artworks, expressing themselves, just getting down to it straight away and drawing—it means something. It reinforces commitment.

New Orleans itself—I hate to say it, but every day is not a holiday in the streets where I'm working. Every day is a deep struggle. Of course, there is life, there is humor, and all of these other things. But I am aware that I have options that many people do not. There are moments of extreme violence that are just inexplicable. We can talk about the physical, nameable aspects—gang wars, guns, drugs—but there are elements you perceive in the thick of it that are just hard to comprehend.

JC: *What kind of change were you trying to catalyze in the GALA project, when you worked with a collective of artists to build props that appeared in 60 or so episodes of "Melrose Place?"*

MC: That was predicated on my studies of viruses and marine military assassins. The world has been absolutely trans-formed by covert strategies employed by militaries, businesses, and state apparatuses. And, of course, the transformation usually works negatively for those on the receiving end. Growing up in and being part of the New York scene in the age of AIDS, I observed the power of a virus. It leaves no one untouched. I began to think about how the consequences of disease are not unlike those that come about when we take over other governments. They're deeply negative, and the methodologies are amazing, exacting in execution.

From there, you start thinking in terms of art. The efficiency of the methodology may be redeployed via conceptual art. That's where the GALA committee comes in. We're moving into a realm that's been deeply criticized by the art world since at least the mid-1960s—commercial television, mass media, particularly prime-time commercial media. And yet, we're undertaking an empathetic engagement. We're not necessarily a hostile virus, there to subvert its message. The question we asked was: Is there a way for an art virus to enlarge the storyline of a nighttime soap opera not only with the consent but also the camaraderie of the writers and producers?

JC: *So where does the work reside? If someone buys the collected DVDs, is that just another phase in the life of the project?*

MC: Yes, that's where it lives, and where it will continue to live, if you discover it. And it's not just on DVD; the show is syndicated to this day, in countries all over the world. We're looking at a host that effectively transmits its message over and over again, perhaps mutating into understanding as well.

Art in the Public Interest: A Conversation with Helen Mayer Harrison and Newton Harrison

by Jane Ingram Allen

A collaborative husband and wife team, Helen Mayer Harrison and Newton Harrison have been making art dedicated to improving the environment since the late '60s. Their work has ranged from small-scale, replicable demonstrations (*Full Farm*, 1972) to complex proposals spanning continents and genres aimed at influencing long-term public policy planning. These installation-based works usually feature components such as maps, charts, and explanatory texts, but they can also include sculptural elements such as the roof gardens in *Endangered Meadows of Europe* (1996). In 2007, the Harrisons were invited to Taiwan by the Council for Cultural Affairs. They gave lectures, toured sites, and held discussions with artists, environmentalists, scientists, government officials, and students. Their recent projects include the five interrelated components of *Greenhouse Britain* (2007–09), which explores the effects of climate change on the island of Britain. A model with six overhead projectors brings rising waters, storm surges, and the redrawn coastline to life, while a proposal for new models of living (made in cooperation with the Land Planning Group at Sheffield University) uses ecosystematically redesigned land to absorb the carbon footprint of a 9,000-person village through forests and meadows. Other parts of the project explore alternative and repeatable housing strategies that incorporate solar power, stilts, and hanging gardens. *Sierra Nevada: An Adaptation* (2011), commissioned by the Center for Art + Environment at the Nevada Museum of Art, is just one part of *Force Majeure*, a recent, ongoing body of work that proposes ecological adaptation on a large scale. To underscore the impact of climate change on this great mountain chain, viewers "walk" a 40-foot-long aerial rendering of the terrain. Watershed maps and photographs viscerally convey the quality of current and potential ecosystems; and animated projections contrast two possible futures for the next 50 years—a degraded and overgrazed landscape versus a regenerated and productive landscape achieved through the assisted migration of beneficial species.

Jane Ingram Allen: *What brought you to Taiwan?*

Newton Harrison: We were invited here to think about the global warming problem in relation to Taiwan.

Helen Mayer Harrison: Water appears in all of our work in some form. For our projects, we work with people from the community we are in, various officials, and scientists from needed disciplines.

NH: David Haley of England, who is working with us on *Greenhouse Britain*, is also working here in Taiwan, and we are talking about *Greenhouse Taiwan*. However, there are often several years between speaking an idea and finding the energy, the will, and sometimes the love to enact it.

JIA: *When did your interest in global warming begin?*

NH: Our first global warming piece was in 1974. It was intended as an amusing work, since the belief at that time was that we were in an interglacial period, which meant that it could get colder as well as warmer—that is to say, the waters could withdraw or advance. This work, *San Diego is the Center of the World*, proposed long-range planning for either case. It argued, in our first "if this, then that" linguistic format, to begin long- and short-range planning to prepare for either possibility. When Lawrence Alloway reviewed the proposal in our first New York exhibition at Ronald

Above: *Full Farm*, 1972. Mixed media, installation view. Below: *Endangered Meadows of Europe*, 1996. Meadows transplanted and growing in a 2-acre roof garden, view of original site.

Feldman Fine Arts in 1974, he observed that we were probably learned, witty nuts from California.

HMH: By 1978, we came to believe that global warming, or the greenhouse effect, was indeed inevitable and everything would begin to change. We expressed this idea as the ending of *Lagoon Cycle*. We began by drawing a map of the world as if the waters had risen. The map was about 13 feet long, and the science at the time said that the waters would rise about 300 feet. So we drew the 300-foot level on a world map as best we could, and the outcome was quite amazing. We have done a number of other global warming pieces, often working with knowledgeable scientists. Some deal with the rising waters, some with agricultural lands and urban spaces, and others with effects on the mountains.

NH: Now that the debate has shifted to address what to do about global warming, our work picks up on ideas from *Lagoon Cycle*. Textual passages in that work asked, "How can we help each other? How can we withdraw?" But also implicit is the question, "How do we defend if the rise is not severe?" We use the term "graceful withdrawal." It will be our greatest challenge as human beings to face this. Al Gore's *An Inconvenient Truth* suggested that through carbon control we can minimize the effects of this phenomenon. I think we're past the tipping point.

HMH: While we may be able to minimize some of the more extreme outcomes, there are profound questions that center around how we go about the business of adjusting to change. By "we," I'm including all the other life that will be impacted by global warming—plants, animals, birds, and insects whose survival is vital as well. While this phenomenon of climate change has happened many, many times in our past, I don't think it's happened under the conditions of consumption and exploitation of resources and systemic shock that are operating in our "now."

JIA: *Is Asia different in its approach to environmental problems?*

NH: There are many Asias, some moving toward wealth, some deeply depressed, some environmentally healthy, some environmentally distressed.

HMH: We have been in several Asian countries for short periods. For instance, Sri Lanka in the late '70s was a cornucopia where one might find an afternoon snack by walking down the street in Colombo and picking fruit off of branches. Then I found out that much of the ecosys-

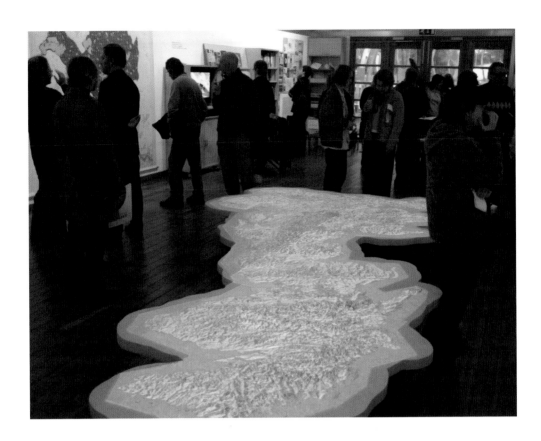

Greenhouse Britain: The Waters Rising, 2007–09. 6 projectors, animation of water rising on a physical topography model of the island of Britain.

tem was gone, replaced by exotic species, largely thanks to colonialism. When our Sava River piece was shown in Japan and took second prize at the Nagoya Biennale, we spent time with people there who were attempting to stop a nearby river from being dammed. It was the last undammed river on the island. We failed, of course. They argued that by stopping the building of another dam, we were trying to "break the rice bowl." Also, Newton spent a fair amount of time in Kyoto, doing an artificial aurora borealis for the American Pavilion in Expo '70.

NH: It seems to me that the environmental issue only emerged in general Taiwanese awareness during the cleanup of the Xindian and the Tamsui rivers. And this only happened when the polluting businesses moved to China for cheaper labor. We've met a few Taiwanese artists who have deep environmental concerns and are enacting them, and there are some very angry ecologists tracing how global warming is affecting the upward movement of species, but as yet nobody will listen to them, let alone act on what they're discovering.

HMH: We think that Europe has taken the environmental lead globally, and England, Germany, and the Netherlands have taken the lead in research and action. Any work that we do emerges from our whole life experience, which is with rivers and watersheds, social systems, and global warming. Furthermore, it has core questions embedded in it: What's farming doing to the topsoil? What's over-foresting doing to the rivers and the watersheds? What is the over-production of sameness doing to the psyche? All of these problems are related to seeing the world as a whole interacting system, which is where we begin.

JIA: *What was your most successful project? How do you define a successful project?*

NH: "Is" is the operative verb, not "was." Our collaboration is our most successful project. As to how we define a successful project—you are seeing it and experiencing it right now.

HMH: We're most interested in bringing forth a new state of mind, first in ourselves, then hopefully in others—that is what our work is about. But this is difficult to measure: sometimes it happens slowly and takes a long time. It is not that immediate, and results only happen when our work gets physical and lands on the ground. In Terre Haute, in the early '90s, for example, we did a work dealing with the Wabash River, the area where the prairies stopped and the mountains began. We were studying how to preserve and improve the Wabash River, and we made a proposal. Nothing much happened because the head of the art department left and the next director was not interested. However, 15 years later, last month in fact, we got a call from Terre Haute, from people who had been working with us, and we accepted an invitation to put together a group and begin thinking about the eco-political potential for well-being in the watershed as a whole, to continue where we left off.

NH: Basically, we never think about success and failure, and the reason for this is not abstract—we can never really tell when and how we may have succeeded. In fact, we may not even know what success is. For example, in 1989, we created an exhibition that proposed the purification and regeneration of the Sava River in former Yugoslavia. It was much loved and accepted by the Croatian Water Department. Then the war started, and Milosevic began to attack upward from Serbia toward Croatia. We had to leave, and we thought the work was lost. The ecologist who was working with us stayed, fought for our basic concept, and then put his own concept in place to save the Drava, the sister river to the Sava. Ultimately, both ideas worked. Now the Sava and the Drava together give the lower Danube about half of its clean water. These two acts, ours and the ecologist's, had a salutary effect on flushing the very polluted Danube estuary as it flows into the Black Sea. We have named this phenomenon of ideas generating ideas "conversational drift." So, we find it best not to worry about success, but to work for the best thing possible in the place and the moment we are in.

HMH: Fundamentally, we have a non-possessive attitude about our work—we make what has been called "art in the public interest," as best as we can define what that interest is in the moment. When our work is presented, it is obvious that its place is in the public domain.

JIA: *Your work is project-oriented, and many times it has no visual product. What do you exhibit?*

Feldhaus Pennine Variation II, 2008. Digital photography, color, graphite, and oil, 30 x 30 in.

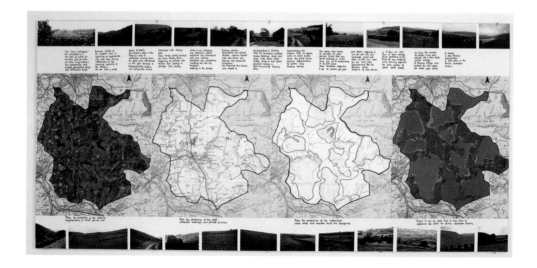

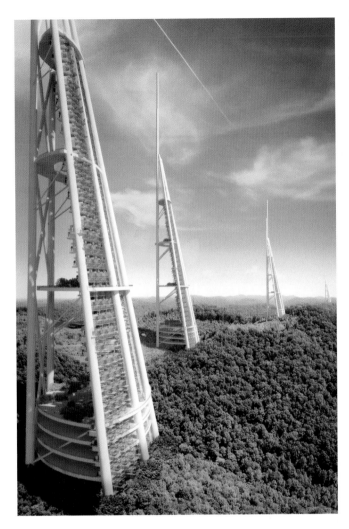

Helen and Newton Harrison, in collaboration with APG Architects, *The Lea Valley: On the Upward Movement of Planning*, part of *Greenhouse Britain*, 2007–09. Rendering for a vertical village, incorporating wind turbine.

NH: Our work is about production, not product, and all of our work envisions. With the Sava River work, we produced an exhibition that was part proposal, part narrative, and part vision of a future. That is to say, could we imagine a new history for the Sava? So, we tend to avoid the term "product." However, *Endangered Meadows of Europe* is a good example of how a particular work might be called an art object. This was a roof garden, very physical. It operated on about five levels. One of them was about contemplation; another was about a complex story of interdependence; another was about the endangered meadows of Europe, as exemplified by four meadows condensed into one on a roof. Scholars studied the meadow, and it was picked up off the roof and moved to a park in Bonn, then to other parks. The seeds were spread. The project brought the original meadow ecosystem of the area back to Bonn. There were 15 fence-like sculptures with texts and photo images of about 15 meadows, from the south of Italy to Norway, made in ceramic tile. We work with a level of complexity that is sometimes considered difficult. We have no interest in doing a work that gives up its information instantly, or in a couple of sound bites. Our Santa Monica work does this on a street corner.

JIA: *How and why do you collaborate? Is it difficult?*

NH: It is an intellectual choice. When I took on the ecosystem, I did not think I was good enough to do it alone. I asked Helen to join me. A male and a female artist working together gives two different approaches. In the book *The Third Hand: Collaboration in Art from Conceptualism to Post-Modernism*, Charles Green goes into this rather deeply and discusses the issues of collaboration.

HMH: It is like a dialogue between two people, an intersecting of stories without naming and claiming. The artist exists in the space between us.

JIA: *What is your next project?*

NH: We never know. The telephone rings, and we are invited to go somewhere and think. We may make a rather elaborate proposal of two or three intense pages as a beginning.

HMH: It's better if it's only one page. Maybe it will be electric and attract the right interest, and, always, we let it happen, or not, as the case may be.

NH: In any given three-month period, there are many invitations, and we follow them, giving lectures, participating in conferences and symposia, creating dialogues. In 1992, the gallery at Reed College asked us to give a talk. We agreed, and from the airplane, we could see clear-cutting vividly. So we did a work about that; it was the same with Holland. Our work is based in a response to urgencies as they bubble up in any particular now.

HMH: Each piece emerges from a few questions: For instance, how big is here? One of our proposals led us to take up the peninsula of Europe at the request of the European Union, the German agency of the environment, and the Schweisfurth-Stiftung. "Here" can be a street corner, as in our Santa Monica work, or a sub-continent, or an island like *Greenhouse Britain*, which we are doing on a grant from the British government.

Poetry in the Mundane: A Conversation with Mags Harries and Lajos Héder

by Marty Carlock

Sculptor Mags Harries and urban planner/architect Lajos Héder formed the Harries/Héder Collaborative, Inc., in 1990 to execute large, permanent public art installations. Welsh-born Harries first came to the public art scene in 1976 with *Asaroton*, trash she picked up at the Boston Haymarket urban farm market, bronzed, and set into the sidewalk. Her production ranges from the early *Fossil*, a subway standee bar with a handprint in it, to performance works, to numerous public commissions nationwide. In addition to large-scale revitalization projects, the duo is known for environmentally engaged, participatory performance pieces. In 1998, to dramatize the sorry condition of the Bronx River, they floated a golden ball down the 10-mile waterway to the accompaniment of dancers and pre-planned community festivals. In 1997–98, to make the presence of Boston's Charles River more palpable, they organized passersby to help wind a ball of yarn 78 miles long, the length of the river.

In 2001, Harries and Héder completed *Drawn Water* at a new $60-million water treatment facility in Cambridge, Massachusetts. Educational and recreational in nature, *Drawn Water* consists of a 2,500-square-foot terrazzo floor mapping the region's water system, a 14-foot-high acrylic water column, and an outdoor water fountain. When someone drinks from the fountain (it's located along a path), a flow sensor generates a dramatic reaction in the water column inside the lobby. Another water-based work, *WaterWorks at Arizona Falls*, debuted in 2003. This revitalization of a defunct hydroelectric plant straddling a canal features a pedestrian bridge and two 20-foot waterfalls created by elevated aqueducts that divert water from the canal and then return it to the source. Environmental concerns were key: not only does *WaterWorks* create "an intensive water environment (without wasting any water) in a desert setting," it also produces enough renewable energy to power several hundred homes. This creative synthesis of power plant, recreational facility, and aesthetic experience received the President's Award for Excellence in Environmental Design from the Valley Forward Association.

History, which played a role in *WaterWorks*, takes center stage in *Terra Fugit* (2006) in Miramar, Florida. Harries says that this work "is about time, giving it meaning in a situation where all traces of anything more than a year old [have been]…obliterated by development." Creating this public oasis of marshland preserve, recreational paths, and water facilities turned out to be no small feat: the project was completed 10 years after the original commission. *A MoonTide Garden* (2007) at the International Ferry Terminal in Portland, Maine, restores a contaminated site, "where they just dumped what was dredged out." In addition to these water-based projects, they have also been transferring their interest in power to solar-collecting and generating works.

Marty Carlock: *How long were you thinking about* Drawn Water, *the installation at the Cambridge Water Department?*
Mags Harries: Eight years. We tried to think of it as a real place to educate people about water and where it comes from. It's important to understand the system. *Drawn Water* connects the tactile experience of drinking the water to the conceptual structures of the water system. I lived in Cambridge for 26 years and had never visited the Water Department, which is within walking distance of five schools. Now I know almost every pipe carrying water through the town.

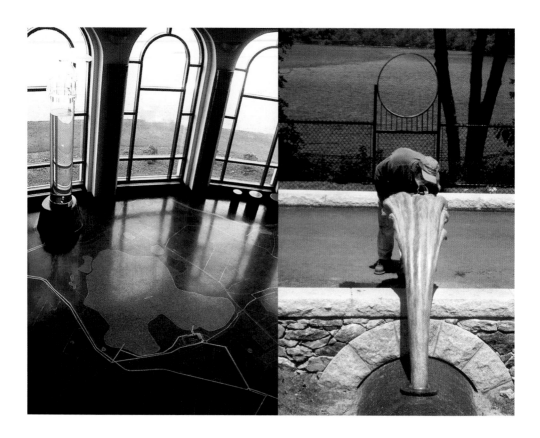

Drawn Water, 2001. Water, bronze, brass, cast iron, terrazzo, acrylic, and light, floor map: 36 x 70 ft.; water column, 14 ft. high; site, 16 x 50 ft. 2 views of project in Cambridge, Massachusetts.

MC: *In general, how do you approach a commission?*

MH: It's a long process. We develop an idea, we start with a dialogue with the client or the design team.

Lajos Héder: Or whoever represents the community.

MH: You look at the plan and try to identify opportunities and places for art to fit. What are the possibilities? How can an artist be part of the team? We try to go into a site without an agenda.

MC: *Do your original concepts change a lot?*

MH: Yes. The plans for *Drawn Water* included a little corridor gallery that they thought would be the exhibit. We thought that the whole thing could be the exhibit—glass walls on the control room and the pump room.

LH: We were coming up with ideas while the architects and engineers were still working. They took some of them. That's fine, that's what design teams are about.

MC: *But 9/11 changed everything, right?*

LH: Because of 9/11, no one can go into the plant, except the lobby during normal operating hours.

MH: That's why we did the map of the Cambridge water system in the floor. It starts with the reservoirs out in the western suburbs but shows the different gauges of water pipes instead of streets.

MC: *How else did you have to modify the project?*

MH: We had an idea of taking the old aerator and doing something with the bathroom.

LH: The architects took that and did their version of an aerator for the fountain in the lobby.

MH: We had another idea, a listening pipe, where you could hear the water rushing through. Eighteen million gallons a day. They didn't like that one.

MC: *Weren't there political problems too?*

MH: We wanted to open the weir building, which you couldn't see, and cut the pipe short to create a waterfall, an acoustic weir. They embraced this idea, and it was approved. Then a group surfaced—that always happens in Cambridge—with a petition to oppose it, because we were supposedly going to impact a meadow.

LH: We initiated a petition drive in favor of it—we each had 400 or 500 fans. We picketed. The thing just hung there for the better part of a year, but it became obvious that it wasn't going to happen and we were going back to the map idea. It became more multi-part, but not as viscerally powerful.

MC: *But you were able to use the waterfall idea in Phoenix, weren't you? You worked with Salt River Project (the utility company) and the Phoenix Parks and Recreation and Water Services Department.*

MH: The gods were kind in Phoenix.

LH: The site had been an old hydroelectric generating plant along the Arizona Canal, which was abandoned about 50 years ago. As we got started, they decided to restore the generators, which provide power for 400 homes.

MH: We wanted to bring the local people to the water. There was terrific recreational potential. We built a Water Room where people come and meet. A path takes you underneath the aqueducts into an outdoor room lined with desert stone and sheets of cascading water. Behind the water screens are artifacts from the original plant.

LH: There are rules about what you can do with water. You have to convey the water, but it doesn't say how. You can go up, down, or sideways. So we surrounded a room with water.

MC: *I understand that at first, even when you were collaborating, Mags approached the creative problems and Lajos did the technical things—made it all happen. Is that true?*

MH: I worked by myself for years and years. I still do sometimes. Lajos had an architectural office.

LH: We crossed over a lot. I'm better in some areas, visualizing unbuilt buildings, working with contractors. It's hard while bringing a project to actuality to see where ideas come from.

MC: *When did water become a focus for you?*

MH: With *River Runes* (1990), a temporary installation at Artpark in Lewiston, New York. And *Wall Cycle to Ocotillo* (1990), although it wasn't on the water, came from our thinking about water, about what is important in the desert.

WaterWorks at Arizona Falls, 2003. Water, land, sandstone, planting, and metal, water room, 40 x 40 ft.; site, 600 x 1000 ft. View of project in Phoenix, Arizona.

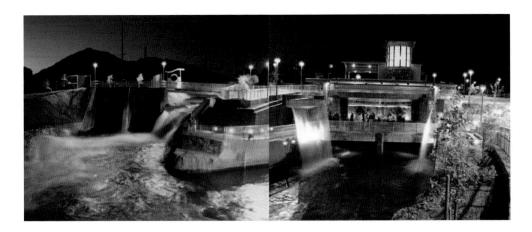

MC: *So you designed bus shelters shaped like all kinds of water jars. What did you want to achieve with* Terra Fugit *near the Everglades in Florida? It responds to runaway development.*

MH: Miramar Park in Fort Lauderdale went through at least three versions, three clients, and two contractors. It's called *Terra Fugit* because things change so fast there, and we argued for keeping a part of the land as it was. On our four-acre site, we created a preserve of virgin land that maintains a small area of marshland as an undisturbed example of what had existed there. There was a lot of consternation about that. People wanted to know why we didn't make it pretty, pave it over.

What happens is they begin by scraping every living thing off the land and blasting for housing. People move in and have no idea what the land looked like. We wanted to keep some of it. We found coral and fossilized limestone that we carved into seating and used to build up the shore.

LH: We try to find available materials that are plentiful, possibly going to waste.

MH: And then Lajos built a burper. It's essentially a bucket anchored upside down in the center of the lagoon, under the water. You can activate it from a gazebo built over the lagoon. When the burper fills with air, it turns over and lets out a bubble, which causes annular rings to move toward the shore, taking the shape of the shoreline. Everything is about time flying and the land mutating. Water to shore, fossils into pathway, grass into house lots, fossil time, man time, alligator time.

MC: *What is your favorite project to date?*

Terra Fugit, 2006. Earthwork, preserved plantings, coral fossil, seating, patterned concrete, interpretive plaques, observation deck, and pump to create ripple in water, approximately 4 acres. View of project in Broward County, Florida.

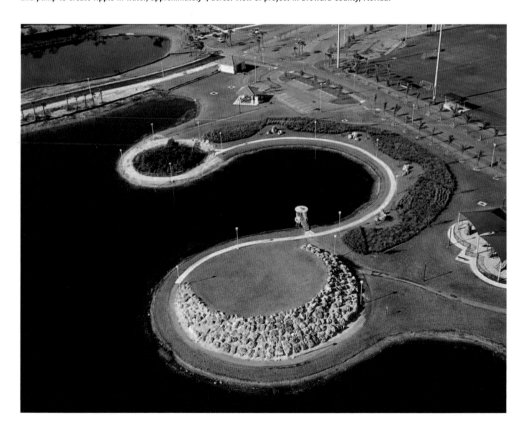

Terra Fugit (detail), 2006.

LH: Arizona Falls. Some sites are marginal; this one was inherently dramatic. The water works is a public utility, but it's run more like a private company. They were more welcoming to ideas. We got to go to the yard that housed all the old machinery and choose some pieces to recycle as decorative elements.

MC: *Which of your environmental performance works has been best received?*

MH: My favorite was the *Golden Ball* that we floated down the Bronx River. We were hired by the National Park Service to draw attention to the condition of the river. It reaffirmed my faith that as an artist you can make a difference.

MC: *Do you think that your work has had an impact, environmentally?*

MH: It's hard to say. You hope your ideas raise people's awareness.

LH: *Golden Ball* did, yes. The first year, 10,000 people came to the banks of the river at various places; it runs through 27 communities. The park service created access where there hadn't been any.

MH: It was very poignant. In the Bronx, they built a typical New York park—very narrow, sheet metal on both sides, and they threw in a few plants. But it was the first access to the river there in 50 years.

LH: Governor Pataki came and announced an $11 million grant. There was more from the National Park Service, $33 million in all, in response to community and municipal initiatives, for land acquisition, parks, and access.

MH: We ran the river again for several years. They still run it every year, but the ball is retired.

MC: *Education has become a major component of your civic works. What else is important?*

MH: We're always trying to reveal something that can't be seen.

LH: Place. A lot of my work in urban design is providing catalysts for community activity.

MH: Weaving the work into the fabric of the place so it can get loved, or looked after, at least.

LH: Poetry in the mundane.

MH: Sequence, pathways. Time is a constant element. Concern for the environment.

Tim Collins and Reiko Goto: Art Has Everything to Do With It

by Glenn Harper

Tim Collins and Reiko Goto bring together aesthetics, ethics, and empathy in projects that are as much environmental research as art. They approach the world as an intersubjective experience shared by plants, animals, and the human beings who are accelerating changes in the host environment (the earth). Since beginning their collaboration in 1987, Collins and Goto have brought together issues of ecological restoration and public space and the potential interrelationships of people and trees. They look not only to art interventions such as those by Joseph Beuys and Helen Mayer and Newton Harrison, but also to theoretical work on empathy by Edith Stein and others.

Both artists participated in the *Nine Mile Run* project (1997–2000), led by the STUDIO for Creative Inquiry at Carnegie Mellon University in Pittsburgh and co-administered by the Pennsylvania Resources Council. Other artists involved in this eco-aesthetic recovery plan for a stream corridor, along with a six-square-mile watershed, included Bob Bingham, David Lewis, Joel Tarr, and John Stephen. As early as 1910, Frederick Law Olmsted, Jr. had already identified Nine Mile Run as a site notable for its beauty and its wastewater problems. *Nine Mile Run* attempted to identify and model sustainable alternative approaches to urban space and its cultural, aesthetic, and ecological components. The multi-year project involved research, public education, brownfields restoration, and gallery installations dealing with the cultural and ecological history of the region. Collins said in 2001 that such projects address the question, "How do artists start to provide opportunities that bring us back to the water and give us some meaningful points of engagement?"[1]

Bob Bingham, Tim Collins, Reiko Goto, and John Stephen, *Nine Mile Run*, 1997–2000. Eco-aesthetic recovery plan for a stream corridor. View of exhibition documenting 6-sq.-mile, multi-watershed project in Allegheny County, Pennsylvania.

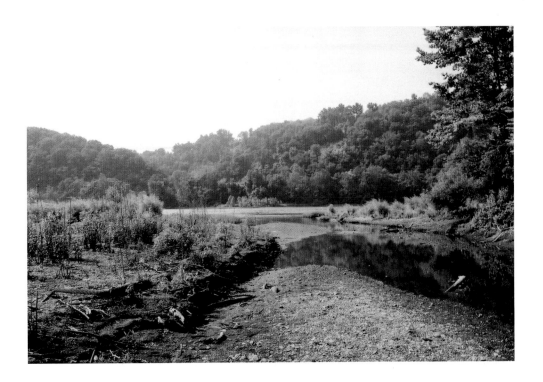

Tim Collins and Reiko Goto with Noel Hefele, *3 Rivers 2nd Nature*, 2000–05. Policy and regulation for eco-aesthetic recovery. View of a 745-sq.-mile watershed project in Pittsburgh.

In 2000–05, Collins and Goto took a larger view of Pittsburgh's water system with *3 Rivers 2nd Nature*, which not only focuses aesthetically on the area's three rivers, 52 streams, and riparian banks, but also supports municipalities and organizations by preserving and restoring the regional environment. In addition to working with communities to map the form, function, and values of Allegheny County, they also worked with attorneys, planners, and scientists to examine policy and regulations, a process that resulted in new parks, preserved land, and zoning practices that protect open spaces. Collins has said that *Nine Mile Run* and *3 Rivers 2nd Nature* "address the meaning, form, and function of the natural ecosystems and public spaces which attend our post-industrial properties and waterways."

After their move from Pittsburgh to Scotland, Goto began to think through the challenges of an empathic approach to her work. The result of her examination, in terms of her collaboration with Collins, is *Eden3: Breath of a Tree* (first exhibited in the 2010 exhibition "Plein Air: The Ethical Aesthetic Impulse" at the Peacock Visual Arts Centre for Contemporary Art in Aberdeen, Scotland). The artists worked with Matthew Dalgliesh, Carola Boehm, Trevor Hocking, and Noel Hefele to develop a system that gives a voice to trees, turning their reactions to changing climatic conditions (specifically the CO_2 content of the air) into sound. The device, which is modeled on the box easel used by 19th-century plein-air painters, produces scientific data, monitoring the impact of changing levels of CO_2 on everything from a single leaf to a forest; in the process, it seeks an empathic exchange with the tree itself. According to Goto, the project references "the human need to hear the breath of people and living things we care for to assure ourselves of their well-being. This technology provides one way of listening to the breath of trees."[2]

For *Eden3*, Collins and Goto selected seven sites and seven trees along an imaginary trail through Aberdeen's rivers and parks. The high-tech box easel records sound corresponding to the tree's respiration as the CO_2 level changes. For the exhibition, photos of the easel and the tree were shown, along with the documented sounds. A studio structure

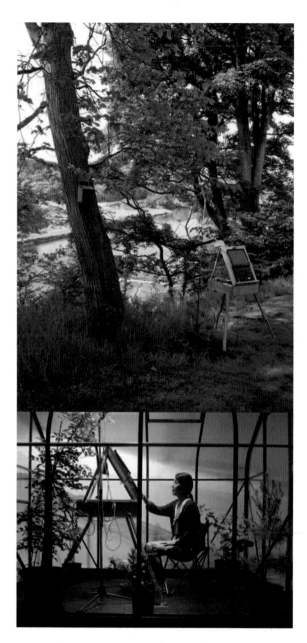

(a greenhouse) where the artists work in proximity to the monitored trees is also part of the project, along with a time-lapse video animation with a voiceover in which Goto and Collins discuss their ideas regarding "the role of artists in the production of aesthetic truth and the distribution of creative freedoms." *Eden3*'s investigation is scheduled to last five years, including the monitoring and research, with exhibitions of the prototype monitoring device and documentation of the project as it develops.

Collins's and Goto's work (both together and separately) maintains a consistent focus on scientific research, natural systems, the role of art in the public realm, and collaboration (not only with each other but also with scientists, other artists, and the public). Their future plans for the development of *Eden3* flow directly from *Nine Mile Run*, *3 Rivers 2nd Nature*, and other engagements with site and environment such as *Breath Between Shadow and Light* (2004), which addressed the relationship of moths with specific plants and sites in Gongju, South Korea, and *Watermark-Aachen* (1998), which revealed now-hidden rivers beneath the city of Aachen, Germany.

Notes

1 "Finding Common Ground: Art and Planning," *Sculpture* (September 2001), pp. 30–37.

2 Angela Lennon, *Plein Air: The Ethical Aesthetic Impulse, Reiko Goto and Tim Collins*, exhibition catalogue, (Aberdeen: Peacock Visual Arts, 2010).

Tim Collins and Reiko Goto, *Eden3—Plein Air*, ongoing. Easel, leaf-sensing equipment, and sonification software, dimensions variable.

Visualizing the Water Cycle:
Buster Simpson, Jann Rosen-Queralt, and Ellen
Sollod at Brightwater Treatment System

by Susan Platt

Brightwater Treatment System in Northern King County, Washington, is a massive sewage treatment plant with mechanical, biological, and electrical systems for cleaning water, a system of pipes running through deep-bored tunnels to Puget Sound, an Educational Center, and 40 acres of reclaimed land on a salmon-spawning creek. The pipes not only carry wastewater to the plant and treated wastewater to the sound, but also distribute thousands of gallons of treated water for reuse.

In 2002, Buster Simpson, Jann Rosen-Queralt, and Ellen Sollod, in collaboration with Cath Brunner, Director of Public Art for King County, developed an "Art Concept Workbook" for Brightwater. The final art master plan, inspired in part by Lorna Jordan's *Waterworks Gardens* (1996) at the East Division Reclamation Plant in Renton, called for participating artists to create a "vision of sustainability." They were asked to make visible both active treatment and natural cleaning processes, such as detention pools and constructed wetlands. The Brightwater Art Master Plan stands as an

Buster Simpson, *Bio Boulevard Digester and Water Molecule*, 2002–11. Cast concrete, reclaimed water, stainless steel, paint, and LED, 9 x 170 ft.

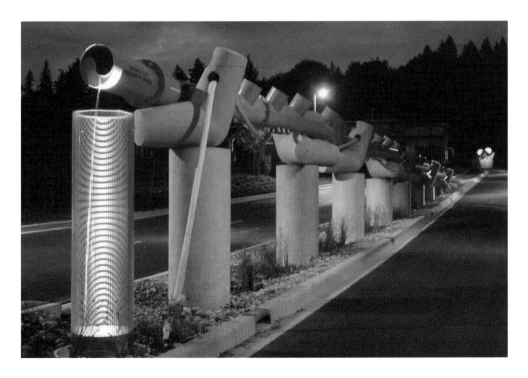

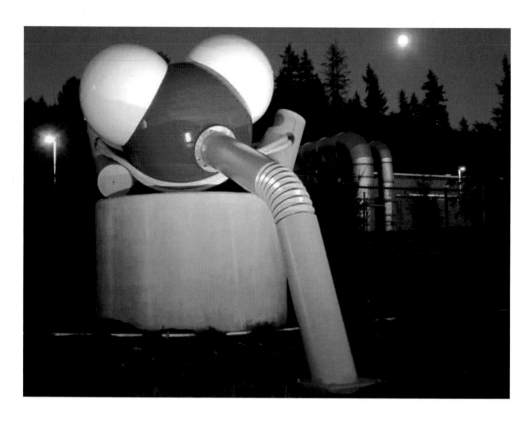

Buster Simpson, *Water Molecule* (detail), 2002–11. Cast concrete, reclaimed water, stainless steel, paint, and nylon rope, 12 x 8 x 16 ft.

inspiring document of what artists can do when full imaginative potential is wedded to the creation of a green world. The realized projects and those in process document how they have had to adjust their ideas to engineering regulations, economics, and other forces and mind sets.

Simpson addresses reclaimed stormwater in a monumental sculpture at the main entrance to the plant. *Bio Boulevard Digester and Water Molecule* suggests a heroic enterprise with a semi-Pop Art aesthetic. At one end, an enlarged red (hydrogen) and white (oxygen) "water molecule," an icon of the treatment plant itself, passes treated water through a "bubble tea straw" into an underground pipe that emerges in the arms of "heroic plumbers," really concrete tetrapods that evoke the muscled laborers of WPA public art. They "carry" the treated water through a purple pipe (plumbing code for treated water) pierced with holes that expose the water to the sun and allow it to off-gas. At the end of the pipe, the water pours into a six-foot-high coil. The "plumbers" suggest communal collaboration as they collectively support the long purple pipe. The entire 170-foot piece is a metaphor for the function of the plant, in which a 13-mile length of purple pipe distributes water to various uses or to discharge, purging the chlorine disinfectant during transport.

Near the main entry point for sewage entering and treated water leaving the building, Rosen-Queralt's *Confluence* represents the speed and volume of water moving through the plant. Water rushes loudly across a constructed pool, an open pipe reminding us of the enormous amounts of water that we expend in sewage disposal. At the center of the pool is a cone-shaped sculpture that Rosen-Queralt refers to as a breathing "gill." Made of flexible strands of coiled wire, it rises, falls, and twists on its side, evoking the movement of a tidal pool, in and out. A third element comments

on waste, slow drips leaking from holes in the sides. When the water accumulates to 12 inches, it automatically flushes out—the water in the sculpture is already processed, and it uses no energy to function. The well is set in a plaza that includes a concentric tile pattern evoking rings of water. A grove of willow trees, once they reach 10 feet, will represent one percent of the volume of water that moves through the plant. *Confluence* reflects Rosen-Queralt's philosophy of water as part of a system of exchanges and intersections. As she wrote in a proposal for an urbanized watershed at the Baltimore Water Resources Department (September 2010): "Understanding the connectivity between nature and technology...is a reminder of the symbiotic relationships inherent in an ecosystem."

Sollod, Brightwater's third lead artist, also gives much thought to the crucial importance of water in our lives. *Collection and Transformation*, her window display in the Environmental Education and Community Center, features 17 large glass sculptures that evoke aquatic micro-organisms. The forms were made in a residency at the Tacoma Museum of Glass hot shop, based on sketches and sand clay models. The glass micro-organisms will be set into a stainless steel honeycomb structure and lighted with fiber optics to create a suggestion of movement. An adjacent window contains recycled laboratory glass, an increasingly obsolete tool as computers replace hands-on testing.

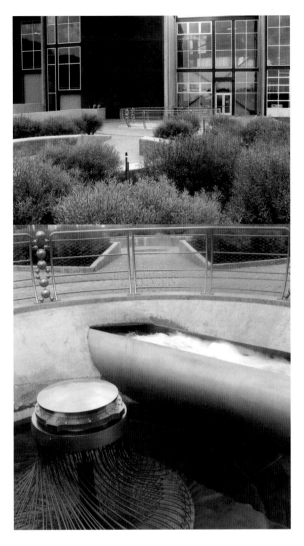

Top and detail: Jann Rosen-Queralt, *Confluence*, 2005–11. Concrete, stainless steel, water, and willows, 10 x 115 x 55 ft. View of site and detail of open pipe and "gill."

As part of the largest water treatment plant ever built, these three projects and many others (including works by Andrea Wilbur-Sigo, Christian Moeller, Jane Tsong, Jim Blashfield, Cris Bruch, and Claude Zervas) honor the importance of water and give visual form to treatment processes. With plans for temporary projects in the restored wetlands, Brightwater is intended to be a destination for recreation and education, as well as a model for returning wastewater to nature. Water as a fixed resource is here returned to the cycle of nature.

Liquidating Tradition: Contemporary Fountains

by Patricia C. Phillips

Situated at the intersection of two main streets in the small town of Wellfleet, Massachusetts, a prominent concrete island is the site of the town's old hand pump. Children yank the handle up and down, but it fails to emit even a trickle of water. Encountering it is a little like stumbling on a pile of old bones or fossils: the remains of an early industrial, civic, and environmental age. What was once the heart of the community is now a symbol of water's diminished cohesive influence in towns and cities.

Like a much-desired downpour that perilously floods rivers and streams after a long drought, the concept of water flows between recuperative and catastrophic associations. However symbolically variable it may be, water remains an indispensable biological requirement. It is this need that led to fountains in early cities. As historian and critic Lewis Mumford has recounted, appreciation of the importance of pure water to urban vitality has stimulated vast municipal improvements in most cities; the distribution of water has long been a great collective enterprise: "The fountain satisfied two important functions that tended to disappear later with an increase in technological efficiency: the public fountain was often a work of art, gratifying the eye as well as slaking the thirst, notably in cities in Italy and Switzerland; and it was further a focus of sociability, providing an occasion for meeting and gossiping...Sanitarians and engineers today, seeking to spread their familiar mechanical benefits to backward countries by laying on water in every house in otherwise primitive villages, often grievously disrupt the social life of the community without offering sufficient compensation."[1]

In modern cities, the fountain's functional role is frequently diminished to a pleasant, cooling presence amid steamy concrete and asphalt. Fountains serve as watery preludes to the sealed buildings where many people spend most of the day. With some rare exceptions, few people consider them as works of art. Nor do they perceive a significant content beyond the cooling function of spraying, spilling, and containing water. Ironically, at the very moment when fountains may provide some welcome social replenishment, there is a growing unease about their contemporary symbolism. As we have become more aware and frightened of polluted rivers and water systems, the fountain can signify reckless waste not unlike an open, gushing faucet. Even if a site carefully circulates its water, there can be a discordance between hard-sought ecological consciousness and the frivolity of hydraulic play. Isn't a fountain in drought-plagued southern California a little irresponsible? Aren't the excesses of the fountain a little disingenuous as we all consider the need for simpler lives?

But as Mumford reminds us, the fountain can be a work of art—and art is an effective agent. Although it rarely provides answers, it can illuminate issues. Some artists who incorporate water into their work are raising significant questions about the steadfast and dynamic dimensions of water symbolism while transforming the typology of the fountain. Perhaps the fountain is no longer a central, singular place. Perhaps water takes something other than its usual liquid form. The fountain suggests an original source as well as a continual passage; it can be a forced jet (like a drinking fountain) or a dependable volume to drain (like a fountain pen).

Artists such as Doug Hollis, Elyn Zimmerman, and Alice Aycock have tested the limits and pushed the boundaries of the contemporary fountain, offering opportunities to consider origins and continuities. In addition to stretching

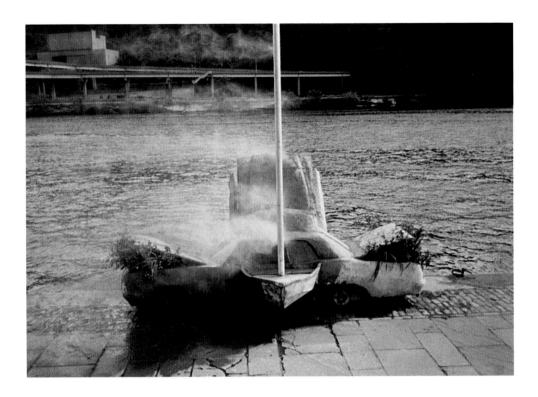

Vito Acconci, *Birth of the Car/Birth of the Boat*, 1988. Junk cars, sailboat, shrubbery, and fog machine, 30 x 16 x 16 ft.

aesthetic conventions and expectations, other artists, through imagery and instrumentation, extend both the use and political content of the contemporary fountain—and of water in Western culture. Vito Acconci has proposed water in several public projects. A temporary installation for the 1988 Three Rivers Festival in Pittsburgh had the narrative title *Birth of the Car/Birth of the Boat*. Made of joined junk cars, a fiberglass sailboat, and shrubs, the piece was installed on the edge of a riverside promenade. The car parts were coated with a viscous skin of cement and coupled suggestively end to end. The vehicles faced the river, and the landlocked sailboat was placed perpendicular to the cars, as if it had been washed ashore. The installation was constantly glazed with spray from a fog-producing machine that also watered plantings in the hoods and trunks of the cars. The perverse joining of terrestrial and nautical vessels gave birth to a new hybrid—a crustacean being that apparently crawled or washed up from the watery depths of the river. The arrangement also offered seating with the unsettling prospect that the viewer might disappear into the fog.

In an enormous, unrealized proposal for Seattle's Pike Place Market (1988), Acconci designed a series of catwalks to run the 500-foot length of the market's back wall. His plan used the steep slope of the site to turn the existing sidewalk into a rushing stream. The open, grated catwalks would have given the sensation of "walking on water." Water would also run down the wall of the building, feeding the urban torrent. At night, roaming searchlights would create strangely luminous and slightly sinister effects for pedestrians. Evoking natural, religious, and penal imagery, Acconci is public art's master of the amenity as a place of psychological discomfort. Water both soothes and threatens; the space both protects and entraps. This is not a fountain of innocence.[2]

Two artists in particular have expanded the idea of the public fountain to a new aesthetic of utilitarianism. Nancy Holt has done several projects that use rain and other common sources of water, though it is not always in evidence. Sometimes the fountain must wait for a storm to realize its intentions. In other passages, water is covert,

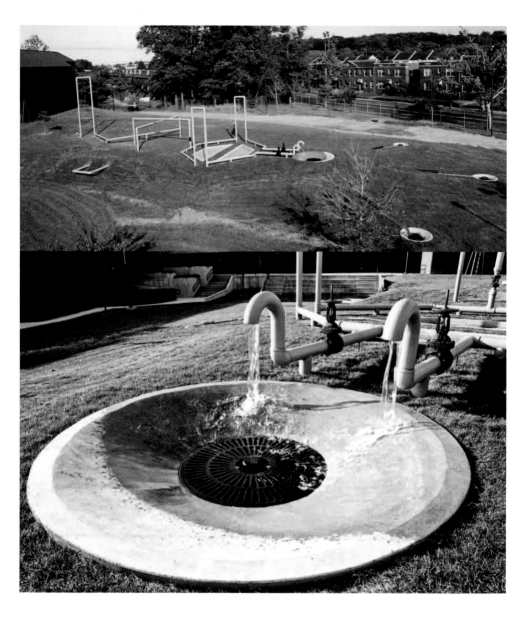

Nancy Holt, *Waterwork*, 1983–84. 6-in. galvanized and painted steel pipe, 8-in. clay channel pipe, concrete, steel, and water, 20 x 70 x 130 ft. View of installation at Gallaudet University, Washington, DC.

contained by pipes and drainage systems; we are asked to believe in a presence that remains unseen and inaccessible. This, of course, mirrors the act of faith central to most quotidian habits. We believe in many operations and systems — such as electricity and plumbing — that are not visually apparent, but the unseen workings of these fountains provide an unusual twist.

Holt's fountains might be classified as examples of a "functionalism" that reflects her interest in the most basic technologies. *Catch Basin* (1982) in St. James Park, Toronto, employs ancient drainage technologies. On a sloping site, rain water is trapped in terra-cotta channels that flow to a catch basin at the lowest point of the topography.

Waterwork (1983–84, dismantled in 1995) followed similar ideas of utility, although this fountain installation also allowed physical participation.[3] Situated in Washington, DC, at Gallaudet University, the work's great valve wheels could be turned to release a flow of water from the municipal water system. The water was directed through closed pipes wandering down the site in a three-dimensional matrix of turns and connections that provided places for seating and play. The pipes led to two big taps that released water into a disk-shaped basin, which then branched off into three smaller basins. Holt's concepts often extend beyond the obvious physicality of the project to consider water's course as it collects on site, enters the city sewer system, heads toward the sea, and ultimately evaporates and collects in developing clouds that release their contents back on the site.

Buster Simpson has done two projects that explore and extend the idea of the contemporary fountain—both its functional and iconographic viability. In Seattle, he has developed a prototype that he calls *Self-Watering Downspout/ Acid Rain Monitor* (1978–84). Simpson's modest interventions are unlike traditional, conspicuously placed public fountains. They are, in fact, quite ordinary downspouts that cling to the sides of buildings and assume somewhat unpredictable configurations. J-shaped joints and limbs create vessels where soil and water can gather and plants flourish. Water does not demonstrably gush and overflow. Like Holt's works, Simpson's projects are more a quiet insinuation than a direct presence.

In 1989, Simpson did a temporary installation at the Hirshhorn Museum and Sculpture Garden in Washington, DC, as part of the "WORKS" series, that used—and subverted—the existing circular fountain in the central courtyard of the donut-shaped building. *Face Plate* created a complex narrative of contemporary and historical environmentalism.

Buster Simpson, *Face Plate*, 1989. View of installation at the Hirshhorn Museum and Sculpture Garden, Washington, DC.

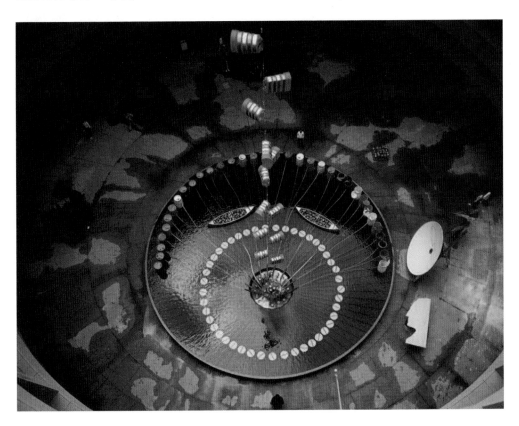

Its subtext involved the "sweetening" of the Potomac River (reducing its acidity) and the Ottawa Indians' tragic exposure to smallpox via British soldiers in the early 18th century. The elements included a collection of 30 colorful toxic-waste containers placed around the circumference of the fountain. Rubber hoses stretching to the fountain's central pool served as conduits to fill the barrels. At the base of each barrel, a punctured inscription acted as a colander through which the water flowed out of the barrels and leached back into the pool. Two plant-filled canoes, a radio disk, and other paraphernalia completed this great iconoclastic fountain-within-a-fountain. Simpson's work devotedly uses the existing systems at a site to make difficult, urgent points about water use.

All of these artists accept the basic idea of the fountain but lend it new meaning, suggesting its paradoxical place in an age of diminished resources and imperiled environmental systems. Today the construction of a charming amenity offers deceptive comfort, silencing nagging questions with seductive, soothing sounds. Following tradition—albeit untraditionally—these artists use water for neither wholly functional nor aesthetic ends; there is some dynamic activity combining the two.

Given that a fountain must use or provide water, can the substance's physical state be variable? Can ice or steam make a fountain? Joan Brigham has studied the emission of steam from manhole covers, grates, and chimneys. She describes steam as "part of the gratuitous gesture that is art" and compares this kind of fortuity to Duchamp's *Bicycle Wheel*.[4] *Steamshuffle* was a temporary, transient installation that traveled to several cities between 1981 and 1987. Eight glass panels placed in a processional arrangement had poems by Emmett Williams inscribed on their surfaces. As viewers walked by, they set off blasts of steam and sound. The unpredictable movement of bodies caused spontaneous atmospherics as the installation played with riotous activity and contemplation—dimensions that fountains have traditionally enforced.

Ever since 1917 when Duchamp placed a common porcelain urinal on its back, called it art, and titled it *Fountain*, the word "fountain" has acquired a generous range of associations. Duchamp's aesthetic activity was one of choice and identification. Artists have since understood their ability to bring new ideas, new thoughts, to common things. These artists choose to consider the fountain in unusual, sometimes extraordinary, ways, in order to challenge accepted notions of water and established systems for its collection and distribution. We no longer bring vessels to fill at the fountain—with the possible exception of our minds. These artists provide ample refreshment.

Notes

1 Lewis Mumford, *The City in History* (New York: Harcourt, Brace & World, Inc., 1961), p. 295.

2 Acconci has returned to water in *Waterfallout-in* for the Visitor's Center of the Newtown Creek Water Pollution Control Plant in New York. Scheduled for completion in 2011, this project blurs boundaries between interior and exterior, land and water, plant facility and the outside world.

3 *Waterwork* was located near the Kendall Demonstration Elementary School, an advanced facility for teaching deaf children. Its playful nature, while appropriate to the location, was also a major factor in its demise. The university, defending its decision to dismantle the work, cited safety concerns. See Benjamin Forgey, "Good New, Bad News: Two Works of Art—One Saved, One Scrapped," *Washington Post*, March 26, 1995.

4 Joan Brigham, "Steam Heat: Winter Fountains in the City," *Places*, 6, No. 4, p. 43.

Keeper of Water:
A Conversation with Betsy Damon

by Terri Cohn

In the 1970s and '80s, Manhattan-based performance artist Betsy Damon posed as a 7,000-year-old bag lady and implored people to share stories from their lives. She wanted to create monuments that would bring people into relation with each other, a mission that has remained central to her work. In 1985, she traveled to Castle Valley, Utah, where she cast a 200-foot section of a dry creek bed in partnership with a team of collaborators. As part of creating this piece, she interviewed local residents, who were trying to control their water quality. Realizing that the water even in such a pristine setting was toxic due to upstream mining and agricultural pollution, Damon made a decision to commit her life to communicating the importance of water to existence on our garden planet.

In 1991, she founded Keepers of the Waters, which started as a collaboration among artists, scientists, and citizens at the Humphrey Institute at the University of Minnesota. Damon took this community-based approach with her when she visited China in 1993 on a Jerome Foundation travel study grant. She was particularly interested in exploring a sacred water site situated in the mountains to the north of Chengdu (northern Sichuan), which was said to have exceptional health benefits. In 1995, she returned to Chengdu, where she directed a Keepers of the Waters event, the first such public art event in China. This two-month project, which included 25 participating artists creating sculptures, interventions, and more than 15 performances, was designed to build awareness about water contamination in the Fu and Nan Rivers. A vehicle for establishing relationships with experts and community members, it attracted media coverage throughout China and led to an invitation to build the *Living Water Garden*, a 5.9-acre public environmental park in Chengdu that commingles education, water treatment, water awareness, recreation, and aesthetics. The park, which officially opened in the fall of 1998, demonstrates that nature has the power to clean water and that artists are a conduit through which new means to sustain our fragile ecologies can flow.

Living Water Garden, 1998. 5.9-acre park. View of project in Chengdu, China.

Living Water Garden, 1998. 5.9-acre park. View of project in Chengdu, China.

Through Keepers of the Waters, which has grown into a nonprofit organization at the vanguard of ecological water design, grassroots organizing, and public art, Damon has continued her commitment to water, people, and reclamation. She inspired students and teachers at DaVinci Middle School to create the DaVinci Water Garden Model Project (2003) in Portland, Oregon, which transforms an abandoned tennis court into a garden that captures and treats stormwater runoff. A system of cisterns, pond, constructed wetland, and bioremediation swale cleans and absorbs 100 percent of the collected water, reducing the amount of runoff entering the nearby Willamette River. The living laboratory also functions as a recreational area and provides a model for DIY stormwater diversion. Other developing projects include a pilot program with Marin County Arts in Florida, documentation of Tibetan water sites that explores the intersections of traditional culture, watershed conservation, and rural economic development, and an environmental education center at the *Living Water Garden*.

Terri Cohn: *How did you choose China as a site?*
Betsy Damon: I've wanted to go there since I was four years old. I went back because my son was there, and then I got a grant to go the sacred water site, which deepened my commitment to water.
TC: *Where is that sacred water site?*
BD: In northern Sichuan. We went to Chengdu—it's a very big jumping-off point—and kept getting stuck there and making relationships. Then I ended up at the first Qi Gong Traditional Chinese Medicine and Environment Conference in Chengdu.
TC: *Was that happenstance?*

BD: Everything was happenstance. I talked about connecting art and science, and the Chinese asked, "Will you come here and do that?" Someone eventually gave me the money, and I went and did the Keepers of the Waters project — two weeks of installations and performances on the Fu and Nan Rivers, which were sewers. It was a wretched place. People took me to every special place in the area. They told me about their plans, and I was astonished by the scope of their vision. I said, "Why don't you make a park? A park that will teach people about water quality." I had a vision in mind, which was limited compared to what I ended up doing. They wanted me to scuttle the Keepers of the Waters project — they don't like public art. It felt like a waste to them to do something temporary, but mostly the invitation to have artists do something like that in public is scary to them. I thought about it, and I didn't want to disappoint all of the artists who came from Beijing, Shanghai, and Lhasa.

TC: *So everyone came to you with the expectation of doing something together?*

BD: Right. I was waiting for permission from the government, but our idea was that if we didn't get permission, we would just go off to a village where they would like the help — make pieces and document them and then publish the documentation. But people started to work to get permission. There were odd things. Since I had a tourist visa and not a government invitation, there was no way they could do a security check on me; but to let me go ahead with the project, they had to do a security check. There were bureaucratic stumbling blocks.

TC: *How did you get around them?*

BD: I have no idea, but we did. When we got the permission, it was as if a gigantic ceiling had lifted, and it was amazing. The government people and the university people, everyone who was working on it, felt that there was an opening.

TC: *This was permission to do the Keepers of the Waters event?*

BD: Right, not for the park. They said, "You do this Keepers of the Waters project, and we'll watch you carefully. If we like what you can do, then we'll ask you back." This was in 1995. They loved it. I worked very hard with the artists to do constructive pieces about water — and they did a wonderful job. They did pieces to engage the public. Some artists came from the States. For instance, Kristin Caskey did a piece called *Washing Silk* — it's in all the Chinese brochures — because the Fu and Nan Rivers running through Chengdu were, and still are, collectively called the Brocade River. People would wash their silk there, and it would come out brighter. Caskey had six people on the river with red rugs and baskets of white silk turning gray — if they had stayed any longer, they would have had boils on their legs. It was a beautiful piece.

One man did a board about water quality with photographs on it and developing trays, showing the river water eating away our faces. He glued beautiful paper down on the sidewalk and sold river water in bottles and invited people to sign their names on a petition — it was so political and complicated, such a layered piece. Another time, they put teacups on a white cloth spread over the floor in a pavilion overlooking where the two rivers come together. Ice made from filthy river water dripped down over the teacups and stained the cloth.

TC: *Americans take issue with "political" art. They still separate art and life in ways that make it difficult for people to look at art and say, "That's really beautiful — and it's also very political."*

BD: I learned from watching the Chinese. That's the kind of work I like to do, and I can't find my way to doing it easily in the States. There, I can automatically do it. We used live ducks in another piece. An artist hung signs around their necks with water quality information, then he set them loose in the river. The ducks started to die. Another artist suspended huge ceramic urns off a bridge. The idea was that the urns, which were used to hold oil, would have fresh water in them, and it would be the only place where things could live. There was a beautiful visual experience of the urns hanging from the Key Bridge. We never told anyone that we couldn't put the water in them, despite the big ropes, because it would have been too heavy. But it didn't matter.

TC: *It was about the idea.*

ReSources: Saving Living Systems, 1998–present. View of project in Sichuan Province, China, and Tibet.

BD: Yes. There were ideas up and down the river about a quarter mile on both sides, and interaction with the public took place on all levels: from old people telling how they would swim in the river to a woman who built a huge cube out of ice—she invited people to wash it clean. She gave them brushes and pails, and for three days it melted. Peasants and children wanted to eat it—and it was sewer water.

TC: *Was the* Living Water Garden *an outgrowth of the Keepers of the Waters project?*

BD: Yes. I thought that after this great success, I could get some money to go back. No way. People would not give to China. But I returned in March 1996, with my son, Jon Otto, and Margy Rudick, a landscape architect who came for a short period of time, and we presented our ideas to a group of 45 experts. There were people from the government, and hydrologists and engineers, and people from the parks department, and people from the last project whose support I needed. We assembled a team to look for a place. They said they'd get back to me in a week. They offered the biggest piece of inner-city park land on the rivers. I think Margy had 10 more days there. We began to design the site, and it looked like a fish. We both saw it and got very excited. She began the drawings, and I continued after she left.

During that time, we began to work with a microbiologist. He did the constructed wetlands and worked out how the water system would work; he set up concrete bins in his back yard and tested them by hand. We also worked with a landscape designer, an engineer, an architect, and a separate tree and plant person, as well as a fountain person. It was a team of about 15 people.

I spent my time networking the idea of the park and environmental education, and in December, I went home. Then I heard that they were going to start building in February. So I dropped everything and went back, stopping in the Netherlands first to do research because they have more of what I need about water than the States.

Margy asked a feng shui expert to look at our plans. He said, "This is really great, but you know there's a problem. The fish's eye is the settling pond—it's the dirtiest water—where the river water comes in." So we put a living water drop fountain out in the middle as a vision. The gills end up being the flow forms, which is perfect—the flow forms take in oxygen. They start out as simple bowls and then transform into a bird. For me, not only does the sculpture have to be integrated into its place, we need a new sculpture—we need a new language that describes the physical universe that we've come to understand from ancient times to now and a future language about preservation.

Art and Water for the Future:
A Conversation with Ichi Ikeda

by John K. Grande

Japanese sculptor and performance artist Ichi Ikeda uses water as his primary medium, a choice strongly connected to global environmental problems. Recognizing that water is one of the earth's most precious resources, he is dedicated to raising awareness of water conservation through international conferences, community activism, public performances, and interactive installations. He encourages viewers to consider the larger context in which they live and to see how their actions can affect the earth's future through large- and small-scale artworks he calls "Ikeda Water." Among the most important of these works are *Water Piano*, *Water Mirror*, *Earth-Up-Mark*, *United Waters*, the Big Hands Conference, *Water Ekiden—Manosegawa River Art Project*, the *Water Market* project, and *80 Liter Water Box*.

Since 1997, Ikeda has been developing a long-term project addressing environmental problems in the Asia-Pacific region. As Ikeda Water continues to expand and grow, he is also developing a worldwide project called *World Water Ekiden*, with the idea that any place can introduce "water for the future" for the next generation. He calls this new perspective on social and natural systems the "Water's-Eye view."

John K. Grande: *Do you consider your work as performance or social activism, or is it rooted in the material of water?*
Ichi Ikeda: During humanity's long history, painters have never drawn an image on water, nor have any sculptors carved a shape with water. Water cannot be controlled. For me, water is a substance that does not conform to one's will, and it has a symbiotic essence that likewise contains communicative qualities. People have commented that I use water as my medium probably more than any other living artist, creating a whole new language with this uncontrollable substance. We express the absoluteness of a personal image from the spirit within. The accepted idea of executing an image through "creative action"—from image to gesture to objectification—has come to be seen as an anachronism. For whatever reason, enormous events become intricate and complicated. If one tries to undo them, they become hopelessly entangled with chaos. These unpredictable events invariably affect the process, from initial gesture to completion of the final object. The role of the artist is thus transformed. I aim to create symbiotic relationships through actions and to develop my artistic activities with water. That's why I use water as my medium, creating a universal language that goes beyond diversified chaos.

JG: *Where does the theatrical, even ritual, aspect of your work come from?*
II: I do not like to be pigeonholed and have a strong interest in discovering the many diverse possibilities within me. I unravel myself through my artwork. In the early 1960s, after doing research in polymer chemistry at Kyoto University's graduate school and participating in a theater company staging the works of Samuel Beckett and Eugene Ionesco, I established my own theater company in Tokyo, bringing art and theater together. I was a playwright, art director, and actor. These various roles remain entangled in me to this day. The process of art is a way to improvise at unraveling my entangled self, not some ritual thing. Instead of forming a concept into a shape, my performance sculpture is more like the unraveling of a cord. Nothing surpasses water as a medium of expression: it holds no bodily form and can metamorphose as a living entity.

JG: *Many artists speak of a structural basis for their work and relate this to the environment. Often they describe nature through a romanticizing lens, but the objectness of their approach does not leave much for the future.*

II: Nothing is definitive. Everything can change at any time. Water is a dual-natured substance, full of contradictions, that guides us toward solutions in a natural way. A lot of my art has been temporary; it exists for a short time, whether it is presented outdoors or indoors. The structures are often made of natural materials like wood and bamboo that decay over time. I strongly believe that my work exists in relation to a post-object culture that refuses the products of materialistic civilization and flows endlessly in a limited space. What is important for the post-object culture is not to throw objects into a turbid stream, but to keep creative time in people's minds. The earth's resources are limited, so when you create art, don't make hasty decisions that waste materials, especially natural ones. The materials that we use are precious resources for the future. When you make your artwork, don't make it for the future of art, make it as art for the future.

JG: *How do we move toward an art that works with the ecosystem, designs with nature, and locates itself within the continuum of natural history?*

II: I use the word "flowable" to enable us, when we begin to collaborate together, to grasp an ordinary fixed situation as a flowable state. In 1997, when Kaseda City in Kagoshima Prefecture invited me to do an outdoor art project, I asked the local people if they could take me to the highest and lowest places in the city. The highest was on top of a mountain, and I had a view of the entire city below. The lowest was at the river, where I could see algae growing and expanding in heavily polluted waters. Although people live in this same environment, they are insulated from it and look at things from the fixed perspective of their daily routines. Many people were surprised when I raised the issue of algae in the river, and it helped a dialogue to develop and got the collaboration going—ordinary life transformed into a flowable state of working with the ecosystem.

Water Station for the "Heaven," 1999. From *Water Ekiden—Manosegawa River Art Project*, Kagoshima, Japan.

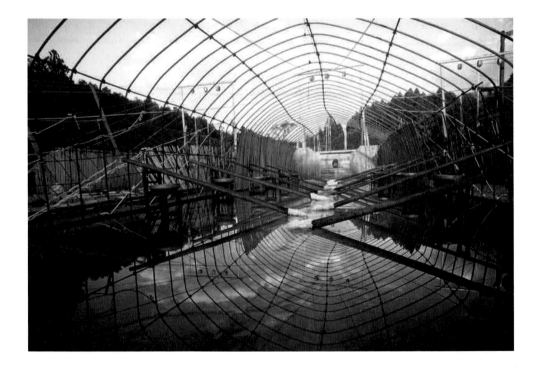

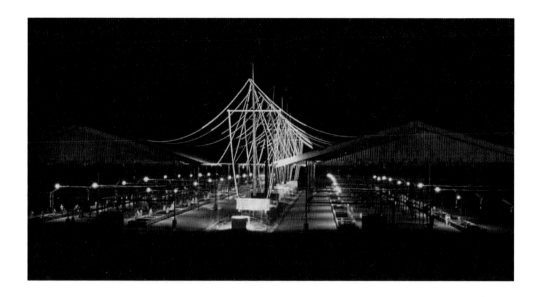

Water Market Kaseda, 1998. Project at the livestock market, Kaseda City, Kagoshima, Japan.

JG: *What is your favorite project?*

II: My personal favorite may be *Water Ekiden — Manosegawa River Art Project*, which I directed in the Satsuma Peninsula, Kagoshima Prefecture, Japan, in 1999. The scale of the work was huge, and it involved collaboration with more than 100 local people. Four communities situated along the Manosegawa River and its tributaries were able to go beyond their local differences and work together. I proposed a dynamic in which we would pursue ideas that included each and every one of the communities' respective cultural backgrounds. For the people in these communities, it was their first experience of cooperating outside the boundaries of their district. I kept saying to them, "An artwork is something like a magnifying lens. Through this special lens, you can see what you have never been aware of: inherent stories of the land, new appearances of the scene, intercommunication between human and nature." Starting from this point in the process, artists and citizens from the river basin have gone on to create a desirable combination of what I would call "commonality and inherency."

Eventually, four water stations were built with an understanding of the water situation in each district. The community located along the upper streams transformed neglected bamboo forest areas into a spacious park with access to the river bank. We planted trees and named this collective work of love *Water Park*. Its greatest merit is the feeling of belonging that it generates. Amazingly, extending the partnerships between people turned my temporary artwork into a permanent park with public facilities. A new community full of creativity for all people has made its appearance along the river. This extensive art project still greatly influences people involved in ecology and environmental art.

JG: *What is the Water Market idea?*

II: Water Market is an exchange of water for water. The first water is water now and the second water means water for the future. When we plan to hold the Water Market somewhere, we concentrate on the realization of these two important processes. The initial process invites local people to participate as what I call "Water Senders." They play the most important role in forming the Water Market. The hope is that the Water Market can be open at any time and anywhere — I always carry the Water Sender Agreement. It reads: "Let us all be Water Senders, sending water, one of the earth's most precious resources, to all people living in the future regardless of cultural, national, or religious differences and disagreements." The number of water boxes placed in the Water Market depends on the number of Water Senders.

Water Station for the "Human," 1999. From *Water Ekiden — Manosegawa River Art Project*, Kagoshima, Japan.

At the next stage in the Water Market, it is indispensable to create a flow of water for the future that runs through the city. In the case of the *Water Market Kaseda* (1998), a new flow of water was activated by uniting several key spots in the city: the Water Hut for collecting water, the Water Market for exchanging water, and the Water Warehouse for sending out water. Water Huts, for scooping up actual water, can be installed as many times as a community likes. In the Satsuma Peninsula, one was built at the meeting of rivers with different histories of flow. And in the case of another in the irrigation channel, aiming to purify water-in-life, about 700 kenaf plants were grown because kenaf can absorb about six times more carbon dioxide than other plants. Through Water Art projects in several Asian cities, more than 280 Water Senders are now registered.

JG: Water Mirror *in Yokohama brought light and life to an urban context. Is this an example of how art can change our lives outside museums and galleries?*

II: Water that comes from a tap is one of the greatest benefits of modern civilization, but it doesn't offer any clues as to the vital and dramatic role that water plays as the respiratory system of the earth. Completely surrounded by concrete and asphalt, *Water Mirror* transformed the immediate urban spatial environment, animating a communication between people and place. Such subtle effects as the wind, falling leaves, and the beating of birds' wings bring traces of nature into contact with a building as its image reflects and sways in water. Your breath can make waves on the water's surface and make *Water Mirror* sway. A building starts to breathe like a living creature when it's surrounded by wave reflections created by breathing. By echoing with living cycles of water and introducing "fertile breaths" into the surrounding environment, you gain some understanding of the earth's systems. Changes in wave patterns become a language addressing the surrounding environment—something that mirrors our symbiotic, mutual relationship, the connections between people, urban environment, and nature. It's limitless. You find that you are a part of what is going to be liberated from the here and now.

JG: Earth-Up-Mark *(1985)* at Hinoemata River and A Navel of the Earth *(1990)* at Yaso Mine Primary School are visually powerful, but they do not seek to control or dominate the natural environment. The same goes for your containers that hold writings awaiting the rains to complete them. This is a joyous way to perceive the artist's role: the art is the transformation.

II: Delve into the earth. Dig into the sand by a river. Form a massive cross-shaped trench. Fill it with blue water. The crossing lines point respectively to the north, south, east, and west. The point of intersection, the center of the cross, is the earth's navel. Through these processes, I feel myself in a state of being in nature. During my performance in *Earth-Up-Mark*, I needed water from the sky. I wanted to do my performance struck by incessant rain and to draw myself toward the greater part of nature. Strangely enough, it became cloudy and began to rain hard. Together with colleagues and viewers, I was happily enveloped in pouring rains, in breaths of nature. For *A Navel of the Earth*, I continued to dig a hole toward the center of the earth. I knew that this simple expression/action brought me into a profound exchange with nature. Many people voluntarily participated in the process of digging toward the navel, even if they knew it was an impossible plan.

JG: *How do your projects come about?*

II: "Primary action" is part of my art philosophy, because it's essential to try and make things happen early on. In the later stages, the method becomes more complex, and competitive dynamics can kick in that make the possibilities of working together more difficult. I am convinced that primary action makes us unravel complicated relations between people and nature. I often give a definition of my action in art projects as primary action, not as performance. In *Earth-Up-Mark*, my primary action was to lay myself down in water. In those days, I organized primary action workshops with other artists on the beach of the Tamagawa River, which flows west of Tokyo. Just four months out of the hospital, I visited the Tamagawa River workshop with a pair of crutches and managed to lie down in shallow water. This was all I could do. Lying between water and sky, I continued to speak to the sky in an impromptu way. I keenly felt that I was just a joint uniting elements in nature.

JG: *Is community help part of the action in your work?*

II: I am constantly looking for possibilities to collaborate with communities. Because water is a material of universal concern, and water shortage is a serious social issue, water represents our social consciousness. It is not just property. The 21st century is the water century. Water is a basic human right. I like to recite the saying, "Everyone owns water and passes it on to future generations," which certainly expands one's perspective on collaboration. When I talk to people, I say, "If you want to have a clean water supply at ground level, and if polluted water comes down the upper stream, you had better tell the people on the upper levels to help with the purifying efforts. If polluted water comes from a tributary of the river, all efforts are meaningless unless the people living there join the effort." This can help build collaborative partnerships.

Connected via the chain of water, *Water Ekiden* proved that collaborative systems work only if identity and joint ownership intertwine. Each person brings unique professional abilities to the overall effort. The architect draws a plan, somebody collects artifacts, another lends tools and machinery. The more levels of interconnection, the more interesting the work. Collaborations are about these various living relationships. They embody our society in miniature. I remember what a carpenter said while working with me, "I don't need any money. Thanks to you, my lifetime will extend more than one year." In another example, at the end of the "Arcing Ark" exhibitions in Kaseda and Taipei in 1997, people planned the final action by offering to carry "Seven Loads of Water" through the river to the sea. They were just crew members of the Arcing Ark, and even though I was absent from the final action at both sites, the actions continued. I believe that my water art project prompted the creation of a new cycle through art. Different from the centralizing forces of dominant culture, this project involved vital forces that cross borders and expanded forces that form links in a new cycle of the human environment.

80 Liter Water Box, 2003. Project for the Third World Water Forum, Toyota Municipal Museum of Art, Toyota City, Aichi, Japan.

JG: *Tell me about* 80 Liter Water Box.

II: In March 2003, the Third World Water Forum was held in Japan. More than 20,000 people from all parts of the world gathered to discuss the global water crisis of the 21st century, hoping to propose collaborative solutions for the future. Surrounded by information and statistics, I wondered how I might connect these serious problems with daily life. Afterwards, we forgot most of the information from those crowded, bustling events. I had to find what role art might have, to plan an art process whereby people could realize the seriousness of water problems. *80 Liter Water Box* simply stated that "water must exist as the fundamental human right for all people." During the Third World Water Forum, *80 Liter Water Box* announced to participants that "one person needs to have 80 liters of water per day to maintain the standard of life to some degree. But, according to the report, three-fourths of the world's population can use only 50 liters of water or less because of 'low water supply.' It is reported that some people in Kenya are compelled to spend a day with only five liters of water. On the other hand, some people in the West use 1,000 liters of water per day just watering their lawns and washing their cars."

There is a very wide gap in water usage between regions of the world. By displaying my *80 Liter Water Box* as the standard, I asked visitors, "More than 80 liters or less?" Just before the Iraq war broke out, the newspaper of the Third World Water Forum, *Water Forum Shimbun*, carried a photo of *80 Liter Water Box* with the caption, "The Future in their Hands." Whenever you are drinking, washing, cooking, taking a bath, or doing something with water, please think of my *80 Liter Water Box* and think of the wide gap in water supply around the world.

The Theater of Flow:
A Conversation with Lorna Jordan

by Suzanne Beal

Movement is of fundamental importance in Lorna Jordan's work. Her environmental artworks range from green infra-structures that enhance watersheds and reveal the cycles and mysteries of water to site-specific sculptural pavilions and gathering places that embody progressions of form, to media works that incorporate light and projections. All of these projects use changing cycles and the drama of animated sequences to heighten our experience of the environment. Jordan's works appear in both wilderness and urban settings, shaping aesthetic solutions for environmental problems while stimulating the human imagination.

Suzanne Beal: *You've lived in Seattle since 1977, and part of your education took place at the University of Washington. How has the Northwest shaped your work?*

Lorna Jordan: I don't think I would have become as interested in water if I hadn't lived in the Northwest. It's prompted me to think about water in a broad, comprehensive way and to appreciate the lush vegetation and the feel of mist on your skin. The rain supports our gorgeous landscapes and carves our dramatic topography. Seattle is surrounded by water bodies, so water has become an important part of my work.

SB: *Your work ranges from primarily sculptural and architectural projects to green infrastructures. How do your approaches and expectations differ when you work with structures versus ecosystems?*

LJ: With a sculptural pavilion, for example, you know it's complete once it's built—you've planned how the forms will come together. But whenever you're working with living materials such as plants, they're small at the start and you have to wait for them to grow and evolve. An artwork that includes living systems moves and shifts over time, and I expect it to take on a life of its own. There's more flux when you're working with landscape than with structural forms. The two have very different dynamics.

SB: *Your projects are often created over a long period of time. How does this process—and the passage of time—inform what you do?*

LJ: Take, for example, *Dune Theater*, which is one of a series of sculptural gathering places within *Cinematic Frames and Progressions* for the Ventura Harbor Wetlands Ecological Reserve in California. The movement of breaking waves inspired the pavilion for *Dune Theater*, and a related form can be found in *Reach* (Lynnwood, Washington). The two pavilions share similar elements such as arching ribs. But where *Dune Theater* is broken up into a series of snapshots, or cinematic frames, *Reach* embodies a single gesture. The sites for the two projects are quite different—one is located within an ecological reserve, the other at the heart of a college campus. *Reach* is inspired by the desire to stretch one's knowledge, while *Dune Theater* is inspired by the crash of a breaking wave. Yet *Reach* was another way to make a gesture that envelops and arches over you—it shifts and changes as you move through it. It's the expression of the form that morphed over time.

SB: *You've executed work in just about every imaginable geographical location, from solitary spaces to heavily trafficked areas such as transportation hubs. How do you develop concepts for such diverse settings?*

Lorna Jordan, in collaboration with Otak, Architekton, A. Dye Design, Michael Baker Engineering, Natural Systems, and Aklali Lighting, *Origami Garden*, 2008. Recycled glass gabion walls, LED lighting, terrazzo, concrete, metal, and drought-tolerant native plants, 8 x 120 x 80 ft.

LJ: Research is key to my process, and I like to take as much time to conduct it as possible. I study the various flows and phenomena that have acted on a place over time and uncover the various layers, be they geological, hydrological, historical, social, or archaeological. And I come to appreciate the traces of those who have passed through a place. I'm interested in the processes and movements that form palimpsests on sites over time.

SB: *What part of your research is most beneficial in determining what you will create?*

LJ: There's nothing like terra firma — actually being in a site, feeling it with your own body, and trying to figure out where you can have the most impact, such as improving ecological systems, creating dynamic sculptural forms, or providing experiences for people.

SB: *What kind of dialogue do you establish with local communities, and how do your works strengthen a sense of identity?*

LJ: I think of myself as a change agent. I listen to how people currently use the site, how they'd like to use it, and what they might know about it. I also present my past projects and explain what led up to them. But I primarily want to hear from them regarding their own perceptions. I listen to their voices as part of my research.

SB: *How do you transform viewers into participants?*

LJ: I've created installations for museums and nonprofit spaces. Through these, I've become intrigued with how people can participate in and complete artworks, rather than just observe them. For example, *Longfellow Creek Habitat Improvement Project* (Seattle) is situated within the heart of a neighborhood with single-family homes. Community members wanted a place where they could become immersed in the creek's environment, and they wanted it to perform as an outdoor classroom. So, my idea was to provide limited access to the five-acre area by designing a series of outdoor rooms with paths to direct movement. These elements allow people to experience and understand wildlife habitats without damaging them. Prior to the work of our design team, the watershed was ravaged with overgrown blackberry thickets, and floods had scoured the creek bed. As a result, the watershed couldn't really do its job in draining stormwater and supporting habitat. In order to improve salmon habitat in the creek, our team introduced woody vegetation, built timber step-ups (to help salmon swim upstream), and provided new spawning and rearing areas.

SB: *How do you inspire people to experience environments? Do you rely on signage?*

LJ: I have a strong opinion about signage. There's so much text in the landscape that I tend not to add more. Signage is often used indiscriminately. It can be difficult for people to switch between their left and right brains if they're stopping to read about a place rather than experiencing it directly. I'd prefer that they tap into their own memories and imaginations. I want people to become immersed in a place and to experience their part in social and ecological processes; I don't want to tell them what to think and feel.

SB: *How much do you direct people's movements? It's interesting to think of you as a choreographer of flows.*

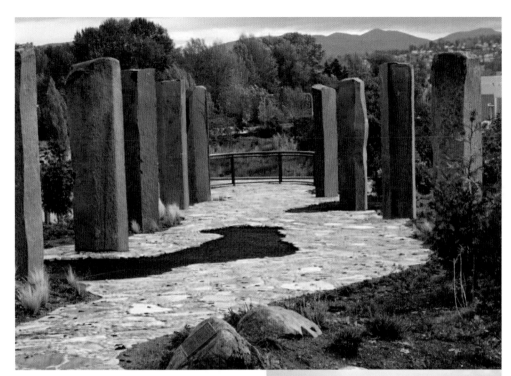

LJ: I've talked to choreographer Donald Byrd about differ-ent approaches in dance. In certain performances, chore-ographers look to control every move; but in other cases, they offer suggestions to performers and then allow for improvisation. The choreographer has a sketchy idea and then allows it to unfold. I see some similarities to the latter approach in my own work. Mine is a subtle form of choreography, because flows, by nature, have a life of their own, but I try to work with them in ways that improve their aesthetics and performance—and that frame how people might experience and interact with them. I'm interested in creating places that immerse people in the changing nature of the environment by expressing the performative aspect of social and ecological processes.

SB: *You refer to plays across form, process, and event as a "systems aesthetic." Can you tell me more about that?*

LJ: My friend Laura Haddad showed me an article written in 1968 by artist Jack Burnham called "Systems Aesthetic." She suggested that there was some overlap between my conceptual approach and the approach out-lined in his manifesto. Burnham said that we were transi-

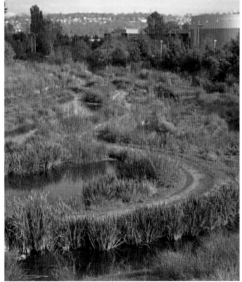

Top: Lorna Jordan, in collaboration with Jones & Jones Architects and Landscape Architects and Brown & Caldwell Consulting Engineers, *Waterworks Gardens: The Knoll*, 1996. Grate-covered channel, basalt columns, plants, water, and paving, 11 x 34 x 100 ft. Above: *Waterworks Gardens: The Release*, 1996. Enhanced wetland, part of an 8-acre site.

tioning from an object-oriented culture to a systems-oriented culture and that "art does not reside in material entities, but in relations between people and between people and the components of their environment." I think this partially describes my approach. But, besides my interest in systems and relationships, I want to create sculptural forms that embody movement.

Waterworks Gardens (Renton, Washington) incorporates a systems aesthetic, or an aesthetic of performance, as well as dynamic sculptural forms. People follow the path of the water from working, to mysterious, to beautiful, to life-sustaining. The stormwater is naturally treated and supports a wetland habitat. The artwork makes visible the ways in which water moves and drains. It fosters reflection about other species and connects viewers to the cycles and mysteries of water by creating a framework for perception. Many stormwater treatment systems are little more than crudely shaped ponds surrounded by a chain link fence. Another way to address these systems is to express them as art and have people follow the path of the water directly. With *Waterworks Gardens*, I wanted to bring water to the surface, cleanse it, and make it visible. The water that would typically run off a parking lot into a drain is suddenly revealed — traceable, knowable, and poetic. *Waterworks Gardens* is about the sublime — exploring the forces of attraction and repulsion as well as the emotions of awe and fear. On one hand, we have a water treatment plant that can repel. On the other, we have an environmental artwork that broadens the program, attracting people to the place and connecting them emotionally to the cycles and mysteries of water. I wanted to express the poetics of water within the context of a wastewater treatment plant.

SB: *What about acoustics? Do they play a part?*

LJ: Acoustics do play a part, because I want to engage all of the senses. At *Waterworks Gardens*, the sound of water leads you into the site. The water is underfoot in a grate-covered channel that cuts through the geometry of a basalt colonnade, two rows of columns arranged in forced perspective. You're lured by the sound and follow it to an overlook where you see the water spill into the first of 11 ponds. Here, it is daylighted, or brought to the earth's surface. In another part of the work, I used the sound of water to screen traffic noise.

SB: *As much as you focus on the natural environment, you remain sensitive to the needs of an urban populace.* Trinity River Cascade *(Fort Worth, Texas) responds to different types of flows: water, vehicular, and pedestrian. How do they interact?*

LJ: The proposed project is located at the intersection of a parkway underpass and a river — it's an urban grotto connecting people to the flows that surround them. There's lots of activity, with cars, pedestrian traffic, and a small train. I wanted to create a theater for interactions among people, water, transport, light, sound, and sculptural forms. I also wanted to invite a slower pace and provide a sense of drama. My design includes a stone weir that acts as a pedestrian river crossing, stacked terraces along the riverbanks that provide river access, and cascades that cleanse and aerate river water. At night, dappled light reflected from the river's surface is projected onto the bottom of the overpass. Scrims along an adjacent roadway include light works that respond to the movement of people, water, and vehicles. On the posts that support the new parkway, chases of light are triggered by the passage of cars above, mirroring their ambient whooshing sounds.

SB: *To what extent do you respond to a particular setting?*

LJ: First, I'm interested in how sites and systems are connected to water and how they fit into their watersheds. I'm attracted to water because it's such a poetic and mysterious substance. It appears in many forms — as liquid, solid, and vapor. We can see our reflections in it, and our bodies are made of it. It appeals to our senses with its coolness, sound, and color. And water has many uses — it cleanses and provides power and habitat. But it is even more than this. The water cycle is a mighty force that carves the earth's surface into watersheds.

In my work, I use the cycles and mysteries of water, as well as the framework of watersheds, as filters through which to experience and improve the ecology of sites and systems — downtowns, neighborhoods, industrial sites,

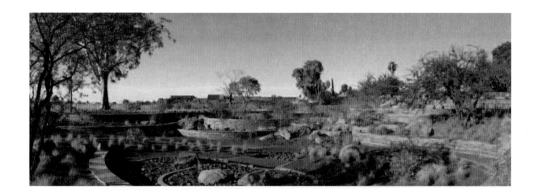

Lorna Jordan, in collaboration with Black & Veatch, Ten Eyck Landscape Architects, and GBtwo Landscape Architecture, *Terraced Cascade*, 2007. Flagstone, strip stone, pebbles, steel, boulders, native plants, and harvested storm water, 20 x 130 x 130 ft.

transportation hubs, parklands, river systems, and ecological reserves. For example, *Origami Garden* in downtown Tempe, Arizona, is incorporated into a transportation center. It's an expressive courtyard folded under an angular community room that floats above. A faceted landscape of earthen planes echoes the shape of the community room and includes native plantings irrigated with harvested rainwater and gray water. At night, LED light works illuminate gabion walls filled with recycled glass rocks, creating a vibrant space for nighttime events and interactions. *Origami Garden's* primary impact is on the urban environment—providing an aesthetic, sustainable habitat for people, with minimal impact on the Salt River watershed in which it is located.

SB: *How do you shift your work for projects in less developed areas such as parks and ecological reserves?*

LJ: I'm currently working on designs for a project called *River Passage Park* along the Bow River in Calgary, British Columbia. The park is an environmental artwork addressing the language and origin of the Bow River—its ecology, its role in shaping the landscape of the region, and its human history. Progressions of forms interact with the terrain and the movements of people and natural processes. Here, large-scale ecological enhancements such as constructed wetlands are expressed as art. Earthworks echo the terraces formed on the riverbanks by fluctuating fluvial processes. People are scaled down in relation to the environment. Smaller areas provide them with lenses through which to experience the river and watershed. Artworks in these places include amphitheaters, river access points, sculptural gathering places, solar-powered elements, overlooks, phenomenological events, and pathways.

Another example of a work in a less developed area is *Terraced Cascade* in Scottsdale, Arizona, which is located within a park and desert wash. This is an earth/water sculpture expressed as both watershed and abstraction of the human body. It provides a means for people to imagine their place within the larger Indian Bend Wash—a watershed with alternating conditions of drought and flooding. Taking advantage of the topography, a series of rib-like terraces and a vertebrae-like cascade are nestled into the hillside. Harvested stormwater intermittently flows down the cascade to irrigate a mesquite bosque that offers shade and respite from the desert sun. Xeriscape plantings offer curious shapes, colors, and textures. A path winds through the artwork, allowing people to explore the terraces, plants, and cascade.

Every site presents opportunities and challenges specific to its context, but my desire for each project—whether it's in the wilds or in an urban area—is to improve ecological systems, express an aesthetic of performance, and create sculptural forms that embody movement. I'm interested in tapping into people's memories and imaginations while providing experiences that range from the scientific and observable to the archetypal and sublime.

The Planet According to Maya Lin:
What is Missing? and *Confluence Project*

by Susan Platt

Maya Lin's "last monument," *What is Missing?*, sounds an alarm for the planet in the midst of escalating mass extinction of species and their habitats. She refers to this as the sixth mass extinction in geologic time, but the only one triggered by a single species, the human race. As competition grows for the last fossil fuels, resource extraction has become even more aggressive in such places as Alberta, Canada, where the entire surface of the land (called the "over-burden," by energy companies, but, in fact, a crucial Boreal forest and carbon storehouse) is being removed in pursuit of tar sands. In Pennsylvania and New York State, natural gas extraction by fracking (rock fracturing) poisons ground water; mountain top removal in Appalachia blows up entire mountains; over-fishing in the seas is leading to mass declines; and ocean acidification from carbon dioxide is destroying many organisms. Noise pollution is another major factor, as massive ships disrupt the sonar wavelengths that whales and other sea creatures require to communicate.[1] According to one recent article, planned dams in Quebec will destroy the habitat of 97,000 pairs of songbirds.[2]

What is Missing? speaks to absence, like those songbirds and all of the other species lost, or about to be lost, by habitat destruction. Collaborating with scientists and environmental groups from around the world, Lin honors the already lost and wants to inspire action to prevent future losses. With vivid video and sound archives from the Cornell Ornithology Lab and imagery from the BBC and *National Geographic*, *What is Missing?* makes it possible for us to see giant fish and turtles swimming in the sea and hear the extraordinary sounds of threatened frogs, birds, and crickets.

What is Missing? includes multiple formats: an interactive Web site, a *Listening Cone*, 70 videos, and the *Empty Room*, a space with projectors in the floor in which visitors can "catch" a projected image of a species. Other formats are a sound ring with embedded speakers, a print book, and a downloadable digital book. In addition to connections to troubled sites all over the world, <http://whatismissing.net> will soon have links to environmental groups and a forum for the public to contribute their own stories. Lin is redefining the idea of a monument from a single fixed work to a constantly changing, multi-sited, multimedia event.

In 2009, the California Academy of Sciences in collaboration with the San Francisco Arts Commission unveiled the first permanent *Listening Cone*—a megaphone-shaped sculpture large enough for people to walk inside. Its narrow end houses a video screen projecting 20 minutes of video and sound recordings of extinct, threatened, and endangered species and their habitats. The exterior of the cone is bronze; the interior is highly polished, recycled redwood. People are asked to remove their shoes before entering. Once inside, the curved space forces awareness of your footing, and the space narrows quickly. The physical dynamic of the cone echoes the condition of the earth: we are increasingly treading on unstable ground, and our planet's options narrow as species and habitat losses escalate. Destabilizing our footing is part of Lin's strategy to stimulate us to think more about what the current crisis means now, and for the near future.

Changing contexts also destabilize expectations, as in the Earth Day 2010 presentation of *What is Missing?* videos in Times Square, an event sponsored by Creative Time. Projected onto an over-scaled billboard in the midst of non-stop sensory assault, three five-minute videos played every hour for two weeks: images of giant blue stingrays or sea turtles

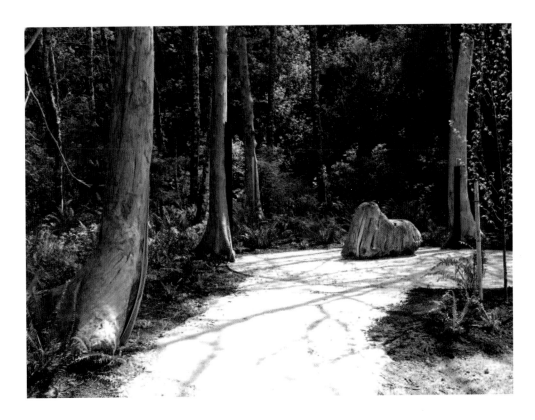

Confluence Project at Cape Disappointment, Washington, 2005–06. Above: View of sacred circle. Below: View of basalt fish-cleaning sink.

swimming in the sea, for instance, paired with Lin's succinct texts. The *What is Missing?* Web site demonstrates how the bird, cricket, and frog songs could be heard over the urban din. Juxtaposing these images of magnificent endangered species with the commercial promotions of Times Square made the dialectical point (which Lin herself never states) that our commodity-based economy and thirst for energy are the strongest forces driving habitat destruction. Corporate capitalization of nature is, of course, the destructive attitude that must be corrected.[3]

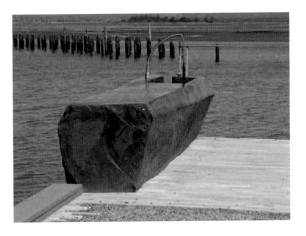

While *What is Missing?* exploits the freedom of nomadic sitelessness and global reach to raise awareness, Lin's second major project, the site-based *Confluence Project*, documents lost and endangered peoples, species, histories, and ecosystems along the Columbia River. The decade-long project, spread over 450 miles and seven sites in Oregon and Washington State, also marks survivals and initiates ecological restoration. The seven sites are (going from east to west), Chief Timothy Park, near the confluence of the Clearwater and the Snake Rivers; Sacajawea State Park, at the confluence of the

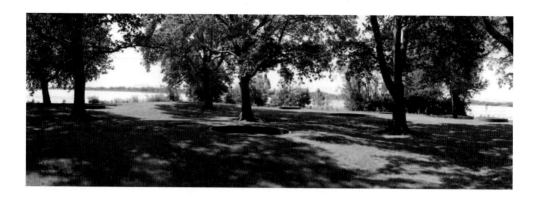

Confluence Project: Story Circles, Sacajawea State Park, 2010. Polished, sand-blasted basalt.

Columbia and the Snake Rivers; Celilo Falls Park, a site of contested cultural confluence; Sandy River Delta, at the confluence of the Columbia and the Sandy Rivers; Vancouver National Historic Reserve, at the confluence of the Columbia River and the Klickitat Trail; Frenchman's Bar Park, at the confluence of the Columbia and the Willamette; and Cape Disappointment State Park, at the mouth of the Columbia River and the Pacific Ocean. Lin sees all of these sites as a single "fluid, ever-changing environment."

The project began as part of the 200th anniversary of Meriwether Lewis and William Clark's Corps of Discovery (1804–05). Antone Minthorn of the Confederated Tribes of the Umatilla Indian Reservation thought that Lin could find a sensitive solution to a potentially thorny problem. For most Native Americans, there was little to celebrate; Lewis and Clark brought conquest, greed, illness, and destruction. Minthorn and another elder, Chief Cliff Snider, a retired member of the Tribal Council of the Chinook Indian Nation, went to New York to tell Lin about the ecological changes to the Columbia River since the Corps of Discovery, the huge loss of species, and the current efforts at restoration.[4] These dramatic ecological changes coincided with Lin's interest in creating a monument to extinction. *Confluence Project* combines ecological restoration, native voices, and extracts from Lewis and Clark's detailed journals. Lin refers to those texts as an ecological "lens" providing an important marker of the environmental changes between then and now.

As Lewis and Clark moved west from St. Louis, they mapped, counted, identified, and enumerated everything that they saw. They documented flora, fauna, native villages and tribes, weather, and daily life. They called their record "a summary statement of the rivers, creeks, and most remarkable places from the mouth of the Missouri as high up the river as was explored in the year 1804 by Captains Lewis and Clark."

In the southwest corner of Washington State, near the rugged edge where the Columbia River joins the Pacific Ocean, Cape Disappointment marks the end of their journey and the first completed *Confluence Project* site. A boardwalk records Lewis and Clark's observations on cast concrete planks. Our relationship to those planks is quite different from our approach to the Vietnam Memorial, where the surfaces are vertical and easily read. At Cape Disappointment, we have to bend over to read, interrupting our progress toward the beach and the sea. That physical sense of interruption, like the destabilizing of our footing in *Listening Cone*, parallels Lin's point: as white explorers charted these lands, they interrupted the course of history and nature.

To restore balance, she worked with park administrators and landscape designers to open up the view and restore drainage, dunes, and native grasses. A trail through the restored landscape leads to a fish-cleaning station. Lin removed the previous metal sink and installed a functional basalt table, inscribed with the Chinook creation myth, which tells the story of cutting fish down the back instead of crossways, leading to the birth of the first humans. An ecological trail leads from the freshwater estuary to the ocean, explaining the changing landscape. Another path

marks the water's edge 200 years ago, its concrete planks incised with the text of the Chinook blessing ceremony used on November 18, 2005, 200 years after Lewis and Clark reached the same spot. The Amphitheater Trail, a path of crushed oyster shells, leads to the secluded Cedar Circle, where an irregular formation of cedar driftwood columns marks the Native American cardinal directions, inside, outside, up, down, and through.

At the Sandy River Delta in Troutdale, Oregon, Lewis and Clark identified the intersection of the Sandy River and the Columbia River as a major passageway and spent several days exploring it. Today, that main channel is blocked by a dam installed in the 1930s (supposedly to improve fish flow) that severely altered the ecosystem. Here, Lin worked with the Forest Service in its ongoing reforestation efforts and collaborated with the Army Corps of Engineers in its plans to remove the dam.

The Bird Blind, Lin's major structure at the site, is located on a patch of land that will be at the Sandy and Columbia River confluence, once the original river delta is restored. Raised on pilings so that flood waters can pass underneath, *The Bird Blind* is the opposite of its name. Lin has created the shelter with 12-foot-high fir slats placed so close together that visitors can barely see between them. Instead of looking out, we confront various texts on the slats: Lewis and Clark's precise journal entries name species, with the dates and places where they were sighted. Lin has added the fate of each species today, whether endangered, threatened, or extinct.

The *Vancouver Land Bridge* speaks to a different confluence. An interpretive trail in the Vancouver National Historic Reserve unites the Klickitat Trail with the bank of the Columbia River. For thousands of years, this trail was used by inland groups to trade with Columbia River tribes; it was broken in the early 19th century when the U.S. military took Fort Vancouver from the Hudson's Bay Company. The new, 40-foot-wide, earth-covered bridge, conceived by Lin

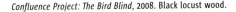

Confluence Project: The Bird Blind, 2008. Black locust wood.

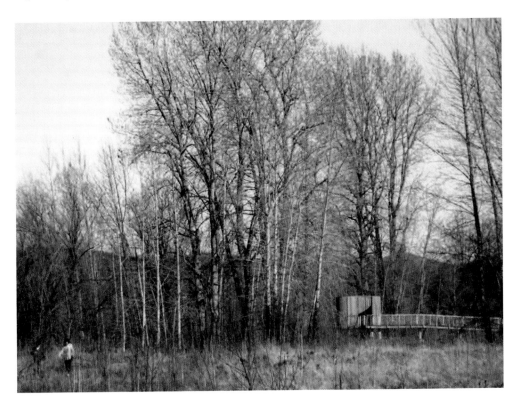

and designed by Native American architect Johnpaul Jones, a principal in the Seattle-based architecture and landscape architecture firm of Jones and Jones, "pull[s] the prairie up, over the highway, and back to the river." The structure, which spans a six-lane highway and train tracks, forms an implied circle, a tribal symbol that evokes life, gathering, communication, and exchange.[5] Wide borders of native plants refer to flora observed by Lewis and Clark and those used by the Indians: Oregon grape, camas, nootka rose, salmonberry, huckleberry, white oak, red cedar, and red alder. Native American artist Lillian Pitt created a Welcome Gate at the site; and on the bridge, two seating areas with cutouts of abstracted petroglyphs, also by Pitt, refer to the 12,000-year-old cultures of the Columbia Gorge.

At Sacajawea State Park, Lin collaborated with the Park Service to restore native plants, dunes, and habitat for salmon along the shorelines. While Lewis and Clark noted their one-day visit to this site in a single sentence, for many Indians, it had been an annual gathering place for thousands of years. This disparity of perspectives thematically anchors the entire *Confluence Project*. *Story Circles*, an "outdoor museum" set at the confluence of the Snake River and the Columbia River, leads around the shore and includes seven basalt circles incised with texts and images relating to the seasonal round of Native American rituals. The circles mark species of fish, plants, and animals, goods traded by the Indians, a tribal long house, and the natural abundance destroyed by dams. One circle commemorates the history and future of the tribes with a Coyote myth about the return of the salmon. Randomly exploring the circles, we move beyond linear thinking and open our minds to multiple dimensions of history, language, nature, and time.

The not yet completed Celilo (Wyam) "Place of Echoing Water upon Rocks" or "Sound of Water upon the Rocks" site at Celilo Falls Park commemorates a collision rather than a confluence. Prior to the arrival of settlers, Wyam Indians lived here for over 12,000 years in what was perhaps the longest continuously inhabited community in North America. They caught salmon in nets lowered from complex platforms suspended over the falls. But the falls were reduced to a silent lake by the John Day Dam, built between 1959 and 1968; and numerous other hydroelectric dams,

Johnpaul Jones, in consultation with Maya Lin, *Vancouver Land Bridge*, 2008. Concrete, decomposed granite/epoxy walkway, topsoil, stainless steel panes, and restored native plantings.

nuclear, agricultural, and industrial pollution, and clear-cut mountainsides have devastated the Columbia River, reducing the salmon harvest from 14 million in 1855 to fewer than 100,000 today.

On the weekend before Celilo's dedication, hundreds of Indians from all over the Northwest converged to grieve the loss of this cultural confluence. Lin played a minor role at the ceremony, as spiritual leaders, dancers, and singers invoked the sad history of the place. Lin's model for the Celilo Falls site is a cantilevered steel ramp that will rise 300 feet and hang 20 feet above the surface of the lake, where the falls used to be. Woven wood railings will evoke traditional basket weaving, and narrative texts on the ramp will tell the geological, historical, mythical, and political history of the site. Sound will also be part of the experience, with descriptions of the sound of the falls and the silence that followed. Wyam Indians, who have never left the site and today live in what is called Celilo Village, declare that the "falls have never left...they still echo in our heart."[6]

In spring 2011, the site at Chief Timothy Park near the confluence of the Clearwater and the Snake Rivers, was dedicated with an earthwork *Listening Circle*. Made of basalt incised with texts, it is integrated with a dramatic, unspoiled landscape, the least altered of the *Confluence* sites. It is a natural amphitheater or sky bowl, chosen in collaboration with the Nez Perce, who were pursued by the U.S. military through the just-created Yellowstone National Park all the way to Canada and then imprisoned at Fort Vancouver. But the Nez Perce survived, and Lin's project celebrates their continued presence. In addition to the earth circle, she has embedded a text documenting all of the flora noted by Lewis and Clark and planted a sea of blue Camas lilies to invoke their journal observations on the flower.

Confluence Project opens a dialogue between the environment and humanity framed by history and texts. In commemorating the Lewis and Clark mission by embedding their texts into the very land that they helped to damage and in dialogue with the cultures that were almost destroyed, Lin has once again enabled us to connect to a painful history in a constructive way. This is not really a commemoration, it is a conversation. Lin invites us to step from certainties to "thresholds," joining the past and present, Native and Western cultures, animals and people, water and land. At Frenchman's Bar, the final site, the main project will be to increase the wetlands and build an environmental research center, sponsored by Washington State University and the Port of Ridgefield, at the Ridgefield National Wildlife Refuge.

Both *Confluence Project* and *What is Missing?* testify to Lin's deep concern for the state of the planet. Ranging in perspective from ancient myths and rituals to the imagery and sounds of digital technology, these projects are not only intended as memorials, they also ask us to take action to save what is left.

Notes

1 See *Science*, June 18, 2010: pp. 1,437–1,598, for a conservative scientific account of the changing oceans.

2 Alexis Lathern, "Hydro-Quebec Seeks New U.S. Markets," *Z Magazine*, October 2010: p. 40.

3 Ahmed Djoghlaf, Executive Secretary of the U.N. Convention on Biological Diversity, stated, "The largest corporation in the world is not Ford or Walmart. The largest corporation in the world is nature. Quoted in Anne Petermann, "Biodiversity Convention Hijacked," *Z Magazine*, December 2010: p. 30.

4 Susan Platt, "Maya Lin's *Confluence Project*," *Sculpture*, November 2006, provides information about the genesis of the work.

5 There are plans for a "Treaty Table" on a new I-5 bridge crossing the Columbia River funded by percent for art. The Treaty Table will reference the Isaac Smith treaties of 1854, which "legalized" the taking of indigenous lands.

6 The Wyam never joined a tribal reservation and therefore have the status of an independent nation today. Recently, and in collaboration with efforts by nearby tribal groups, they have gotten new housing, sewage, streets, and a long house, promised many years ago. Their fishing rights have never changed. Their leaders invited Maya Lin to talk with them about what texts will be inscribed on the Celilo ramp.

Brandon Ballengée: Deviant Histories

by Glenn Harper

Brandon Ballengée's multi-disciplinary works develop from ecological fieldtrips and laboratory research conducted in collaboration with scientists, students, and members of the public. As Jens Hauser points out, Ballengée's melding of eco-art and bioart includes "the collecting and conservation of amphibians or other wetland species with deformities and malformations—or promoting the growth of such anomalies in controlled laboratory simulations...selective breeding and micro-surgery projects to intervene in natural developmental processes, the presentation of these animals either alive, or cleared and stained in a highly aestheticized fashion, or the colorful, oversized, and abstract, yet seemingly alive scanner photographs of the specimens' physiologies."[1] Ballengée, who is based in New York, has developed projects in the Americas, Australia, Asia, and Europe.

Ballengée says that his work was inspired by observing nature and its decline in suburban Ohio, where he grew up: "A nearby stream emptied into a marsh that was filled with mysterious life. I would spend hours...catching and drawing vividly colored salamanders, diverse species of fish...and other fantastic creatures. When I was a teenager, the largest forest trees were cut and sold to a lumber company. Today, half the forest is under a housing subdivision and

Left: *DFA 23, Khárôn*, 2001/07. Unique chromogenic print, 46.5 x 34.5 in. Right: Installation view of *Malamp: The Occurrence of Deformities in Amphibians*, installed as part of "Biological Agents," at Gallery 400, the University of Illinois at Chicago, 2008.

Above: *Love Motel for Insects: Lough Boora Variation*, 2010. Outdoor installation with black ultraviolet lights, wood, fabric, and invited insects, 2 x 30 meters. View of installation at Sculpture in the Parklands, Lough Boora, Ireland. Below: Installation view of "Praeter Naturam," at Parco Arte Vivente, Turin, Italy, 2010.

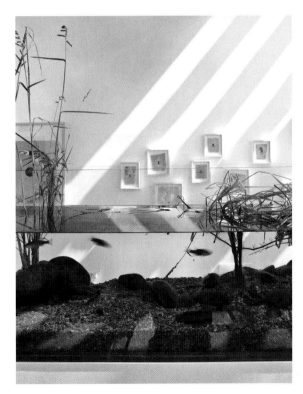

most of the stream runs through pipes."[2] His "early work dealt with this sense of loss...As this interest grew, I wanted to dig in deeper, so I began collaborating with biologists and participating in ecological surveys. This evolved into conducting primary biological research and the fusion of my art with these practices."[3]

Collecting specimens has become the heart of Ballengée's work. For "Hudson River Projects" at Wave Hill's Glyndor Gallery in 2003, he presented *Breathing Space for the Hudson: Charting the Biodiversity and Pollutants of the Hudson River*, a survey of the river's health in the form of fish tanks, each one representing a different section of the estuary—from salt to brackish to fresh water, along with aquatic life from each region. High-resolution digital prints of five uncommon underwater creatures scanned from specimens complemented an interactive element: viewers were encouraged to look up their homes on four suspended maps

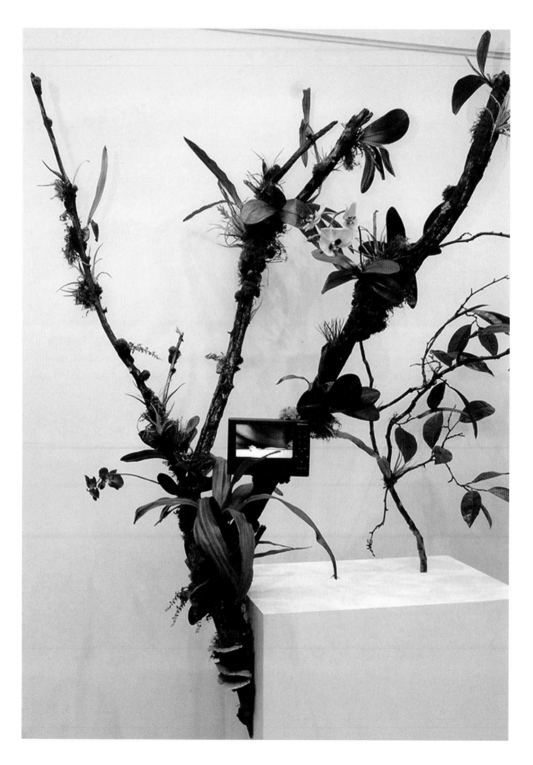

Tropical Cloud Forest Displacement, part of the ongoing series "Eco-Displacements," 2006/07. Mixed-media sculpture, natural history specimens and artifacts, and video by Valerie Druguet and David Rosane, 3 x 1 x 2.5 meters.

that identified sources of pollution along the river, from New York City to Troy. In an earlier work, *The Ever Changing Tide* (2001–02), Ballengée collaborated with scientists on the collection, identification, and documentation of the numerous aquatic organisms available for consumption at seafood markets in Flushing, New York. The research resulted in gallery exhibitions (at the Queens Museum and several natural history museums), as well as a multilingual installation in a local fish market showing fish species (many available in fish markets such as the one hosting the installation) in danger of extinction.

A significant portion of Ballengée's work deals with amphibians: "Since 1996, I have been focusing on the global decline of frog, toad, and salamander species and the increased numbers of deformities I find in their populations. Amphibians are a 'sentinel' species...About one-third of them are declining or already gone. A world that they cannot live in cannot support much else."[4] He considers his various projects dealing with amphibians as part of an overarching project called "Malamp," or the "Malformed Amphibian Project."

Several recent projects in England have continued the "Malamp" series, in addition to investigating other species. In 2007, in collaboration with The Arts Catalyst and SPACE (a London gallery), Ballengée and local ecologists conducted research and led a series of fieldtrips into the meadows and marshlands at Gunpowder Park in the Lea Valley, on the border between London and Essex. A study day, with urban ecologist Dusty Gedge and wildlife photographer David Cottridge, gave artists an opportunity to develop their ecological art practice and allowed environmentalists to engage with artists. Ballengée also used his residency in the park to delve into the reproductive cycle, with *Love Motels for Insects*. These sculptural works use ultra-violet light to study and photograph spiders, moths, beetles, and other nocturnal creatures. To accompany the installation, he organized an urban bug hunt that revealed the insect life of Hackney. (Ballengée's other habitat-sculptures include *Micro-habitat for Snakes*, created for the Geumgang Nature Art Biennale in 2004.) In the months following the on-site segments of the Gunpowder Park project, Ballengée worked with scientists to examine and document the collected specimens.

During the summers of 2007 and '08, at Yorkshire Sculpture Park, Ballengée collected samples from ponds and lakes to research rates of deformity and mutation in resident frogs, toads, and newts. In the summer of 2008, he set up a public bioart laboratory in YSP's Longside Gallery, inviting visitors to discuss the project and participate in his research. During both summers, he led school groups and visitors in collecting samples and conducting aquatic surveys. These U.K. projects, which resulted in the monograph, *Malamp: The Occurrence of Deformities in Amphibians*, also led to "The Case of the Deviant Toad," a 2010 exhibition at the Royal Institution of Great Britain, exploring issues of biodiversity and ecological change.

Ballengée's "Praeter Naturam," a 2010 exhibition at the Parco Arte Vivente in Turin, collected and summarized the results of his public actions and research at sites across Europe, Asia, and North America since 1996. This survey and other recent projects demonstrate that Ballengée continues, as Sara Feola says, "to explore the ever more urgent aspects of global climatic change and the ever growing influence of man upon the environment."[5]

Notes

1 Jens Hauser, "Sculpted by the Milieu—Frogs as Media," in *Brandon Ballengée: Praeter Naturam*, exhibition catalogue, (Turin, Italy: Parco Arte Vivente, 2010).

2 "Bio-art with Brandon Ballengée," in John K. Grande, *Dialogues in Diversity: Art from Marginal to Mainstream* (Grosseto, Italy: Pari Publishing, 2007).

3 Ibid.

4 Ibid.

5 Sara Feola, "Praeter Naturam," <http://www.curamagazine.com/en/?p=1408>.

Suspended in Time:
A Conversation with Yolanda Gutiérrez

by John K. Grande

Yolanda Gutiérrez creates ecological interventions using materials direct from nature. The precarious balance between life and death and the preservation of wildlife are major themes in her innovative work. In *Santuario*, she structured nesting sites that successfully drew migrating birds back to their native shores in the Xochimilco Ecological Zone of Mexico (1995). In 1995, a wildlife reservation on the island of Cozumel, off the coast of the Yucatán peninsula, hosted *Retoño*, another important habitat project. *Conviviendo con aves y mariposas* (2004) fits specially sized and crafted ceramic prostheses to trees in the Chajul Tropical Biology Station at the Mount Azules Biosphere Reserve, providing perches and feeders for local birds and butterflies. The duality between life and death has always been a significant theme in Mexican art and culture. In her objects, installations, and outdoor interventions, Gutiérrez brings a sharp, contemporary perspective to this age-old cycle.

Gotas Virgenes (Virgin Drops), 1995. Glass spheres and sterile water floating in a contaminated lake, dimensions variable. View of installation in Mexico City.

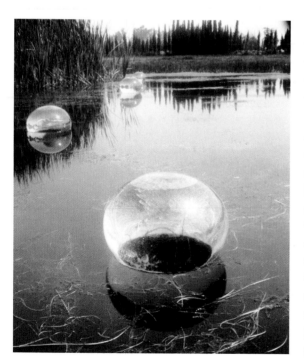

John K. Grande: Semilla de Artista *is a bronze cast of a seed. There can be something threatening in the way that nature protects itself, just like the forms in this sculpture.*

Yolanda Gutiérrez: For me, it is like the way that humanity has to learn to grow, to learn to understand our lives. To be an artist is to be very conscious of that. I think you have to suffer a bit. The seed is not protected. Instead, it is in an adverse environment, which is a metaphor for human suffering. In order to grow spiritually, one has to go through some pain.

JG: Gotas Virgenes (Virgin Drops) *consisted of glass spheres filled with chlorinated sterile water floating in a small, contaminated lake in Mexico City. Can you tell me about your intention?*

YG: This was one of my first ecological pieces, and I wanted to create a contrast between the clean, clear water in the spheres and the polluted water in the lake. I had 60 of those glass spheres floating on the lake, and I wanted to

address the question of whether the culture of nature, of which we are a part, is sacred.

JG: *The forms capture a feeling for the universe, using a simple element (water within and on top of the water), yet it is evident that the inspiration comes from the specific context of your culture.*

YG: Yes. These ideas are born out of ancient Aztec culture. The sources are not contemporary.

JG: *You draw on nature as a primary force, yet there is often a humanistic expression, for instance of life and death, in your work.*

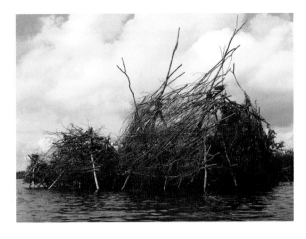

YG: And the relationship of man, nature, and god, because one of the first things I learned about nature is that it is a manifestation of god.

JG: *The early work* Santuario, *which you made in Mexico's Xochimilco Ecological Zone in 1995 with baskets, is both beautiful and practical.*

YG: Yes. These are sanctuaries for migrating ducks, so that they could nest within the sculpture.

JG: *Are these baskets used in agriculture?*

YG: They were for carrying the fruit of nopales (cactus), which are heavy and have needles. I worked with an ornithologist to find the best ways to make the nests agreeable for birds.

JG: Reina Madre *(1996) is a portable sculpture, a crown of thorns with an overtly religious message.*

YG: *Reina Madre* is about how we talk about nature and ecology. We talk, but in reality nothing happens. I used sea sponge and thorns from cacti. For me, the culture of nature and how we treat it is like the way Christ was treated when he received the Crown of Thorns. In other words, maltreated until it is dead.

Above: *Retoño*, 1995. Branches, leaves, and organic materials, 150 x 2 x 6 meters. View of marine bird habitat created in Cozumel, Colombia. Below: *The Hunter's Powers*, 2008. Wood and paint, 20 x 15 ft.

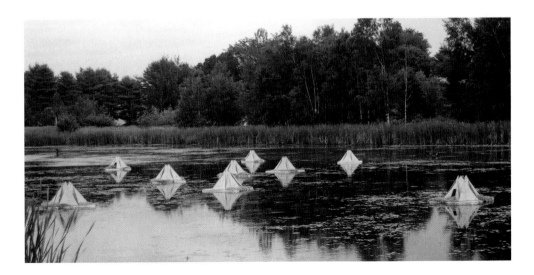

JG: *Tell me about* Retoño *(1995), your floating habitat project in the Cozumel lagoon.*

YG: *Retoño* was designed for seabirds. The egrets who nest on Cozumel are not in danger of extinction, but they are threatened. I made a 150-square-meter structure of tree branches. A lot of large egrets and other bird species have lived in that sculptural space—around 200 birds, including 14 different species.

JG: *Is it still there?*

YG: It lasted for about three years because it was in the water.

JG: *You created an organic, somewhat decorative design for* Esîimulo *(1995). After you made the initial design, you let nature and the birds work on and around it. This is an interactive nature sculpture that uses the participation of the birds themselves for its ongoing transformation.*

YG: I made *Esîimulo* in Playa del Carmen, in an island park just for birds. It has an area for flamingos, and I made nests for them, mixing sand, water, and shells with other strengthening materials. I put all of these things around the nests to stimulate the birds to use these materials in

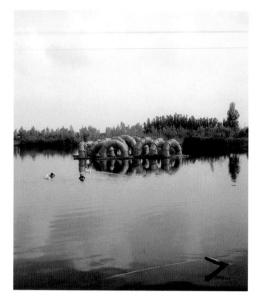

Santuario, 1995. Cane baskets, 1.5 x 14 x 8 meters. View of migratory bird sanctuary created at the Xochimilco Ecological Zone in Mexico.

the fabrication of their nests.

JG: *Have you been influenced by any earlier artists?*

YG: My work has no relation with modern artists in general, but I appreciate Andy Goldsworthy's sculpture. Ancient culture and mythology are my inspiration.

JG: *Your work reflects the bioregional history of the place where you make it.*

YG: I collect materials in the places where I live or where I travel to work, because then the people who see the exhibition automatically connect to it. In general, my materials have an emotional, psychological, and cultural charge, and that is how I try to create the metaphors for the work. For example, in *De noche un viento frio las trajo (At night a cold wind brought them)*, I have a special process with leaves and compose these elements to be like skeletons of butterflies. I use nails and cactus spikes as well. Following ancient Mexican culture, the white butterflies are spirits of the dead, those who come to visit us on the Day of the Dead on November 1.

JG: *You recently installed an ephemeral intervention at the Royal Botanical Gardens in Canada (2008) that communicated between the earth and the sky with a tree serving as spiritual conductor. Can you explain this work?*

YG: The point is the tree, a 150-year-old pin oak. I want people to remember what the tree means to human culture. For many ancient peoples, including the Aztecs in Mexico and the Iroquois in Ontario, the tree is the connection between earth and sky. Imagine the tree as a conduit through which energy spirals up from earth and down from the sky. The Iroquois would carve a mask or face in the tree and perform ritual dances around it to bring it energy. In this installation, the spiral patterns of energy in the ground involve complimentary opposites, always in movement. The earth rows follow the outer lines of the spiral designs and include healing plants—sweet grass, tobacco, and sage.

JG: *Your work embodies a personal world view. Is making sculpture a kind of journey for you?*

YG: Yes. There is a moment in choral singing when you cannot listen: it happens when all the voices are in the same vibration. Art can be the same. There is a moment when art achieves a resonance and synchronicity.

Trans-Species Art:
A Conversation with Lynne Hull

by Robert Preece

Lynne Hull specializes in sculpture that doubles as wildlife habitat. She has made safe roosts for raptors in Wyoming, butterfly hibernation sculptures in Montana, salmon-spawning pools in Ireland, and nesting sites for wild ducks and geese in the Grizedale Forest Sculpture Park in England. Carved hydroglyphs capture water for desert wildlife, and floating art islands offer an inviting habitat for all sorts of aquatic species, from turtles and frogs to ducks and herons, to songbirds, swallows, and insects. For over 35 years, Hull's mixed-media work has focused on ecological realities in the American West and at sites around the world. Her "clients" include hawks, eagles, bats, beavers, spider monkeys, and migratory birds traveling from Canada to Latin America, but she pays attention to even the smallest creatures. For instance, in 1993, she made perches for frogs, toads, and newts who were having trouble climbing out of an abandoned swimming pool. She placed rocks for shelter and basking, planted aquatic vegetation, created a driftwood island, and wittily titled this new world *The Uglies Lovely*.

Scatter, 1987. Carved sandstone, 48 x 36 x 3 in.

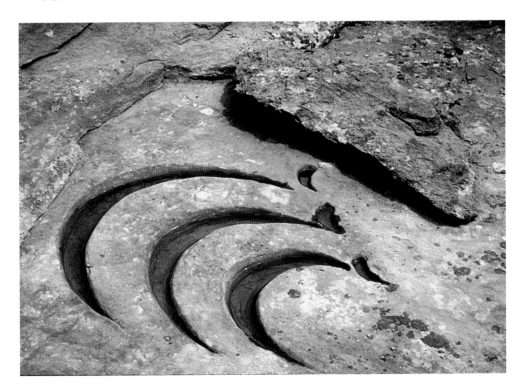

Hull has worked with a number of agencies over the course of her career, including state wildlife departments, the Forest Service, the Bureau of Land Management, and the National Park Service. She has completed projects in 14 states and eight countries. *The Exiled Oxbow* (1995–97), created in collaboration with the Salina, Kansas, Parks Department, the Arts and Humanities Commission, and the Land Institute, features native prairie and wetlands restoration along a bend in the Smoky Hill River, where the river was cut off from the main channel by massive flood dikes. In 2008, she finished *East Drake Pondworks*, a public art commission featuring 16 sculptures in the city of Fort Collins, Colorado, north of Denver, where she lives and works.

Robert Preece: *What inspired you to make art focused on wildlife?*

Lynne Hull: I suppose it was from living so long in Wyoming. I lived there on and off for 30 years. Wildlife species are very visible there, but the traditional audience for contemporary art — humans — is very small. That's how I developed "trans-species art."

RP: *What keeps you coming back to art focused on environmental concerns?*

LH: I am convinced that the loss of biodiversity is the most important survival challenge that we face as a species. And I believe that artistic creativity can be applied to real world problems and have an effect on urgent social and environmental issues. I am increasingly aware that, in order to survive, other species need a change in human values and attitudes. I hope that my work offers models for more equitable solutions.

RP: *Have there been practical challenges over the years?*

LH: Absolutely. Those challenges include funding, getting permission to do the work on site, and finding collaborators or consultants to advise on wildlife in the area. Working in certain countries at certain times has also been tricky. For

Duck Island, 1998. Recycled wood and mixed media, approximately 12 x 18 x 8 ft.

example, I've had concerns about my personal safety at particular times in Kenya, Colombia, and Northern Ireland (in 1993–94).

RP: *Scatter (1987) combines art and water in the form of a hydroglyph. What was required to organize and complete this work?*

LH: The main issues were finding the right site and getting the property owner's permission. Also, I was down on my knees hand-carving in hot desert situations for days at a time. When I want to make a hydroglyph on public land, I have to get an environmental impact approval to do the work—another type of challenge.

RP: *What kinds of animals visit these works—and when?*

LH: It depends on the piece. Small mammals and rodents visit *Scatter* at night, and birds visit during the day. I once found mouse droppings around the edges of a hydroglyph called *Deer Ledge Hydroglyph* (1987), and an owl had built a nest in a crevice nearby. I like setting up life webs, where different species support and interact with each other.

RP: *What were you considering in terms of function and form when developing* Raptor Roost L-2 *(1998) and* Lightning Raptor Roost *(1990)?*

LH: For the roosts, I consulted with

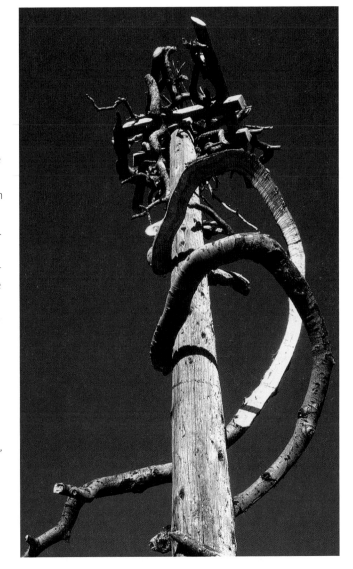

Twist (detail), 1993. Wood, 30 ft. high.

raptor biologists who understand the specifications that the birds seem to need or accept. Then, I worked out the aesthetics within those parameters. My background as a potter contributed to this approach. For example, a teapot has to hold hot water, have a handle so you don't burn your hand, and a spout that pours and doesn't drip. Similarly, birds have certain needs, like the size and height of the nesting platform necessary for the specific nest to fit. If the elements are too big or too small, certain birds won't use the sculpture.

I often build a model and experiment with the shapes until they look right to me. *Lightning raptor roost* was inspired by lightning strikes, which are a dominant element in that landscape. *Raptor Roost L-2* was inspired by found objects from a deserted homestead, and the colors came from the landscape.

RP: *What about the functions of* Duck Island *(1998)?*

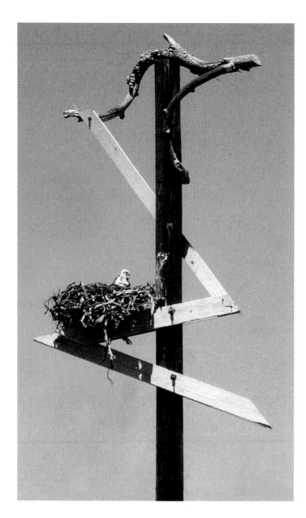

Lightning Raptor Roost, 1990. Wood, metals, and latex skin, 20 ft. high.

LH: As with the other works, the function sets the brief. In this case, the sculpture has to float, and the more levels that it occupies — above and below water — the greater the number of species that can find a niche to use it.

RP: *Was working on* East Drake Pondworks, *which is a larger and more formal public art project, a different experience for you?*

LH: It was a very different experience. I was able to work with materials that I hadn't used before, like concrete, metal, and water infrastructure. I also worked with several subcontractors.

RP: *What are some newer projects?*

LH: I'm currently working with Yolanda Gutiérrez in Mexico and Patricia Lara in Colombia. We call ourselves "3 Artistas." We want to construct "Migration Mileposts," linking communities in the hemisphere that share migratory birds through a variety of conservation and awareness-raising projects in each country. With the economy, we're facing challenges like many others, but we're hopeful.

RP: *Have you been able to widen your influence?*

LH: The Internet has changed things a lot. Communication is a lot easier; for example, I've been talking with interested people in Mongolia. I'm thinking about becoming more available on-line for talks and offering more on-line presentations and tutorials, in addition to making trips. It's about getting the ideas and the work out there. If this inspires a new generation to take my ideas further into their own environments, then that's great.

RP: *There's a certain quality in your work that touches the heart.*

LH: It's totally been about heart and soul. Of course, you have to be very analytical, in addition to working with aesthetics. But I've come to think of my sculptures as eco-atonement for the loss of wildlife that humans have caused. This is my art, but it's also spiritual work. This is what I contribute.

Equal Opportunity Housing

by Elizabeth Lynch

As humans claim more of the natural world, artists and designers are seeking new ways to provide or preserve habitat for increasingly encroached-on animals. Sponsored by a wide range of organizations supporting public art, conservation, and tourism, these projects supply homes for animals while attending to human aesthetic concerns. Perhaps because people have little problem sharing space with birds, birdhouses have become a popular entry point to art for animals, and that familiarity has also extended to bat houses. Artists have created a myriad of interesting solutions in a variety of different settings. For example, in *Quarry Rings* (2010), which was commissioned by the Seattle Office of Arts and Cultural Affairs, Adam Kuby reclaims an old gravel quarry to create nesting spaces. Drawing on a background in landscape architecture, urban forestry, and zoo design, Kuby raised five ring-shaped gabion cages on steel columns, each one filled with stones that leave space for strategically placed plastic boxes. These containers are accessible via species-specific entryways — cylinders for swallows, open "shelves" for other nesting birds, and long, rectangular slots for bats.

Gitta Gschwendtner, *Animal Wall*, 2009. Woodcrete, approximately 52 x 4 meters.

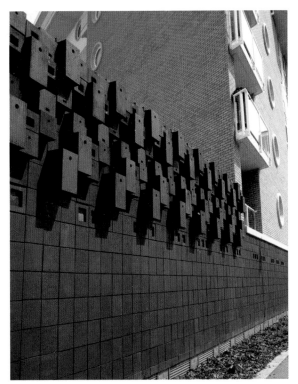

Thomas Sayre, who often uses earthcast concrete in his work, has discovered that this material also lends itself to building housing for creatures. In 2003, he completed *Nest* for a private residence in Staunton, Virginia. The 16-foot-tall, beehive-shaped structure is surrounded by native plants and grasses. Small, round openings break its smooth, stepped surface, welcoming birds and insects. *Phuket Cheddi*, a similar but more dramatic work (it rises 50 feet) in Phuket, Thailand, is punctuated by more than 2,000 empty bottles that Sayre cast into the concrete to allow birds and bugs safe passage. The Meadowsweet Dairy sculpture collaborative also used concrete in their *For the Birds* on Southeast Farallon Island, off the California coast. Like Kuby's work, the mound of reused concrete rubble contains subtle entranceways leading to inset birdhouses.

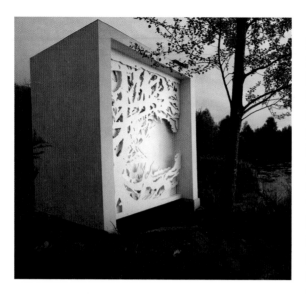

Jorgen Tandberg and Yo Murata, *Berkeley Bat House*, 2009. Wood, hemcrete, and lime render, 4 meters high.

Gitta Gschwendtner's austere *Animal Wall* (2009) complements a human housing development in Cardiff, Wales, by providing shelter for displaced wildlife on a large scale. Located between a private community and public riverside, her 50-foot-long structure provides approximately 1,000 nest boxes for birds and bats, balancing the 1,000 new human habitations. Its site at Century Wharf, a gated community, convinced Gschwendtner to respond to "the natural habitat in Cardiff Bay, [which] has been greatly diminished following extensive development in recent years. My approach... is to reintroduce some wildlife back into the area." Gschwendtner, whose background is in design, fabricated the wall from woodcrete, "a mixture of cement and wood fiber...[that] is much lighter than concrete and has great insulation properties." The wall incorporates four differently sized animal houses, developed in consultation with a local ecologist. The clustered boxes begin at a height of about three meters above the ground, "ensur[ing] that [the animals] will have the least amount of disturbance during nesting."

Two recent projects designed specifically for bats, Jorgen Tandberg and Yo Murata's *Berkeley Bat House* (2009) and Joyce Hwang and Ants of the Prairie's *Bat Tower* (2010), were created for relatively quiet areas—the Wildfowl and Wetlands Trust's (WWT) London Wetland Centre (an urban wildlife sanctuary) and Griffis Sculpture Park in East Otto, New York. Both houses provide optimal nesting boxes incorporated into stark geometric forms that stand out against the surrounding landscapes. While *Bat Tower* features zigzagging angles and an open, slatted form, *Berkeley Bat House*'s cube-shaped structure frames a series of layered plywood panels cut in organic designs reminiscent of tree branches and foliage—the panels create roosting places for bats and add visual drama for humans. As Tandberg explains, it also highlights the artifice of its natural environment: "The Wetland Centre is a layered space—a completely artificial nature built over the course of a few years, and every slope and hill...is carefully planned. The bat house, shaped as a picture in a frame, exists then within a picture in a frame, as layers of nature and artifice."

The *Berkeley Bat House*, supported by WWT, Arts Council England, the Bat Conservation Trust, the Mayor of London, Plus Equals, and the RSA Arts & Ecology Centre and sponsored by the Berkeley Group, began as a competition initiated by artist Jeremy Deller. Tandberg and Murata, who were architecture students at London's Architectural Association, had no experience designing homes for animals when they discovered the brief on-line. When their proposal won, Tandberg took a year off from school, consulting with "bat experts, ecological consultants, and sustainability experts" who contributed design elements such as a black roofing surface that draws heat and keeps the interior at a constant, bat-friendly temperature. The large, empty interior allows for maintenance, and additional vertical and horizontal panels provide bat dwelling zones. The walls are made of hemcrete, a wood and concrete mixture similar to the woodcrete that Gschwendtner used in her work, with ideal insulating properties; it also binds CO_2.

Other habitat projects address larger problems of a shared environment, attempting to counter the destruction caused by human behavior. The recent ARC International Wildlife Crossing Infrastructure Design competition spurred

interesting, and most importantly, practical, proposals for allowing animals safe passage through territories divided by high-speed roads. In the brief, which focused on the I-70 corridor in West Vail Pass, Colorado, ARC stressed the importance of feasibility and ecological responsiveness. The brief featured images of bears, deer, and foxes attempting to cross highways and rural roads, as well as a model, a highway overpass in Banff that caters to animals instead of cars by providing a wide, green pathway connecting the two sides.

The winning design, a collaboration between designers MVVA, led by Michael Van Valkenburgh, and builders HNTB, builds on the basic concept of the Banff crossing, adding attractive fencing to channel animals away from the roads and species-specific pathways that allow them to travel safely through their preferred environment (forest, meadow, shrub edge, and scree). These specially planted "habitat corridors" permit animals to move almost exclusively within their native niche habitat—hoofed animals retain the clear view that they need, and small creatures remain sheltered by trees or grasses—with no need to veer outside their comfort zones. The team devised their innovative proposal out of common materials and stressed that the design would be affordable, giving commissioners one more reason to fund the large-scale project.

Engineering an extensive abode for creatures in a completely different habitat, Jason deCaires Taylor's work combines habitat reclamation, aesthetic invention, and human approachability. An artist and scuba diver whose travels

Michael Van Valkenburg Associates and HNTB engineering, *hypar-nature*, 2010. Rendering for the ARC Wildlife Crossing Competition.

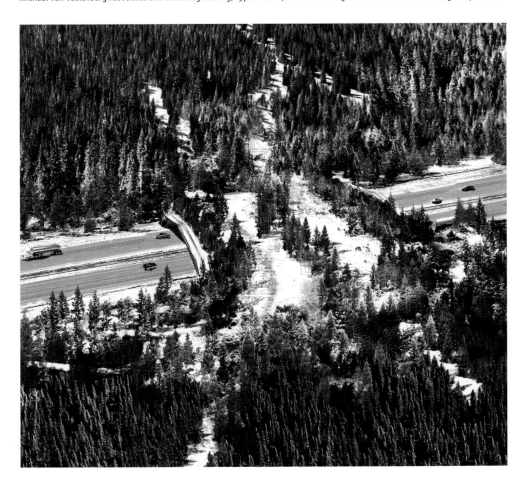

Jason deCaires Taylor, *The Silent Evolution*, 2009–10. Cement, sand, microsilica, fiberglass, and live coral, 400 life-size figures. View of installation in the National Marine Park of Cancún, Isla Mujeres, and Punta Nizuc, Mexico.

and time spent below the water's surface have bolstered his concern for ocean habitats, he creates sculptural forms for the ocean floor. *The Silent Evolution* (2009–10), an arrangement of 400 life-size human figures created from a mixture of cement, sand, microsilica, and fiberglass, provides an ideal foundation for an artificial coral reef. Humans are welcome to dive and observe the undersea works. As coral slowly colonizes the sculptures, recognizable figures set in familiar tableaux transform into increasingly mysterious, abstract, and amorphous shapes. Often placed in areas that have been damaged by storms or human activity, deCaires Taylor's reefs provide positive human intervention and a way for native underwater life to take root.

As these projects demonstrate, artists have taken a keen interest in sheltering familiar and accepted animals, as well as less beloved species. Housing projects can also lead to more ambitious endeavors, such as ARC's efforts to solve broader problems of shared space. By educating, building awareness, and provoking people to action, these works raise the question of what other threatened animals and ecosystems could benefit from artists' intervention.

Presidio Habitats: A Model Art and Wildlife Collaboration

by Maria Porges

A multi-part, site-specific sculpture installation in a national park? As improbable as this sounds, such an exhibition was on view in the Presidio of San Francisco from May 2010 through fall 2011. Eleven works, placed in carefully chosen locations, were created to support or encourage animal and bird species currently or formerly living in the park. Thirteen additional project proposals were housed in a handsome, light-filled temporary pavilion (made from reclaimed shipping containers) designed to introduce this ambitious endeavor to visitors.

Ai Weiwei, *Western Screech Owl Habitats*, 2010. Porcelain vessels, 16.5 x 12 x 8.5 in.

Participants included internationally acclaimed sculptors Mark Dion, Ai Weiwei, and Fritz Haeg, as well as the celebrated landscape architect Walter Hood; important San Francisco conceptual/social practice artists such as Amy Franceschini, Mark Thompson, Nathan Lynch, and Rigo 23; and several innovative architects and designers, among them Philippe Becker Design, Chadwick Studio, and CEBRA.

The Presidio—a former army base—is now a National Historic Landmark District and part of the largest urban national park in the U.S., a group of sites known collectively as the Golden Gate National Recreation Area. As the name, *el presidio*, suggests, the site was first established as a Spanish military outpost nearly two and a half centuries ago. The Spanish fort displaced the Native American Ohlone people who had been living in this strategic spot near the mouth of the San Francisco Bay since the 1200s.

Throughout the period of its human occupation, the Presidio has provided a refuge for a wide variety of plant and animal communities. This safe haven is now assured: 1,000 acres of cypress and eucalyptus groves, coastal wetlands, and vast open meadows are protected under the Park Service's rigorous stewardship. But the Presidio also remains a place where people live and work. Since the last military personnel left in 1994, many of their residences have been rented out to a new generation of families, the massive barracks and offices leased to businesses,

foundations, and a museum. As in every national park, each proposed alteration, whether to landscape or buildings, is evaluated for possible effects on the site's historical character (in this case, several World War II bunkers and centuries-old archaeological sites) and, just as importantly, its natural environment.

Even temporary placement of sculpture in such a highly regulated place presents potentially daunting obstacles. Extensive requirements had to be met, and much of the installation was done by hand, without heavy machinery, while maintaining a proper distance from existing habitats; work had to be completed during the few months when it could be done without disturbing animals or plants.* "Presidio Habitats" owes its successful launch to the vision, patience, and persistence of For-Site Foundation executive director Cheryl Haines, working in partnership with the Presidio Trust, which was founded by Congress in 1996 as part of a management and funding model unique among national parks. The timing of such a project—asking artists, architects, and designers to imagine outside-the-box habitats for the park's nonhuman inhabitants—seemed uncannily perfect. Both the realized projects and the proposals suggest the kind of relationship that all of us should aspire to have with the islands of the natural world that remain within urban sprawl. These innovative habitats suggest that, one at a time, a diaspora of displaced birds and animals can (and should) be made to feel at home.

Ai Weiwei's blue and white porcelain nest-containers for the Western screech owl provide palatial Ming Dynasty-style digs for these small birds. Several handsome drum-like forms were strapped to the branches of an immense cypress tree near the former residence of the general in charge of the base. Though screech owls have not been seen in the Presidio for some 10 years, they might return, or perhaps, some other species will find these lofty homes attractive. (If any of these designer habitats is occupied at the end of the temporary installation period, the park service will leave it in place.)

Mark Dion with Nitin Jayaswal, *Winged Defense*, 2010. Reclaimed Presidio siding material (cypress), reclaimed Presidio terra-cotta roof tiles, plywood, and steel, 4 x 5 x 3 ft. on a 20-ft.-high pole.

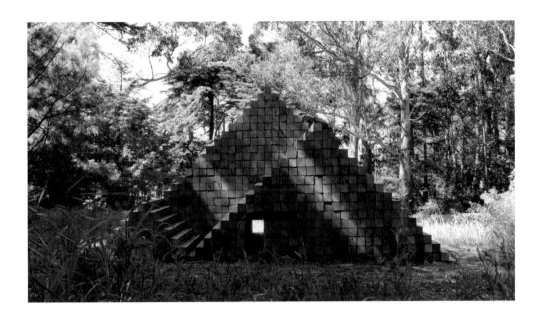

CEBRA, *Sculpture Habitat for the Gray Fox*, 2010. 350 stacked, interlocking, surplus Presidio cypress wood components, 10 x 20 x 6 ft.

Just downhill from the general's house, *Winged Defense*, by Mark Dion with Nitin Jayaswal, acknowledges bats as human protectors, eating mosquitoes before they eat us. The white walls and tile roof of this tiny house perched high on a pole mimic characteristics of the nearby army buildings. The interior—filled with vertical slabs of plywood—offers the kind of hang-out preferred by bats. It seems "move-in ready," as real estate agents like to say, attractively sited in a lush green gully framed with picturesque WPA stonework walls.

Other pieces, such as Nathan Lynch's proposed re-staging of the fabled race between tortoise and hare, are only conceptually connected to the idea of providing a home. Designed to entice the blackleg jackrabbit back to the Presidio by appealing to the animal's (supposed) vanity, Lynch's proposal offers wonderfully elaborate start and finish gates. Its mordant wit—involving a proposed media campaign—gives it a kind of stinging incisiveness missing from the habitat works. Sweeter, but equally compelling, Amy Franceschini's proposal for a series of events called *Night School at the Wildlife Refuge* honors the memory of the now extinct xerces blue butterfly, last seen in an empty lot in the Presidio in 1949. Franceschini envisions participants sitting around a fire in a recently completed group campsite in the park, engaging in conversation and then spending the night in specially designed sleeping bags that hang from tree branches like the pupae of butterflies.

Response to "Presidio Habitats" was enthusiastic, with many visitors taking the time to seek out each piece and savor it for themselves. It will be interesting to see if any of the homes become occupied—and if this fascinating project will inspire other visionary site-specific sculpture installations in parks around the country—projects that are, as Haines says, equally "for the place, and of the place."

Notes

* It is ironic, perhaps, that the vegetation covering these verdant acres is largely the result of human intervention. Like San Francisco's Golden Gate Park, the Presidio once consisted of sand dunes. Its handsome forests were planted by the army, since the Spanish had cut down most of the native trees. It is the resulting mix of introduced and indigenous species that the park service strives to protect.

Fritz Haeg's Alternative Possibilities

by Marty Carlock

Fritz Haeg doesn't like to make conventional objects. He is a mover and shaker who parachutes into a locale and shows people what's possible: "Working with local people, I'm a catalyst for something to happen." He admits that his role isn't clear. "What is art? What is an artist, a designer? I have no idea. I'm thinking about how people occupy the land. How do I live here?"

Visitors to the 2008 Whitney Biennial encountered some of Haeg's more object-oriented work in *Animal Estates Regional Model Homes 1.0: New York, New York*, a multi-part series of events and installations in the sculpture court and on the exterior of the museum. Like much of his work, it grew out of the site: "The question is," he says, "what can happen here that can't happen anywhere else? What is possible here at this moment?" At the Whitney, he built 12 homes for animals who lived on Manhattan Island 400 years ago and are unlikely to return any time soon—a huge, twiggy eagle's nest over the entrance canopy, a barn owl box looking like a mini-Whitney, and a stylized beaver dam and lodge in the courtyard. "The point is to acknowledge what was there," he explains. As a follow-up, Haeg and 18 students built 18 birdhouses for tree swallows and American kestrels at the Massachusetts Institute of Technology's Center for Advanced Visual Studies, using plans from the Minnesota Department of Natural Resources.

Animal Estates Regional Model Homes 1.0: New York, New York, 2008. View of beaver pond and lodge at the Whitney Biennial.

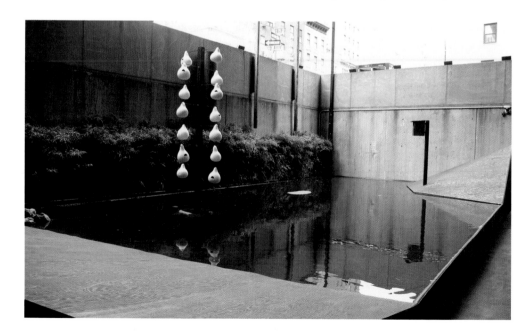

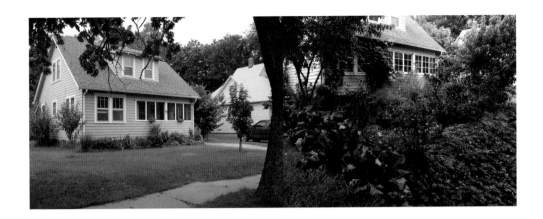

Edible Estates Regional Prototype Garden #1: Salina, Kansas, 2005. Before and after views.

Initially, Haeg's work might seem identical to projects produced by a Cub Scout troop. In fact, he seldom creates anything that, on the surface, looks unusual. (His architecture is something else again.) For instance, photographs of his *Edible Estates* depict lush gardens in front of ordinary houses, but the story of how those gardens came to be there is unique. Haeg chose residences in Levittown-type settings, where every house has a tidy, uniform front yard. Finding enthusiastic householders, he designed one-of-a kind vegetable gardens, recruited volunteers to help plant them, and raised funds for topsoil and plants. It became a community happening, with the bonus of food for the residents. "After the [2004] election," he explains, "I got hung up on the Red State/Blue State thing. I started wondering, what kind of project could I do that could be viewed and discussed by an art critic in New York, a friend in L.A., my aunt in New Jersey, and somebody in Nebraska, and they would all get it. I realized that the space of the front lawn cuts across every barrier. Almost everybody has one. This space is so charged with symbolism and so terrible. Cities are engineered for isolation on every single level. They prize as little eccentricity as possible, as much control as possible. How can we re-introduce evidence of how our urban lives are made possible? Where do our resources come from, where does our junk go? In this case, I wanted to create a place for people and plants to have communion."

In part, Haeg envisioned *Edible Estates* as a makeover, a way to take back the hostile no-man's land of the suburban front lawn. "People are ready for alternatives and eager to question these archaic traditions," he says. "The land where you live can be a public declaration about who you are and what you believe in." The first *Edible Estate* was planted in Salina, Kansas, in July 2005. It was followed by another in Lakewood, California: "I wanted to make it very decorative, so I designed spiral-shaped beds. They also became a kind of urban wildlife refuge. You'd be walking down the street past dried-up front lawns and see a little cloud of hummingbirds, butterflies, and bees."

The Internet produced volunteers to install the beds and the plants. Haeg likens the process to barn-raising: "Everywhere we did this, kids showed up wanting to dig. They would ask, 'Can we plant a tree?' The kids take owner-ship of these gardens." Other gardens have been planted in front of council housing estates, commissioned by Tate Modern, and at an apartment complex in Austin, Texas, commissioned by the Arthouse. In these locations, Haeg says, the garden creates a sense of connection with the land that did not exist before.

In some cases, communities have objected to the departure from uniformity. Speaking of one project, Haeg recounted, "One neighbor hated this garden, absolutely hated it. Every time a bird or a squirrel showed up, she'd complain to the owner, 'You're attracting wild animals.'" But the homeowners themselves, and many of the neighbors, love the gardens. With the vegetable garden in the front yard instead of in the back, passersby stop to chat as the gardeners work, recalling the community spirit and interaction once generated by the front porch.

Building community is at the core of Haeg's work. A native of Minnesota, he studied architecture at the Istituto Universitario di Architettura di Venezia and at Carnegie Mellon, lived in New York, and then moved to Los Angeles. He has taught at Parsons School of Design, the USC School of Architecture, and Art Center College of Design. In Los Angeles, he bought a geodesic dome on a hillside, renovated the interior, and installed extensive gardens. He realized that his house seemed isolated: "I didn't know anybody, and after New York, where everybody lives so close, I didn't know what to do. There's a feeling that if you're a serious artist, you should be alone in your studio. Social activity can often be dismissed as superficial."

Haeg started hosting *Sunset Salons*, themed gatherings open to all comers, recruited by his postings on the Internet: "In practicing architecture, you sit and wait until somebody comes along with money and allows you to build—or in art, to show. I decided to create my own opportunities." Haeg's salons were usually all-day events. There was an all-day knitting session—"people all over the house, knitting, teaching other people to knit." Local performance troupe My Barbarian wrote and performed *Nightmarathon Hextravaganza*, a six-hour morality play. There was a literary salon, when people read from their works, then split up and wrote on their own. Unlike ordinary, invitation-only parlor salons for artists and literati, Haeg's events are open to anyone and gather people who don't know each other beforehand: "I don't know if this would have been possible without the Web site. On the Internet, you can find a community of people of like mind." The salons became so popular that Haeg decided not to post notice of them until the day before, "so things wouldn't get too crazy. I would have 100 people at my house. These events galvanized the sense of community."

In Los Angeles, Haeg began growing his own food: "Hosting events, teaching, and gardening replaced the more conventional art activities that I had pursued in New York." *Edible Estates* and *Animal Estates* both developed from this new attitude. In 2006, the salons transformed into a more formal series of education-based initiatives known as *Sundown Schoolhouse*. The first season included nine students meeting for a 12-hour day once a week for 12 weeks

Edible Estates Regional Prototype Garden #4: London, England, 2007. View of installation in London.

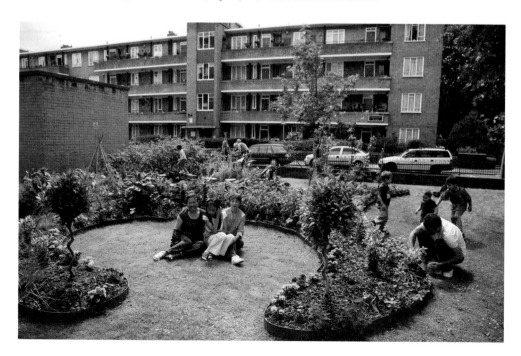

Edible Estates #7: Descanso Public Demonstration Garden, 2008. View of installation in La Cañada Flintridge, California.

to focus on the theme "Tobeapart." Haeg says that it was about "how to maintain your identity and be a whole individual while also becoming part of something bigger. For the first two hours, we didn't speak. It was entirely non-verbal—movement, dance, yoga. We got to know each other physically by sharing space." The season ended with "the students taking a 12-hour bicycle tour around Los Angeles while wearing red capes designed for the occasion by Andrea Zittel."

His events, Haeg says, come from "a desire to understand the role of art. What does it mean to make art today? You expect to have sacred experiences in churches, or in art museums, profound experiences. I'm suspicious about the forces around those places of power. I have the salons to demonstrate that religious places and museums aren't the only places for profound experiences, they can also happen at home and among friends."

After 10 years of teaching in colleges, Haeg has realized that a lot of formal education is "highly isolating." He says, "You go into the classroom, and you think that's where learning happens; and then you leave and the implied message is that learning stops now. I'm interested in the time in between, what most people think of as 'junk time'— cooking, cleaning, shopping—the modest activities of daily life when some of our most meaningful revelations happen." Haeg's goal is to show people alternate possibilities: "All you need is that door into another way of doing things."

As a long-term project, he envisions a capitalist commune: "I'm interested in failed utopias, why they didn't work. This one would recognize that we live in a capitalist society, but we can take from it what we want. We would all own our own land, but we would grow our food together." Haeg is direct about his skill at promoting his ideas, saying, "I have to develop an identity for a project. I hate the terms 'branding' and 'marketing,' but language is powerful; if you give something a brand name, it has legitimacy."

He adds, "I'm in the art world right now because there's no other place for what I do. It's one of the only places in society that doesn't demand an economic return. Projects can fail, do fail. That's part of the story. I dislike art that tries to solve social problems. I'm interested in revealing stories about how we're living today, in making work about it. It doesn't mean you solve it or change it. I'm bearing witness. It's being an honest voice for what you see around you. I don't make art about things. I make art that totally *is* the thing."

Bob Bingham: Building Environment

by Glenn Harper

Bob Bingham often works collaboratively on projects that incorporate live plants with natural materials and mechanical and electronic devices. His projects address issues of sustainability and examine the interconnections of the natural and the built environment.

Bingham's work evolved from "green" mixed-media installations in the public realm, leading to projects like *Urban Semi-Wilderness Area* (1994–98) and *Nine Mile Run* (1997–2000). *Urban Semi-Wilderness Area*, a site-specific installation in Pittsburgh's Mellon Park, transformed two acres into a semi-wild plot, bounded by a group of birch trees dedicated by members of the community and marked with plaques. The main gesture of the project was an agreement with the city's Parks Department that the designated area would not be mowed, which allowed the two acres to evolve into a natural habitat. According to Bingham, the biodiversity within the project more than doubled over four years. Three faux-marble passageways, adorned with morning glory vines, led viewers from existing sidewalks through the wild area to a formal garden (part of the original park), a scenic overlook with an informational sign, and benches in a wildflower garden.

Nine Mile Run was much more ambitious. A collaborative effort joining artists, engineers, scientists, historians, and planners (including Tim Collins, Reiko Goto, and John Stephen, Joel Tarr, and David Lewis, among others), *Nine Mile Run*, based

Urban Semi-Wilderness Area, 1994–98. 2 views of site-specific installation in Mellon Park, Pittsburgh.

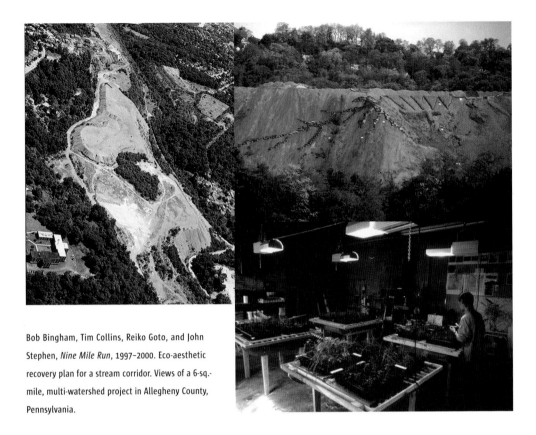

Bob Bingham, Tim Collins, Reiko Goto, and John Stephen, *Nine Mile Run*, 1997–2000. Eco-aesthetic recovery plan for a stream corridor. Views of a 6-sq.-mile, multi-watershed project in Allegheny County, Pennsylvania.

at the STUDIO for Creative Inquiry of Carnegie Mellon University in Pittsburgh, not only addressed issues of a historic watershed (once planned as a park but used by the steel industry as a slag disposal site and more recently identified by the Pittsburgh master plan as a site for 1,200 residential units), but also created a model for projects in other urban brownfield sites. The project outlined an aesthetic and cultural policy for reclamation efforts reconnecting the community to the water and the native landscape, while also presenting a series of on- and off-site exhibitions.

Bingham recently proposed a Google Earth Camouflage to "green" the Garthwaite Center for Science and Art (already a LEED-certified building). He points out that, however sustainable the building might be, from the air it is a stark white interruption of the surrounding forest. Bingham suggests that this (and other buildings) be re-imagined from an overflight (or Google Earth) perspective so that the built environment would blend into the natural environment. His challenge is to "imagine if we had building codes that required developers to replace the existing natural growth/habitat on top of or into a proposed building…not attempting to reproduce a forest ecosystem, but to provide a model of diverse strategies as examples: a living roof with a naturalistic meadow of perennials and grasses, agricultural food crops, fruit trees, alternative energy systems, rain water storage, and a small area for human habitation."

Since 2008, Bingham (along with collaborators Ally Reeves and Robin Hewlett of the STUDIO for Creative Inquiry) has been working on *One Mile Garden*, a community project in York, Alabama, that includes a central garden at the Coleman Center for the Arts and satellite gardens in school, church, and community sites across the town. The plan also calls for additional sites to be added, radiating through York, as the project continues. Bingham aims to bring opportunities for education, access to healthy food, and community building to York through community gardening, using a cooperative approach to form, function, and decision-making. So far the project has featured the "One Mile Meal" (a community dinner made with local ingredients), other food events, the inclusion of innovative local gardeners

Bob Bingham, with digital imaging by Claire Hoch, *Google Earth Camouflage: A Revision Request*, 2008. Rendering for the Garthwaite Center for Science and Art, Weston, Massachusetts.

like Catherine Shelton (a self-taught organic gardener enlisted to help establish the first of the community gardens), an orchard, and an exhibition at the Coleman Center. The artists will also participate in the planting and harvesting seasons and develop a food distribution system.

Through his teaching (at the STUDIO for Creative Inquiry), Bingham inspires young artists to apply their creativity to the expanded environment. He has established a course in environmental sculpture and a university-wide course on eco-art that involves collaboration with the Pittsburgh Parks Conservancy on a series of initiatives, including the removal of invasive species, improving soil retention, and creating rain gardens.

Plant Art: Is There Room to Grow?

by Brooke Kamin Rapaport

It's not a new movement, per se. It may lack the scale and tough-minded idealism of 1960s Earth Art. And it does not embrace the formal visual language of 1980s artists who used similar materials. But young Americans working today who use plants are causing a quiet stir. It is their urgent belief that using flora as a primary medium addresses major issues confronting contemporary art and society. Although their plant works attempt to revive a subject firmly rooted in American traditions of art-making, these artists are having trouble growing and showing their pieces in this country. One is grafting manmade objects onto a growing plant; others are making rooftop gardens in urban settings. Their work can consist of abstract forms made out of greenery or plant-based materials that spawn conceptual art projects. In conversation, most of these artists say that they long to free their plant sculptures from a studio or gallery setting and return them to the outdoors. "The plants belong in nature," said New York artist Laura Stein. "It's where they thrive."

With their outdoor sites, it seems natural that American sculpture parks would support plant-related works on their grounds. But this isn't always the case. For some parks, the required maintenance would be too high. David Collens, the director and chief curator of Storm King, is a pragmatist when it comes to making an outdoor piece with plant materials and describes a chronic condition in the Northeast: a hungry deer population. Deer devoured the plant part of Nam June Paik's *Waiting for UFO* (1992), commissioned by Storm King. The work now has plastic plant materials, including ersatz palm and ficus.

So where can young artists who use natural materials show their work outdoors? Collectors seem cautious about acquiring a piece that can take several growing seasons to achieve a mature aesthetic statement. Museums are unlikely to add an object with living organisms to their holdings, fearing that insects or molds might infest the historical works already in their care. And while some sculpture parks, public gardens, and arboreta welcome innovative work by plant artists, many think it best for artists to find their own spaces outside conventional institutional frameworks. The challenges of working outdoors are legion: juxtaposing a plant piece with the vast, all-encompassing scale of nature is a radically different experience from creating work in a studio or for a gallery; plants often require continual, time-consuming care, and the growth time for a plant/sculpture can be an unpredictable factor. With all these issues in mind, some sculpture park administrators fear that the quality of plant works will suffer if they are shown outdoors.

"One of the challenges about exhibiting plant-based work at Wave Hill is that we are an internationally renowned garden," says Jennifer McGregor, director of arts and senior curator at Wave Hill in the Bronx. "When I visit an artist's studio, it strikes me that the artist's work would be overwhelmed in the context of our gardens." McGregor feels strongly that artists would meet with greater success by bringing the visual language of the botanical world into an urban environment: "I'd rather see us collaborating with a community garden or with spaces in the Bronx that need attention."

Joan Bankemper realized just such a project. Since the early 1990s, she has achieved some renown in New York for her own and others' downtown rooftop gardens. In 2001, she collaborated with the McColl Center for Visual Art in Charlotte, North Carolina, on a community garden and bird sanctuary. Bankemper launched a partnership with members

175

of Edwin Towers, a 10-story building housing a largely African American community and many senior citizens. The garden's perimeter is a circle of bricks about 100 feet in diameter. Within that circular form, she created a loose grid of plots measuring between three and five feet. Neighborhood residents are able to rent these plots for $10 a year. Some grow tomatoes, cucumbers, and collard greens; others tend flowers. To enliven the garden, elderly women from Edwin Towers have collaborated with Bankemper to create birdhouses that attract brown-headed nuthatch, chickadees, titmice, wrens, and bluebirds as they migrate south. "It is a thriving bird sanctuary and community meeting place," according to the artist. "It is not just changing the physical environment, but community building."

Other plant artists want their works to be considered art objects like any other sculpture, though with a medium more complicated to maintain than, say, welded steel. "Steel is no longer relevant," says Brooklyn-based Samm Kunce, "It doesn't say anything anymore." Kunce's goal is to have an impact on a natural setting. Her subject is gardening — but not the stuff of an English country estate with its lush shrubbery, topiary, and orchestrated plantings. With a sculptor's hand, she turns plants into abstract forms that contend with the forms of the landscape. She has worked in outdoor settings, mostly in Europe, and has made objects from plant materials in indoor galleries. *Clover Bed* (1999) is installed at the Bauhaus-Universität Künstlergarten in Weimar, Germany. Three U-shaped undulating ripples of clover, approximately 12 feet in diameter, gently nestle into this public setting. Kunce's piece does not pretend to make the grand gesture of an earthwork. It is an intimate gradation of waves in the landscape, poised to cradle anyone who leans back and rests his or her head on a clover pillow.

Kunce has also investigated the "technologization" of the plant world. In 1995, she installed *Law of Desire* at the John Gibson Gallery in New York. Cascades of grass fall from the ceiling, suspended on chain ropes. Acknowledging the quest to support life through artificial means, the grasses were nourished with gro-lights and water pulsing through

Samm Kunce, *Law of Desire*, 1995. Grass, felt, gro-lights, PVC liner, and pumps, 40 x 30 x 13 ft.

Mark Dion, *Vivarium*, 2002. Maple log, soil, aluminum, tempered glass, wood, and ceramic tile, 7 x 5 x 25 ft.

vinyl tubes attached to square PVC-lined troughs on the floor. This graceful rearrangement of greenery survived only through the intervention of machinery—a somewhat disturbing metaphor for the human ability to both sustain and displace natural processes.

Pennsylvania-based Mark Dion, who focuses on natural history and archaeology, has brought critical attention to plant art with his *Vivarium*, which sequesters a fallen, decomposing maple trunk in a glass box with a tile surround. *Vivarium* (2002), whose title refers to a container of life, functions as a greenhouse (a protector of life), but it also resembles a coffin (a protector of death). The felled tree section lays in state like a decomposing corpse, playing host to swarming mosquitoes and ant colonies, ferns and fungi. In the succinct life/death drama encapsulated here, one organism's decay can be life-affirming for another species.

Dion is acutely aware of the issues surrounding plants and their display as works of art. In 1998, he realized *The Tasting Garden* adjoining the Storey Gallery at the Storey Institute in Lancaster, U.K. Could he create this type of garden in the U.S.? "It's not surprising to me that artists are having a problem doing plant-based work here. Here, culture is about the immediate…[but] there's no way to make plants grow faster than they will," Dion says. A large, walled, permanent project containing rare varieties of fruit-bearing trees, *The Tasting Garden* includes an on-site arborculturist's house. In the fall, neighbors and visitors are allowed to pick the ripe apples, pears, cherries, and plums: "The idea is that they can experience a garden through taste in addition to smell or vision." The project is based on agrarian community models in which gardeners and farmers sell their produce locally. Dion is working to preserve almost extinct varieties of plant life—heritage trees whose fruits do not come cleanly packaged on a grocery shelf—underscoring the scientific knowledge and hard labor necessary for cultivation.

Like Dion, Laura Stein is preoccupied with scientific issues, examining the effects of intervention in her plant pieces. In the 1980s, she trained at the California Institute of the Arts in Valencia, California, with John Baldessari, doyen of conceptual artists. At the frontier where nature and culture meet, Stein finds her subject matter. She recently showed a studio visitor live tropical palms and a rubber tree that sprouted artist-introduced leaves made of supple leather in addition to their own leaves. She hopes that the plants will "host" the new material and incorporate it into their growth. The work would then confirm something of nature's ability to absorb or consume humankind's larger interventions.

Stein's molded tomatoes embody "a cultural metaphor" for the American consumer's expectation of fruits and vegetables on demand, nature be damned. At first endearing, these objects quickly take on the aura of science fiction. Critiquing store-bought tomatoes that look and taste like candle wax, her tomatoes are hand-held symbols of a messed-up natural order—mutant forms, with faces. In *Filled* (1996), a rich, red, artist-grown tomato has the face of the cartoon character Sylvester molded into its skin. A rugged green stem pops up from its little bulbous head. Stein is a master at growing works that sit on the edge where plant materials lose their mundane qualities and become symbols of the paradoxes in contemporary culture. She cultivates her plants in her Manhattan studio, photographing them and casting them in video projects. Her goal is to relocate more projects away from the studio by creating an outdoor garden.

Paula Hayes, a Brooklyn-based landscape designer and artist, has created a number of gardens for city clients. One, which incorporates moss and a biomorphically shaped hedge, will take several years to realize its envisioned form. Hayes calls working with moss "a heroic act. You have to be in a completely committed relationship with the planting." Soil pH, the degree of humidity, the irrigation system, sunlight, and wind all affect the work. Taking moss from her client's home out into the streets of New York has enormous appeal for Hayes. The as-yet-unrealized *Moss City* is intended for an abandoned lot that could measure 16 to 20 feet wide by 120 to 180 feet deep. Hayes proposes cultivating a plot of hair cap moss, which is well-suited to shade and sandy soil. The work is conceived as a community effort, located ideally in Harlem, the East Village, or the Bushwick section of Brooklyn, near where she lives: "I would like it to be in a neighborhood where some transformative aspect for the community could happen." Hayes would work with local residents to cultivate and tend such a garden. Taking advantage of the fact that moss is rootless, *Moss City* would be composed of sections that could be reconfigured or moved to other sites. Across the work's emerald-green landscape, rounded resin forms would jut up from the ground. Moss would eventually crawl over the resin, forming what Hayes calls a "small skyline"—a site full of texture and color, all from clumps of the simplest land plants.

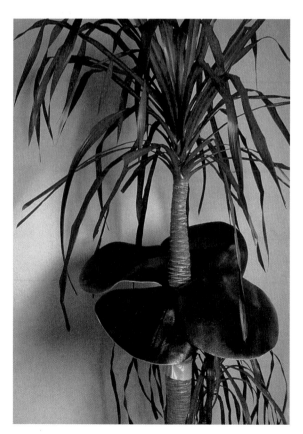

Laura Stein, *Grafty*, 2002. Plant and leather, 80 x 30 x 32 in.

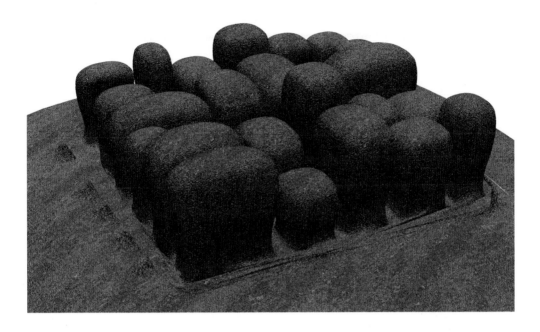

Paula Hayes, *Moss City*, 2002. Computer rendering of planned moss sculpture and garden.

For Hayes, living successfully with plants is fundamental to ecological and human survival. As a child in upstate New York, she was raised on a family farm that grew corn, hay, and potatoes. In addition to a master's degree in sculpture, she is steeped in horticulture and has interned with a master grower, an experienced horticulturist, and an agricultural farmer. She is so committed in her belief that people and plants go together that she has devised a system whereby clients can carry a plant along with them. After observing parents who carry their infants in a snuggly, and in recognition of cultures where mothers "wear" their newborns in fabric wraps, she created *Plantpacks* (1999), soft carrying devices for small plants. The wearer bears a cactus, potato plant, or fern nestled into a felt strap with a supporting band that has a fake fur base. Each *Plantpack* has an exit tube to drain water. So far, the *Plantpacks* have reached club kids who think they look cool with a potted palm on their chests or backs. Hayes hopes that once people get over the curiosity factor, they will sympathize with her vision and its therapeutic benefits: "Having a being that weighs approximately the same weight as a newborn infant is comforting. It is alive, and you develop a connection with it that is very physical when it is strapped onto your body."

The relationship between living plant and human body is fundamental to many artists who work in this medium. Albany-based Victoria Palermo, for example, installed *Lawn Chairs* (2000–01) at The Fields Sculpture Park at the Art Omi International Arts Center in Ghent, New York, a work that embraces visitors in a viridian sward. The three chairs resemble late-'50s organic furniture, like the classic Arne Jacobsen Egg Chair or Eero Saarinen's Womb Chair. But Palermo's objects are made of grass. The chairs sprout their thick, verdant fur by virtue of a hidden irrigation system. Bringing this project to fruition was demanding, said Peter Franck, former co-curator of The Fields with Kathleen Heike Triem and director of Architecture Omi. "Working with planted material is a challenge because the pieces require constant care. We encourage artists to work in this medium, however, because it is an extremely provocative expression, especially in the context of an outdoor sculpture park."

Of course, garden art has its detractors, including those who like the look of plants but aren't interested in the "refined sensibilities that you get from highfalutin' gardeners or expensive architects," as Brooklyn sculptor Charles

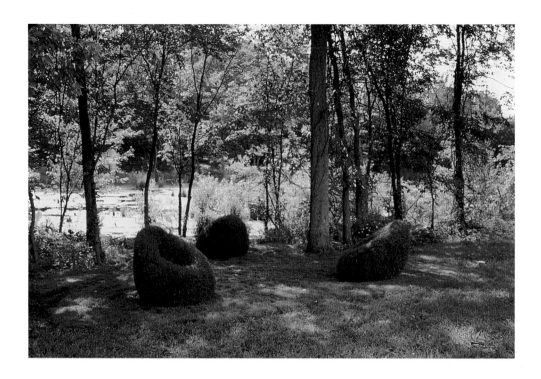

Victoria Palermo, *Lawn Chairs*, 2000–01. Sod and dirt, approximately 20 ft. diameter. View of installation at Art Omi.

Goldman said recently. He finds the traditional hedgerow garden maze—that symbol of privileged leisure—too elitist. So he adapted it to everyday buying habits and routines, using materials bought at the Home Depot to realize *E-Z Maze*, a work that can be commissioned from his Web site. With a section of six-foot-high Permahedge, a plastic swath of greenery woven through chain link fence, everyone can instantly acquire mature plantings for the backyard. The color and texture of this artificial green shrubbery "has been carefully chosen to ensure a natural appearance even when viewing up close," declares one fencing Web site. Goldman realizes that *E-Z Maze* can be read as a wry comment on our prefabricated surroundings: "It comes off as a bit ironic, but it's not meant that way. You want a maze and the possibility of transcendence and an experience that's outside of home, work, and dinner. Whatever it takes, I am going to help give that to you. And if it has to be quick, then I will give it to you quick. It's using a vocabulary that's already prevalent in the world around us and accepting that." *E-Z Maze (Right Angle)* was installed in February 2003 in an empty lot adjacent to the Portland Institute for Contemporary Art in Oregon.

Plant work is growing, with dignity and a quiet power. With the increasing sophistication of plant artists, outdoor sites are ripe for new partnerships. The dynamic participation of sculpture parks could embolden not only the plant artists themselves, but also the public. Audiences would benefit enormously from projects that help us to understand the fascinating intermediate zone between the natural and the manmade. In addition to the parks' traditional outdoor exhibitions, which regularly feature the most important developments in sculpture in the 20th century, they now have opportunity to propel the very definition of sculpture.

Mara Adamitz Scrupe:
How Does Your Garden Grow?

by Christa Forster

Beneath the surfaces of Mara Adamitz Scrupe's lovely installations, powerful ideas put down roots, train themselves into the terrain, and inform native landscapes and communities in ways that have far-reaching reverberations. *Garden for the Third Coast*, created in 2005 for the Buffalo Bayou Art Park (BBAP), was the culmination of her year-long residency with BBAP, a nonprofit that places temporary public art in spaces across Houston and Harris County, Texas. BBAP housed *Garden for the Third Coast* at 5106 Center Street, its headquarters located in a neighborhood historically occupied by migrant workers that hugs Buffalo Bayou. Thanks (or no thanks, depending on your point of view) to urban development, the area is becoming trendy. BBAP and another nonprofit, Spacetaker, occupy one of the few characteristically old and dilapidated structures remaining in the neighborhood.

BBAP, born from a renegade public sculpture show in 1987 along Buffalo Bayou's Watermelon Flats, appreciates artists like Scrupe who incorporate a social agenda into their work (Steven Siegel and Tania Preminger have also been artists-in-residence). "Mara's work is in line with our mission and vision," said then-director Kevin Jefferies. "She addresses important issues in ways that are subversive, but subtly so. Issues like ecology, sustainability, native plants,

Garden for the Third Coast: The Buffalo Bayou Plants Project, 2005. Fabricated tables, grow lights, native plants, handmade stoneware planters, light boxes with Duratran images, and mixed media, detail of installation.

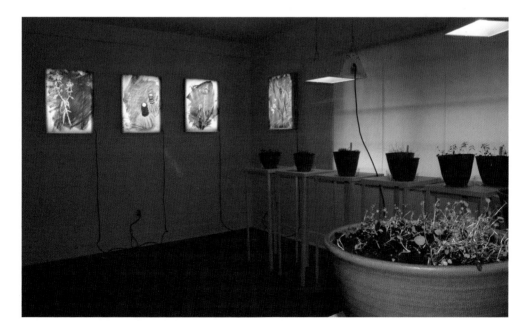

Back to Nature: Collecting the Preserved Garden, 2004. Fabricated aluminum and glass greenhouse with grow lights, misters, circulation fans, endangered native plants, handmade stoneware planters, 15 light boxes with Duratran images from the artist's collection of amateur floral paintings, and artist-designed solar power station, installation view.

quality of life." Such issues matter deeply in the struggle to figure out how Houston, one of the most polluted cities in the U.S., can survive and thrive into the future. Scrupe's Web site, <www.scrupe.com>, outlines her goals for the Buffalo Bayou Art Park project: "*Garden for the Third Coast* is an environmentally proactive initiative 1) to educate Houston's diverse communities about the native flora of the city and its importance for human, animal, and aquatic life, 2) to make important practical contributions toward restoring native Texas bayou plants to forest, tributaries, wetlands, prairie, and riparian ecosystems, and 3) to help preserve and improve the overall environmental health of the bayou, thereby significantly contributing to the city's quality of life in the present-day and for years to come."

The project was completely accessible, drawing a wide array of visitors, from artists and art aficionados to real estate agents and home gardeners. Scrupe drew images of endangered bayou plants—rattlesnake master, spotted bee-balm, and Turk's cap, to name a few—on Duratran transparencies and mounted them on biomedical light boxes (normally used in gene-splicing processes). The box-drawings were fastened at regular intervals to the walls of a small, dingy room, cords dangling to the floor, kinks and all. The haphazard hang of the cords seemed to reflect Houston itself, which, due to a lack of zoning laws, presents an urban hodgepodge of gas stations next door to mansions, adult bookstores down the block from churches. In a corner of Scrupe's room, 12 long-legged steel tables formed an arc, crowned by potted seedlings of the same bayou plants featured in the Duratran drawings. For months, the seedlings were sustained by a solar-powered gro-light system that Scrupe designed and installed. If visitors felt moved to interact with the plants, a plastic spray bottle sat next to the legs of one table, encouraging people to mist the seedlings. Outside the room, under the stenciled title of the installation, another table held handmade packets of Texas wildflower seeds, complete with instructions for when and how to plant them. At the close of the show, the seedlings were distributed to gardeners around Houston for transplanting at various bayou locations.

Scrupe uses Duratran because of its associations with the advertising industry. The same material appears in the glowing ads on the sides of bus stops and the walls of airport terminals. "When people ask me what I do," she says, "I often say, 'I sell plants.'" Obviously she understands ideological strategy: the allure of "pretty" work plays an important role in the act of "selling" her plants. *Garden for the Third Coast* was surprisingly beautiful, given the ugliness of the project space: low ceilings, wide dirty windows outfitted with burglar bars; a room with no level lines, cracked walls, plywood floors painted an industrial gray, and one overhead fluorescent light fixture. No stranger to challenging environments, Scrupe relishes the problems that she encounters while transforming a space. "Obstacles turn out to be incredibly beneficial for creative thinking," she says. In this case, she covered the windows with vellum, diffusing the blinding winter sunlight. This allowed her to capture the shadows of the burglar bars, which mirrored the long legs of her welded steel tables. The radiant Duratran images arrested and tantalized the eye, and the growing seedlings softened the space, infusing it with a welcoming spirit. "So much of the language of projects these days is about space and how the artist uses the space," Scrupe says. And indeed, in the midst of a gentrifying ghetto in central Houston, she transformed a dead space into a sanctuary.

Scrupe has spent 20 years coaxing her ideas into visual language. As an undergraduate at Minnesota's Macalester College, she changed her major from language and linguistics to art because she realized that visual language offered her more latitude of expression. She began making three-dimensional art, employing ceramics, woodworking, and welding—skills that she still uses in her projects. However, she grew impatient with object-centered work: "Objects can encompass ideas, but I needed what I made to encompass not only visuality and beauty but also a strong idea as a motivating force." The force that motivates her work is the natural environment, and she categorizes herself as an "environmental artist working with renewable energy systems and native and ethnobotanical plants in the creation of projects about place for museums, arboretums, landscapes, and public spaces."

Scrupe spends many months researching the locations of her installations. The special conditions of the local environment inspire the specific ideas in each project. She wants her ideas to inspire, enrich, and nurture her chosen environments and communities. "For a long time, I reacted to art's power to change the world by putting up a kind of battlefront; but finally I realized that we are all muddling through life, trying our best. If we're lucky, over time, we're able to transform our attitude into a gift-giving one. Rather than turning ideas into a battle, we can turn them into something kind, meaningful, larger than a fight." Scrupe herself has been enriched by living on a 40-acre tract of land along the historic James River in Central Virginia. Along with her husband, Daniel Holm, and several other families in the area, she has formed the James River Residency for a Healthy Environment, a citizen advocacy group that works with local industry to clean up the surrounding environment. Besides adding a level of political activism to her life, living close to nature has deeply affected her work: "The vision for my sculpture and installations has come directly from living in nature, in a quiet, rural setting, among country people. It is based on ideas about the interstices of nature, technology, and community, but proffers harmony rather than discordance as its foundation." Her work is underpinned by a sense of ethics, but instead of providing answers to problems or codes of behaviors, Scrupe presents questions. "People can come into my work at various points," she says. "In the end, the work is not about what I think, it's about putting it out there and asking people, 'What do you think?'"

In December 2005, she created *respire, contemple, toque, siente, abrace*, a public art intervention commissioned for the Bienal Internacional de Arte al Aire Libre in Caracas, Venezuela. Scrupe wanted to give a gift of natural beauty to the people of Caracas. "Because we had only four days and a total project budget of $1,000 to create an ephemeral outdoor work on the subject of 'nature and urban people,' I decided on an interventionist strategy. I went all around the city and digitally photographed urban trees…Caracas [is] a city of 10 million inhabitants topographically situated at the bottom of a 'bowl' of land surrounded by mountains. The air is dreadfully polluted, but the city has many trees and green spaces, which help a lot. I simply wanted to draw attention to the remediating

qualities of trees in terms of air pollution and also to give a kind of 'gift' of natural beauty to the city's people—especially to those who might not be able to afford to buy art." In discussing her strategy, she mentions that some of the other artists judged her work as insipid, insinuating that the photographs resembled travel posters. "Exactly," Scrupe says. "Many of the other pieces seemed to me to be preaching to people who don't have a choice. People in Caracas don't have the first idea of how to deal [with the pollution]. They're trying to figure out how to eat. They didn't need to be reminded that their environmental situation is grim. Beauty seemed to me to be the most cogent means with which to discuss the disparity." Scrupe's project consisted of 50 posters placed in public spaces: storefront windows, downtown buildings, graffiti-covered walls. Each poster was mounted on 10mm PVC and signed by the artist. "They lasted about a day before they were stolen and presumably are now providing artwork for someone's home (or office even?), which is exactly what I had hoped would happen. I have an image of a high-quality, signed, and dated photo poster mounted in someone's living room in some part of town where 'contemporary art' may be completely unknown."

Scrupe's work reflects compassion for her fellow humans, as well as criticism of our penchant for convenience and instant gratification. In *Paradise*, for example, a work commissioned in 2000 by Harvard University's Graduate School of Design for the centennial celebration of the Landscape Architecture Department, Scrupe recycled three mini-vans, gutted them, and moved them to campus. Inside the minivans, she planted several different plant species native to the coastal regions of the Eastern U.S. (varieties of cabbage, beans, peas, and squash, as well as medicinal herbs). Such species provide excellent nutrition for human beings, in addition to supplying other useful substances and materials. These heirloom plants are currently threatened with extinction. Major seed companies prefer easier-to-grow, better-looking varieties that also lend themselves more readily to genetic engineering. Like many of Scrupe's projects, *Paradise* promotes consideration of the earth through recycling, self-sustaining technology, and the protection of vital native plants. It also reflects worries about the damage to the food web, and by extension to the earth and its inhabitants, that could be inflicted by chemical companies and agribusinesses.

Paradise, 2000. 3 minivans refitted as greenhouses and solar-power systems.

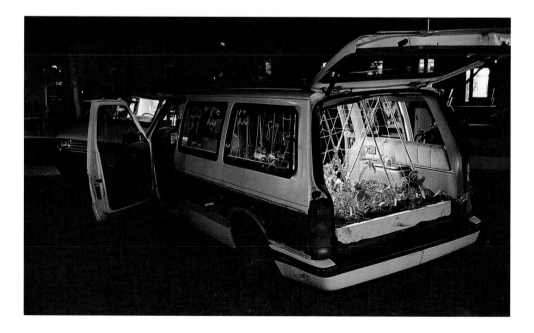

Scrupe's criticism and activism are often masked by beauty and wit. In *Suspicious Science* (2001), a permanent installation for Lithuania's Europos Parkas, she created a "glowing garden" of grotesquely large resin vegetables, which was illuminated at night by means of an artist-designed, solar-powered generator. Here, Scrupe addresses the interrelated issues of ozone depletion, fossil fuel pollution, and foods grown in contaminated soil. The sumptuous but mutant vegetables also evoke the possible outcome of nuclear pollution.

Fota Lichens Project, 2005. 10 light boxes with Duratran images of native Irish lichen, fabricated aluminum tables, and living lichen in hand-blown bell jars, installation view.

Fota Lichens Project (2005) enchanted viewers into considering the negative effects of urban development. This installation, sponsored by the Crawford Municipal Galleries of Cork City, Ireland, and exhibited in the Flower Room of historic Fota House, included 10 large Duratran images of native Irish lichens, each mounted in slim-profile stainless steel biomedical light boxes. Displayed on freestanding aluminum tables, the light boxes were accompanied by living specimens presented in hand-blown glass bell jars and texts describing the ecological significance of lichen and their usefulness in assessing environmental conditions. The installation's elegance complemented Scrupe's message: these vulnerable lichens are failing, therefore the greater environment is vulnerable to failure, too. The atmosphere gave the feeling that one was in the presence of a gracious hostess who draws you into her argument so that you cannot help but be intrigued and inspired by it.

Scrupe continues to explore the effects of spreading sprawl, researching patterns of land development relative to particular natural environments and obtaining permission from landowners to search for and identify native plants in the landscape. Before the bulldozers and heavy equipment arrive, plant rescue missions begin—digging, removing, and potting many important native species. At the close of these botanically based projects, she donates the rescued plants to gardeners in the hope that they will repopulate ecosystems with native flora. Whether outdoors or in the gallery, Scrupe's work gives a positive twist to gloomy environmental prognostications: with heightened awareness and personal commitment, we can maintain our paradise.

Vaughn Bell: Committing to Ownership

by Twylene Moyer

Take a mountain for a walk, adopt a parcel of land small enough to nestle in your hand, or cradle a plant against your chest: Vaughn Bell's absurdist situational investigations establish direct contact between individual beings, transforming human passivity into engagement. The notion of "landscape," with all its historical (and art historical) baggage, lies at the heart of her inquiry. Tamed and domesticated, civilized by the human hand and rendered more or less picturesque, beautiful, or sublime through the improving application of culture, constructed landscape reforms an unruly and uncouth nature. It exists to serve, its parameters subsuming living elements into an inert composite, an abstraction with no reality or agency outside of human application. This detachment, which has defined the Western approach to nature for centuries, promotes a mindset that mistakes control and mastery for custodianship. You can't really care for an abstraction: So how can you begin to address climate change and think about a truly sustainable culture when you see the natural world as an inanimate picture?

Village Green, 2008. Acrylic, hardware, native plants, soil, organic matter, water, and water sprayers, dimensions variable.

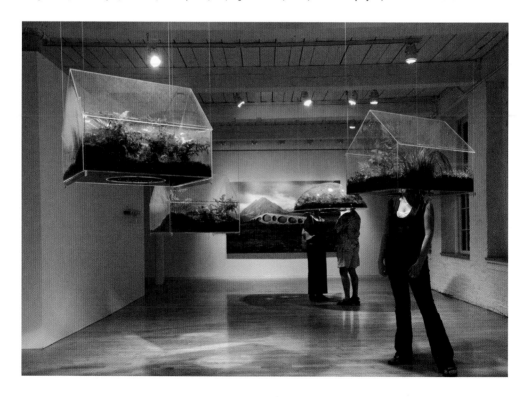

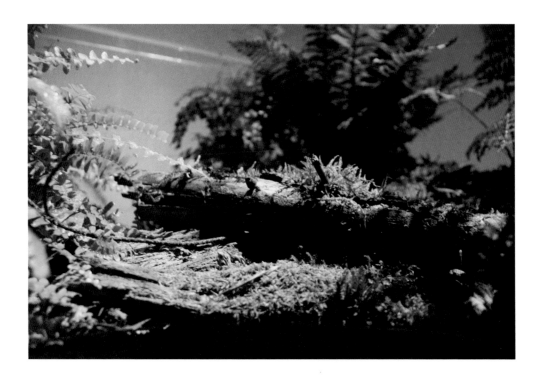

One Big House, 2009. Acrylic, hardware, plants, soil, organic matter, water, and water sprayer, 40 x 40 x 40 in. View from inside a biosphere.

Bell's work upends willful disengagement through the most direct and efficacious of means—intimate bodily and physical experience. Her witty, scale-shifting installations and performances play on basic human psychology—we empathize with and form attachments to individual things or beings inside our immediate sphere; anything outside this charmed circle, including people, can be treated in aggregate, as generalized categories without real substance and little capacity to touch our lives (birds are just birds until you feed worms to one special fledgling). Bell applies this insight to landscape and its denizens, transforming impersonal abstraction into personal relationship by cultivating one-to-one connections with the power to change attitudes and received ideas.

Her "Biosphere" works, installed in galleries and museums, offer temporary encounters with this brave new world of responsibility and pleasure. Suspended terrariums, each one containing a miniature living ecosystem, bring vast expanse down to human scale. But Bell goes further. Openings at the bottom of each biospere accommodate at least one human head, inviting viewers to break through the plastic barrier and immerse themselves in another realm. Inside these terrestrial isolation chambers, everything intensifies—details of color and texture, atmosphere (moist and oxygen rich), and odors (loamy). Smell and vision have to adjust their focus to accommodate the lush profusion, every-thing appearing at an extreme, myopic proximity in which the undifferentiated unfolds into an expanding terrain of unique entities.

The "Portable Personal Biospheres" (PPB) transform these terrariums into silly, yet sensible biological breathing/survival aids. For urbanites, the green bubbles provide immediate relief from unrelenting concrete and air pollution. Each living cocoon wraps the user in sweet earthy smells and a refreshing green horizon, but there are strings attached. Unlike its gallery counterpart, which elicits only a fleeting encounter, the PPB asks for a sustained relation-ship, a commitment. It is not maintenance-free—its small-scale ecosystem requires care or it will die.

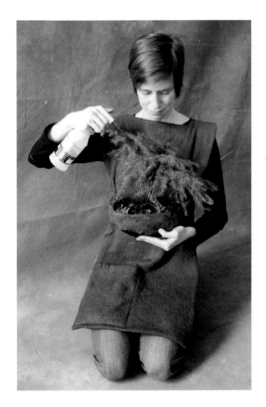

Garment for Flora-Fauna Relationship, 2006. Performance with sewn cotton carrier, soil, baby hemlock tree, and water, dimensions variable.

Endurance over time poses challenges for any kind of human relationship. Asking people to commit to the non-human world makes the task even harder. But Bell doesn't ask the impossible. Again following basic psychology, she mimics and pokes fun at our chosen bonds, transferring them to the "ridiculous" idea of bonding with plants. Held against a carer's chest in the *Garment for Flora-Fauna Relationship*, a plant prompts the same kind of reflexive response sparked by a baby. The garment allows a new kind of closeness and communication to take root. Human and companion plant sit together, travel together, and breathe together, exchanging oxygen and carbon dioxide, each supporting the other. And yet, the plant, like a child, is dependent: it will not thrive on neglect or abuse. Caregivers can also tend a *Personal Forest Floor (Portable Mountain)* (2003–08), a small, organic landscape on wheels that allows it to be walked like a pet. Though Bell has called the image of someone dragging a mountain around the city on a leash "totally absurd," the interaction becomes no less real than the relationships that millions of people formed with their electronic pets in the 1990s—adults as well as children virtually fed, walked, and groomed these primitive beeping devices, and mourned their deaths.

If the idea of bonding with a plant on any kind of emotional level seems stupid (some people deny that plants possess any form of sentience), Bell has one final card to play. Most human relationships, particularly in a consumer society, consist of intense and lasting attachments to the truly inanimate—we care for and maintain these objects simply because we own them. Whether we've paid for them or not doesn't matter—they belong to us and no one else; their state of upkeep reflects on and in some measure defines us. Bell's "Cultivation Utility Actions" with the CUV Vehicle pair these powerful motivators—empathy and ownership—by offering urban dwellers the opportunity to adopt and nurture a pocket-sized piece of land. No money is exchanged, but prospective owners must sign adoption forms stating their intent and commitment to the care of their land. For those who enter fully into the spirit of the contract, this sustained cultivation will be more intense than the relationship between suburbanites and their yards (unless they are serious gardeners). Though some parents ultimately fail their charges, everyone tries, and, for many, the experience is catalytic; for the first time, they understand (on a visceral level) the deep connection between plants and humans.

In many ways, Bell's work embodies the environmentalist credo that our relationship to the land should be mutually beneficial—a "do unto others" philosophy of respect and custodianship aimed at reversing years of selfish misuse. As she travels around the country for exhibitions and urban actions, she extracts and preserves indigenous, often overlooked bits of land, which she then offers as much-needed doses of nature to city dwellers (*This Land is Your/My Land*). More than metaphors, her personal biospheres and plots of land serve as microcosms of a larger neglected world. Once you're hooked, caring for your mini-world can't help but instill an interest in caring for the world at large. Bell

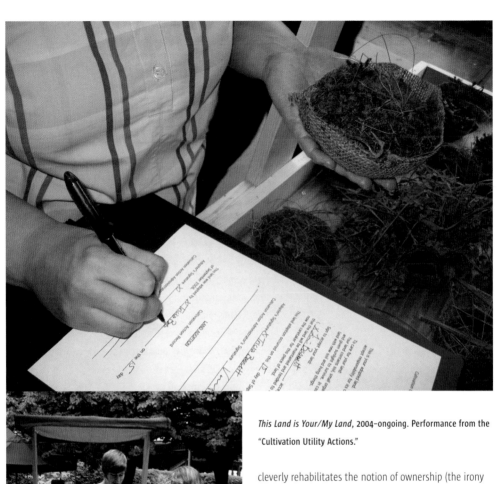

This Land is Your/My Land, 2004–ongoing. Performance from the "Cultivation Utility Actions."

cleverly rehabilitates the notion of ownership (the irony being, of course, that we can't own nature, which is why we don't care for it in the first place), emphasizing care over exploitation: no one wants to be judged a bad owner. Under this new regime, we begin to see trees, plants, and animals as individual beings, each one worthy of right treatment and respect. Many potential care-givers ask Bell what happens if their charge dies. As she told *Arcade*'s Abigail Guay, "All they can do is take on the responsibility for [their] biosphere with a clear intention. But we can't control everything...so they have to be prepared that they might fail. It becomes a really funny philosophical conversation about how we have to proceed in spite of the fear of failure."

Mechanical Botanical:
A Conversation with Doug Buis

by John K. Grande

As early as 1958, Marshall McLuhan recognized that "the effects of the electronic revolution are…pervasive in every sphere of human perception and association…The young…respond with their entire unified sensibilities to these forms of codifying and packaging information."* McLuhan understood that our perceptions were being channeled by the packaging of information. The situation is now more pervasive than ever with computers, the Internet, and virtual reality determining many aspects of contemporary life. Yet for many people, physical, environmental concerns remain foremost, and many artists are addressing our relation to the natural world in interesting and thought-provoking ways.

Doug Buis, a former resident of Long Beach, California, who now teaches Thompson Rivers University in British Columbia, has been exploring the meeting of technology and environment for well over a decade. Some early works, such as *Seed Chairs* (1991), were somewhat naive and homespun in their use of machines, yet Buis has rapidly evolved his own language of sculpture, building inventive and topical contraptions that seize on social, environmental, and technological issues in a subtle way, as if to emancipate sculpture from a purely esoteric and aesthetic paradigm and highlight the very real concerns of rapid technological and environmental change.

John K. Grande: *You alternate between micro-works and large-scale machines such as* The Heart of the Matter *(1992),* Walking Lightly *(a canoe with two "heads" and "arms" that swing tree branches), and* Sowin' Machine *(1996). At both scales, your works address the relation between human culture and nature.*

Doug Buis: *Sowin' Machine* has to do with definitions. It was created for the "Digital Gardens" exhibition at The Power Plant in Toronto, and I wanted to take the idea of digital, as in computer, and rehabilitate it, returning it to digits, as in our fingers. That's why the planting machine looked like an arm that reached out and dropped seeds. The video-interactions had a random effect instead of planting seeds of the viewer's choice.

JG: *It's a kind of dummy machine, then?*

DB: With a lot of these landscapes, I've been fabricating the idea of virtual reality. A number of years ago, I saw a Macintosh ad that pictured a computer with images of leaves on it. The ad stated, "This morning Johnny went to the Amazon twice and then went to the Louvre." Bullshit. Johnny didn't go to the Amazon. We all know that there is a difference between the experience of being in the jungle and seeing a pixelated version of the jungle. To reach the point where you no longer go to the jungle and only see a pixelated image — we are starting to replace experience with a simulacrum, an image.

JG: *The message is clear: reality is not what it is, and we can transform reality in any way we want.*

DB: In a sense, the message is that we no longer need the real, as long as we have its image. We don't need the jungle, we don't need museums or art galleries, because we've got them on file.

JG: *Your digital micro-gardens seem to hit the nail on the head in this respect, poking fun at how the image is replacing the real.*

DB: I like to turn it all on its head. In the small, contained diorama *River* (1996), a distorting screen makes the interior

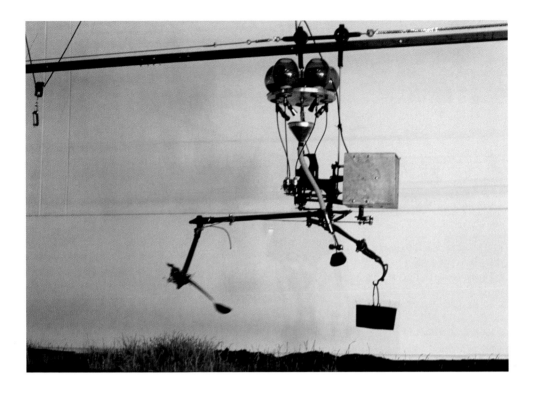

Sowin' Machine, 1996. Steel, soil, wood, mechanical and electronic parts, closed-circuit video system, seeds, glass, and mechanism, installation view.

resemble a video. It looks like an image of virtual reality, an object reassembling an image of itself. Yet the river scene inside is real. It's the title that makes people think of it as virtual reality. They somehow assume and wonder, "How did the artist get that neat water effect?" In fact, it is what it looks like — real flowing water, an assemblage of micro-elements. People look into the micro-gardens and explore what is inside because they look so real.

JG: *What I find interesting about* Machine with Grass *(1992) is the idea that nature is on the surface, but underneath there is a machine that drives it. Was this your intention?*

DB: *Machine with Grass* comes from a different approach, but it is linked to my miniature landscapes. The commonality is perception. I am really concerned with our ability to perceive. *Machine with Grass* worked with very elemental phenomenology. I was thinking of ritual and rhythm — the effect that rhythm has on our consciousness and how it can bring us into non-verbal states. The whole idea of the machine was to create a state in which you were not perceiving the moving grass within your particular framework of perception, and so it would soften your perception of what grass is. You might look at other grass differently. It was a romantic notion of consciousness, almost New Age.

JG: *Kind of surreal?*

DB: It has that absurd element, but the absurdity, that collision of absurd elements, is what takes it out of the percep-tual framework. You can't define it in one specific way, and once you can't define it, you perceive it differently.

JG: *I think of Maya Lin's* Wave Field *(1995). To me, it is scary — a metaphor executed outdoors, with natural elements, for our control of nature. Your approach always has a humane side to it, plays on nostalgia with a home-built feel to it.*

DB: A lot of environmental or political art simply strives to give an opinion. There is something problematic with that. Everybody has access to the same information — that's not the problem. The real problem is our inability to perceive.

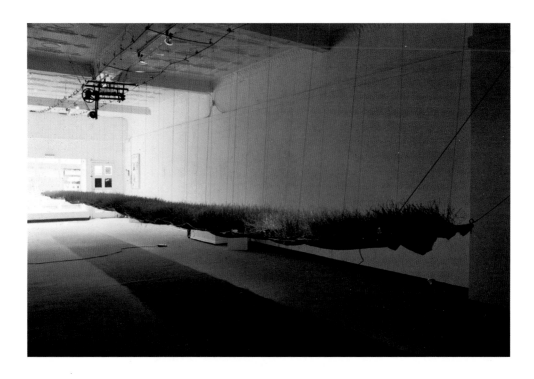

Machine with Grass, 1992. Grass bed, cables, steel, motor, canvas, and mechanical parts, installation view.

We are locked into rigid frameworks of perception. For example, if you are a logger, you define a tree very differently than a tree hugger.

JG: *The strangely denaturized landscapes in advertising are appropriations used to present an ideal of what we look for in a landscape. The real landscape is much more complicated — there are details that can never be codified. We are used to editing this out of our perception.*

DB: Belief systems are the same way. We eliminate all the awkward things, experiences that don't fit our structures. Even artists do that.

JG: *Does bringing your works into an exhibition space present a similar problem? In a video and Internet world, how can you compete? How can you have an impact?*

DB: I prefer bringing the objects to a place. They are still real. You build a whole scenario. It is like planting trees in a park: the setup may be fake, but the trees are real, and they do what trees do. Nature parks are fake forests, but they are still more real than virtual reality. They are different forms of seduction.

JG: *You mean that your scenarios are part of the language of today's culture?*

DB: In some way. In *Landscape with Short River* (1998), *Brief River* (1999), and *Mountain in a Box* (1999), there is a potential problem, not in the language of the objects, but in the potential baggage that we carry to them. In *Landscape with Short River*, when you recognize that the powdery landscape on top is supported by a wheelchair, you make all kinds of associations that aren't necessarily true. There is an obvious pun going on. The wheelchair is under the landscape, not on the surface. I guess that's why there is a sense that the earth is sick, but if you look at the thing, it's really about the surface. I am not trying to talk about the state of the earth; I just want to renegotiate our relation to its surface.

JG: Brief River *almost looks like a return to Minimalism. It makes me think of some of Smithson's gallery installations.*

DB: That little river construction perfectly fits the California landscape construction. The Army Corps of Engineers created all of the canalized rivers that you see on the West Coast—Minimalist rivers.

JG: *How do you relate your recent pieces to earlier works like* Chaotic Encounters, *which used wind to create forms and played with notions of chaos theory? As the generated wind moved sand inside a 30-foot-long Plexiglas and aluminum tunnel filled with random objects and machine parts, it sculpted new, dune-like forms.*

DB: *Chaotic Encounters* is all about how the forms, like sand dunes, are created by chaotic systems and resemble mechanical objects, like transmissions. They are either formed by laws of physics or made to conform to physical laws.

JG: *Sculpted by nature.*

DB: Yes, but not only—human intervention is also there. I let natural forces create *Mountain* (1999). In an obvious way, I would reach the very top, pour sand on it, and fix it with gel medium. I didn't form it or sculpt it by hand, I just let it go.

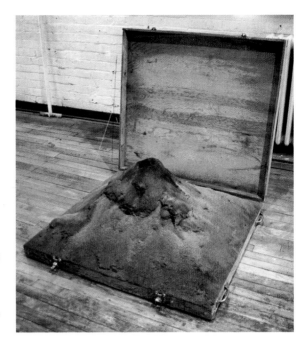

Mountain in a Box, 1999. Steel, foam rubber dust, soil, and pigment, 35 x 40 x 38 in.

JG: *This kind of work makes a rather pointed statement. There is an uneasy feeling of artificiality that responds to an obsessive need to control and dominate natural forms and environments. Your pieces can be seen as an aside to the dominations of early Land Art. They are containers, and the landscape becomes a kind of memento.*

DB: They are like little sketches. They are not only ironic—all of these landscapes are totally artificial. The landscape in the bathtub or on the wheelchair is a completely artificial one.

JG: A Bath *(1999) has a dark stripe on the bottom, a surface coating that could look natural at a glance, but on closer inspection seems totally unreal. You are jogging our traditional associations with things.*

DB: By colliding two things together. The interior looks deeper because of the color gradation. The surface changes as you look at it. The bathtub has no water in it, unlike some of the other works. The emphasis is on tactile reality as opposed to conceived reality. I had wrenches with little trees coming out of the wall. Some were rusty, others covered with matter. Rust and growth are both oxygen-related processes. Life is a kind of rust on the earth's surface.

JG: Earth with Protective Cover, *a miniature planet surrounded by an armadillo-like, metal cover, is a succinct comment on eco-consumerism, the double-bind notion that one can replace harmful consumption with an eco-friendly kind and thereby save the environment.*

DB: That was another absurdist piece. I think that we are going to reach a crisis point. We are all complicit. We do not have to own the land, we can simply appreciate it.

Notes

* Marshall McLuhan, "The Electronic Revolution in North America," in *The International Literary Annual* (London: John Calder, 1958), p. 166.

The Culture of Nature:
A Conversation with Mark Dion

by Julie Courtney

Mark Dion has a hunger to know all there is to know about nearly everything. For more than 20 years, he has explored the crossroads of art and science, vision and the production of knowledge, collecting and modes of presentation. Playing various roles, he takes a humorous, yet critical look at the relationship of nature and culture. His installations and site-specific projects raise a variety of probing questions: How do we construct history? How do we transform natural expressions into culture? How do we classify objects and creative ideas? Many of his works, including the popular *Neukom Vivarium* (2006) at the Seattle Art Museum, address the environment directly. Removed from the forest ecosystem and installed in a closed art terrarium, this 60-foot nurse log continues to support new life through its decay. *South Florida Wildlife Rescue Unit* (2006) is a three-part installation that traces the history and exploitation of the Everglades, from its initial exploration in the late 18th century through almost 200 years of devastation to present-day attempts at restoration. More than a lament, this project offers a prototype for action—a mobile station that can rush to save endangered plants and animals. Part how-to guide for would-be conservationists, part pipe dream, the emergency vehicle salutes grassroots activism while underscoring the need for strong policy decisions. In this, as in all of his projects, Dion teaches us to look at our surroundings in very different ways, giving us an appreciation not only of the grand complexity that underlies the natural world, but also of the most mundane details, which he transforms into fascinating and gorgeous objects worthy of rapt attention.

Julie Courtney: *Why do you refer to yourself as a sculptor?*

Mark Dion: I like to affirm the term "sculptor" because I am deeply connected and committed to the culture of things. I utterly reject the notion that an intellectual or critical art must be dematerialized or textual in nature. Clearly our understanding of who we are, of our history, is crucially informed by our ability to read the vast record of human material culture. Objects speak, and they expand that speech in syntax—objects in relation to other objects. I am not a traditional sculptor since I rarely make objects from scratch; instead, I make meaning by contextualizing and combining elements, which is not a novel approach. Gaining knowledge through an encounter with objects that share my existence in time and space is very much my practice. I also make photographs, curate, collect, draw, produce prints, and orchestrate performances; however, all of these practices remain rooted in an investigation of material culture. In many ways, the term "sculptor" is helpful because it lacks specificity. Like most artists, I am highly allergic to categorization. Over the past 25 years, I have been dubbed an eco-artist, post-conceptualist, institutional critique artist, site-specific artist, and social practice artist. I do not invest energy in such labels; I am more concerned with the viewer's experience.

JC: *Who has inspired you?*

MD: I am eclectic in my perspective, and my methodology was inspired by artists who shared an interest in questions of documentary practice and a complex empirical approach to representing social ecology—artists like Martha Rosler, Allan Sekula, Hans Haacke, Lothar Baumgarten, and Helen Mayer and Newton Harrison. I looked with great care

Fieldwork 4, part of *Systema Metropolis*, a collaborative project with the Natural History Museum, London, 2007. Mixed media, approximately 83.75 x 71.5 x 335.75 in.

at Beuys, Smithson, Matta-Clark, Broodthaers, and Cornell. But my interest also extends to Flemish and Dutch still-life painting. Since my specific interest is the culture of nature, my peers making work around this theme continue to inspire me — Alexis Rockman, Paul Etienne Lincoln, Walton Ford, Bob Braine, and Henrik Håkansson.

JC: *Many of your large-scale endeavors are realized at museums. What makes for a good host institution? Do you prefer for a museum to leave you alone and let you shape the project?*

MD: I have been fortunate to work in partnership with a wide range of institutions, from public universities to natural history museums, zoos, and art collections. The most productive of these projects involve access not only to the collections, but also to the wealth of expertise and insight embodied by the staff. Projects like *Systema Metropolis* with the Natural History Museum in London, *The Marvelous Museum* with the Oakland Museum of California, and the exhibition that I recently developed with the Oceanographic Museum and Aquarium of Monaco and the New National Museum of Monaco take years to evolve, and I become very close to the institution and staff.

Museum people are the caretakers of objects. Since I share this appreciation for how objects speak, we tend to get along. We often have the same critical background and share the same conceptual framework, but institutions

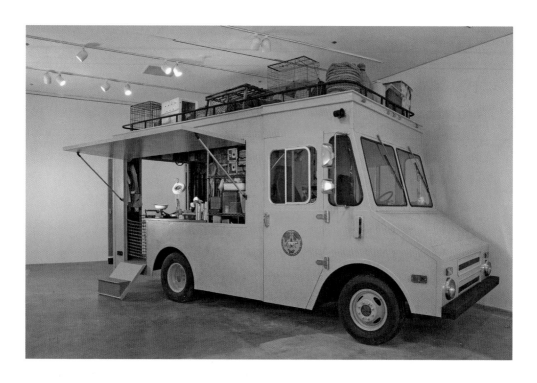

South Florida Wildlife Rescue Unit: Mobile Laboratory, 2006. Mixed media, 227 x 91 x 107 in.

may be more cautious, committee driven, and afraid to offend. From the outside, they seem monolithic, but deep in the offices, one finds a battleground of ideas and positions. Often, artists are brought in to say what the institution would like to say, but can't—artists provide a level of deniability. My job in working with museums is to expand their vocabulary by introducing the complexity of contemporary art, to provide a critical assessment of their history and practice, and to discover and employ unused resources in the museum itself, all of this while maintaining my own agenda of exploring the history of the visual culture of nature, promoting the conservation of wild places and wildlife, and affirming that what is good for the environment also contributes social justice. On top of all that, I want to work with inspiring and generous people and to learn more and have a ripping fun time. That is my job in a nutshell.

JC: *Often in your work, there seems to be no indication that you have made anything—the intervention is almost seamless with the museum's own collection. Is that your intention? Doesn't the institution want to capitalize on your name and reputation?*

MD: I have a serious respect for natural history and social history museum display. As a sculptor, I am fascinated by the problem of how one conveys impossibly complex concepts through objects and stagecraft. The museum is allied with a sculptural sensibility since it is where one gains knowledge through encounters with things. I want my projects to integrate into the visual language of the museum but to resist illustration. Therefore, it is imperative to negotiate the question of labels in a sophisticated manner in order to prolong and deepen the experience. If viewers identify the work too quickly and easily as art, they can simply check that conceptual box in their heads and move on. I never want people to fixate on the "Is this art?" question. I want them to ask, "Is this an interesting situation, experience, or thing?"

JC: *Your projects often have a performative aspect. How far do you carry that? Sometimes you seem to be the mad scientist in his laboratory, or the explorer who sends his findings back to his collectors.*

MD: The relationship of my work to performance is complicated, but it proceeds from the principle that I never pretend to be someone or something that I'm not. There is no acting or re-enacting. When I work in a laboratory setting, identifying fish and preserving them in alcohol, I am not an ichthyologist but Mark Dion trying his very hardest to do the job of an ichthyologist. When I dig artifacts out of an eroded riverbank, I am not pretending to be an archaeologist, I am shadowing aspects of a field that I respect too deeply to want to masquerade. So, my projects highlight the difficulty of obtaining expertise in the scientific fields. They are precisely about how hard it is for me to classify those fish or categorize those salvaged shards—I struggle and often fail. Sometimes, when I send material back from the field, I may not even be visible to viewers in a traditional audience-to-performer relationship. One must take it on faith that I am out there somewhere. Only the results of my collecting are visible, as in *Travels of William Bartram—Reconsidered* or *On Tropical Nature*. Sometimes I am visible, but more like a specimen than a scientist.

JC: *Through your work, we find ourselves considering things that normally we'd never even notice. You dignify the detritus of life by arranging objects in thoughtful ways. The viewer pours over these collections, fascinated by the various connections and relationships.*

MD: In the works that explore archaeological or museological display, the fulcrum is that viewers must find themselves in the piece. These works must defy the logic of thinking about history as events and situations of which we are somehow not part. The gathering of objects must always allow viewers to encounter something from their experience. The collections represented by *The Tate Thames Dig*, *Rescue Archaeology*, or even *Travels of William Bartram—Reconsidered* feature numerous components of historical importance, but everything is fragmentary and imperfect. These important objects are presented side by side with curious and indefinable objects, things that are uniquely homemade, damaged, absurdly commonplace, and ravished by the elements. I arrange all of these specimens in conflicting categories and taxonomies. Sometimes the principles are easily discernible (by color, material, use, or form); other times, the arrangement might prove a bit more obtuse. In the final arrangement of a visual cabinet or installation, one encounters not only a vast array of the types of things that might be collected, but also an encyclopedia of methods by which things can be arranged and displayed. They are collections of types of collections, compendiums of how one might organize knowledge.

JC: *How do you see your interest in material culture as facilitating your commitment to environmental/social issues?*

MD: Archaeology fascinates me because it is a field in which we attempt to piece together a sense of a previous society based on fragments from their material culture, often imperfectly preserved. This is an extraordinary task of sleuthing and puzzle mastering in which the values and assumptions of our own culture must be suspended. It is a necessarily fragmentary field; there is intelligent guesswork, but certainty remains elusive. Much of my archaeological work attempts to imagine what kind of material culture record we will leave for future researchers.

Travels of William Bartram—Reconsidered (detail), 2008. Mixed media, dimensions variable.

This is an amazing thing to ponder, since our excessive, disposable culture produces such a plethora of artifacts that will not biodegrade and that take up vast amounts of space. What will future archaeologists think about American society, which seems so intent on environmental suicide, which is cavalier about leaving a legacy of poison, degradation, and resource depletion? In all of my archaeological endeavors, there is a rather overt ecological agenda.

JC: *Can you elaborate on what you call the "history of the visual culture of nature?"*

MD: For me, the culture of nature means ideas about nature rather than nature itself. The visual culture of nature is the vast realm of images that represent the natural world in popular culture, fine art, and advertising. It starts perhaps with cave painting and fetish sculpture and surrounds us with thousands of expressions each day. It speaks in the voices of science, folklore, religion, agriculture, and resource extraction. No discipline has a monopoly on what gets to stand for nature for a particular group of people at a particular time, but clearly there are vested interests that strive to dominate the social construction of nature. Part of my job is to attempt to tease out and separate the various strands of this Gordian knot in order to find a complex understanding and produce something that contributes to future constructions.

JC: *How can an understanding of past systems of explanation and approaches educate us or assist with current problems? What can they tell us about our contemporary paradigms and prejudices about the natural world, our place within it, and responsibility for it?*

MD: My approach, I hope, tends to be historical. I strive to evoke past history rather than nostalgia for a "Golden Age" that never was. It is crucial to understand the roots and origins of the ideas that dominate the discourse and therefore our actions toward and our relationship with the biosphere. In order to understand where we are, it is important

Urban Wildlife Observation Unit, 2002. Mixed media, view inside the *Mobile Laboratory*.

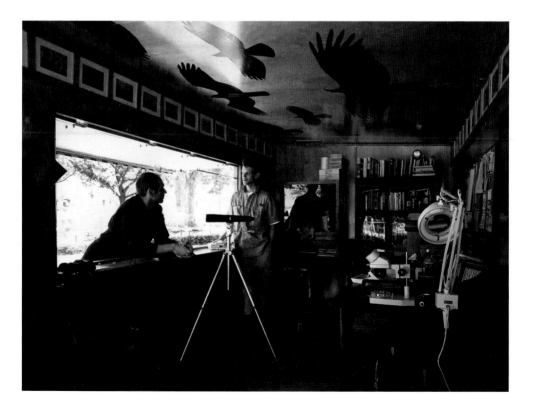

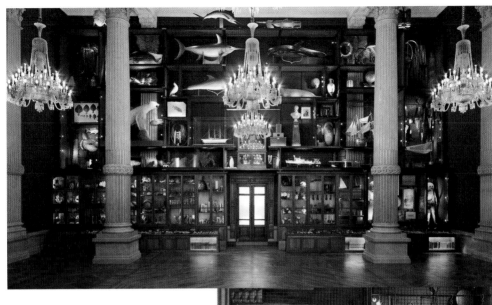

to have a reasonable idea of where we have come from. My process is sometimes like following footprints on the beach. Many of the major conflicts and irrational attitudes established in our conceptualization of the natural world have their origins in the dominant religious faiths and their texts. Others may be found in the evolution of scientific thought and economic systems.

JC: *What can you do in the gallery/museum context that can't be done with works directly in or affecting the environment? How does the approach to educating the public change?*

MD: Working with museums and galleries gives a remarkable range to the material forms of expression that I can use to make an argument. The audience has a high level of curiosity and engagement and shares a basic framework of references. Ideas determine actions, and the museum is an important realm of ideas. In terms of having a direct and measurable effect on environmental crisis, I am not sure that a museum exhibition is going to stop the gas company from destroying the water table around my Pennsylvania farm. However, I believe that it is important to build a broad

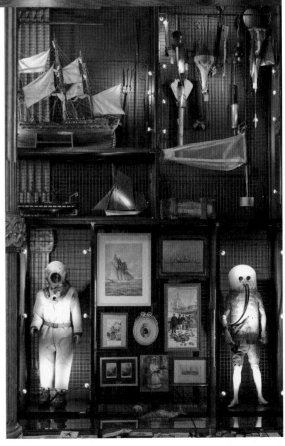

Oceanomania: Souvenirs of Mysterious Seas, 2011. 2 views of installation at the Musée Océanographique de Monaco, 2011.

199

culture of resistance, which expresses itself in many domains of social life. It is important to find and bond with voices of social justice from all over: from the academy, in popular culture, in grass roots politics, at cocktail parties, and in all aspects of social life. I need to find my position confirmed in many realms of experience, or I will feel isolated and insane. The gallery and museum are legitimate sites of the culture of resistance and social justice as far as I am concerned. There is no mandate determining a single approach to being political or critical. Not every project needs to be agitprop or a withering critique; there are many ways to be politically engaged.

JC: *What is exciting in your future?*

MD: I've been working on two major exhibitions about the ocean that take two contrary events as their starting point: first, the decade-long Census of Marine Life, a vast scientific collaboration that turned up more than 6,000 new species; and second, the Deepwater Horizon oil spill, a catastrophe of such magnitude that, even after a generation, its effects will still be difficult to comprehend and assess. The first show, "Voyage on Uncanny Seas," opened at Gallery Diet in Miami in February 2011, and the second, larger project, "Oceanomania: Souvenirs of Mysterious Seas," debuted at the New National Museum of Monaco and the Oceanographic Museum in Monaco in April 2011. Both of these projects gave me the opportunity to explore issues that I care deeply about and to examine in my own practice through the methods of other artists.

The Monaco project focused on how visual artists have seen the ocean historically and how our understanding has changed. The ocean is no longer considered a vast and savage realm to be dreaded or conquered, but a fragile and finite ecosystem under tremendous environmental stress. I selected artists who are not afraid to take a stance, to speak with clarity and complexity. The show was organized into five chapters: "Captain Nemo," which explores the duality of that melancholy figure; "The Uncanny Sea," which highlights the marine realm as explored in Surrealism but also looks at the strangeness of divergent life forms; "Davy Jones's Locker (Sunken Treasure)," which is a collection of marine art from the New National Monaco Museum that I curated; "Travels on Imperiled Seas," which features contemporary artists considering the ocean environment; and "From the Expedition to the Aquarium," which is my intervention at the Oceanographic Museum. My project includes 15 earlier works engaging the ocean as a theme, as well as a vast, new cabinet constructed to hold and discuss the heritage of the museum and safeguard it from future disastrous renovation. The goal of "Oceanomania" is to help chart and understand how artists can respond to and participate in the global environmental crisis. When someone looks back from a future of depleted seas, coral graveyards, and vast dead zones, I would like them to know that not all artists were fiddling as Rome burned.

Center for Land Use Interpretation:
Learning from the Cultural Landscape

by Glenn Harper

Matthew Coolidge says that the Center for Land Use Interpretation (CLUI) investigates how human beings interact with the surface of the earth. He founded the organization when his studies in geography and geomorphology stretched beyond traditional disciplinary bounds and began seeking out "interpreters of our position here on earth that were outside of the normal views, people who often were artists."* From its base in a Los Angeles storefront office, CLUI creates exhibitions, conducts tours, maintains an archive (the Land Use Database), and sponsors the American Land Museum (a network of regional landscape exhibition sites in development across the U.S.).

CLUI's programs have included a number of provocative and thoughtful presentations on the environmental impact of land use, including studies of erosion and waste disposal, and its exhibitions have documented such subjects as "Pavement Paradise: American Parking Space" and "A View into the Pipe," an excavation exposing Los Angeles's main sewer pipe. The tour "A Trip to the Dump: Riding the Waste Stream of Los Angeles" offered a journey down the waste stream, from curbside to transfer station, to the largest landfill in the region.

CLUI, image from "Ground Up: Photographs of the Ground in the Margins of Los Angeles," 2003.

CLUI, image from "Urban Crude: The Oil Fields of the Los Angeles Basin," 2009.

Neither an environmental group nor an artists' collective, CLUI designs its programs to promote an awareness of the significance and results of land use practices and policies, rather than staking out a specific activist or aesthetic position. In keeping with that strategy, CLUI relies on artists in its exhibitions, workshops, and residencies to provide a platform for the interpretation and investigation of human practices and their environmental results.

Curator Denise Markonish, who included CLUI's "Massachusetts Monuments" project in the Mass MoCA exhibition "Badlands: New Horizons in Landscape," explains that "sustainability and [the] politics of land use are at the forefront for artists who look at how people use the landscape." CLUI's projects exploring oil fields in Alaska, Texas, and California clarify its process. Without any overt environmental agenda, "Urban Crude: The Oil Fields of the Los Angeles Basin" demonstrates the extent of oil drilling still going on within the city in terms of its proximity to populations, schools, and alleged cancer clusters. It also documents the moveable buildings used by the oil companies as camouflage for their rigs.

In "The Formations of Erasure: Earthworks and Entropy," CLUI collected recent photographs of 1970s Land Art works that have not been maintained. The images reveal that these projects "have receded from the pure, intentional form of the artist's idea, into a new dynamic form that represents a collaboration between humans and the nonhuman world." According to curator Sarah Simons, "An earthwork is there whether you can see it or not. When it becomes invisible, all that is happening is that the site rises as a component in the work."

David Pagel's comment (in the *Los Angeles Times*) on one CLUI project can also be applied to all of the group's activities: "Although there is not a single work of art on display, 'Pavement Paradise' does art's job efficiently and with significantly less to-do than usual." Kyeann Sayer (at <www.treehugger.com>) confirms the impact of CLUI's work: "Checking out their exhibits (on-line or in person) can result in that feeling you get when you finally see the image hidden in a Magic Eye graphic…suddenly you have a point of view that tweaks conceptual divisions among landscape, land, and culture that you previously took for granted."

Notes

* KNME Public Television, Artisode 2.1.

Nothing is More or Less Alive:
A Conversation with Eduardo Kac

by Carrie Paterson

Since the early 1980s, Eduardo Kac (pronounced "Katz") has created challenging combinations of the biological, the technological, and the linguistic, raising important questions about the cultural impact and ethical implications of biotechnologies. An innovator and pioneer of forms, he began experimenting in the pre-Web '80s with works that used telerobotics—systems of remote communication linking software, invented hardware bodies, and live creatures with humans. Telerobotics and "telepresence"—his term for the human embodied experience of these works—emerged in wider view in the 1990s, preceding even more radical work in bioart. In addition to transgenics, bioart also includes the biotechnological, in which biology and human networked systems cooperate in synergy toward new modes of expression in living beings.

Kac's work addresses issues that we all struggle with today, especially in regard to the place and impact of humans within ecosystems. His bioart confronts received ideas about evolution, human/animal relationships, and human/plant communication, offering new perspectives on the confining binary thinking that considers "self" and "other" as intractable categories. Through his practice, we see ourselves as components of larger organic systems that include non-humans, transgenic creatures, and our own technology.

Carrie Paterson: *Is bioart experiencing its coming of age?*
Eduardo Kac: Bioart will need decades to complete the initial process of arriving. More discourse and practice, as well as a basic repertoire of works, need to be established to define the field. Most critical discourse has made little room for bioart, its concerns or its forms. A space has been opened for it, but it's still far from the mainstream.
CP: *Where do you see yourself situated within the disciplines of art and science?*
EK: There is a general perception that I'm a science guy—but I'm not. I have no specific investment in science. Poetry and philosophy form the axis of my work.
CP: *Can you clarify what you consider to be the crucial differences between art and science?*
EK: Science is based on hypothesis, testing, and development of truth, and most importantly, the repeatability of this procedure. Art is a singularity. Art is about what happens at that very moment when we create it or experience it.
CP: *How do you understand the two disciplines to interact, and how do they collaborate with each other? It strikes me that while many artists use science as a jumping-off point for philosophical and aesthetic investigations, what you do is different.*
EK: I don't see myself involved in a conversation between art and science. I simply make art. Many artists would be perfectly happy to make a series of works "about" a phenomenon, and most audiences are comfortable with that procedure. But representations of an idea are far removed from life forms. When a bioartist creates life, it is not a metaphor; it is literal. Bioart undoes the metaphoric system of art. Of course, since at least the late 19th century, artists have been questioning conventional representation. Magritte's *Ceci n'est pas une pipe* is a radical attack on the semiotics of art. Bioart, however, has a radical materiality at its core. It's not to say that language can be rid

of metaphors—our thought process cannot escape metaphor. But, to be clear: the practice of bioart is not the creation of visual metaphors; it is the creation of real life.

CP: *Your telepresence project* Ornitorrinco, *which you started in 1989, dissolves the need to use language to encounter another body, and the viewer literally inhabits this other body and communes with it. Why did you call the robot after the platypus?*

EK: I wanted to signal "hybridity." The platypus is perceived by the general public as being a hybrid between a duck and a beaver, but it's not. It is itself. We don't need to decompose the animal into two familiar, harmonious parts to understand it.

CP: *The body of the robot doesn't make any formal reference to the animal, correct?*

EK: *Ornitorrinco* is a completely invented body. It's not meant to represent; it is itself a new hybrid.

CP: *Your use of the word "signaling" seems appropriate considering the development of what you have referred to as "Internet ecology." Can you explain the nuances of that term?*

EK: By "Internet ecology," I mean two things: first, my work has always merged two entities often perceived as disparate, namely nature and technology; second, the network is an ecology in the sense that it is a shared finite resource, like a physical environment.

CP: *And* Ornitorrinco *was created for a very specific environment.*

Teleporting an Unknown State, 1994–96. Telepresence work with live plant, Internet, server, video projector, and Web cams, dimensions variable.

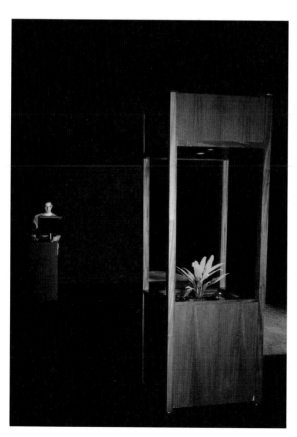

EK: Yes. *Ornitorrinco* was born to exist in a ubiquitous network environment.

CP: *How does the displacement of human consciousness into this environment affect participants in the work?*

EK: My hope with *Ornitorrinco* is that you experience certain insights: that you can entertain multiple subject positions, that these subject positions are fluid, and that you can navigate them. *Ornitorrinco* is not a simulation. It is a stimulation. It's not about using robots to experience things that we can do already. It's about creating new modalities of presence.

CP: *Is this where your concept of "telempathy" originated? Where the viewer is immersed in the environment of the "other"?*

EK: No, that came from *Telepresence Garment*. It's the opposite gesture from *Ornitorrinco*. When you wear the garment, you become the telerobot. Other people are in *your* body. If I perceive the potential for a system to become locked into "self" and "other," I will undo it.

CP: *In* Telepresence Garment, *you inhabit an environment controlled remotely by others. You get input through an audio receiver, and you enable the act of vision through a small camera attached to your left eye, but you can't say any-*

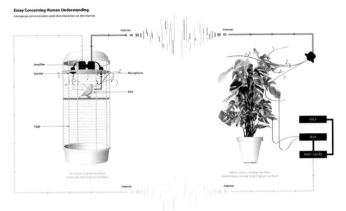

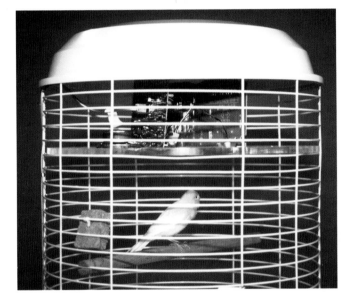

Above: *Essay Concerning Human Understanding*, 1994. Networked interspecies communication with live, bidirectional, interactive, remote sonic exchange between a bird and a plant, detail of installation. Top: Connectivity diagram.

thing or see because you are bound in a constraining fabric.

EK: You become a sort of cell.

CP: *The other person sees from the perspective of* Telepresence Garment. *Is this how telempathy is created, or does something besides the visual drive this connection?*

EK: The remote participant present in your body sees through your eye and whispers directions in your ear. You've lost almost all sensorial feedback. The other who is in your body now has to take care of you.

CP: *So empathy arrives through the act of caring for the "other"?*

EK: Caring for and putting yourself in the position of the other, in spite of the distance.

CP: Teleporting an Unknown State, *which you began in 1994 and presented in 1996, extends the concept of telempathy to non-humans. This piece required a cooperative community of Internet users with Web cams to broadcast light from the sky to a seedling in a gallery in New Orleans. Tell me more about how this piece connected viewers to the life of the seedling.*

EK: Without the photons from the social network, the plant would die. When viewers walked into the gallery, they could not see the projector that was transmitting the sunlight, only its cone of light coming through a circular hole in the ceiling onto the seedling on a bed of earth. The circularity of the hole and the projector's lens were evocative of the sun breaking through darkness. Then, the slow process of plant growth was transmitted live to the world via the Internet for the duration of the exhibition.

CP: *This is another example of "Internet ecology." I'm curious about how these two systems come together. Is there a historical reference that unites flora and the Cartesian grid that we have come to develop as the global mapping device of the Web?*

EK: Do you know La Mettrie? In *L'Homme Plante* (1748), he proposes an equivalency between man and plant. He writes about alternate methods for locating subjectivity, beyond Descartes's mind-body dualism. He opens up the Enlightenment.

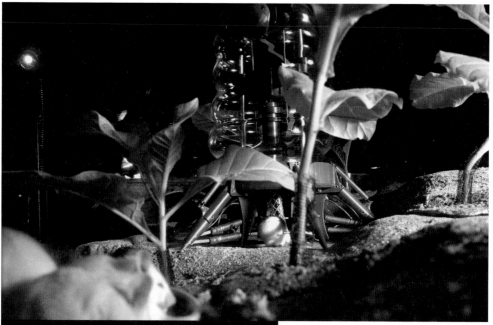

The Eighth Day, 2001. Transgenic work with biobot, GFP plants, GFP amobae, GFP fish, GFP mice, audio, video, and Internet, dimensions variable.

CP: *La Mettrie relates to your* Essay Concerning Human Understanding *(1994), which was included in your show "Life, Light & Language" (2011) at the Centre des Arts outside of Paris. How is the piece exhibited?*

EK: At one location, there is a bird in a cage, which sings through the Internet, and another facility houses a plant on a pedestal. The plant is exposed to the singing of the bird and, in response, produces sounds that are transmitted back to the birdcage.

CP: *I was interested to read in the* Leonardo Electronic Almanac *that you monitor the plant's vital signs using electrodes and translate its responses to the bird song using software originally designed for people.*

EK: Yes. The program was designed to detect human mental activity, but here it is employed to inspect the vital activity of an organism generally understood as devoid of consciousness.

CP: *So, the plant becomes a mirror for the human consciousness observing it. But the piece is a closed-loop system in which humans cannot directly participate, correct?*

EK: I will not discriminate against humans, but the work is for the bird and the plant.

CP: *This is a beautiful idea—to create systems of aesthetic exchange that go beyond human sensory capacity and involve*

the living presences of other beings, as well as their well-being. How did you arrive at this concept?

EK: I started to ask myself a string of questions. What could art be like if it recognized possibilities for sensorial experience other than the human, if we created art for non-humans? Would we be able to identify aesthetic experience in non-humans? If so, would we not be able to learn from these creatures and create other kinds of art for humans? Understand the richness of the non-human world and recognize aesthetic experience that is particular to them? This is the challenge that I presented to myself about 20 years ago.

CP: *We haven't talked about* Genesis *yet, and perhaps this is a good segue — the idea of a creature experiencing the aesthetics of its environment in its own way. I'd like to focus on the idea of the textual body as it becomes conflated with the* Genesis *bacteria. In* Genesis *and other works of bioart, do you mean transgenic creatures to be considered as "living literature"?*

EK: Texts do not exist until they are in the environment for which they are written, which in the case of bioart is a living organism. When texts are encoded as DNA, they realize themselves as functional genes in a living body. So, in this sense, yes.

CP: *But do you consider the bodies of the* Genesis *bacteria as texts?*

EK: I don't. The text is the part that I write and that both humans and bacteria mutate; I create the text specifically for that environment — the bacteria body. It is in the service of the living.

CP: *The biblical text translated and transmutated by the bacterial body is the so-called "dominion passage." Others have questioned your use of this excerpt in terms of what it might suggest ethically, about humans manipulating or having control over other species. What is your response to that line of thinking?*

EK: In terms of ethics, any human being who believes that we have any power over bacteria is full of himself or herself. In the event of a nuclear holocaust, bacteria would live on, and evolution would continue anew. The extra-biological feature of containing a text, and that this process creates a chimerical figure — all of this is a relatively small gesture when you consider life on earth and evolution. There isn't a sense of control or dominion over bacteria. The work asks whether we are *their* minions.

CP: *You've commented before on the fact there are 10 times more bacterial cells in our bodies than human cells. This is really hard to imagine.*

EK: We have 10 trillion human cells and 100 trillion bacterial cells, and we would be better described as a symbiotic unit, or a network. We are ambulatory ecosystems. One thing we have learned from the genome project is that we have to look beyond the chromosome to the "hologenome." What we are in the world is a consequence of our co-evolution with the bacterial cells in our body, and with viruses. The transgenic has historically been figured as the monstrous "other." But we now know that we have genes from bacteria and viruses in our chromosomes. When we look at ourselves in the mirror, we should realize that we have always been transgenic.

CP: *Recognizing this would encourage a new kind of empathy for transgenic creatures, particularly those who arrive through your work to challenge our semiotic system. How would you like people to engage with* Genesis, *for example, in terms of empathy?*

EK: I'm trying to develop empathy in simple ways — you look at the other, and you perceive your relationship to the other. The *Genesis* bacteria did not exist in the world before I created them. In the gallery, they glow and you glow, because in addition to the special UV light for the bacteria, I also use regular black lights. Through this mutual glowing, you stop looking at bacteria as different and notice similarities. This is a starting point, and everything else flows from this.

CP: *Once this transgenic creature presents itself, there are new ethical dilemmas. You have written about "performative ethics." Can you explain this term?*

EK: "Performative ethics" is not meant in the sense of performance art, but in the sense that it involves your actions — it is ethics in action. The ethical imperative is intrinsic because the work is alive. One could say that ethics is or should

Natural History of the Enigma, 2003/08. Transgenic work with Edunia, a plantimal with the artist's DNA expressed in the red veins of the flower, dimensions variable.

be a concern in every sphere. But you have to be careful because that statement assumes that everyone has the same definition of the word. The same problem exists for the word "beauty." One could say that, in art, ethics should somehow be a part of aesthetics—however, when you are dealing with real life, ethics cannot be an afterthought. You are creating a living creature no less alive than yourself. It may not have neurons, but it is not less alive. There is no "more" or "less" alive. This is the first thing a bioartist has to recognize.

CP: *What about the whim of the creator? Can you kill something that you've made when you believe it's appropriate, for example, after* Genesis *has been shown and the exhibition comes down?*

EK: Yes, you can kill something, but you have to take this on a case-by-case basis: apply the logic of your garden to people and you would have a holocaust. You have to be very careful if you extrapolate the killing of the bacteria after the art exhibition into other spheres. If I wash my hands, I kill bacteria. The clear problem is in the rhetorical gesture of deliberately confusing say, bacterial killing, with other kinds of killing, not in the use of biomedia.

CP: *I'd like to hear more about the larger political implications of this part of your practice.*

EK: Politics is about relations of power: who has the power, who controls it, and to what end. Discourse is used politically to control hearts and minds. We are living in the age of what Foucault called biopolitics: the moment in history when governments control biological systems. What kind of control is handed over to a company like Monsanto, to the detriment of the environment? There is no positive outcome except to the shareholders of the corporation. So, when an individual (the artist) creates work that defies the logic received from the dominant political and economic system, the work clearly states that the world can and should be a different place.

CP: Cypher *(2009), a home kit for transmutation of one mysterious poetic line, continues with "performative ethics." Can you give an overview of the kit?*

EK: *Cypher* brings together my different interests, from the construction of the kit to the code. The sculpture is completely handmade. It opens like a book and has a booklet inside. The centerpiece is a poem encoded in the DNA inside bacteria in a vial, which is translated into English in the booklet.

CP: *How do you engage language differently in* Cypher *and* Genesis?

EK: In *Genesis*, I made a code, a conversion principle to translate biblical text that exists outside the code. In *Cypher*, the text is the code; the code is the text.

CP: *It reminds me of a Flux Kit.*

EK: It's unrelated to Fluxus because all the technology is literally at your fingertips. It's a mini-lab—not for contemplation, but for action. There is a political dimension in the DIY aspect of the kit. Are you prepared to do this, or are you not, and what does this mean? You are taking things into your own hands. This signifies a counter-gesture. If an individual carries out this gesture and shares this opportunity with others, the work is pregnant with possibility.

CP: *What you're saying relates back to the ethics question. When you ask viewers to empathize with the position of the bioartist and to have some responsibility for the bioart that they create, they also must answer the ethical questions in the first person. But let me ask you a different question—in terms of poetry, what does the kit ask of the user?*

EK: The kit asks if you are prepared to engage with another modality of art and poetry that doesn't conform to the traditional readerly act. You're invited to literally give life to the poem.

CP: *All codes are meant to be transmitted and read. They are secret and imply an imperative for reading the text. What is the imperative implied by the kit, if it departs from the standard experience of being a reader?*

EK: To engage in a first-person perspective with these technologies. Otherwise you leave them in the hands of others, and you will always be the recipient of those narratives. You will never be able to philosophize with a hammer, to sound out the idols, to seize the tools to come up with your own narratives.

CP: *Would you situate yourself within or perhaps adjacent to 21st-century practices like experimental philosophy and field philosophy?*

EK: I'm not a philosopher, I'm an artist. But, I have said that art is philosophy in the wild. The kind of art that I'm interested in making is engaged and transformative of the material world. Art is philosophy in action. Consider Edunia, the flower that I created for my transgenic work *Natural History of the Enigma*. That flower, as an ontological hybrid between plants and humans, is now there, and the community of life opens and welcomes it. It's a double gesture—both poetic and philosophical.

CP: *The handmade paper sculptures in* Edunia Seed Packs *take the form of winged creatures—like butterflies or bats. They seem to reference transformation and sensory perception beyond human capacity. Why did you choose these forms?*

EK: I don't see them as winged creatures. You could, for example, say that they open like books. I think that they can be different things for different people.

CP: *Is there anything else you want to say about your central concerns as an artist?*

EK: It's important to open discursive space, but not lock yourself in. We need to be aware that everything is in perpetual transformation. We have to develop modes of existence that are comfortable with this state of flux.

We Are the Landscape:
A Conversation with Steven Siegel

by John K. Grande

Using pre-consumer and recycled materials—discarded newspapers, crushed soda cans, empty milk containers, and shredded rubber—Steven Siegel creates public art and site-specific installations in natural and urban contexts that reinvent the role of sculpture for an eco-conscious planet. Connecting art-making and environmental processes, he builds impressive trash sculptures that reflect the deposit-and-decay cycle that underlies the making of the land. His multi-layered newspaper ridges and large boulders made of compressed cans and plastic bottles awaken awareness of the sheer scale of consumer waste in a beautiful, integrative way. Installed across Europe and North America, as well as Asia, Siegel's works prompt dialogue about society, landscape, and form.

John K. Grande: *Your sculptural production has been considerable, with commissions in numerous public and private venues. Many of your projects approach sculpture through process, with a sensitivity to the specific environment. Can you give a few recent examples?*
Steven Siegel: The suite of pieces for Grounds For Sculpture presented a challenge because it is a very manicured setting, not the sort of place where I normally work. I managed to find an out-of-the-way place that was a little rough,

Grass Paper Glass, 2006. Grass, paper, and glass, 3 cubes, 8 x 8 x 8 ft. each. View of work at Grounds For Sculpture, Hamilton, New Jersey.

Like a rock, from a tree?, 2008. Newspaper, 8 x 40 x 12 ft. View of work in Gongju, Korea.

and we enlisted many people—paid staff and volunteers—to help with the project. Typically, when I work on a site, the first thing I ask about is the kind of free material that might be available in large quantities. The staff found a huge quantity of glass from a nearby factory that was going out of business. That became the starting point for the work.

JG: Grass Paper Glass, *the piece at Grounds For Sculpture, presents cubes or containers that are, and contain, the raw product refuse materials that you used to make them. Do you consider this sculpture to be a comment on economies of scale?*

SS: Most things that we do as a species have an enormous impact on the environment. When I went to see what was available for the project, there were 10,000 pounds of glass waiting. It was a challenge to come up with a plan for materials that were foreign to me. The entire project was predicated on what I had to start with—the glass. Because the glass pieces were a foot square, the thing that came to suggest itself was a cube, and I decided that three would be more interesting than one. This glass was material that a manufacturer had overproduced and was going to throw out. Overruns and unusable material are normal. If you look at the work, you are looking at an infinitesimally thin slice of the solid waste stream. The other thing that Grounds For Sculpture does very well is landscaping. The grass cube, for example, has both internal and external irrigation systems running through it.

Typically these projects require one or two paid skilled people, but then we also get a lot of volunteers. They can be students, or they can be retired. It all depends. It becomes a communal activity for several weeks, and the work is designed, in part, to meet the skills of the participants.

JG: *The configurations of your works come about as a result of getting to know a place, the land that you are using. Do you have a preconceived idea before you visit a site like Yatoo, in Gongju, Korea, before you start working?*

SS: I will have an idea, particularly if I have just learned something from a particular process that I want to continue. I recently did a paper piece near Mirabel in Quebec that had a flat top, and this seemed like a good starting point for the piece in Korea. It is about evolution and process versus concept—how things evolve over time.

JG: *You recently made a piece in Wyoming. Does that use newspaper again?*

SS: No. It is a configuration of 30 cubic yards of wood mulch, representative of my interest in evolutionary biology. I call these works "container pieces" because their means of organizing materials is more akin to biology than geology. Recently, my interest in science has moved toward life and evolutionary biology.

I have slowly been moving away from paper for 15 years, but the paper pieces are popular. I will continue to do them as long as there are interesting sites in new places. My discovery of paper as a medium 18 years ago grew out of an interest in sedimentary geology. I was thinking about how we reintroduce materials back into the landscape, specifically in landfills. What would geology look like in a few million years? I made the first newspaper piece near my home in New York State and referred to it as *New Geology*. I started with one newspaper and began stacking them. It was very labor intensive and involved tons of newspaper, and it was very much about accepting the process. *New Geology* was time-related if it was anything. Weather, climate, and the seasons all acted on the piece. The paper would freeze solid in winter, fade and expand with the effects of rain and forest light. The paper withstood a lot.

JG: *You exhibited a new series at the Turchin Center for the Visual Arts in North Carolina (2008) that addresses your interest in evolutionary biology.*

SS: I completed "Wonderful Life," a group of 52 wall pieces, six years after I accidentally got into it. It is about the simple, cumulative changes that generate form, from generation to generation. There being no wolves, competition for mates, or climate change to force natural selection in the studio, the artist's eye served as the determinant, what we used to call sensibility. The title is borrowed from Stephen Jay Gould. He described the matrix of life forms found in the fossil record of the Burgess Shale in British Columbia as containing a variety perhaps never surpassed in the history of our planet.

JG: *The layering of our landscape includes manufactured refuse, so what we call "natural" may, in fact, not be natural at all.*

SS: I don't really believe in the word "natural," because I believe that we are the landscape, not only by our physical presence, but also by the messes we leave and the way we reconfigure all of the material around us—from the roadway

This one is flat, 2008. Newspaper, 7 x 25 x 10 ft. View of work in Mirabel, Canada.

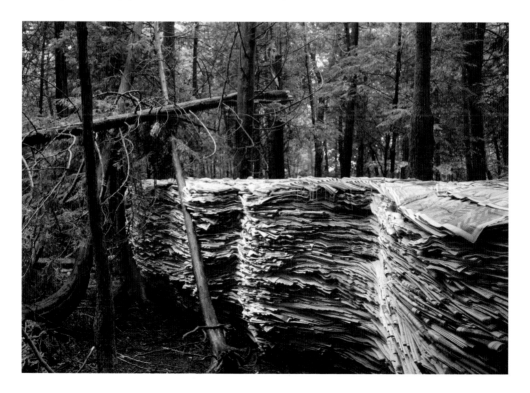

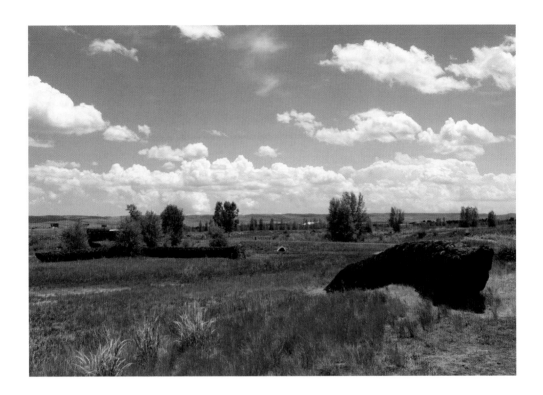

It goes under, 2008. Wood mulch, wood chips, and window screening, 250 ft. long. View of work at the University of Wyoming.

to the recycling of cans to nuclear waste. Our presence is there in every molecule. My interest in geology eventually evolved into the next step. Many of the raw chemicals found in rocks eventually sparked life, which as it evolved became increasingly complex. The first reproductive cell was infinitely more complicated than any stone you will find on the mountain. So, as a metaphor to work from, life enables one to organize materials in much more complex ways. It opens up whole new horizons. The generation of form is paramount for me. All of my interest in science, and the politics and social and ecological issues, is there, but aesthetic concerns are at the top.

JG: *So, your work is quintessentially sculptural, with a sensitized understanding of the specific environmental context. Is the Wyoming piece,* It goes under, *more like a bioform?*

SS: If your organizing principle is layering, you limit the kinds of materials that you can use: newspaper, flat stone, and maybe some industrial materials. Life, unlike the landscape, is not about layering. Life is about containers. Starting with the atom, the molecule, the cell, a tree, even humans—all of these elements are containers. This means that you can stand up and function, from your DNA right up to your eyeballs. It is all incredibly complex. Understanding how all this is built through the process of evolution serves as an over-arching metaphor. *It goes under* is part of a series that I have been working on for years.

I have come to believe that the evolution, the refinement, of a craft is very similar to the evolution of a species. Natural selection, environmental influence, mutation—these things are there. A craft evolves because it is easier this way, or that tree was in the way, or we needed the water to stay off this part. There are parallels to the natural world. Once a craft gets established, I get bored with it and want to invent another one.

JG: *The Wyoming sculpture partly disappears and gives a sense of flow into the landscape.*

SS: The original plan used a modular system, and the framework was prefabricated in the museum's woodshop. All

of the sections were made in advance, to be assembled on site, where they could be put together in whatever configuration I wanted. We got about two-thirds of it framed, and the Laramie River flooded. For one week, the site was inundated with water. We couldn't work anymore, and I was ready to go home before it occurred to me that we could work on the other side of the water. The piece appeared to dive down into the water and come up the hillside on the other bank. When the water receded, we went back and finished the first part. With no water there, it looks like it dives down into the ground and comes back up at another place, hence the title.

JG: *Nature intervened directly in* It goes under, *contributing to the process and final form of the work.*

SS: I have discovered that when the site generates the form, it is more interesting. These works are particular to the sites where they were built.

JG: *You mentioned a newspaper piece in Quebec. Were the trees part of the support structure?*

SS: No. The trees configured the piece as they did for my recent Korean work. I decided that a level top would contrast with the slope of the forest.

JG: *So that relates to the skyline or light.*

SS: It relates to horizon. If you walk through a landscape, you are vertical, or plumb. When you look at a slope, you are aware it is sloping because your eyes are level. The flat top on this piece sets off the landscape and everything around it. At Yatoo in Gongju, south of Seoul, I did something similar. The sculpture is on the steep hillside of Mount Yeonmisan. There are huge boulders on the hillside that make the piece.

JG: *What are you working on now?*

SS: I am currently working on a studio project, a single piece of indeterminate length that should keep me busy for a few years. It has the working title *Biography*, and it is very crazy and exciting. It represents the evolution of an object within the physical constraints of the object. It is a timeline, like a landscape, with references to many things that have interested me, and it involves many of the materials that I have used in the past.

JG: *What is it that makes a sculpture work?*

SS: I would like the visual arts to be appreciated in the same way as music. If it needs to be explained, it probably isn't very good. Let's get rid of the verbiage, let it stand on its own.

The Art of Activism:
A Conversation with Barbara Hashimoto

by Collette Chattopadhyay

Barbara Hashimoto's recent work resides at the intersection of sculpture, consumer culture, and environmental concerns. She collects and shreds junk mail to build large-scale naturalistic forms that ironically resemble the earth itself. Using the seemingly limitless supply of printed advertisements delivered in the mail every day, these pieces expose the excessive use, and abuse, of natural resources.

Many people learned about Hashimoto's *Junk Mail Experiment* during a 10-month-long exhibition in the Chicago Arts District (2008). Conversation spread via the Internet, garnering the work not only local, but also national and international attention. During the fall of 2009, she created an installation at the Musée du Montparnasse-Paris at the request of Les Amis de la Terre, who championed her project for its commitment to using the earth's resources with prudence and care.

Collette Chattopadhyay: *Where has your work taken you since you left Los Angeles?*

Barbara Hashimoto: It's been a fruitful and very challenging time for me because my entire working situation is different. My work as an artist-in-residence at BauerLatoza Studio, a multi-disciplinary architectural firm in Chicago, has put me in a very different position. In Los Angeles, I was working alone. My working patterns in Chicago are different, and a new direction has emerged. I experienced something similar when I was in Japan, in terms of what kinds of space, equipment, and materials were available. I didn't have much access to ceramic facilities here, as I did in past studio locations, so I looked for something else to work with. Being at the architecture firm, I was looking for a project that would engage everyone. That's how I started *Junk Mail Experiment*, but it's taken on a life that I didn't really expect.

CC: *How did the project evolve?*

BH: When I began collecting junk mail, I thought that I would devote a year to the project. At that point, I couldn't imagine what would happen as one piece led to another. People started asking me to present my constructions in relation to things that they were doing. In the case of the Chicago Arts District project, they invited me to present the work for a month in relation to Art Chicago. But that initial one-month exhibition period ended up being 10 months. What excited me with this project was that it reached out to people and they then invited me to take the process somewhere else. That concept is very different from the ways in which I've worked before. I had not overtly discussed these kinds of environmental issues — wasting paper and the destruction of trees and forests — in my earlier work. These concerns, along with the exploration of privacy and consumerism, reach the hearts of many people who are working for social change. And, I'm not an activist.

CC: *Well, it sure looks like you are now. Tell me about the size and public appeal of these works.*

BH: I collected some 3,000 cubic feet of junk mail for the Chicago Arts District installation, which was a meditative and playful environment. People responded because everyone has something to say about the accumulation of junk mail in their lives. Activists and environmental groups came to see the work, as well as others who wanted to know what they could do. So, I'd share the names of organizations, places to sign petitions, or rallies to join.

White Trash, 2008. Shredded junk mail and Japanese tansu chest, 5 x 16 x 6 ft.

It was a huge space, very visible and illuminated at night, so the exhibition could be seen 24 hours a day. Web-based social communities started video sharing and blogging. Environmental group and individual Web sites spread the word. Someone came at night, photographed the exhibition through a window, and put the pictures on Flickr. That's how news of the work reached Paris, and the French environmental group Les Amis de la Terre asked me to collaborate with them.

CC: *Does* Junk Mail Experiment *have conceptual links to some of your earlier projects? In* Tokyo Bay Project, *you were taking something unwanted or undesirable and transforming its perception in society. Do you see synergy between these works?*

BH: They are dealing with different conceptual issues. *Tokyo Bay Project* was about the conflicts and reconciliations of a place associated with war, making a place of contemplation at a site that had been used for military embankments on the mouth of Tokyo Bay. I created something similar in that space in as much as the place was a mess, a dumping ground. At the time, I was studying Zen Buddhism, and part of Zen practice—especially when you do a retreat—involves cleaning the temple before you pray, even though it's always spotless. Cleaning the temple, preparing the space, was also part of my job as a studio apprentice in Japan in the early part of my career. That led to a foundation for how I work.

I felt something very strong in the spaces at Tokyo Bay. I wanted to clean them out, and after I did so, I filled them with materials from the area as well as with saffron monk's cloth. I wanted to create a type of sanctuary for meditation, like those I had seen in the countryside in Thailand—very sparse, very clean, and very simple. I realize now, in thinking about this in relation to *Junk Mail Experiment*, that that's what I wanted to create in both of these installations. I wanted people to come in and be in the space with the material.

CC: *The relationship of the junk mail project to feminist dialogues also seems interesting, in terms of picking up, cleaning up: activities traditionally assigned to women. At the same time, the junk mail works seem both whimsical and hilarious in ways that break standard meanings—for instance, the burying of the piano under junk mail and the muffling of sound and its associated meanings.*

BH: The performance piece still remains my favorite part of the whole experiment so far, and it happened very early on. It was my first public presentation. It was one of those moments when everything came together simply, without extensive labor. I had just started to collect junk mail in June, and we did that performance in October 2007. I have

a concert grand piano in my studio by default. That's where it was (in the building), and of course, it's a beautiful instrument.

I often work late at night, shredding and shredding. You know how that moment happens, when you look at something and then you look at something else and it just comes together? That's how I knew that I wanted to build an installation using the piano. I started playing around at night, tossing shredded junk mail onto the piano, playing the piano, and then noticing how everything was muffled. I knew immediately that I wanted to do a performance with somebody playing and me building the installation. Edward Torrez, a principal of the architecture firm, is also a musician. I approached him, we had a little dialogue, and he knew exactly what I wanted. We had one rehearsal. For the performance, he played one of his own pieces, and it became a duet as we responded to each other. Someone shot it straight on with one video camera, not editing anything, and that's how it was recorded.

The junk mail, of course, just kept coming and coming. As my movements became frantic, he played in a way that responded. As a conclusion, I lay down and "fell asleep" in the mound that had been created. At the end, I got up, and he unburied himself as people clapped. Then there was a surge, begun by children and followed by adults, as people started jumping and playing in the mounds of junk mail. The children built nests, and by the end of the reception, everyone was in there.

CC: *What did you plan for Paris with the junk mail project?*

BH: First, I went to work with the space and to see what had evolved. Before I arrived, Les Amis de la Terre organized groups of children to collect junk mail. They brought the material to the exhibition space about three or four days before the opening, and we started building and shredding there. I invited the community to participate in the process. They also asked me to do a performance. I didn't plan anything specific—I wanted to let the space and the whole process speak to me. In Chicago, I was able to control every aspect of how the work was presented, from the lighting

Dango, 2010. Shredded junk mail, 20 x 23 x 50 ft., approximately 24 in. diameter each.

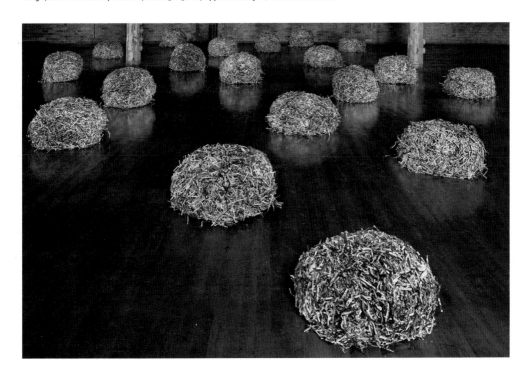

Junk Mail with Grand Piano, 2007. Video stills of performance with Barbara Hashimoto and Edward Torrez.

to everything else. The Paris project, by contrast, was a real collaboration and a huge risk because I left it up to them to bring the junk mail to the site.

CC: *Another issue that's interesting in relation to this body of work is the subliminal emphasis on the abject as manifest in your rescuing, salvaging, and making art from things that are usually tossed out and assumed to be irrelevant. That, of course, lends irony and poignancy to your junk mail projects.*

BH: I want to do some large weavings and cast sculptures made of paper. I have all this material that I want to use and remake into something else. I really want to get into the studio and experiment more. After working with these environmental issues, I can't just take this stuff to the dump and trash it. It's a problem because I have hundreds of garbage bags and people in the studio don't like it. They want it out of here.

CC: *Have the junk mail pieces moved your work from its earlier, material-centered focus toward the transitory and ephemeral? The furrows, rows, and mounds that you created in* Junk Mail Landscape *in the Chicago Arts District exhibition have disappeared. How did you come to be interested in the ephemeral in sculpture, and are you at peace with transient physicality?*

BH: That's interesting in relation to basic Japanese artistic processes. As you know, I have worked for a long time in ceramics, which is probably one of the most durable of all mediums. While I was training in Japan, I naturally became interested in the tenets of wabi-sabi, one of them being the imperfect and the ephemeral. I really pushed the ceramic medium in that way, so I don't see such a huge shift. Of course, my past installation work was transitory. The materials for *Pink Tatami*, which I did in Japan, were returned to a farmer as straw matting that went back into the earth as compost. However, I am also interested in creating works that will last longer, and one of my dreams would be to take that mass of junk mail and turn it into some kind of permanent public art piece that would tell the story of one year's collection of junk mail.

Bob Johnson: Putting Trash in Its Place

by Twylene Moyer

Bob Johnson defines his approach to public art as "artful trash management." Since 2003, the artist/philosopher has been creatively harvesting waste streams, culling detritus gathered during river clean-ups in order to produce *RiverCubes*. Each one of these compacted compositions repurposes hundred of pounds of discarded goods, everything from tires, wheels, and shopping carts to bikes, bumpers, rope, farm implements, and consumer electronics.

Conceived as "ecoventions," these practical works combining art, ecology, and social action begin with river site scouting and relationship forging. Visits to solid waste management facilities glean information about local practices and identify operations willing to lend equipment and staff to the crushing process that forms the sculptures. Meanwhile volunteers gather raw materials during community revitalization efforts, gaining firsthand understanding of improper dumping and its effect on water quality, as well as waste reduction strategies and alternative means of disposal. In addition to the *RiverCubes* themselves, Johnson's coordinated activities set into motion an ongoing legacy of education, awareness, and advocacy initiatives engaging urban youth groups, garden clubs, and students in art and ecology. Considered as independent artworks, the cubes eloquently critique the callousness spawned by affluence and the siren call of rapid obsolescence. Positioned along trails, near their points of origin, they stand as shocking, and sometimes uncomfortably humorous, testaments to a consumer culture run amuck.

As Johnson realizes, it is impossible to "manage" such accumulations, which sicken rivers and streams across the globe and threaten to displace entire communities. River clean-ups, while removing obstructive debris, must still dispose of all that reclaimed trash; hauled away to a landfill, it fades from memory, and we forget that our garbage has an afterlife. The only way to deal with unwanted materials is to change attitudes toward "waste," which Johnson restricts to use as a verb, not a noun. As artifacts, the cubes not only repurpose extracted garbage, they also keep it in the consciousness, offering indisputable evidence of destructive human practices. More than just sculptures made from garbage, the cubes cannot be detached from

Girty's Run Harvest, 2003–04. View of installation on trail at Three Rivers Rowing Association Millvale Boathouse.

Left: View of Three Rivers Arts Festival, 2004. Above: Volunteer Phil Matous at work.

their "native" environment without losing their purpose. Johnson is adamant about this point. Despite funding difficulties, he refuses to sell individual cubes to corporations and collectors unless they participate in the entire social sculpture process, and even then, they only sponsor "their" cube, which remains along the river—ownership is not the point.

Like other masters of re-purposing such as Nek Chand in India and Mohsen Lihidheb, a Tunisian artist and activist who collects trash along the Mediterranean and transforms it into large-scale installations, Johnson adapts outsider art strategies to catalytic public projects. His multi-pronged *RiverCubes* approach is particularly effective because it allows individuals to take charge of their environment and to initiate change for themselves. Though his efforts have mostly focused on the Pittsburgh area, he was recently invited to the U.K. by Shelley Sacks for a *RiverCube* reconnaissance mission, and future collaborative projects are in the works in Rome and Brisbane, Australia. Johnson hopes that *RiverCubes* and Artful Trash Management will point the way to as-yet-unrecognized methods and means of improving the health of our culture and our waters. In the meantime, his collaborative projects follow the restorative example set by Hayao Miyazaki's brave heroine in *Spirited Away*—to release a pure river from the filthy casing of a "stink spirit" requires nothing more than a willingness to roll up your sleeves, extract the foreign contaminants, and cleanse the muck.

Environmental Incentives for Public Art

by Twylene Moyer

As economies tighten and funds for new public art become scarce, artists have a new ally in the battle to win the hearts of developers and commissioning agencies—environmental benefits. Several recent projects provide demonstrable, "value-added" results beyond aesthetic considerations.

In Scotland, the Dundee City Council unveiled one of the first public sculptures to take advantage of a ground-breaking technology that could transform urban air quality. Though Dalziel + Scullion's *Catalyst* (2008) takes the form of a car, it rehabilitates that icon of pollution. Rather than making their life-size auto from conventional sculptural materials, Dalziel + Scullion, who are known for environmentally and ecologically attuned work, used photocatalytic concrete—a material originally developed in 2006 by the Italian firm Italcementi for an imposing white concrete church designed by Richard Meier. The addition of titanium dioxide (the main ingredient in the best white pigments) allows the concrete to clean itself, minimizing the need for maintenance, but it also has another, even more important ability—it eats surrounding smog. Extensive testing, much of it sponsored by European Union research into "smart"

Dalziel + Scullion, *Catalyst*, 2008. Catalytic cement, life-size.

FoRM Associates, *Northala Fields* (aerial view), 2003–09. Clean demolition spoil, plantings, and water, approximately 2000 x 1500 x 105 ft.

anti-pollution agents, has determined that construction materials containing TiO_2 (including concrete, plaster, paving, and paint) help to destroy pollutants released by car exhaust and heating emissions. The process works through photo-catalysis: sunlight touching a sculpture, a building façade, or a road triggers a chemical reaction that breaks down airborne pollutants, converting harmful nitrogen oxides into inert nitrates that drain off with rainfall and feed nearby plants.

A percent-for-art commission for a multi-story carpark, *Catalyst*, as Matthew Dalziel says, "point[s] the way to how cities with notoriously bad air quality...could, in the short term, mitigate some of the worst effects of air-borne pollutants." Since their introduction, photocatalytic concrete and other smog-eating materials have become increasingly widespread, as companies around the world develop products for use in public space. In the U.S., Sasaki Associates, a leading planning, landscape architecture, and urban design firm, issued a report in December 2006, advising Los Angeles (one of America's most polluted cities) to adopt TiO_2 concrete and other materials for its outdoor spaces.

When innovative materials won't suit a project, artists can give themselves an environmental edge by repurposing old ones. In 2007, Atlanta-based sculptor Dwayne Bass and green builder/developer Dave Radimann realized that public art could make a significant contribution to the recycling of construction waste. At Commonwealth Braselton, an industrial building in Braselton, Georgia, Bass constructed three tower-like works exclusively from materials found at the job site—a "very cost effective and environmentally beneficial" arrangement. Unused materials do not need to be removed from the site and dumped, nor do they need to be sorted and hauled away for recycling. Green builders and developers have another incentive to seek out artists: the U.S. Green Building Institute awarded Commonwealth Braselton a LEED (Leadership in Energy and Environmental Design) point for the sculpture. This kind of collaborative synergy could inspire more builders to seek LEED recycling and innovation in design credits, while providing artists with expanded sources for non-traditional materials and additional venues for their work.

In the U.K., FoRM Associates, a cutting-edge, interdisciplinary design firm led by artist Peter Fink and architect Igor Marko, has made creative waste disposal a key factor in its approach to livable urban environments. At *Northala Fields* (2003–09), a multi-use community park in outer London, FoRM provided open space and recreational facilities at no cost to taxpayers. The Borough of Ealing, which commissioned the project, acquired the neglected land in 1997 but

lacked sufficient funds for its redevelopment. Fink and Marko, in collaboration with ecologist Peter Neal, won an open competition in 2000 with a dynamic proposal that exceeded the borough's "Land Art aspirations." Their concept combined elements of "social participation, biodiversity, [and] cultivation" and, most crucially, incorporated 1.5 million cubic meters of inert construction refuse, which provided $10.5 million—enough to fund the entire project.

The process was complex: construction companies brought detritus from major building projects around the Southeast, including displaced material from Heathrow's Terminal 5 and rubble from the Wembley Stadium reconstruction, paying to dump at *Northala Fields* just as they would at a regular landfill. Using this material saved space elsewhere and shortened hauling time, saving resources and "contribut[ing] to shrinking the ecological footprint of London," Fink says. If *Northala Fields* had not claimed this construction spoil, 13,000 trips of several hundred miles to outlying dump sites would have been necessary, not to mention the amount of energy required to passively process such quantities of material.

Northala Fields' four grass-covered mounds, sited along the A40 highway, range from 60 to 100 feet high. A spiraling pathway climbs the tallest form, leading to an observation platform that provides views of London. Other features of the 18.5-hectare park include playgrounds, fishing ponds, bicycling and walking paths, and a boating pond. The new landscape also creates mixed woodland and meadow habitats supporting a variety of species (birds posed a special problem because of the site's proximity to an airfield). A new drainage system captures ground and surface water, feeding into recreational and ecological catchments that include an educational wetlands area. The use of recycled materials extends to every possible element of the park, from crushed concrete (gabion retaining walls and paths) to timber (seating and trash bins), plastic (path edging and fishing platforms), and reclaimed granite cobbles.

Though local politics briefly threatened the process when the borough government changed hands, residents advocated for their park and ultimately prevailed. FoRM stressed community involvement from the project's outset,

FoRM Associates, *Equating Ecologies*, 2008. View of proposal for a project in Quito, Ecuador.

cut & fill

FoRM Associates, in collaboration with AID Architects, *Izolyatsia Landscape Park Masterplan*, to be completed 2011. View of project in Donetsk, Ukraine.

recognizing that a genuinely sustainable park (or any other public endeavor) can only be developed through a commitment that outlasts political cycles—support for innovation must involve residents, the people who will use and enjoy these resources. With equally innovative proposals to reclaim an abandoned airport in Ecuador (*Equating Ecologies*) and transform a former coal and steel center in the Ukraine (Izolyatsia Landscape Park, scheduled for completion in 2011), FoRM proves that the desire for a greener, forward-looking public realm is almost universal—and attainable. Their success demonstrates the potential opportunities out there for artists who open themselves to collaboration and embrace inventive ways of approaching problems.

Off the Grid: Self-Powering Sculpture

by Elizabeth Lynch

Artists have long been at the forefront of sustainable energy technologies, using the sun and the wind, for instance, to power kinetic and light elements. Such self-fueled works not only fund themselves (a clear benefit in the eyes of cash-strapped commissioning organizations), they also provide important community services, educating the public about alternative energy sources and demonstrating environmental commitment. While this conservation-minded practice is commendable in itself, at least a few artists have begun to investigate its inherent potential: If you're using sustainable energy to power your sculpture, why not take the next step and use your sculpture to help power the community?

In Cambridge, Ontario, *Solar Collector* (2008), by Matt Gorbet, Rob Gorbet, and Susan L.K. Gorbet, responds to "the intersection between manmade artifacts and nature." Every evening at dusk, an interactive network of aluminum shafts—powered by solar energy and designed to mirror the sun's motion—lights up in a series of patterns created by individuals across the world through the Internet. The 12 shafts—arranged in an arc, each one supporting a series of LED lights and solar panels—are pitched at successively sharper angles. Their composition allows them to mark the summer and winter solstices. *Solar Collector* is installed near the "first LEED Gold-rated public facility in Ontario, for the Emergency Medical Services." The commissioning brief encouraged alternative energy, and the artists' interactive, on-line component enables the work to spread educational information about solar power. Matt Gorbet describes the

Matt Gorbet, Rob Gorbet, and Susan L.K. Gorbet, *Solar Collector*, 2008. Aluminum, glass prisms, solar panels, LEDs, software, and electronics, approximately 65 x 35 x 20 ft.

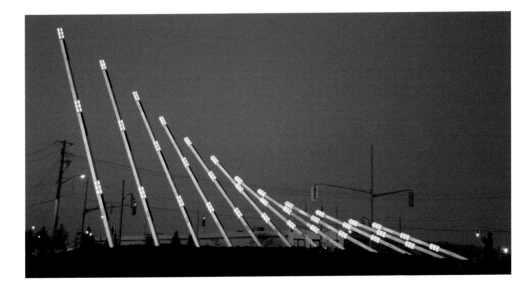

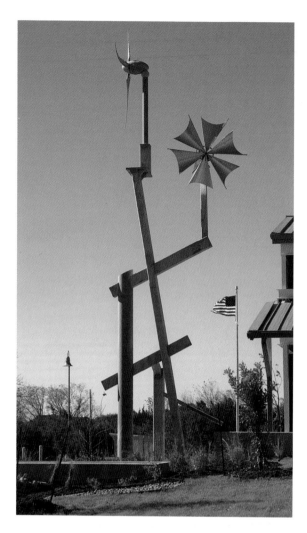

James Hetherington, *Elements*, 2007. Submersible pump, galvanized steel, oxidized and powder-coated steel, powder-coated aluminum, wind turbine, and water, 50 ft. high.

"two mantras" behind the work: "The form of the piece should reflect the forms of solar energy, and public art should be accessible to the public."

A project for California's San Diego-Coronado Bay Bridge also uses sustainable lighting to educate. Led by artist Peter Fink and lighting designer Mark Major, this collaborative work, which emphasizes connections to the surroundings of the bay, is slated for completion in 2014. The low, curved bridge rises over a suspension channel, and the team plans to illuminate each of its supports in a programmable array of lighting that will define the area. Using power from wind turbines, its energy-neutral lighting will respond to movement all around, shifting in response to the rate of bridge traffic and the passage of ships below.

At San Antonio's John Igo Branch Library, James Hetherington's *Elements* (2007), a kinetic sculpture incorporating a functional wind turbine, generates hydraulic energy to help power the building. Hetherington says, "*Elements* was conceived as both an energy demonstration and a work of public art...incorporating a contemporary windmill turbine, as well as a working, abstracted interpretation of a historical windmill." Commissioned by the city's Design Enhancement Program, the turbine in *Elements* "harvests power from intermittent wind sources to produce electric power." That electricity powers a pump circulating water through a channel flowing into the library and back to a reservoir. The waterway ties the sculpture to the building (which incorporates recycled materials and solar elements) and its grounds: "*Elements* synergistically combine[s] energy concerns, animal habitat preservation, and other ecological issues without altering the library's theme [of conservation]."

Integrating form, function, and context, public art should be a natural partner for sustainable energy, and not only in terms of education and demonstration. Iconic sculptural form, combined with movement, also has the potential to generate energy, and it is surprising that artists have not taken a leading role in the development of new prototypes for solar panels and wind turbines. While many people want sustainable energy, they object to the often clumsy, obtrusive appearance of solar arrays and wind farms. (Dalziel + Scullion's *Breath Taking* (2003), a photographic billboard project in cities throughout the U.K., explored this reluctance, responding to the heated debate sparked by planned wind farms.) There is an opening here, an opportunity to venture beyond explanation and education, and it is rooted

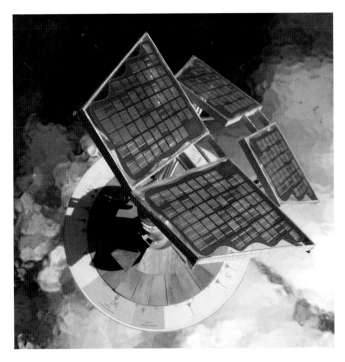

in aesthetics—familiar territory for artists.

Several artists, including Rein Triefeldt, have challenged the precedence of industrial designers in the field of solar power. Almost 10 years ago, this kinetic artist, who uses solar energy to power his work, initiated a partnership with Hoekstra Solar company (of the Netherlands) to develop public artworks that also function as solar-energy generators. While that large-scale experiment did not succeed, it set an important example, and Triefeldt continues to use his sustainably powered work as an educational and advocacy tool. His Solar Tree Project, an outgrowth of a lecture series at a Hillsborough, California, elementary school, resulted in plans and maquettes for sculptural trees featuring solar panels that produce energy specifically for the grid. He has worked with several schools

Mags Harries and Lajos Héder, *Solar Light Raft*, 2009–ongoing. Teak, photovoltaic solar collector panels, stainless steel, aluminum, and LED lighting, 16 x 10 ft. diameter. View of project in Stapleton, Colorado.

to raise awareness, encouraging educators to teach children about the importance of conservation. The Arts Council of Princeton is currently partnering with a middle school to build its own sculptural solar tree.

Mags Harries and Lajos Héder, who first started feeding the grid with the hydro-power generated in *Waterworks*, have turned to solar with *SunFlowers, an Electric Garden* (2009) in Austin, Texas. Commissioned for a LEED-certified, mixed-use development and placed along a pedestrian/bicycle path, the 15 large-scale steel flowers do more than screen unsightly views of nearby loading docks. During the day, the petals collect energy in their photovoltaic solar panels, feeding it into the grid while providing cooling blue-tinted shade; at night, the stamens are illuminated with LED lights powered by rechargeable solar batteries. *Solar Light Raft*, a project that began in 2009, continues this line of inquiry. This work-in-progress for Stapleton, Colorado, will emphasize four large solar panels at the top of a tower that evokes the crow's nest of a ship. The panels, arranged at angles like sails, will rotate to point to different compass marks and city features, providing the power for their own rotation and lighting while feeding the town's electricity needs.

Harries and Héder have a longstanding commitment to environmental issues: "Working with the sun and its energy has long interested us, both for its environmental benefits and its poetic/metaphorical qualities." As the need for sustainable energy grows (and as consumers become more familiar with new energy technologies), artists have the opportunity to create new roles for their work, harnessing sculpture's proven aesthetic power and using it to drive change.

Generating Energy in Time and Space:
A Conversation with Ned Kahn

by L.P. Streitfeld

MacArthur Fellow Ned Kahn is one of the most undefined artists working today. And that is just the way he likes it. His refusal to be pigeonholed grants him the freedom to embark on projects of his own choosing, whether they be wind curtains to cover the urban blight of a concrete parking garage or indoor weather systems in public spaces. While the avant-garde has always used the crossing of boundaries as a calling card, Kahn smashes borders in the most fundamental manner—through transformation of the elements. His unique collaborative form of public art reflects an intensely personal inquiry shading into a universal quest—to make spirit visible in matter.

The result is an art form for the 21st century, one that cedes to nature even as it transmutes elemental forces into energy. In his recent work, he applies his theoretical knowledge to practical purposes. Beginning with an unrealized project for the Connecticut Science Center in Hartford, Kahn has shifted the direction of his wind curtains, moving from aesthetic display to power generation. As part of the design team for the headquarters of the San Francisco Public Utilities Commission (SFPUC), he convinced the architects to peel back a section of the façade to create an air funnel for a series of vertical-axis, power-generating wind turbines shielded with a lattice composed of thousands of hinged polycarbonate panels attached to LEDs. When triggered by the wind, the motion of the panels translates into flashes of light, the firefly-like effect revealing the wind's passage. The excess power generated by the turbines (the lights need only a little) feeds the building's electrical grid. Such works (SFPUC is scheduled for completion in 2012) place Kahn at the forefront of an evolutionary public art movement that underscores the interconnectedness of life on a planet whose limited resources are threatened by human contamination and waste.

L.P. Streitfeld: *Your work creates a marriage between art and science, a synthesis that reflects your upbringing. Your mother, Renee Kahn, is an artist and your father, Sam Kahn, was a pioneering child psychologist. How did your parents influence your early development?*

Ned Kahn: I was lucky to have such an incredible art teacher as my mom. When I was a kid doing little drawings, she gave me amazingly good critiques. She would take me to a junkyard, and I somehow got enamored of things that moved. I would bring home boxes full of various springs and bolt and glue these things together. As a 10-year-old kid, I started making kinetic sculptures. I just decided that sculptures need to move, and I have been basically doing that ever since. My dad straddled the science world and the art world.

LPS: *So this early development translates to your current process in the public realm.*

NK: It is all about taking one form of energy, often invisible, and converting it into something else, a visible energy form.

LPS: *That would be the reverse of the alchemical process, which attempts to transmute physical matter into the quintessential element—spirit.*

NK: Everything I do plays with the notion of substantiality and insubstantiality. One of the insights of meditative practice is that all the things that seem solid and real are really fluctuating, changing phenomena.

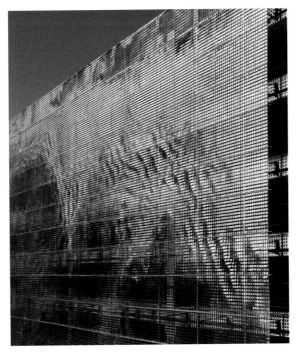

Wind Veil, 2000. 80,000 aluminum panels, 260 ft. long. View of work in Charlotte, North Carolina.

LPS: *The process of constant change is embedded within your process.*

NK: I think a lot about how someone thinks of something new—the whole idea of creativity. I need a scaffold, something to push me along. A lot of times I go to a junkyard and see something that is really beautiful or interesting to me. I bring it home and put it in a pile with all the other things. And then I'll be struggling with something else six months later and see this object as the solution.

LPS: *From the time you graduated from the University of Connecticut with a degree in environmental science, you have struggled to penetrate the most fundamental questions of nature. How did you become associated with Frank Oppenheimer?*

NK: That was a major bit of luck. I had a foot in the art world and a foot in the science world. I just wandered into the Exploratorium (in San Francisco) right after college and became Frank Oppenheimer's apprentice. He was dying and needed someone to be his arm in the shop.

LPS: *What was the biggest inspiration he provided for your future work?*

NK: He was one of the first people to speculate about cosmic rays. He built a metal sphere lined with detectors that could see cosmic rays, with extensive wires connecting to a recording device. They attached the sphere to a giant helium balloon and launched it in the desert. He showed me pictures of it all dented in the middle of brush and rock and described the excitement of opening it up and looking at the data. It made all the art that I had ever seen in my life completely trivial. I thought, "What if you made an artwork that had just a tiny shred of excitement to it—to see something completely unseen by anyone else?" That set me on my path.

LPS: *What is your process in collaborating with scientists?*

NK: I read a lot of science journals. Whenever I get interested in a topic, I seek out scientists working in that field and tell them what I am working on. Sometimes great collaborations and friendships have resulted. I have done a lot of weather-inspired work, so I befriended atmospheric physicists and cloud scientists. I did a residency at an oceanography research school and ended up building a sculpture for the lobby. One of the oceanographers got me excited about underwater avalanches. I had no inkling that they occurred on the bottom of the ocean and ended up making an interactive avalanche. Other times, I get scientists involved because I need knowledge of a specific area. For instance, I was working on a steam-powered vortex for the Children's Museum of Pittsburgh. It's a 30-foot-tall twisted glass structure powered by a local steam plant inside. The idea is to use the heat from the steam to create a tornado. I got a cloud physicist to help with his knowledge and intuition about physical forces. While I was developing an ice vortex for a museum in Anchorage, Alaska, I talked to a number of ice and cold matter physicists.

LPS: *What about the uncertainty principle, the role of consciousness in experiments?*

NK: I have had really interesting conversations with scientists about this on a direct physical level. I was showing

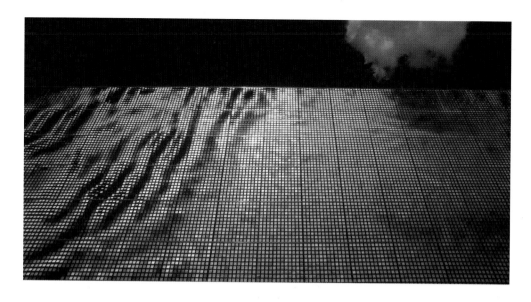

Technorama Façade, 2002. 80,000 wind-animated plates, 222 ft. long. View of work in Winterthur, Switzerland.

movies that I had shot to a room full of atmospheric physicists, and we got into a conversation about how you see these beautiful rhythmic waves in the wind. When you are up on a scaffold or a lift immersed in the field with all these articulated pieces, you see beautiful, distinct waves go by right in front of you, but you don't feel any pulsing in the wind. Is there something about this detector that I have built that creates those waves? How much of what you are seeing is the "untaken" wind, and how much is the dynamic of the detector? In a crude way, this discussion mirrors the struggle of Heisenberg and every scientific experiment: How much is the detector and how much is nature? That is the essence of the things I have made—they are hybrids. In my mind, the whole human race is struggling with the murky zone between man and nature right now.

LPS: *You mean global warming and its transformation of the atmosphere?*

NK: There is no untainted nature left, no place that hasn't been messed with. And so, what is the "messed with" now? All this stuff about global warming—every time there is weird weather attributed to global warming—all this fear is of the unknown thing that we don't understand.

LPS: *You are articulating an evolutionary form of sculpture as a middle path between humanity and nature. How did this develop?*

NK: At the Exploratorium, I got interested in turbulence. The first thing I built there on my own was a giant soap film, a bar loaded into soapy water. If you illuminated it right, you could see the subtle colors and textures of the film. It was basically a two-dimensional visualization of complexity and turbulence. I became fascinated with how intricate and unpredictable and interchanging this thing was. I went on to become interested in weather and all sorts of turbulent things like swirling fog vortexes and sand blowing through windswept landscapes. They were all contained energy systems—plugged in or people activated—but they had energy flowing through them. The energy would basically sculpt and re-sculpt. I did an alien landscape with sand moving around glass beads to form ridges and valleys and avalanches continually building up and collapsing. The thing never stabilizes; it is always doing something different. But all natural systems are like that—they all have an energy field blowing through them. In a very direct sense, that is what all creatures are. Each one of us is an amazingly organized collection of molecules completely dependent on energy flowing through us—energy contingent on the air that you breathe, the food you eat. As soon as you cut off that energy source, the creature dies.

LPS: *The consciousness of interconnected life on the planet flows through the core of your work.*

NK: Oppenheimer talked about these little pockets of purpose in a purposeless universe. Life is pockets of amazing order and pattern fighting the tendency of the universe to dissipate. So, I started thinking about artworks that would have that kind of energy flow about them.

LPS: *It seems that you have crossed over from the transmutation of the four elements in your early work to the quintessential element in your mappings of invisible energy in a field.*

NK: It seems static somehow to talk about an element. I am always enthralled with process. It is interesting to think of a static cube full of perfect air as a turbulent, flowing process like wind. Instead of thinking about water, you can say wave. Instead of solid, you can talk about the way sand flows.

LPS: *From your earliest experiments to your most recent tracking of invisible energies, it seems that you have been on an alchemical process all along.*

NK: I have never been the kind of artist who starts with a theory and figures out how to manifest it. Pretty much everything I have done was arrived at experimentally just by trying things and building prototypes. Ninety percent of what I do is to try things that give nature an opportunity to surprise me. A lot of these tests are failures. I build something and then I try it and it's boring and it ends up in a pile of stuff or gets turned into something else. Sometimes I discover something completely different than what I expected.

LPS: *How do you know when your question gets answered?*

NK: It has to do with the idea of richness or complexity. It is what I gravitate toward—I keep messing around until I find something that does that. Then I talk people into doing it on a bigger scale.

LPS: *Your collaborative process seems to be evolving a new consciousness of human impact on the environment.*

NK: One of the reasons for getting scientists involved is to show them what we are thinking of building for the prototype.

Avalanche, 2009. Steel disk, glass beads, and garnet sand, 8 ft. diameter. View of installation at the Children's Museum of Pittsburgh.

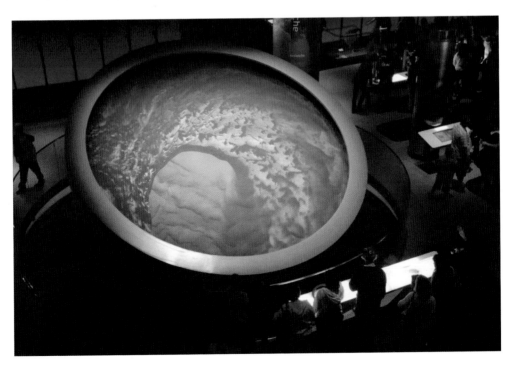

I ask if it looks right to them. Someone who really knows the math and physics behind a particular phenomenon can help guide us.

LPS: *But the artist must have the imagination to take the prototype to the next level.*

NK: It does require a leap of faith. Some are short leaps and others are vast — beyond imagining. Most of it is developing an intuition of how things change with scale. That can only be accomplished by doing things and seeing what happens.

LPS: *How do you implement your ideas into the mechanism of a public art project?*

NK: It comes down to fear in its many guises. In a recurring nightmare, I am sitting in front of a room full of grumpy people who just want a figure on a bronze horse, and I am trying to talk them into lining the underside of their freeway bridge with 40,000 small vessels of water that are going to vibrate from the vehicles driving over the bridge. And they are all wondering: Who is going to clean them? Will this cause birds to change their flight pattern and crash into the bridge, and will this cause the bridge to collapse into the river? It becomes a crazy exercise — let's get a bunch of people together and imagine the worst-case scenario. It is amazing that anything gets done. But I have pulled off a bunch of things. I made an eight-story vortex in Germany for the Expo: we spent $10 million, but we pulled it off with two weeks to spare.

LPS: *Innovative projects dealing with global warming will require huge leaps of faith.*

NK: I started a project in Hartford for the new science center. This giant wall generates electricity from sunlight, but it also moves in the wind and becomes a beautiful kinetic thing. A lot of stuff that I am tied into these days tries to figure out how to create energy in a visually interesting way. A lot of people put solar panels on the roof, the kind

Rainbow Arbor, 2007. Stainless steel and mist sprayers, 75 ft. long. View of work at the Skirball Cultural Center, Los Angeles.

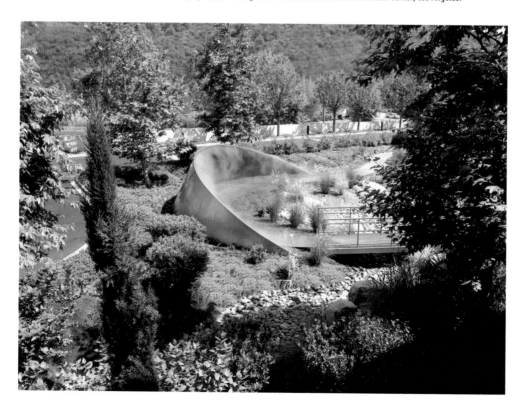

Firefly Wall, to be completed 2012. Tens of thousands of wind-activated LEDs, view of project at the San Francisco Public Utilities Commission.

of thing that you never look at twice. A lot of people are down on wind power because they think wind turbines are ugly. So, I have been interested in figuring out how to take some of these things and morph them into art and make them visually interesting and changeable.

Social Sculpture: The Nexus of Human Action and Ecological Principles

by Patricia C. Phillips

Joseph Beuys brought a distinctive perspective to socially based, environmental work that evades categorization. The model of the artist as environmental activist, he planted trees, protested forest and wetlands destruction, and even ran—unsuccessfully—for a seat in the European Parliament in 1979 as a candidate for the Green Party. In this role, he exchanged his shaman persona for that of an activist teacher.[1] His work was dynamically dimensional, fiercely independent, and widely inspirational, setting an example that continues to be a relevant, if problematic influence for new generations of artists pursuing ecological and systemic inquiries, as well as performative, collective, and relational processes. When Beuys the artist engaged in collaborative, community-based work, he became "a transitional phenomenon, striving to unspecialize. What many of his closest collaborators considered reckless—the 'dissipation' of his energies across Green politics, popular democratic forms, free (unaffiliated) universities, and so forth—he himself would have considered recklessness to neglect. He had one hand in conventional modes of artistic production and the other in activities, which, conventionally, had never before been considered 'art.' This is the heart of what he meant by 'everyone an artist'—not that everyone should paint or sculpt but that all people could become attuned to the cultural dimensions of everything they did."[2]

Beuys created one of his most legendary works in 1982 at Documenta VII in Kassel, Germany. *7,000 Oaks* took legions of people and five years to complete. At the opening of the international exhibition, he arranged to have 7,000 basalt markers dropped in a wedge-shaped pile in the Friedrichsplatz. Each piece of stone was a mate in search of an oak sapling. The ambitious objective of the socially collaborative and materially distributive work was to plant 7,000 trees, each with a companion stone marker, throughout Kassel. As trees were planted and the city experienced a "green" renaissance, the immense pile of stones in the Friedrichsplatz slowly diminished. For Beuys, the process of working with trees was about more than the natural world, it represented a new way to understand the human: "It is a new step in this working with trees. It is not a real new dimension in the whole concept of the metamorphosis of everything on this earth and of the metamorphosis of the understanding of art. It is about the metamorphosis of the social body in itself to bring it to a new social order for the future…It has a lot to do with a new quality of time. There is another dimension of time involved, so it has a lot to do with a new understanding of the human being in itself."[3]

Though Beuys never saw the project to completion (his wife and son planted the final oak tree after he died, at Documenta 8 in 1987), *7,000 Oaks* remains one of the most striking realizations of his idea of a "social sculpture" that understands art as a means of transforming society and stimulating new forms of human consciousness. "Every art action Beuys made looked to a future in which our continued survival will depend upon our ability to adapt, and to marshal senses and powers of intelligence now lying dormant."[4]

The transactional idea of "social sculpture" sought to merge conditions of the natural environment—and an increasingly complex, intricately connective concept of ecology—with local communities and societies through active, transformational participation. The site and material of sculpture became the nexus of human action and ecological principles in order to generate initiatives and forms that could require many years to unfold. If there was a strongly

Joseph Beuys installing *7,000 Oaks* at Documenta VII, Kassel, Germany, 1982.

articulated intent, the results were often dispersed, indeterminate, incremental, and so "natural" as to be rendered invisible. But they were still art, of a highly effective kind: "Beuys was not a philosopher. He was a sculptor, and his life's work was to uncover and demonstrate certain principles sculpturally. That this led him [to] pedagogy and social communication on a scale unheard of for avant-garde artists is a measure of the necessity and timeliness of those principles."[5]

Shelley Sacks, founder of the Social Sculpture Research Unit at Oxford Brookes University in the U.K., studied with Beuys in the 1970s and remained an informal student until his death in 1986. During this period, she divided her time between South Africa, where she was born, and Germany. In 1990, she moved to the U.K. and established a base for her global work. Since the '90s, she has added new dimensions to a particular legacy of social sculpture that includes far-flung sites, urgent social and economic issues, and an intensifying involvement in extended media, social networks, and flexible pedagogical forms in an animating pursuit of public engagement through generative dialogue. The most persistent feature of her practice is a concept of ecology that artfully conjoins natural systems with human desire and individual consciousness through progressive pedagogy and contemporary participatory models. Like the late Brazilian educator and theorist Paulo Freire, who pursued his work of emancipatory education, adult literacy, and social justice through the transformative actions of individuals working together rather than the radical restructuring of educational systems and social organizations, Sacks focuses on the potential of individuals in communities to engage in transformative reflection through significant encounters with deep ecology. Like Beuys in *7,000 Oaks*, Sacks frequently focuses her participatory installations around trees, plants, and issues of global agriculture.

University of the Trees (2006–present), an ongoing, on-the-ground, and on-line social sculpture project hosted by the Centre for Contemporary Art and the Natural World, is a series of measured interventions and intimate conversations that began in Haldon Forest near Exeter. The different iterations function as "mobile labs" for observation, experimentation, and discovery. *University of the Trees: Mobile Lab 2*, for example, involves placing a yellow felt mantle around the base of a tree in order to designate a provisionally activated space in which to explore the significance of forests

Shelley Sacks, *University of the Trees Tree Band*, 2006. Gray felt with gold-stitched lettering, 9 x 1 cm. Detail of project in Darmstadt, Germany.

and the role of human stewardship in these, and other, sites. Using felt rings and other subtle instruments, the peripatetic, pedagogical project becomes a university without infrastructure. It can move, assemble, and dis-assemble, dynamically reconfiguring itself and its location to provoke creative reflection and actions with established organizations or informal confederations of people. Its organic, responsive structure is constitutively flexible, agile, mutable, and adaptable to the contingencies of different sites and circumstances. Anyone (and any place) can acquire a kit and, with the support of practice centers, activate an alternative academy for focused discourse on sustainability and equity. With sensitive materiality and a minimal structure both immersive and dispersible, the mobile labs model and reveal what sustainability can be — and requires of us.

In 1996, Sacks began work on *Exchange Values: Images of Invisible Lives*, which has had a number of iterations, including a version at the 2002 World Summit for Sustainable Development in Johannesburg. There, the project joined global consumers with the products and voices of banana growers from the Windward Islands to consider modern agriculture, multinational production, distribution, and human values and actions. Cured, dried, flattened, and stitched banana skins, tagged with the identification number of a particular grower, were stretched on metal frames spaced and mounted on walls. Each frame included headphones so that participants could listen to the recorded voice of the grower. In the center of the space, more than 10,000 unnumbered banana skins were scattered on the floor. This mound of unidentified skins (contained in the center recess of a huge round table since 2007), in conjunction with the stories of independent growers subject to the vagaries of the market, avarice, and other restrictions, draws consumers into a more embodied understanding of the global economy of food production and distribution.

Ort des Treffens: 100/1000 Voices (2008–10), a citywide sonic project in Hannover, Germany, explored an idea of place with an expanding circle of citizen-participants. In collaboration with Alex Arteaga, Lukas Oertel, Anja Steckling, Nicholas Stronczyk, Wolfgang Zumdick, and the Kulturburo of Hannover, Sacks created opportunities for reflection and listening processes, many of which occurred in 50 indoor and outdoor listening spaces across the city. Invitations to participate were distributed through the project Web site, radio, and posters and leaflets. The catalyst was a leading question: "What am I doing in the world?" With the recorded reflections resonating across the city, the query stimulated

a process to envision a more sustainable, democratic city of the future through two open-ended but carefully structured processes: *Ort des Selbsttreffens* and *Ort des Einandertreffens*. The first occurred anywhere and anytime—at home, in the office, or in a public space. Sitting on a yellow felt circle, individuals were invited to reflect on "what they are doing in the world," with one of the *Ort des Treffens* team serving as listener or witness. In the companion initiative, *Ort des Einandertreffens,* small groups of people who had engaged in the first process came together in public space outside the parliament building, sitting on larger felt circles to exchange ideas, thoughts, and perspectives on the future of Hannover.

The series of 100 public events within the protected and symbolic space of yellow felt (a material with a sensation of warmth central to Beuys's work) ultimately became a "golden circle" where people imagined ways to make a city of expanded democracy and increased sustainability. The project, now continuing as an independent citizens' initiative, unfolded over six months and was logistically complex, yet it did not leave an enduring material presence. The material base of social sculpture is the creative, imaginative space between people whose consciousness may actualize visions of social change. Proceeding with a trust in the ephemeral and ineffable characteristics of a collective process, the consequences have the potential to be progressively redefining.

While Beuys's concept of social sculpture was often strategic and centered on his own auratic persona, Sacks's methodologies are deliberately tactical and inclusively democratic. She describes her "flexible frameworks" and ephemeral actions as "instruments of consciousness." In some respects, the work engages in a form of crypsis. Rather than calling attention to itself, it is companionable and assimilable within its context.

A more recent project, *Earth Forum*, currently linked to the Climate Fluency Exchange in South Africa, is a one-day, net-based "permanent conference" process that people can use to examine ideas of sustainability, globalism, human participation, and the role of the imagination in ecological and social justice. All of Sacks's projects emanate from an integrated platform of actions and performances, pedagogical and temporal formats that support and enact

Shelley Sacks, *Exchange Values: On the table—Forum*, 2011. 5-meter round table with 10,000 unnumbered banana skins, view of project at Voegele Kultur Zentrum, Zürich.

Shelley Sacks, in collaboration with Alex Arteaga, Lukas Oertel, Anja Steckling, Nicholas Stronczyk, Wolfgang Zumdick, and Kulturburo of Hannover, *Ort des Treffens—Selbsttreffens process*, 2009. View of project in Hannover, Germany.

an animating belief in creativity and conversation as agents of lasting and consequential social transformation. In scope and breadth, her undertaking embraces a growing number of participants and stakeholders across the world, merging the conceptual with the instrumental to create proliferating models that, if never conclusive, are fundamentally—courageously—open-ended and consequential.

Notes

1 David Levi Strauss captures the difference between Beuys's mystical and commonplace sides: "In fact, Beuys in his Hare nature was less a shaman than an ordinary Anthroposophical man; that is, his inquires were seldom in extremity as the shaman's are, but rather in the direction of more common and communal work: producing warmth, planting trees, talking with animals, sweeping up, farming, teaching." See "American Beuys," in *Between Dog & Wolf: Essays on Art and Politics In the Twilight of the Millennium* (Brooklyn: Automedia, 1999), p. 46.

2 Ibid., p. 49.

3 Joseph Beuys, "Joseph Beuys: Interview with Richard Demarco," in Jeffrey Kastner and Brian Wallis, *Land and Environmental Art* (London: Phaidon Press Limited, 1998), p. 267.

4 Strauss, op. cit., p. 49.

5 David Thistlewood, "Joseph Beuys' 'Open Work': its Resistance to Holistic Critiques," in David Thistlewood, ed., *Joseph Beuys: Diverging Critiques* (London: Liverpool University Press and Tate Gallery Liverpool, 1995), p. 3.

Piero Gilardi and Parco Arte Vivente: Generating Living Art

by Twylene Moyer

Piero Gilardi has devoted his career to creating an "inhabitable" art that establishes a permanent interaction between individual and environment. From the "Tappeti-natura" or "Nature-carpets" that made his reputation (meticulously molded and painted polyurethane floor installations and wall reliefs simulating riverbeds, leaves, and fruit) to his recent experiments in "living art," all of his projects harness technology and participation as tools to restore contact between urbanized humanity and nature. Fiercely independent, he has consistently put his beliefs into practice by making art an accessible part of ordinary life. In the early '70s, he abruptly dropped out of the art scene and spent the next 10 years focusing on a variety of art-as-life activities—conducting creative therapy with psychiatric patients, directing street theater, organizing factory actions and protests, and initiating community outreach programs and political actions that took him from Kenya to Nicaragua, to the last outpost of the Mohawk Nation in northern New York State (all while writing theoretical analyses of culture and society).

When Gilardi returned to the conventional art world in the early '80s, he shifted his attention to interactive, computer-based environments, using these virtual experiments not to escape the real but as a means to improve social relationships and expand environmental understanding. Anticipating Bourriaud's relational aesthetics, Gilardi pursued increasingly active and experiential ways to engage people in the issues raised by the Nature-carpets—particularly the precarious relation between humanity and nature—but found himself limited by definitions, conventions, and art world expectations. To circumvent these barriers and to set an example of a living art that serves the needs of a specific locale and community while generating change beyond physical confines, he spent years laying the groundwork for his most ambitious undertaking to date—the Parco Arte Vivente (Park of Living Art), a six-acre green space/art and action center in the heart of Turin's working-class Lingotto district.

A social sculpture grown to architectural scale, PAV, which opened in 2008 adjacent to the headquarters of Turin's environmental agency, embodies all of Gilardi's principles: it is a re-imagined, multi-use public

View of the greenhouse and pedestrian square at PAV.

Piero Gilardi, *Vegetal Mutations* (detail), from the "Bioma" installation, 2008.

space in a changing city, a recreational area, a research facility, a think-tank bringing together art, science, nature, and ecology, and a community education center. Located in a former industrial area that later served as a dumping ground for construction debris, PAV became a "Third Landscape" for Gilardi, a transitional space of catalytic vitality whose pioneering spirit and adaptability were modeled on the tenacity and transforming growth of the volunteer vegetation that had already begun its work on the site.

Every aspect of PAV's design and planning strives to uphold the principles of openness and relational thinking. Gilardi conceived his project in reverse: the site is structured by the ongoing processes of living things (plants, animals, and people) working in relation with each other to generate unexpected outcomes, as opposed to a predetermined concept that dictates results. Following Gilardi's specifications, the largest structure at PAV, the Bioma building, optimizes energy conservation while minimizing environmental burden. Sunk partially underground, insulated with berms that extend the green roof gardens, and oriented to exploit solar energy, the building blends into its surroundings, the gabion masonry of its exposed walls further blurring the line between structure and landform (Gilardi translates "Bioma" as "hybrid.") This indoor/outdoor, octagonal "cell" of galleries and courtyards, complete with connected greenhouse, generates spatial relations with the surrounding park while providing an appropriate anchor for PAV's various activities. It also houses Gilardi's "Bioma" installation, a six-room, high-tech, interactive celebration of the senses— *Vegetal Mutations* (sight), *Odor Essences* (smell), *Nature Reliefs* (touch), *Mutable Sounds* (hearing), *Waterplay* (taste), and *Invisible Energies* (the brain and extrasensory perception)—that investigates our various points of contact with the world around us.

A similar synthesis occurs in the park, where meadowland supporting a variety of insect and plant life blurs into a number of permanent and temporary outdoor artworks. These commissions, many by young artists, promote new

thinking about sustainability and the environment, encourage connections with the land, and interpret the history of PAV's site. Dominique Gonzalez-Foerster's *Trèfle*, PAV's first commission, transforms the floor plan of a medieval Coptic church into a three-dimensional, conservation-minded landform filled with opportunities for discovery. Bordered by tall walls of hedges, the clover-leaf footprint of this enormous earth and stone mound can be explored across three levels; passageways lead along, below, and above ground, taking visitors through cascades of vines and carefully planted thickets of flowering shrubs and other vegetation. Lara Almarcegui's *Scavo*, which resembles a large-scale archaeo-logical dig, burrows deep into the earth. A specialist in urban excavations, Almarcegui painstakingly removed stratum after stratum of soil and debris to reveal the ruined foundations of an early 20th-century factory, a 19th-century foun-tain, a medieval well, fragments of a Roman wall, and evidence of a Neolithic settlement. Finally, 15 feet below the surface, she reached "natural terrain" uncontaminated by human-made debris. Visitors descending into the pit move back through time and memory, reliving in a comparative instant the slow build-up of human activity that shaped this piece of land.

PAV also hosts temporary indoor exhibitions (recently featured artists include Eduardo Kac, Brandon Ballengée, and Andrea Polli) and sponsors an annual competition for new "people- and action-specific" environmental art that responds to local needs and expands the concept of living, collectively and individually. The 2011 shortlist, which focused on "The PAV biosphere: Inner and outer osmotic boundaries," featured a wide range of projects connecting art and life, from an exploration of the "vegetal body" to creative community garden schemes, to works for animals and insects. These and other artists' projects reinforce PAV's educational activities (some conducted by visiting artists and researchers), which include participatory labs for adults and children (planting letter-shaped mini-greenhouses that represent indefinable aspects of life; glow-in-the-dark books; and the popular bio jelly pop) and more intensive workshops

Lara Almarcegui, *Scavo*, 2009. Detail of installation.

Exhibition view of Brandon Ballengée, "Praeter Naturam," 2010.

for adults, young artists, and students. Modeled on Kaprow's Happenings, these one- and two-day events blending art, lab work, and outdoor research aim at changing behavior and culture through learning and creative action. Viral in potential (like the art actions of Joseph Beuys and Shelley Sacks), the PAV workshops rely on participants to take their insights and discoveries out into the world, where they can grow without limit.

More than just a park, a gallery, or a venue for outdoor sculpture, PAV is a creative organism with a generative force of its own. Having liberated discrete functions and practices from their conventional moorings, this new hybrid invests them with potential and purpose in the service of something beyond the dead ends of commerce and entertainment. Using art as a lever to lift intellectual, cultural, and social barriers, Gilardi and his collaborators have set in motion a limitless experiment in living outside received parameters, one that continually evolves to accommodate unbounded ideas, directions, and relations. Curiosity, play, and invention—whether we call ourselves artists or not—demonstrate just how humane our cities and our lives can be when we open them to the lessons of a larger environment whose balance we respect, preserve, and emulate.

Mary Mattingly: Planning for Survival

by Elizabeth Lynch

Mary Mattingly, whose practice responds to the threat of environmental and economic catastrophe, believes "that if we separated the world into three types of people, it could easily be [those] who protect the people/things that are taken advantage of, [those] who exploit those things (intentionally or not), and [those] who don't pay attention." She places herself and her work firmly on the side of the protectors, proposing creative, viable solutions instead of simply exploring problems. Planning for crises that will change the planet's natural balance in ways that some refuse to contemplate, Mattingly has designed concepts, prototypes, and trial realizations of wearable and nomadic homes that challenge complacent patterns of energy-intensive, high-consuming lifestyles. Her works establish alternative economies, are suitable for hostile climates, and function by purifying water and generating electricity on the go.

Waterpod, a self-sufficient, waterborne ecosystem and public art project that Mattingly created in 2009 for the waters surrounding New York, reflects her apocalyptic worldview and optimistic sense of human efficacy: "In preparation for...an increase in population, a decrease in usable land, and a greater flux in environmental conditions, people will need to rely on...alternative living models." Her "floating, sculptural, eco-habitat" consists of a 120-foot-long barge fitted with living quarters and the accoutrements of a small farm — a coop with four chickens, a water purification system, solar panels and a bicycle-powered generator for electricity, geodesic domes to house hydroponic and vertical gardening, and a gathering space. Constructed from donated and repurposed materials, the vessel marks the beginning of an experiment in urban sustainability. Mattingly, who extensively documented the project so that it could persist in some way after being disassembled, says that *Waterpod* "is a living sculpture from idea to implementation."

The nomadic vessel, sponsored by the City of New York and the Arts Action League, docked at locations along the East River, New York Harbor, and the Hudson River. Mattingly recruited a large team, including Gabriel Krause and Tressie Word, who contributed to the design, and Carissa Carman, who designed the living systems. Mattingly and Alison Ward (another artist and the boat's chef) lived on *Waterpod* for the duration, accompanied by a rotating group that included Ian Daniel (co-curator), Jes Gettler, Derek Hunter (lead builder), Mira Hunter, and Eve K. Tremblay. Individually, their motivations ranged from an interest in futuristic utopias to "the nomadic nature of the project...[to] creating structures from reused materials...[to] self-sufficiency...[and] the curatorial possibilities in a mobile, ever-evolving space." *Waterpod* also welcomed visitors, hosting visiting artists, ecologists, composting tutorials, and gardening workshops. The artists struggled with long working hours and close quarters and triumphed in the good will of visitors who, often donating their time to help on board, became instant community members.

Mattingly has recently expanded on such community-based themes in other works. Her over-arching goal is "to encourage innovation as we visualize the future 50 to 100 years from now." *Flock House*, an installation included in Smack Mellon's "Condensations of the Social" exhibition (2010), allowed other artists (Ian Daniel, EcoArtTech, Kim Holleman, Paul Lloyd Sargent, Kadar Brock and Stephanie Gonzalez-Turner, and Tressie Word) to participate in short residencies. They lived in a prototype for an airborne habitat that visualized another option for survival in a future where resources are limited and precious. *Flock House* residents used the opportunity to complete varied projects inside and outside the gallery, collecting

Mary Mattingly and collaborators, *Waterpod*, 2009. Repurposed barge and mixed media, 120 ft. long.

and measuring garbage from Brooklyn Bridge Park, hosting public presentations about conservation, and organizing urban hikes to explore local ecology. Visually, *Flock House* played on scaffolding forms—it perched on stilts on a high platform, incorporating ladders for access and a series of bucket planters that formed a hanging garden.

Mattingly says, "I'm deeply saddened and disappointed by the plenty we are surrounded by and what little good we seem to make of it all." She has created a concept for a handheld device, the *G-Simpod*, that directly ameliorates

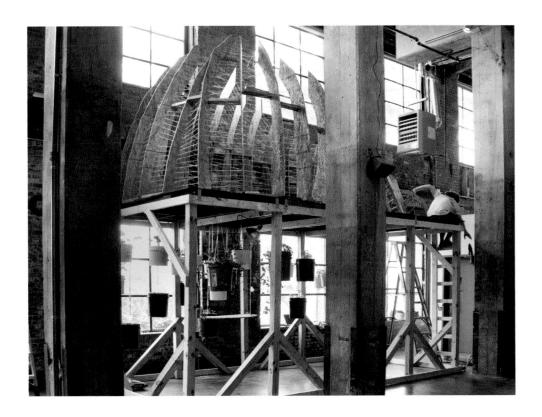

Mary Mattingly, *Flock House*, 2010. Reclaimed wood, plastic buckets, aluminum armature, soil, plants, twine, hose, wheels, desk, chair, lamp, and bed, 8 x 16 x 23 ft.

its user's emotional and physical needs, obviating the need for resource and product consumption and transforming societies into idealized, blissful utopias. Another ongoing series, "Wearable Homes," anticipates further advances in all-weather outdoor clothing, enabling people to be increasingly self-reliant with fewer resources. Mattingly's renderings and prototypes translate her architectural innovations into garments featuring solar-cell-bearing hoods, web-toed water shoes, and inflatable storage compartments. The layered clothing that she envisions can be adapted for different climate extremes.

With a background in studio art, Mattingly cites growing up in a waste-conscious family and general mindfulness as her driving motivations. Her photographs and sculptures often develop into or document larger undertakings, and sketches for a large-scale project like *Waterpod* evolved from conception to realization as she found the right scope and form for her ideas. She consistently returns to collaborative work and a shifting idea of home. In 2012, she plans to expand on *Flock House*, creating a new version of the elevated dwelling "as a public artwork and migrating sculptural living space" to continue her search for alternative and independent living systems.

Futurefarmers: Tradition Telling Truth to Power

by Twylene Moyer

The inventive imaginations at work in the art collective Futurefarmers know no limits. Since 1995, their innovative practice has found compelling visual ways to "cultivate consciousness," using a signature blend of critical analysis and optimistic problem-solving to tackle everything from the complicated paths of food-production networks to anti-war computer games and an on-line registry of unused arable land in San Francisco. Led by "pollinator" Amy Franceschini (who also founded Free Soil, an international collective of artists, activists, researchers, and scientists); artist, builder, and inventor Dan Allende; artist and creative explorer Ian Cox; and designers/developers Sascha Merg, Josh On, Stijn Schiffeleers, and Michael Swaine, the Futurefarmers studio serves as a platform for art projects, an artist residency program, and research interests. The collective embraces teachers, gardeners, scientists, engineers, illustrators, and anyone else willing to share their skills and contribute to the common goal of creating collaborative, participatory work that "challenges current social, political, and economic systems."

Rather than subverting existing systems, the Futurefarmers strategy simply sidesteps them and substitutes new, cooperative forms of interaction. Taking a page from Newton and Helen Mayer Harrison's 1972 *Full Farm* installation and the off-the-grid, whole systems survivalism of the New Alchemy Institute (a co-op founded in the 1970s by John Todd and Nancy Jack Todd to integrate agriculture, aquaculture, and ecological design), Futurefarmers starts from the premise that human health depends on the health of the environment.[1] From galleries and museums to neighborhoods and the Internet, their most successful projects start by raising awareness, but they don't stop there — they go on to offer alternative modes of living/producing that inspire creative independence, local cooperation, and sustainable practices. This grassroots approach invests heavily in a belief that most people want to and will improve their lives if they have the opportunity

Rainwater Harvester, 2009. Wood, plastic, and metal, 10 x 12 x 4 ft.

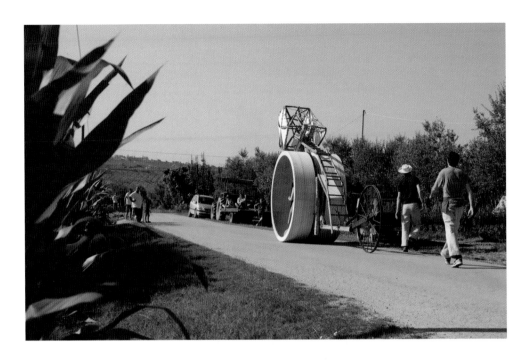

This is Not a Trojan Horse, 2010. Wood, metal, and canvas, 40 x 20 x 8 ft.

to do things differently. By creating meeting spaces, sponsoring discussions, and kick-starting long-term public projects, Futurefarmers creates a wealth of opportunities—from rural to urban settings—giving people the knowledge and tools necessary to initiate change for themselves.

Blending traditional knowledge, freewheeling hippie improvisation, and futuristic whimsy, projects such as *Victory Gardens*, *Photosynthesis Robot* (2003), and *Rainwater Harvester/Greywater Feedback Loop* (2007) demonstrate a "yes-we-can" attitude that can be adapted by anyone anywhere.[2] Like learning to tell "time" from the *Sundial Watch* (2004), the actions of planting and harvesting food and building a sculptural machine to recycle water remind us "to depend on our own devices," to learn from, protect, and connect with natural cycles and rhythms instead of relying on packaged goods, processed foods, and technological interfaces. Though the Futurefarmers vision comes with a good dose of old-fashioned thrift, simplicity, and self-reliance, it is neither nostalgic nor Luddite. Lost skills, fading knowledge, and vanishing connections become weapons of resistance, capable of defeating corporate biopolitics, waste, pollution, and exploitation, particularly when used in conjunction with a savvy multimedia approach to globalization and its environmental consequences.

This is Not a Trojan Horse (2010), a mobile community center/"vehicle for social and material exchange," offers a clear demonstration of what Futurefarmers calls "tradition telling truth to power." Designed in cooperation with architect Lode Vranken, this human-powered wooden horse roamed through Italy's Abruzzo, where big box stores, parking lots, and gas stations are quickly replacing rich pastures and farmland and agribusiness standardization threatens the nuances of time-honored production. Lured by the cities, young people are leaving behind an aging, and diminishing, farming population. During its 10-day tour, *This is Not a Trojan Horse* collected traces of rural practices, storing seeds, tools, products, and stories contributed by remaining farmers. Through this nomadic gathering site and repository, local tradition becomes the basis for global renewal. The sculpture gives form to new social and political thinking, first locally then in outward-spreading waves via the Internet and other initiatives. Collecting this first round of local

ammunition was just phase one; after its tour, the horse returned to Pollinaria — an organic farm and arts and sciences artist residency based in Civitella Casanova — where the seeds were planted to celebrate and preserve Abruzzo's biodiversity; it remains there, waiting for future excursions.[3]

While *This is Not a Trojan Horse* focuses on the traditional farming aspect of the equation, other projects emphasize the "future" in Futurefarmers, offering forward-looking, high-tech improvements to daily life. *Lunchbox Laboratory* (2008), a prototype classroom algae-screening kit created in collaboration with the Biological Sciences Team of the National Renewable Energy Lab, allows young scientists to play an important role in renewable energy testing. Distributed to science classes throughout the public school system, such kits could accomplish the monumental task of identifying

Soil Kitchen, 2011. Mixed media, 2 views of project in Philadelphia.

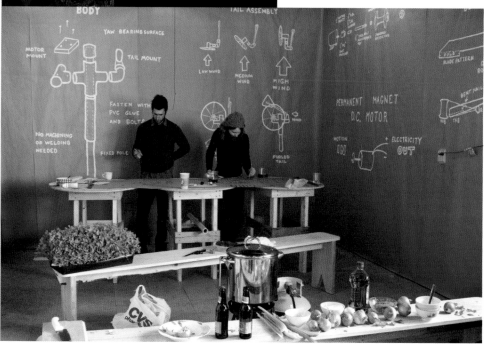

the most productive strains of hydrogen-rich algae (there are millions) for use as biodiesel fuel, while inspiring and training a new generation. Whether these students continue in the sciences or not, their participation in such a large-scale network—comparing notes with their peers and interacting with experts around the country—will give them an irreplaceable sense of engagement, demonstrating the importance of research and development in the search for alternative technologies.

Can-do community involvement resurfaces in two recent urban projects. *Soil Kitchen* (April 1–6, 2011) took its cue from Don Quixote, a visionary with the courage to tilt against invisible giants—not windmills, in this case, but industry and utility monopolies. To understand and potentially reverse their centuries of wear on natural resources and local land, this temporary windmill-powered architectural intervention in North Philadelphia (another collaboration with Lode Vranken, in a derelict building next to the Don Quixote monument at 2nd Street and Girard Avenue), created a multi-use space where residents could enjoy free soup (homemade from local ingredients courtesy of Peg Botto and Cosmic Kitchen) in exchange for soil samples from their neighborhood. Mounted on the roof of *Soil Kitchen*'s home base, the DIY windmill acted as a sculptural beacon, inviting people not only to imagine a potential future of green energy, but also to participate—to "literally take matters into their own hands." The exchange of soil for soup provided an entry point for further dialogue and action, both supplied through workshops, events, and informal training sessions.

Commissioned by Philadelphia's Office of Arts, Culture, and the Creative Economy, with a grant from the William Penn Foundation, *Soil Kitchen*, which also coincided with the Environmental Protection Agency's 2011 National Brownfields Conference, brought together a creative mix of concerned citizens, activists, artists, developers, and policy-makers to learn, exchange ideas, and pool resources.[4] Local media outlets and city officials spread the word, as did libraries, community centers, schools, businesses, art institutions, and soup kitchens. EPA scientists were on hand to test the soil samples for heavy metals (including lead, arsenic, and cadmium) and pH, and representatives from the Agency for Toxic Substances and

Soil Kitchen, 2011. Mixed media, view of project in Philadelphia.

Top: Detail of *Pedestrian Press*. Above: View of shoemaker's atelier. Both from the Futurefarmers "urban thinkery" at the Solomon R. Guggenheim Museum, New York, May 4–14, 2011.

Disease explained the results—what they meant and how to make the soil healthy for growing food. *Soil Kitchen* also produced a Philadelphia Brownfields Map and Soil Archive. Workshops covered everything from wind turbine construction, composting, and the anatomy of urban soil to communal food networks and cooking lessons. Through this informal and productive exchange, *Soil Kitchen* "provide[d] sustenance, [while] re-establish[ing] the value of natural resources through a trade economy," once again giving people the tools they need to be informed and take action for themselves.

A 10-day "urban thinkery" sponsored by the Guggenheim (May 4–14, 2011), focused on the pleasures, and importance, of labor (always an undercurrent in Futurefarmers projects). Loosely based on the open forum of Simon the Shoemaker's Athens workshop, where Socrates supposedly led discussions, this event conjoined the ideals of free speech and autonomy with the opportunity to think and create—in other words, to get your hands dirty. A cobbler's bench and shoe racks in the museum's rotunda

anchored a series of actions and dialogues throughout the city, including a session with labor historian Bruce Laurie drawing connections between labor and intellectual uplift, a tour of the Gowanus Canal with social theorist and urban geographer Neil Smith highlighting the need to reconnect the environment and labor in order to reclaim nature and society, a soot/ink-collecting expedition with environmental scientist Gillian Stewart who studies the role of atmospheric dust in sequestering CO_2 in the ocean depths, and a walk with New York City environmental scientists Thomas Matte and David Wheeler to consider air pollution, lifestyle choices, and health concerns. Mixed with egg and honey, the collected sidewalk dirt became a special ink—the main ingredient in a participatory set of actions. Several times during the project, at different locations, Futurefarmers asked passersby to join in, don specially designed shoes, and operate the *Pedestrian Press*. After inking up, volunteers walked along unfurled rolls of paper, becoming a "printing brigade" that recorded texts from a series of commissioned *Sole/Soul Sermons*.

Shoes, like all simple, crafted things, have a particular significance for Futurefarmers, as Franceschini noted: "Shoes have continuously found their way into our work through various manifestations—from making snowshoes that helped scientists find green algae in the Colorado Rockies to constructing platform shoes with little vials that secretly took soil samples that were sent out for testing from brownfields and Superfund sites."[5] Collapsing the artificial distinction between doing and thinking, this blurred metaphor of the physical and the immaterial drives home the essence of the Futurefarmers message: mind and body, nature and culture, are false oppositions. In their whole systems approach to social and environmental problems, both aspects—ideas and praxis—require constant searching and mending. Reconnecting to the physical, to the made, to the creative, means reconnecting to the environment. Like all Futurefarmers solutions, this can be done individually and together—all it takes is some imagination and honest labor.

Notes

1 *Full Farm*, an indoor allotment consisting of four pairs of containers growing various vegetables, was recently restaged in the 2009 exhibition "Radical Nature," at the Barbican in London. The New Alchemy Institute, which was based in Cape Cod, survived until 1991. Creative and insightful, its prescient integrations of food, shelter, waste recycling, and energy technologies (in the form of land and water-based "arks" and bio-shelters) represent some of the first large-scale applications of biomimicry. John Todd has continued to develop restorative "living machines" to clean up toxic ponds, industrial chicken plants (Tysons Foods, Berlin, Maryland, 2001), and sewage-infested canals (Fuzhou, China, 2002). By 2005, more than 30 systems were operational. For an introductory history with details about numerous projects, see Nancy Jack Todd, *A Safe and Sustainable World* (Washington, DC: Island Press, 2005).

 As artists-in-residence at Pasadena City College, Futurefarmers worked with students to build a *Reverse Ark* (2008) using an inventory of recycled materials. Following Buckminster Fuller's call to reject "yesterday's fortuitous contrivings" as the only means to solve problems, this "living laboratory for learning, inquiry and improvisation including mini-workshops, lectures, video screenings and frameworks for reflection" doubled as a new kind of life preserver.

2 *Victory Gardens* and *F.R.U.I.T. Network* (2005) are discussed in Amy Lipton and Patricia Watts's essay "Public Art Ecology, on page 52 of this volume.

3 For more information about Pollinaria's agricultural and habitat initiatives, as well as its artist residencies, visit <www.pollinaria.org>.

4 The City of Philadelphia has embarked on an ambitious plan to become the greenest U.S. city by 2015. *Soil Kitchen*'s multi-pronged approach to green energy, soil testing and improvement, and nutrition reinforced other city initiatives.

5 Quoted in Paul Laster, "Intervals: Futurefarmers at the Guggenheim," <www.thedailybeast.com/articles/2011/05/06/intervals-futurefarmers-exhibit-at-the-guggenheim-museum.html>.

Art, Environment, and Politics:
A Conversation with PLATFORM

by Terri Cohn

Since 1993, PLATFORM, a visionary group of London-based artists working across disciplines and bringing together environmentalists, human rights advocates, and community activists, has been using conversation, storytelling, and walking as means to envision solutions to social and ecological problems. The form and content of PLATFORM's work consistently and poetically merge the political with the personal. The group has been involved with *90% Crude* since 1996, a self-described "journey" through 11 projects that investigate the impact of transnational corporations on individuals, the environment, and society at large. Current projects include *C Words: Carbon, Climate, Capital, Culture* and *Unravelling the Carbon Web*, a research, advocacy, and public education initiative focusing on oil corporations in Iraq, the former Soviet Union, Nigeria, and the Arctic. (Educational publications and additional information about these and other projects are available at <www.platformlondon.org>.) Here, Dan Gretton, James Marriott, and Jane Trowell describe the strategies and processes behind their campaign for an alternate future of social and ecological justice.

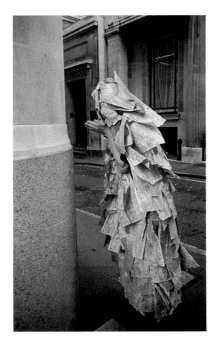

Wedding on the Walbrook: Still Waters, 1992. Distilled water and business pages, performance with Nick Stewart and Peter Butcher.

Terri Cohn: *Do each of you have different roles in the group?*

Dan Gretton: PLATFORM started with our wanting to bring together the energy of activism with the imagination of theater and performance. Today, art, environment, and politics are our three zones of constituency. At the moment, I'm doing a long piece called *killing us softly* about the psychology of genocide. I'm looking at individuals within corporations today and individuals who were behind the Holocaust. We started *90% Crude* in 1996, looking at the deep culture of transnational corporations and trade. I began to make links with what had been a personal area of inquiry, thinking that there are many connections with the story of transnationals if you look at it historically.

Jane Trowell: I've always found it difficult to categorize the work—part creating excuses for debate through the arts, part political agitation, part very personal, which I found difficult because a lot of activism in the '80s was about mass and masses of people. When I met Dan at university, in 1983, he told me that PLATFORM was doing a project about water in the city and the burial of the Thames in central London. He asked if I was interested in collaborating, and I had no doubts about it; it was the right project for me. One of the things I've got from working with PLATFORM is the consensus model of working, which is extraordinary. It was like dog eat

dog in the '80s in England. It still is a brutal environment for active democratic models.

James Marriott: I started out in theater, but I became pretty disillusioned. There was an '80s culture of radical plays, but the only change was on the stage. I wanted to see if it was possible to make theater engage in real life, balancing the poetics of the stage with the pragmatics of change in human beings in real space. PLATFORM plays with a tension between those two things. Student politics of the time tended to focus on the issues of "elsewhere," but we were interested from the very begin-

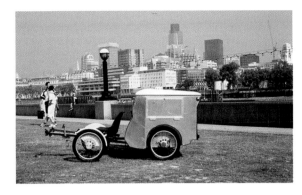

The Agitpod, 1997. Solar-powered, quadricycle cinema.

ning in what is happening *right here* on this street, in our place, and wanted to create works that were involved in the immediate and the local, using that as a lens through which to see wider issues.

I went back to college and trained as a sculptor. I draw a lot of my understanding from sculpture, from its essence as a forming process—the idea of trying to create form, trying to create structures and images that give shape to things that have hitherto been formless. Joseph Beuys has been really important to our work because of his understanding of art's relationship to politics—how politics itself could be made into a sculptural form.

TC: *You've written three manifestos; you must have a methodology that's central to your work.*

DG: In the past year, we've been rethinking the theory behind the work, and because we're approaching 20 years of doing it, we came up with "the three Ps," production, pedagogy, and process. We've tried to create new ways of looking at everything we do in light of those categories. Production is what's in the public domain in terms of performance, street-based work, or a walk. Pedagogy is a heavy word in our culture, with rather negative connotations but also a radical history. In the past five years, education work has been a big influence on how we do events, what we call "engaged pedagogy."

JT: It's a kind of eyeball-to-eyeball activism, working with people.

DG: Process is the network aspect: the conversations that we have with people, the e-mails, or the visits. We've done a lot of international work with groups in Eastern and Central Europe, Canada, a little bit in the States.

TC: *What form does your work take?*

JT: Basically, the content of the work seems to evolve through process, which includes internal communication. Themes arise from things that won't go away. They also arise from what seems to be the most powerful way of getting this message out, getting this sensibility into the world, or communicating with people.

TC: *It sounds like conceptual art. Conceptual artists work with whatever form manifests the idea.*

JM: Perhaps '70s work is the closest we come to that, at least from my understanding, from a sculptor's point of view. What we're doing is thinking up the ideas. The process of creating an idea—of coming to an understanding and thinking, "How can we create something that provokes change?"—that's the real work. When we've churned it over enough that forms come out—they can look like a newspaper, a performance, or a piece of hydrotechnology—they're just the outward excrescences of this stuff that we're working on. What we're trying to do is find things that provoke democratic change—ways of relating and improving the relationship between humanity and nature, making a more ecological balance. To do that, we use lots of different disciplines and forms.

JT: The overall political intent of the work is something that we discuss together, sorting out if we agree on something with enough passion to move forward. Within that, there are many ways of operating. Sometimes two of us collaborate;

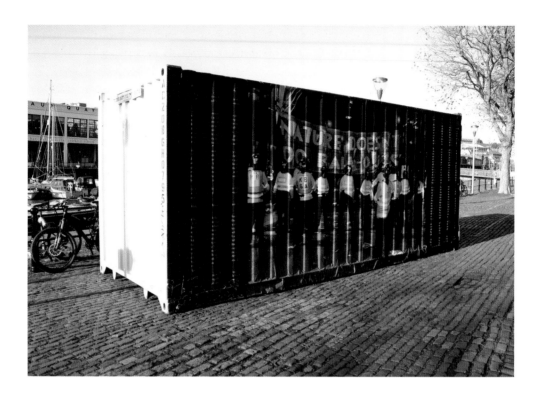

Labofii, from *C Words: Carbon, Climate, Capital, Culture*, 2009.

sometimes we seek partners to collaborate with. We think that our place is to create space for in-depth exchange. Together with a corporate researcher and activist, James is working on a project called *Gog and Magog*, about Shell and BP. For *90% Crude*, we worked with a journalist to create a commuter newspaper for London. It was a direct imitation of a defunct commuter paper called *Tonight*—the idea was that people would say, "Oh, its back." It's about oil and human rights, and we distributed it on December 10, 1996, which is Human Rights Day.

DG: And, it was partly paid for by the Arts Council of England.

JT: A year later, we did one about climate change, timed to appear during the Kyoto conference.

JM: For *Delta*, which is about an area at the mouth of the river Wandle, we tried to make a work that provokes people to think about the river as an incredible physical power, because it was a milling river for a thousand years, as well as an inspirational or spiritual power, with sacred sites along its length. Now, it's black for most of the year from the road runoff; it's full of shopping trolleys, tires, and cans. We wanted to stick a little micro-hydro turbine in there and generate flow in the river and use the flow to light a nearby school.

The idea of doing that is completely bonkers, frankly. From an economic point of view, it's extremely expensive. From the point of view of hydro-engineering it's also stupid, because the flow rate of the river is tiny. But if you come at it from the point of view that it needs to be done, in and of itself—just as sculpture needs to be done, in and of itself—then all those things can go out the window.

DG: Sometimes you can ambush people, because they don't know what you are if you say you're an artist or an arts group. We had an example of that recently, researching the role of corporations in the Holocaust. We visited a company called Saurer in a little town in Switzerland that manufactured the gas trucks. We got an interview with the corporate communications spokeswoman by saying, "We're an arts company from London." We then managed to present infor-

mation to her about her company's role in the Holocaust. She was absolutely horrified; she had never seen it before. But we got our foot in the door. If we had said that we were historical researchers, she wouldn't have touched us with a barge pole.

TC: *Walking is a major activity in your work.*

JM: We try to use walking as a means by which other people can also embody the process. I think a good example is *Gog and Magog*, which explores the nature of a contemporary corporation. What is this thing? What does it do? What is its impact on the world? How are we already inside it? One of the ways in which the work manifests itself is through a day-long event. There is a presentation explaining how Shell and BP impact ecology, democracy, and justice. We also try to explore the companies' structures and how the members of the audience are already members of the structure, even though they may not be part of BP or Shell. Then we go out into the city and walk to buildings for three hours. Through that process, through the traffic and the heat on the soles of their feet, they physically get to see the relationships—how all these different organizations fit together—they embody the nature of reality, and I think that's incredibly important.

JT: It's the notion that something is really there, and you don't just do a site visit. Something about it is much greater than you: it's been there longer than you, it'll be here long after you, it's seen everything at least five times, especially in a small packed country like England.

JM: One of the things that's really important for us is the sense of place, the locality of where we are. We work in our own home, London, the tidal Thames ground. We're saying, "Let's look at this place; let's think about this place through time." This place, this location right here, underneath this carpet, has thousands of years before human beings set foot on it. It has the point at which it became settled, it has the point at which it was an island with a Norse name, Bjorn Mansey (today Bermondsey, an area of south London), it has the point where the first plow covered it. Layer

Experiments Against Enclosure, Trapese, from *C Words: Carbon, Climate, Capital, Culture,* 2011.

Where are we going?, from *C Words: Carbon, Climate, Capital, Culture*, 2011.

upon layer upon layer existing on this point, and we need to understand that and draw that, like a well, into our understanding, in order to understand what the hell the future is about. We try to re-imagine this place over a long period of time. Capitalism is built on the basis of immediacy. Building an understanding of the past is a powerful form of resistance.

JT: More than any other project we've done, *Gog and Magog* is a six-hour storytelling session—the walks are storytelling. People come together with other people who might have very different motives. Average folks create, in physical process, a storytelling in walking.

JM: Stories are an instrumental form of truth, a representation of truth that is useful, because they enable you to cope with the world. Power structures constantly try to stop you from creating stories about them, stories are a means of excavating reality.

Christy Rupp: Daylighting Dirty Secrets

by Twylene Moyer

Christy Rupp, who grew up around Love Canal, New York, hates cover-ups. She has been exposing the dirty secrets behind globalized food and energy production since the 1970s, using sculpture, collage, painting, and photography to conduct provocative investigations into toxic waste, water pollution, resource exploitation, and genetic engineering. Laugh-out-loud funny, terrifying, and infuriating in equal measure, her work frequently parodies the conventions of consumer culture, turning products into weapons aimed at an "inherently amnesiac" corpocracy of hypocritical double-speak and denial.

Many of Rupp's works challenge the authority of an expert opinion in thrall to corporate bottom lines and political expediency. In *Poly Tox Park* (1984), a site-specific commission at New Langton Arts in San Francisco, a seething heap of decay and corrosion became a monument to those guardians of the public trust (politicians and scientists alike) who skew their regulatory stewardship in favor of a manufacturer's ability to comply while compromising consumer and worker health. Rats, standing in for the American citizenry, chew on their own tails.

Poly Tox Park, 1984. Detail of site-specific installation in San Francisco.

The "New Labels for Genetically Engineered Food" series (2000) cuts through the obfuscation of dubious food industry claims, vividly spotlighting what's at stake in labeling standards. (*Social Progress* [1986], sponsored by Public Art Fund and installed in Manhattan, took an early swipe at genetically "improved" corn and other foods.) Some of the store-bought containers in the *New Labels* collection make common-sense demands — *Tell Us What We Are Eating*; others reveal those little details that the FDA has deemed inconsequential to health — *Randomly Mutating Food*; and some satirize the feel-good assurances of advertising slogans — *Grown in Toxic Sludge But OK to Eat*, *Thank You For Taking Part in Our Experiment*, and *Genetically Altered for Your Enjoyment*. In these and other works, Rupp masquerades as a subversive one-woman corporate entity, creating products that provoke and spur action rather than induce complacency. Glass-bead necklaces in the shape of common viruses, a set of tumblers etched with images of "perfectly harmless" drinking water contaminants, and "patented" indigenous

textiles like the *Hand-Wringing Dishtowel* with color-coded terrorism alert levels sewn into the fabric keep us focused on the half-truths we swallow, what and who we choose to believe.

The dishtowel is part of larger series exploring bio-piracy and how the race to stake ownership and reap profits exploits natural and human resources. Pharmaceutical and agricultural multinationals scour the poorest and most remote regions of the world for useful plants that they then patent and market, making it illegal for native communities to grow or sell their traditional assets. Operating, as Rupp says, "like a one-celled organism, with no acknowledgement that I'm part of a system," she mimicked corporate behavior, grabbing as much as she could and branding it under a series of facetious logos, including Me First© and Benefit Package Obliteration©.

The greed that drives ever-increasing productivity and rising profit margins, together with their inverse values of decreasing environmental and human health, also informs the series "Extinct Birds Previously Consumed by Humans." These meticulous skeletal re-creations of dodos, Carolina parakeets, and other disappeared avian species are built from the bones of industrially raised chickens (gleaned from fire station barbeques and a soup bone wholesaler). Rupp calls these birds "fast-raised" food—from egg to plastic packaging in six weeks; from live bird to fodder in about 20 seconds. While working, she discovered a telling by-product of the rapid and cheap food machine: the bones are abnormally brittle, with so little structure that using them as a sculptural material was "like gluing chalk together"; she had to use archival paper as an additional support. Just like medicinal plants or seeds, business reduces these chickens to property, commodities on an assembly line. Leaving aside the truly grotesque conditions under which these birds live their brief lives, their bones provide a cautionary tale for everyone up the food chain. Weakened by improper conditions, inadequate diet, and artificially accelerated growth, they cannot form normal tissues—we eat them and ingest their antibiotics, hormones, and pesticides at an unknown cost to our nutritional requirements.

Recently Rupp has turned her attention from the industrial farm complex to the coal and oil industries, taking on mountaintop removal and fracking in the Amazon and rural New York State in a powerful series of conceptual Web-based "position-papers." The latest in what she calls a "long list of weapons of mass destruction," these extreme and extremely violent methods of mining and drilling have the potential to pollute at a scale that mirrors their degree of destruction. *Frack-Me-Not* graphically illustrates the end result of the "Halliburton Loophole" in the U.S. Clean Water Act, which permits companies to pollute clean water in pursuit of domestic energy and pass the cleanup costs along to taxpayers. The Marcellus Shale Formation, which runs from western New York State down to West Virginia and contains the largest natural gas source in the country, has long been considered untouchable; but growing fears of dependence on Mid-East oil (combined with a misguided reluctance to fund alternative energy research) have made this deeply buried and widely dispersed deposit much more attractive. Rupp's project reaches to the devastating heart of the proposed drilling—farmland turned

Tell Us What We Are Eating, 2000. Plastic container with vinyl label, 10 x 8 x 3 in.

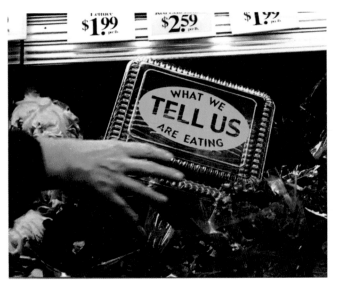

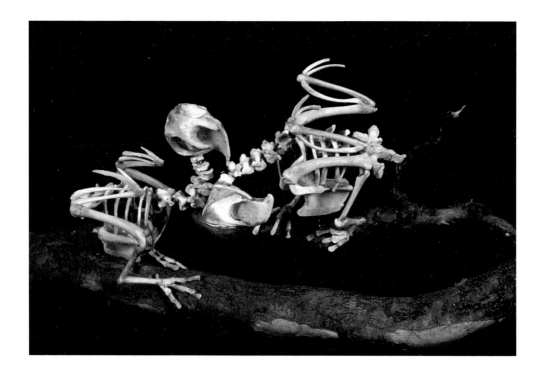

Carolina Parakeets, Eastern US, 2007. Fast-food chicken bones and mixed media, 8 x 22 x 6 in. From "Extinct Birds Previously Consumed by Humans."

wasteland, waterways and aquifers polluted by the release of contaminated water used in the fracturing (the loophole); and scores of health issues.* Not to mention spills: How do you clean an aquifer?

Frack-Me-Not, Road Trip (a toxi-tour through oil-ruined parts of Ecuador), and *Mountain Top Removal* demonstrate Rupp's characteristic approach to activism through art. Her clever collages and passionate texts render scientific data and abstract outcomes personal and visceral—for everyone, not just those directly affected. Her goal, in *Frack-Me-Not*, is to inspire involvement, to galvanize support that will force legislators to pass anti-fracking legislation. Her message is clear: you can't trust the government to do the right thing on its own; it will dredge up minerals, natural gas, and oil at whatever cost necessary and then try to bury the consequences of those actions where no one will find them. Rupp doesn't believe that art can change things by itself, but it can provide an alternative platform for information and open dialogue: it can question, expose, and advocate. Some things need to see the light of day.

Notes

* Although the oil and gas industries, as well as regulators, have argued for decades that fracking is safe and has never contaminated underground water supplies, a largely unnoticed EPA report from 1987 documenting just such a case of drinking water contamination came to light in August 2011. In addition to presenting evidence that many industry representatives were aware of the problem, the report suggests that there may be more incidents, but researchers were "unable to investigate many suspected cases because their details were sealed from the public when energy companies settled lawsuits with landowners." For more information, see Ian Urbina, "One Tainted Water Well, and Concern There May Be More," *New York Times*, August 3, 2011.

The Yes Men/Yes Lab: Lying To Tell the Truth

by Twylene Moyer

Dow Chemical liquidates Union Carbide and uses the resulting $12 billion to clean up the site of the Bhopal disaster, covering the costs of medical care for hundreds of thousands and funding research into the environmental hazards of its other products. In New Orleans, a HUD spokesman announces that the agency will reopen public housing units, reversing its post-Hurricane Katrina decision to replace them with new development; in addition, big oil will contribute some of its record profits to rebuilding wetlands destroyed by tanker canals. ExxonMobil and National Petroleum Council (NPC) representatives admit that U.S. and Canadian energy policies (notably the carbon-intensive strip-mining of Alberta's tar sands and the development of liquid coal) are increasing the chances of huge global calamities. The Iraq War ends; the U.S. sets its sights on building a sane economy; and the Republicans see the light when it comes to climate change.

This is indeed "All the News We Hope to Print," as declared by a special edition of the *New York Times* released in 2008—"hope" being the operative word.[1] Everything in this alternate reality, where the needs of people and the environment trump the rights of capital, originates in the minds of Andy Bichlbaum and Mike Bonanno, who together form the activist duo the Yes Men. To build a better world, they use any means necessary. They call their strategy "identity correction," explaining that "by catching powerful entities off-guard, you can momentarily expose them to public scrutiny...everyone sees how they work and can figure out how to control them." In other words, as their identity correction guide graphically demonstrates—catch them with their pants down. The Yes Men understand that private interests leave no room for public conscience; executives will always put profits before people ("greenwashing" and other PR to the contrary). The only way to hold them accountable is to out their wrongdoing, drive public opinion against them, and use shame and/or legislative coercion to force them into a position that at least approaches responsibility.

So, how does it work? Bichlbaum, Bonanno, and their associates impersonate business spokesmen and government officials, co-opt ad campaigns, launch doppelganger Web sites, and introduce probable but spurious products. What they say in these undercover operations—issued as if directly from the mouth of power—gets picked up by the media and reported as "truth." Denials from the targeted entity spawn another wave of coverage, followed by another assault of Yes Men counter-propaganda. Their best projects unleash a dizzying vortex of confusion that collapses the barrier insulating power from justice. The mainstream media can't help but enter the fray, hoodwinked into reporting stories and issues omitted by their primary sources (official briefings and press releases). After the perfect storm, there is no more hiding—ignominious behavior, the lies told to cover it up, and admissions of guilt are all on the record. Thanks to the media circus, truth can no longer be rejected as special-interest fiction. Though the Yes Men play on the lunatic fringe (and have a great deal of fun), their Dada-inspired antics, and by extent their message, reach beyond the choir. Their over-the-top publicity campaigns in reverse have done more to convince people of the health and environmental dangers posed by corporate malfeasance and government complicity than the scariest doomsday scenario or heartfelt entreaty, no matter how earnest. And everyone is welcome to join the party.

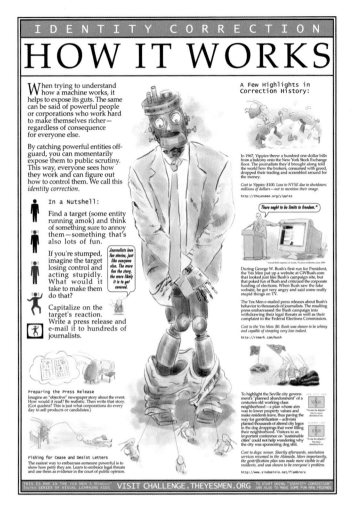

The Yes Men and Cristian Fleming, *Identity Correction Challenge*, 2009.

Bichlbaum and Bonanno have an unerring feel for the opportune satirical wedge that once driven into a façade of misinformation will bring down an entire edifice of corruption, and they use these weapons with pointed skill against climate-change deniers, polluters, and resource exploiters of all stripes. When putting the right words in the corporate mouth isn't enough, they aren't afraid to up the ante and push things to hilarious and sometimes shocking extremes. In one of their earliest actions, they collected signatures for a mock Bush/Cheney campaign petition "supporting" global warming because it would harm competing nations while leaving the U.S. relatively unaffected. At the same Calgary, Alberta, oil conference where they appeared as ExxonMobil and NPC representatives and admitted their part in precipitating crisis, Bichlbaum and Bonanno reassured the audience that they would "keep the fuel flowing" through something called Vivoleum, which would work in perfect synergy with expanding fossil fuel production. Oil executives listened with rapt attention as the Yes Men unveiled a new kind of "renewable" energy source—oil rendered from a limitless flow of human bodies, available in endless supply thanks to increasing natural and manmade disasters. Though Bichlbaum and Bonanno were discovered and escorted out before they could deliver their punch line, it was reported: the "commemorative candles" distributed to and lit by the oilmen in memory of an Exxon employee burned Vivoleum made from the flesh of that same worker—a janitor who died while cleaning up a toxic spill.[2]

Taking corporate callousness to its absurd (and logical) conclusion, these actions underscore the conveniently forgotten truth that capital has never respected life, human or otherwise. A singularly ingenious piece of black comedy—part of a long (and ongoing) series targeting Dow—unmasked the cynicism and disdain "justifying" the chemical giant's refusal to clean up its mess in Bhopal, India.[3] At a London banking conference in 2005, two "Dow representatives" introduced a new computer program that would accurately appraise the value of a human life and help businesses determine the exact point where human casualties will cut into profits. An additional feature recommended (impoverished) regions offering the cheapest death tolls. Their well-received presentation placed the "Acceptable Risk Calculator" (ARC) in a grand tradition of ethically criminal products, including the technology sold by IBM to the Nazis

for use in identifying Jews. To put a friendly spin on these "golden skeletons in the closet," they introduced Gilda, the new face of Acceptable Risk. Willingly taking the bait, several bankers posed for photos with the life-size, gilded human skeleton and signed up for ARC licenses.

Prop sculptures like Gilda and the Vivoleum candles play an essential role in the Yes Men repertoire, piercing the heart of an issue and taking the mind into directions where words can't or won't go. In 2009 (still awaiting a clean-up), the Yes Men teamed up with 20 Bhopal activists to launch a new brand of bottled water at a Dow headquarters near London (only to find that all of the executives had fled the building). B'eau-Pal derived its unique mineral qualities from "25 years of slow-leaching toxins," including nickel, chromium, mercury, lead, and volatile organic compounds. Attractively bottled, this ersatz luxury product distilled water concerns around the world while giving the lie to Dow's promise that it "is committed to creating safer, more sustainable water supplies for communities around the world."

Perhaps the wittiest and most effective of the agitprop satires got under way on September 21, 2009, just before the U.N. Climate Change conference. More than 2,000 volunteers throughout New York City distributed a 32-page "special edition" of the Rupert Murdoch-owned *New York Post* with the headline, "We're Screwed." Apparently forgetting its conservative bias, the paper covered deadly heatwaves, extreme flooding, and other lethal effects of climate change, featuring articles on Pentagon alarm, U.S. government denial, and China's alternative energy plan. The following day, a savior miraculously appeared. Halliburton, polluter extraordinaire and favored U.S. government contractor, unveiled three new prototypes of its SurvivaBall, "an advanced technology [that] will keep corporate managers safe even when climate change makes life as we know it impossible." First introduced by company "representatives" at a 2006 Catastrophic Loss conference in Florida (sponsored by the insurance industry), the SurvivaBall takes cynicism to a whole new level. After listing a catalogue of coming disasters, the spokesmen dismissed recommendations to cut carbon emissions as unthinkable: "Doing that would seriously undermine corporate profits...so a more forward-thinking solution

The Yes Men, *Gilda the Golden Skeleton* lounges in a field of rape, 2005. View of project in Scotland.

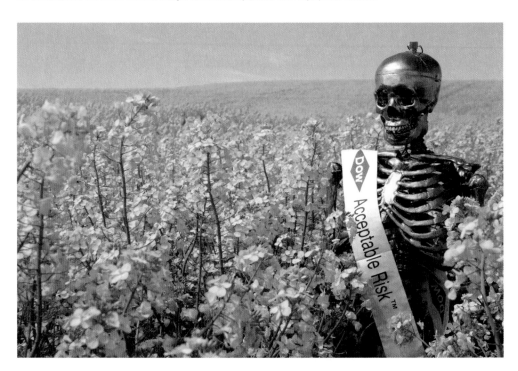

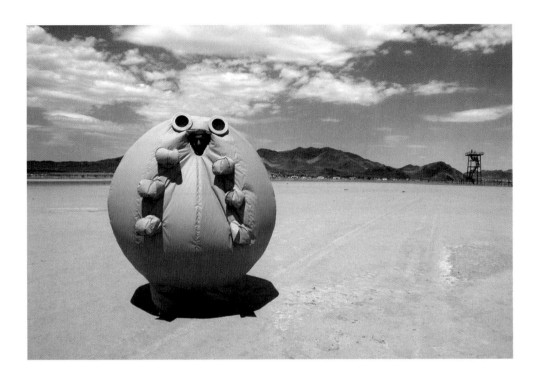

The Yes Men, with costume design by Sal Salamone, *SurvivaBall*, 2006–ongoing.

is needed." The huge inflatable orbs, they explained, "build on Halliburton's reputation as a disaster and conflict industry innovator," featuring sophisticated communications systems, nutrient-gathering capacity, on-board medical facilities, and "a daunting defense infrastructure to ensure that the corporate mission will not go unfulfilled even…[after] catastrophes or the consequent epidemics and armed conflicts." Presumably more effective than the body armor supplied to U.S. soldiers in Iraq, SurvivaBalls allow the chosen few to circumvent the laws of chance and guarantee the survival of the richest.[4]

On September 22, 2009, at the Climate Change conference, SurvivaBalls went public in Balls Across America, the first in a series of civil disobedience/direct actions inspired by the Climate Pledge of Resistance. More than two dozen people gathered along New York's East River, hoping to hold delegates in place until they'd agreed on sweeping cuts in greenhouse gas emissions. They were arrested, of course, but their outrageous "hazard" suits appeared on CNN and countless other media outlets around the world. In a later action at the U.S. Capitol, the protesting balls (some rolling down the steps) demanded a binding agreement on climate change.

Balls Across America gave the Yes Men a new participatory dynamic, one that they've continued to expand on with Web and social networking actions that allow everyone to effect change with infectious humor. The Fix the World "Identity Correction" Challenge, <http://challenge.theyesmen.org>, invites individuals and groups to share documentation of their efforts in categories that include "Liberate stupid footage," "Create a ridiculous spectacle," and "Engage in jobjacking." Site users contribute ideas, join or create new groups where they live, and become eligible for Yes Men training sessions.

As their tactics and faces have become more familiar, the Yes Men have increasingly turned to behind-the-scenes strategizing. Sharing the secrets of their success with activist organizations from around the world means more operatives exposing more truths and reaching greater numbers of people—it also provides these groups with an energizing,

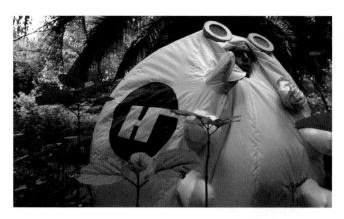

The Yes Men, with costume design by Sal Salamone, *SurvivaBall*, 2006–ongoing.

and ultimately more effective, communications model. Yes Lab, a consulting service that helps groups develop effective, mediagenic, activist projects, offers a full-service course in smoke-and-mirrors truth-telling. First remotely and then in person, the Yes Men help with everything from approaching a chosen target and choosing the project, developing an action plan, training (including media handling, improv, writing, and video editing), and staffing (which can be supplied by the Yes Men network) to designing fun, public activities that reinforce the issue at hand. As the Yes Men say, "If Yes Lab participants put in the needed work, the actions developed can garner a great deal of visibility—much more than a few paid ads."

This increasing focus on collaborative effort reflects an important cornerstone of the Yes Men philosophy: "Figuring out what we, ourselves, can do to change the world, given our skills and abilities." Their skills undeniably lie in using art to re-direct the course of public debate through humor and public spectacle, as Rainforest Action Network and Amazon Watch discovered when they teamed up with the Yes Men to create a day-long comedy of errors by pre-empting Chevron's "We Agree" greenwashing campaign.[5] The phony Web site <www.chevron-weagree.com>, which appeared before Chevron could launch its ads, featured four "improved" versions, complete with downloadable pdf files to be used in street-postering. As the PR war raged, people began submitting their own ads on <www.chevronthinkswerestupid.org>, many of them printable. The end result was a vaudeville-style upheaval of fact/fiction in which a number of press outlets, from industry mouthpieces to the AFP, and even a watchdog group, produced accidental mash-ups of real and fake information, ensuring that Chevron's attempt to gloss over its poor environmental and human rights record, particularly in Ecuador, back-fired.

Other Yes Lab projects—including another strike at Dow initiated by writer Anna Lappé and a "hoax to rule them all" with Toronto activists Black Flood that refocused attention on Syncrude and the Alberta tar sands—have met with equal success, raising public awareness with the ultimate goal of forcing companies to atone for their violations of the public trust.[6] Despite their stunning successes, the Yes Men realize that real change—whether punishing exploitative corporate practices, getting the government to honor emissions limits and safeguard precious resources, or simply persuading people to change their personal behavior—won't happen without tactically applied persuasion. In the battle to win the hearts and minds of public opinion—the force that will ultimately drive large-scale change—the unrelenting Yes Men approach has a clear advantage. Win them over with laughs, take their blinders off, and show them that there's something for everyone to do: "It might not quite fix the world, but it'll correct some identities, and it'll be lots of fun."

Notes

1 The edition of 80,000 copies, released in New York and Los Angeles on November 12, 2008, featured articles detailing dozens of new initiatives, including the establishment of national health care and a maximum wage for CEOs. News of its release was picked up by media outlets around the world.

2 See Novall Scott's story, available at <http://www.theglobeandmail.com/report-on-business/pranksters-disrupt-oil-patch-conference/article106173/>.

3 The war on Dow began in 2004, the 20th anniversary of the pesticide plant leak that released methyl isocyanate gas and other chemicals, killing thousands and leaving more

The Yes Men, in collaboration with Amazon Watch, Rainforest Action Network, and Cesar Maxit, *Chevron We Agree*, 2010. View of posters created as a part of fake "We Agree" Web site.

than 120,000 people requiring lifelong care. After launching <dowethics.com>, which the U.S. State Department recommended as a source for Bhopal information, Bichlbaum (under an alias) spoke for the chemical giant on BBC World News. His promise of clean-up and restitution spread like a virus across radio, television, and the Internet. Two hours later, Dow issued a press release denying the statement, thereby ensuring further coverage of the phony clean-up announcement and the story behind it. By the time the original story was discredited, Dow's stock had plummeted by $2 billion, and a long-buried saga of suffering and refusal to make good was restored to public scrutiny. The Web propaganda war continues to this day, and the Yes Men still update <www.dowethics.com>. In fact, the second hit on a Google search for "Dow Bhopal" (after Wikipedia) is the spoof site. The third is <www.theyesmen.org>.

4 <www.survivaball.com> details all the technical specifications of the suits and provides a handy usage guide.

5 Ecologist blogger Lauren Selman provided the tip-off after Chevron approached her to appear in its ads. A second lead came when Chevron's ad agency, McGarryBowen, asked Washington, DC, street artist César Maxit if he could help wheatpaste the new Chevron posters. Instead, he sent the Chevron files to the Rainforest Action Network. The original fake ads included "Oil companies should clean up their messes—We Agree" and "Oil companies should end the wars they helped start—We Agree." For a run-through of this complex web of coordinated actions, see <http://theyesmen.org/hijinks/chevron>.

6 When a Dow Chemical PR firm asked Lappé to contribute a video about the future of water for a new feel-good ad campaign called "The Future We Create," she gave them exactly that. Her submission stressed the threat posed by toxic chemicals to water and people and identified Dow as one of the biggest sources of such threats. After the video was rejected, Lappé partnered with Yes Lab to create a new Web site <www.afuturewecreate.com>, which contains her original video and a wealth of information on water pollution.

The tar sands/Mordor hoax (May/June 2011), which duped the media, movie fans, and environmental groups alike, alleged that Peter Jackson would be using the Alberta tar sands as Mordor in *The Hobbit*. This social media-driven rumor mill—timed to coincide with the lead-up to a U.S. decision on a tar sands pipeline—re-focused attention on the devastation perpetrated to life and land by oil giant Syncrude. See Judy Rebick's unraveling of the entire story at <rabble.ca/blogs/bloggers/rabble-staff/2011/06/one-hoax-rule-them-all-hobbit-movie-tar-sands-hoax-revealed>. More information on the horrors of strip mining oil from tar sands and the negligence of Syncrude can be found at <rabble.ca/news/2010/06/it's-official-syncrude-tar-sands-criminal>.

51 Declarations for the Future— A Manifesto for Artists

by Frances Whitehead

Why

1. Climate change = culture change
2. Sustainability is a cultural problem
3. Culture is everywhere
4. Ethics and aesthetics are inseparable
5. We need a new metaphysic
6. This is ideological
7. This is pragmatic
8. This is a call to arms.

How

9. Opt in
10. Question autonomy
11. Seek agency
12. Claim knowledge not just creativity
13. Move beyond critique
14. Demonstrate alternatives
15. Put up or shut up
16. Connect the dots
17. Be suspicious of expertise
18. Redirect contemporary practice.

What

19. Think systemically
20. Contend with complexity
21. Champion diversity
22. Create legibility
23. Solve more than one problem at a time
24. Sit at the collective table
25. Innovate through collaboration
26. Account for intangibles
27. Subvert the cultural quo
28. Violate your own taste
29. Get comfortable being uncomfortable.

Where

30. Start where you are
31. Re-localize radically
32. Envision place-based practice
33. Develop spatial literacy
34. Work at all scales
35. Create situated knowledge.

When

36. The world is dynamic
37. Adaptation is key
38. Our perception is limited
39. The future arrives every day
40. We are running out of time.

Who

41. We are world makers
42. We are culture workers
43. We are change agents and double agents
44. We are proactive
45. We are problem-finders
46. We are at home in the future
47. We claim intentionality not morality
48. We practice in public
49. We know we don't know
50. We make new knowledge
51. We change culture.

Why (does it matter)?

1 The discourse of climate change has replaced disciplinary-specific models of ecological action with a meta-disciplinary, systemic understanding. The culturally based behaviors that drive these deeply interconnected problems will not be changed by technological solutions alone. Climate change adaptations are **changing our cultural future**.

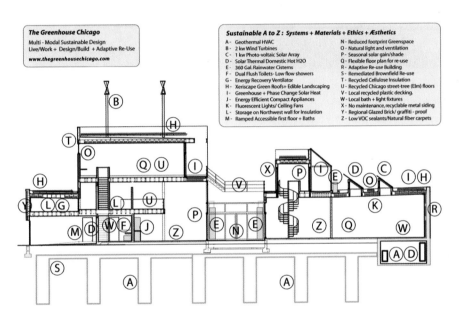

The Greenhouse Chicago
Multi - Modal Sustainable Design
Live/Work + Design/Build + Adaptive Re-Use
www.thegreenhousechicago.com

Sustainable A to Z : Systems + Materials + Ethics + Æsthetics

A - Geothermal HVAC
B - 2 kw Wind Turbines
C - 1 kw Photo-voltaic Solar Array
D - Solar Thermal Domestic Hot H2O
E - 360 Gal. Rainwater Cisterns
F - Dual Flush Toilets- Low flow showers
G - Energy Recovery Ventilator
H - Xeriscape Green Roofs+ Edible Landscaping
I - Greenhouse + Phase Change Solar Heat
J - Energy Efficient Compact Appliances
K - Fluorescent Lights/ Ceiling Fans
L - Storage on Northwest wall for Insulation
M - Ramped Accessible first floor + Baths

N - Reduced footprint Greenspace
O - Natural light and ventilation
P - Seasonal solar gain/shade
Q - Flexible floor plan for re-use
R - Adaptive Re-use Building
S - Remediated Brownfield Re-use
T - Recycled Cellulose Insulation
U - Recycled Chicago street-tree (Elm) floors
V - Local recycled plastic decking.
W - Local bath + light fixtures
X - No maintenance, recyclable metal siding
Y - Regional Glazed Brick/ graffiti - proof
Z - Low VOC sealants/Natural fiber carpets

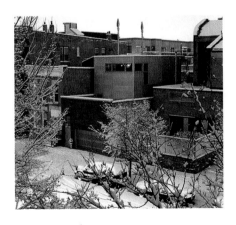

2 The four-pillar model of **sustainability adds culture** to the "triple bottom line" of "social, economic, and environmental" criteria for evaluating sustainability. First described in 2001 and recently adopted by UNESCO, the key insight is that a broad cultural "framework," not a cultural "sector," is essential for the achievement of a sustainable society.[1]

3 Understanding culture in this expanded way requires artists to work "upstream." We must act throughout all sectors and disciplines to integrate cultural expertise into wider decision-making, *in situ*, revealing that **culture is everywhere**.

4 Systemic thinking brings the relation of **ethics and aesthetics** into high relief. If a new aesthetic is to be had, it is a systemic one, beyond appearances, a diverse aesthetics evolved to address more than human factors.

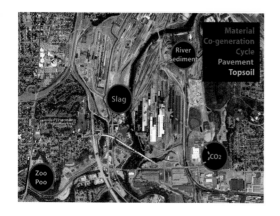

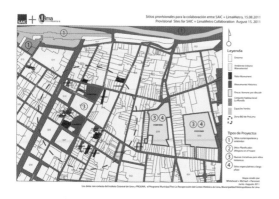

Above: Frances Whitehead with Lisa Norton, *SUPERORG. net*, 2005–07. Detail of Steelyard Commons Sustainability Plan, Cleveland. Below: Frances Whitehead, Douglas Pancoast, and Vince Michael, in collaboration with the Municipality of Lima, Peru, *The Lima Project*, 2011–ongoing. Project to integrate urban agriculture into the Barrios Altos historic district. Detail of "La Huerta" at UNALM.

5 New forms of cultural expression will be generated that account for the logics, epistemologies, and ontologies of the future, the necessary emergence of **a new metaphysic**.

6 While there is an **ideology** at work, the research into forms and instantiations is only beginning. The long-theorized "both/and" model opens a space not only for ethics + aesthetics, but also for art + science, art + design, art + community.

7 It is also **pragmatic**. The expertise of artists, their cultural literacy and imagination, is required for survival. This is an opening, an opportunity to remodel culture at all levels and to evolve new practices and outcomes.

8 It is vital to our collective future that **artists step up**. What will be sustained and who will decide? How will these vital cultural decisions be made without our participation? Herein lies the urgency, our **call to arms**.

How (do we get there)?

9 There is **no opting out** of climate change.

10 Perceptions and strategies to the contrary are a function of the persistent myth of **artistic autonomy**, which ultimately limits art, culture, activism, resistance, subversion, agency, praxis, and culture change. All models that divide knowledges and essentialize "culture" exclusively into "artworks" should be examined. **Disciplinary autonomy** further limits what we can contribute; even collectivity largely maintains specializations of labor, knowledge, and practice.

11 The mindset of specialization obscures our deeper **agency**, our ability to identify conditions of receptivity. The symbolic economy of art, operating alone, has limited agency. What agency might be found by combining the symbolic with practical action?

12 Operating as cultural experts and innovators, artists can claim not only the cognitive and dispositional status of **creativity**, but also disciplinary **knowledge**. We must develop a new epistemology of art practice, one allowing a knowledge claim based on inquiry, expertise, and disposition.

13 Claiming knowledge, innovation, and creativity is not enough. We must perform our claim by **moving beyond critique**. Critical capacity is an invaluable tool, but critique alone is not going to deliver solutions.

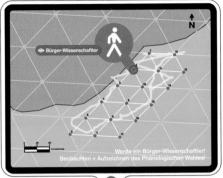

The Phenologic Forest, 2008–ongoing. An interactive geocaching game for youth establishes a "citizen science" network for phenologic observation in the Hessian Forest of Darmstadt, Germany, based on the coordinate grid used by the Deutscher Wetterdienst.

14 Our **alternative** visions **demonstrate** our synthetic skills. Here, we differentiate our knowledge and methodologies from anthropologists—artists both produce and evaluate culture—and from designers—artists both design and execute the work.

15 Our collective situation is fraught with "moral hazards," but we must act *anyway*. We cannot claim creativity if we cannot **deliver models** for the future.

16 Connecting the dots is at the core of our work. Artists are adept at creating multi-criteria works that negotiate different audiences and points of access, that navigate the tangible and intangible. These skills can be used to integrate cultural aspects into all projects.

17 Artists possess the key skill of "not knowing"; we admit limitations. Climate change has precipitated a renewed interest in "wicked problems," problems paradoxically unsolvable by the expertise that created them. We must be **suspicious of reductivist forms of expertise**, including our own. Artists give themselves permission to intervene in any system without invitation. This strategic irreverence is not merely cultural mischief—we must also look inward.

18 As we understand the systemic nature of climate impacts, we must evolve new ways to integrate artistic expertise, to move away from specialization toward dynamic and adaptive models. We must **redirect art practice**.

What (do we do)?

19 Emerging from evolutionary biology, **complexity** science is becoming a key influence on public policy and climate action. The ability to think in **whole systems**, especially closed looped systems, dynamic and metabolic, is crucial.

20 Understanding cities and their bioregions as **complex adaptive systems** forms a core competency for the future and opens possibilities for conceptualizing new modes of cultural activity—new sites and opportunities for engagement.

21 Adaptation and evolutionary innovation **favor diversity** of all kinds: a diversity of approaches creates alternative perceptions and feedback, more innovative systems, and additional **complexity**.

22 Comprehension of these interconnections foregrounds the need for **legibility beyond visualization**. The complexities

at work in the world are outside the scope of any single discipline. The traditional role of the artist, to make the invisible visible, takes on new dimensions, re-cast as "seeing systems."

23 Much like the multi-level artwork, a "radically multi-functional" approach **that solves more than one problem at a time** is required for problems that lie at the intersections of interdependent sub-systems.

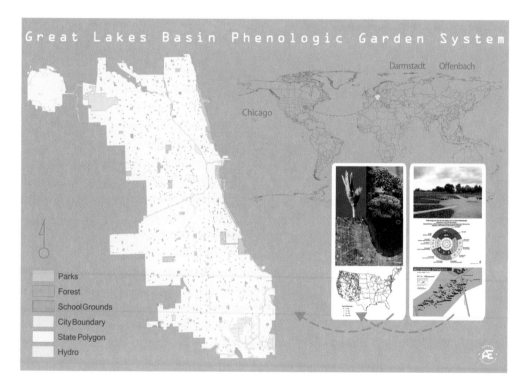

Great Lakes Basin Phenologic Garden System, Chicago Park District, 2008–ongoing. A phenologic planting and observation system for the Great Lakes Basin anchors a bioregional climate-monitoring system, using seasonal events like the Japanese Cherry Blossom Festival to re-establish a sense of "seasonality" in public consciousness while generating data.

24 The promise of "relationality" or of the "expanded field" is not yet manifest.[2] We must join our colleagues from all communities of practice at the **collective table**.

25 Multi-, trans-, and in-disciplinary **collaborations** that deploy a participatory model hold the greatest potential for systemic **innovation**.[3]

26 Artists are expert in qualitative assessment—how cultural values are represented and embodied—and in navigating subjectivities, activities largely eschewed in quantitative civic processes. Previously **unaccounted-for intangible valuations** can lead to policy formation and adoption of new methods.

27 This participatory model redirects disciplinary territory and subverts conventional artistic practice, the "**cultural quo**."

28 Operating both inside and outside our disciplinary expertise, both inside "culture" and (possibly) outside "art," is required to build an alternative platform for new cultural futures. We must be willing to **violate our own taste** in favor of the truly experimental.

29 Those who contribute to the task of re-imagining the future will become **comfortable with the discomfort** of participating in the unknown.

Where (does it happen)?

30 In an interconnected systemic paradigm, there is no privileged location, so **start where you are**. This adage offers a simple, but profound answer to the apparent enormity of the tasks ahead.

31 But this statement also reveals a transferable method. Extrapolating laterally from the **locavore logic** of the Slow Food movement, food miles and foodshed beget culture miles and culture shed, a **radical re-localization**.[4]

Frances Whitehead, David S. Graham, and A.P. Schwab, *SLOW Cleanup: Designed Civic Experiments with Phytoremediation*, 2009–ongoing. A whole-systems approach to cleaning polluted sites in Chicago, using plant-based phytoremediation. Piloting the use of ornamental, flowering, and fruiting plants, the project aims to increase the plant palette for this technology. Interpretive materials increase awareness of the interconnectivity of natural and cultural systems in urban ecology.

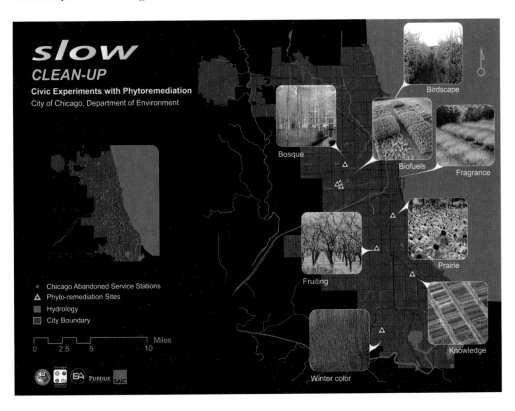

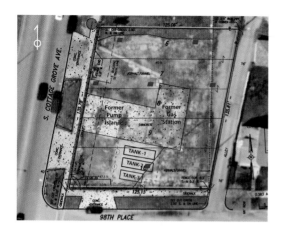

32 Resistance to globalized, commodity culture and its anes-thetizing sameness is coupled with a reduction in the carbon footprint of transportation, signaling a future for alternative, **place-based practices**.

33 These new cultures of "place" will be geospatially inter-connected (g)local hybrids, both/and/here/there. New **spatial literacies** are required for these practices.

34 We will learn to **work at all scales**, micro and macro, as we map practices of time, space, and system.

35 Sustainable cultural futures will be built on bioregional realities. Eco-migration and resettlement will demand the creation and demonstration of **situated knowledge** and practices, especially in areas not previously seen as cultural.

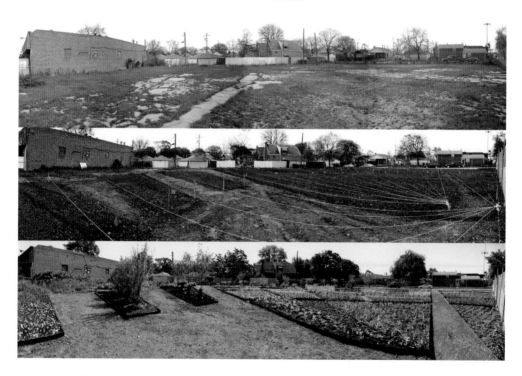

Top: *SLOW Cleanup*, 2010. Geo-technical survey of tank excavation and soil borings, Cottage Grove Heights, Chicago. Above: *SLOW Cleanup*. 3 views of Cottage Grove Heights Laboratory Garden: prior to development, 2009; after soil preparation and layout, May 2011; and after test-plot planting, June 2011.

When (will it happen)?

36 The **dynamics** of the natural world extend to the metabolic ecology of cities, the understanding of which must be approached with equally dynamic strategies. Compre-hension in long time frames, coupled with the ability to work with scientific and social/cultural "uncertainty," is required.[5]

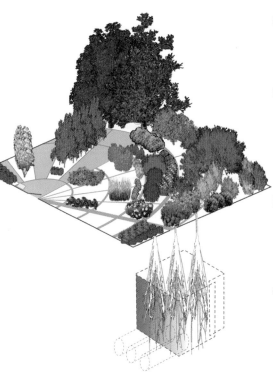

37 Inventive climate mitigations and **adaptations** can be found that increase the quality of life and reduce impacts, replacing the quantitative economy with a qualitative one.

38 Research into "temporal discounting" in economics reveals a biological and cultural tendency to value the present over the future. This "hyperbolic" or "exponential" discounting **limits our perception**, creating a present-biased "temporal myopia" an invisible valuation that must be brought into consciousness.[6]

39 The inability to comprehend the present-ness of the **future, which arrives every day**, or the impact of decisions that inscribe some cultural futures and preclude others, has evolved into the shorthand method, "Work from the **future backwards** to the present."[7]

40 The realities of climate change are beyond debate, but questions of timing, impacts, and strategy remain. As artists, we must learn to imagine the cultural policies and challenges of the future. **We are running out of time**.

Above: *SLOW Cleanup*, 2011. Digital rendering of Cottage Grove Heights Laboratory Garden Concept with gas tank excavation. Right: *SLOW Cleanup*, 2011. Greencorp, Horticulture Training Program participants installing large trees at the Cottage Grove Heights site, spring 2011; Martha Brennan, Project Manager.

Who (can we be)?

41 The designation of "artist" may not always be useful as we collectively re-"**make the world**" to achieve sustainability.[8]

42 **Working in the culture** at large may necessitate strategic identity shifts as a dimension of our role as "**change agents**."

43 We will operate both inside and outside "art" and other worlds as **double agents** (or triple or quadruple) — an ontological project.

44 We bring the **proactive**, critical practices of art-making to tasks and disciplines not associated with activism, making (art) with purpose.[9]

<http://embeddedartistproject.com>

45 The prescription against artist as problem-solver becomes the art of systemic **problem-finding** (problem articulation).

46 If we are able to adopt these frameworks and bring our knowledge to this systemic task of world-making, we will find ourselves **at home in the future**, creating new, currently unimaginable art forms.

47 In this philosophical space of ethics and aesthetics, the artist's focus on **intentionality** remains critical. How to operate in this space is not clear. The "habitus" of art-making is a part of the problem.[10] "Normal art," a parallel to Kuhnian "normal science," as a conservative and static impulse will be subverted.

48 This is where an experimental artist's ability to operate laterally, to boundary hop between disciplines and discourses, models the innovative outcomes that can arrive by **practicing in public**.

49 Admitting that **we do not have the answers**, and that we might find them through conversation with unlikely partners and collisions of disparate expertise, makes a case for the professional amateur.[11]

50 The legacy of the avant-garde has positioned artists as key experts in idea development and innovation. We are professional producers of **new knowledge**, even though this dialect is not ours and we stand critical to its assumptions.

51 As both critics of and producers of new knowledge and contemporary culture, who hold agency and ability to **change culture**, we must join others in visionary redirection toward the sustainable.[12] **Climate change = culture change**.

Notes

1 Jon Hawkes, *The Fourth Pillar of Sustainability: Culture's Essential Role in Public Planning* (Sydney: Common Ground Publishing Pty Ltd, 2001).

2 See Nicolas Bourriaud, *Relational Aesthetics* (France: Le Presses Du Reel, 1998) and Rosalind Krauss, "Sculpture in the Expanded Field," in *The Originality of the Avant-Garde and Other Modernist Myths* (Cambridge, Massachusetts: MIT Press, 1986).

3 See Jacques Ranciere, interview with Marie-Aude Baronian and Mireille Rosello, 2007, available at <www.artandresearch.org.uk/v2n1/jrinterview.html>, and Lee Fleming, "Perfecting Cross Pollination," *Harvard Business Review*, September 2004: pp. 22–24.

4 On the Slow Food movement, see <www.slowfood.com>. The concept of food miles appears in A. Paxton, *The Food Miles Report: the Dangers of Long Distance Food Transport* (London: Safe Alliance, 1994). For the foodshed, see Jack Kloppenburg, Jr., John Hendrickson, and G.W. Stevenson, "Coming into the Foodshed," *Agriculture and Human Values* 13:3 (Summer 1996): pp. 33–42, available at <www.cias.wisc.edu/wp-content/uploads/2008/07/comingin.pdf>.

5 Union of Concerned Scientists, "Certainty vs. Uncertainty: Understanding Scientific Terms about Climate Change," <www.ucsusa.org/global_warming/science_and_impacts/science/certainty-vs-uncertainty.html>.

6 Larry Karp, "Global Warming and Hyperbolic Discounting," available at <http://escholarship.org/uc/item/5zh730nc>. See also <www.paulchefurka.ca/Hyperbolic Discount Functions.html> and <www.theoildrum.com/node/2243>.

7 Gail & Medek and Tony Fry, "Proposal for Boonah Two—Redirective Practice and the City," 2007, available at <www.riba-usa.org>.

8 Nelson Goodman, *Ways of Worldmaking* (Indianapolis: Hackett Publishing, 1978).

9 For more information on Make Art with Purpose (MAP), see <http://makeartwithpurpose.net>.

10 See Pierre Bourdieu, *Outline of a Theory of Practice* (Cambridge: Cambridge University Press, 1977), p. 78.

11 See Charles Leadbeater and Paul Miller, "The Pro-Am Revolution: How Enthusiasts are Changing our Economy and Society," 2004, available at <www.demos.co.uk/publications/proameconomy>, and The Public Amateur blog site, with Claire Pentecost, et. al., <http://publicamateur.wordpress.com>.

12 Tony Fry, *Design Futuring: Sustainability, Ethics and New Practice* (Oxford/New York: Berg Publishers, 2009).

Eve Andrée Laramée:
Revealing What No One Wants to See

by Twylene Moyer

Eve Andrée Laramée has been exploring the "mutable, triadic relationship between art, science, and nature" for more than 20 years. Synthesizing exhaustive research and visually poetic metaphor, her polemical installations draw incongruous, and revealing, connections that transcend received authority and so-called hard facts. From an equation of human blood and sea water (*Cellular Memories*, 1996) to an alternative pedigree for the digital computer traced through the history of textiles and the performing arts (*A Permutation Unfolding*, 1999), these works rethink how we formulate our knowledge and perceptions, how we use science and art as "maps" of beliefs about the natural world. While many of Laramée's investigations focus on the abstract and conceptual, others expose concrete human impacts on the environment. Like the Center for Land Use Interpretation, she explores what the Situationists called "psycho-geography," but her investigations step beyond the bounds of neutral presentation. Seeing her role as an artist as "part messenger, part activist, part whistle blower," she has become increasingly committed to collaborative works aimed at initiating public dialogue and solving problems for affected communities—particularly in regard to atomic waste.

Parks on Trucks: Project for the City of Aachen, Topiary Truck, 1999. Mercedes-Benz diesel flatbed truck, topiary plants and annuals, soil, gravel, and geotextile, truck bed, approximately 40 x 8 ft.

Sugar Mud: Window (detail), 2003. Golden yellow sugar, light from window, and yellow theater gels on window glass.

Intersections between real and constructed lands and histories play an essential role in Laramée's strategy. Frequently she creates detailed map drawings to juxtapose otherwise disconnected elements, drawing them together into damning patterns of environmental and human degradation. Other projects, such as the ironic *Parks on Trucks: Project for the City of Aachen* (1999), take a more direct approach. Working with bio-geographer Duane Griffin, Laramée created three distinct landscapes, each one inhabiting its own Mercedes-Benz flatbed truck. Microcosmic representations of how humanity constantly transforms nature in contradictory ways, these "parks" conflated the extremes of "sacred" fetish and raw resource. One truck contained a topiary garden of "artificial nature." Medicinal and poisonous plants filled the second. The third truck, planted with a crop of corn, simultaneously polluted and cleaned the air. Weighing the truck's emissions against the amount of CO_2 sequestered by the growing corn, Griffin calculated a carbon-neutral distance of travel—one third of a kilometer in three months. As this traveling exposé circulated through the city, it offered a clear demonstration of biogeochemical balance and how the tilting of the cycle feeds global warming. At the same time, it challenged the false Arcadia promised by auto industry advertising, a mythical land where SUVs and sports-cars roam freely through a habitat of lush forests, rugged mountains, and other unspoiled settings.

For Laramée, it is as important to understand the cultural interpretations at work behind our interactions with a given site as it is to understand the effects of our actions. In *Sugar Mud*, a 2003 installation at Wave Hill in the Bronx, a mound of golden sugar set a gallery ablaze with the same radiant aura that suffuses Hudson River School paintings. Rather than allow this sugary sweet glow to work its magic in formalized suspension, Laramée contextualized the fiction, outlining a backstory that peels away idealized surface to reveal ugliness below. At the same time that the Hudson River painters were drawn to Yonkers and other riverside sites, the sugar processing industry was playing an increasingly important part in the local economy. Refined sugar comes at a price, producing PCBs and dioxins, which were dumped into the river. This "sugar mud" was later dredged from the river at Yonkers and deposited in a

"Historical Area Remediation Site" in the New York/New Jersey harbor. To demonstrate the effects of these displacements (the U.S. Army Corps of Engineers removed 80,000 tons of matter), Laramée, along with marine geologists Roger Flood, Vicki Ferrari, and John Ladd, produced a series of benthic maps that profiled the river floor and showed the scars of the dredge canal. The transplanted toxins, removed to the ocean, joined thousands of tons of other detritus in an artificial reef. Laramée discovered that the Atlantic Beach Reef, which covers 413 acres off the coast of Long Island, consists of 30,000 tires, 404 auto bodies, 10 ice cream trucks, nine barges, a tugboat, a steel crane and boom, surplus armored vehicles, concrete slabs, pipes, and 350,000 tons of rock from another Army Corps project. As she explained in an interview about *Sugar Mud*, "That bit of information alone is important for people to be aware of, if for nothing else than the sheer bizarreness of the fact that the New York State Department of Environmental Conservation builds these reefs 'to enhance marine habitat and provide more accessible fishing grounds for anglers.'"[1]

Sugar Mud demonstrates how cultural perceptions of a site play into its valuation and fate. In the 19th century, industrial growth trumped aesthetic appreciation, but in the 20th century, historical value and the "branding" of the Hudson as an iconic American landscape (coupled with its truly horrific condition) fueled rehabilitation efforts. Of course, some "lesser" site, in this case, the ocean, must receive the refuse.

The invisible information that Laramée uncovered in New York pales beside her discoveries in the southwest. For the last 10 years, she has been investigating the environmental impact of atomic weapons research and development at Los Alamos National Laboratories in northern New Mexico and sharing her findings in a series of related works—what she calls "a public service announcement in the form of installation[s] and community-based action/social sculpture[s]." The first of these installations, *Fluid Geographies* (2001–06), focuses on the 17,500,000 cubic feet of

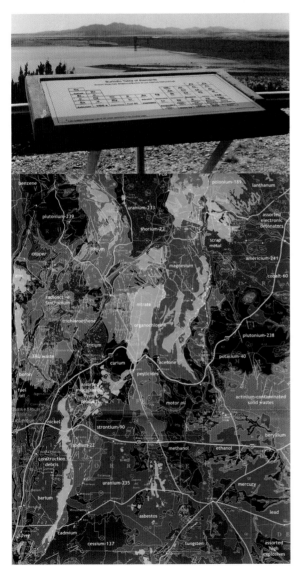

Below: *Fluid Geographies*, 2001–06. Laminated digital inkjet print inserted into historical plaque at the Cochiti Dam Scenic Overlook, downstream from Los Alamos National Labs, 24 x 48 in. Documentation detail of social sculpture/community action, Buriodic Chart of Known Contaminants at Los Alamos, 24 x 48 in. Bottom: *Fluid Geographies* (detail), 2001–06. Digital inkjet print on paper, 30 x 40 in.

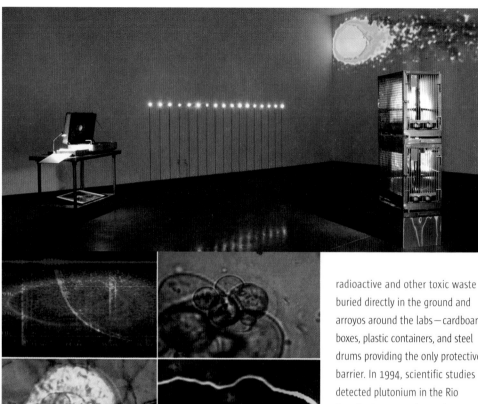

Top: *Halfway to Invisible*, 2009. Stainless steel, viewer-reactive kinetic cage sculpture, video sculpture in aluminum suitcase with Cold War artifacts, video projection of cell in uranyl acetate solution, 60 light boxes with transparencies and lenses, archive of scientific documents about health impact of uranium mining around Grants, New Mexico, and documentary photographs of uranium mining and milling sites, 30 x 33 ft. Above: *Halfway to Invisible*, 2009. Video stills from sculpture interpreting mutation caused by exposure to radiation on the cellular level.

radioactive and other toxic waste buried directly in the ground and arroyos around the labs—cardboard boxes, plastic containers, and steel drums providing the only protective barrier. In 1994, scientific studies detected plutonium in the Rio Grande; in 2000, other radioactive materials, including strontium-90, polonium, and uranium, were found in the region's drinking water, ground water, and aquifers. As Laramée went on to discover, the rates of brain, nervous system, and thyroid cancers were considerably higher here than in other state and national populations. *Fluid Geographies* gathered these interconnected threads, tracing their combined story through digital prints, maps, photographs, and archival documents, in conjunction with a video projection and mirrors engraved with the names of the 55 known contaminants buried around Los Alamos. Then, Laramée and her team, under the auspices of LANL: Lost Artists in Nuclear Landscapes, gathered at the Cochiti Lake Scenic Overlook, downstream from the labs, for the outreach portion of the project. They placed a map of the Los Alamos watershed marked with the waste deposits at the pull-off, inserted a "Buriodic Chart of Known Contaminants Buried at Los Alamos" in the information plaque, and spoke to tourists about radioactive water contamination.

The video/sculpture installation *Slouching Toward Yucca Mountain*, which features 19 fictional characters exploring a post-atomic-age West, examines American beliefs about nature, conquest, land use and ownership, and environmental

justice. Taking aim at "cowboy extraction" economies, this conflation of fact, Western and sci-fi film cliché, and environmental exposé unearths the legacy of an ill-advised attempt to develop Yucca Mountain as a deep repository for high-level radioactive waste. Geological faults and climate uncertainties put an end to the project, but the maze of excavated tunnels remains as a witness to the misuse of the West's empty "wastelands."

These first two works underscored the deeply frightening fact that the U.S. has no master plan for permanently disposing of radioactive waste, which remains in temporary storage at hundreds of sites across the country. Laramée's next two projects focus on the hardest-hit victims of this scarcely acknowledged environmental problem, attempting to raise awareness of their plight and improve their condition.

Halfway to Invisible (2009), which was commissioned by Emory University, spoke directly to the Centers for Disease Control in Atlanta about a group of people who, between 1949 and 1989, were knowingly endangered by the U.S. government. During that 40-year period, uranium mines in the Four Corners region produced more than 225,000,000 tons of ore. As Laramée learned, poorly paid miners and other uranium workers, most of them from the Pueblo cultures of the Southwest, were neither informed of the dangers posed by radiation, nor given protective gear. Even basic safety protocols were ignored: exposure migrated from mines to homes, as unsuspecting laborers carrying radioactive dust on their bodies and clothes returned to their families. To demonstrate the environmental and biological crimes of this atomic age malpractice, which may have permanently altered evolutionary processes and produced genetic casualties among the indigenous peoples of the Southwest, Laramée unleashed a flood of overlapping evidence. Her compelling installation gives physical presence to these shadowy, hidden facts, each nuance taking on an appropriate visual form: a viewer-activated kinetic sculpture made from laboratory animal cages, a video projection of cell mutation after

Prototype designs for *Water Filter Social Sculptures* (detail), 2010–11.

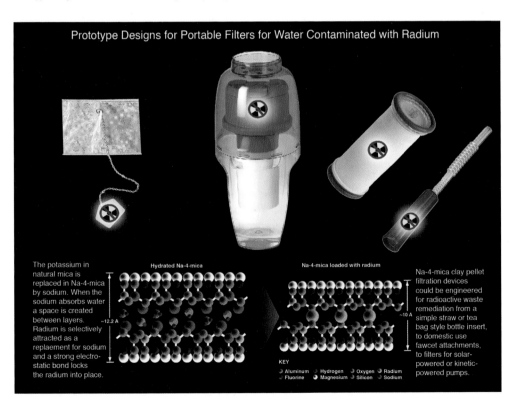

uranyl acetate exposure, a video sculpture housed in an aluminum Halliburton attaché case with Cold War-era Civil Defense artifacts, an archive of documents and photographs, 60 light boxes presenting superimposed image sequences (genome maps, extremophile organisms, and woven baskets), and an ambient soundscape. No one left this stunningly rendered indictment untouched by the price of defense and the limits of technology.

With the Republicans persistently raising the idea of uranium mining (this time near the Grand Canyon), Laramée's work serves more than just a documentary function. As her atomic legacy series proves, the effects of uranium mining are pervasive and long-lasting. The people of the Southwest still live with land and water contaminated between 15 and 60 years ago, and these radioactive isotopes are not going to disappear any time soon: hundreds of sites still contain plumes of contaminated ground water, not to mention several hundred thousand tons of contaminated soil.[2] In fact, the U.S. government estimates that water resources at atomic legacy sites will not be completely remediated (using filtration and reverse osmosis) until 2025. No one has said what to do in the meantime.

Laramée's *Water Filter Social Sculptures* (2010–11), a low-tech, inexpensive, DIY approach to filtration, provides a solution that fills in the gaps left by large-scale government clean-up efforts. Working with a research team that includes Sridhar Komarneni, who developed Na-4 mica, a synthetic clay body that absorbs and stabilizes radioactive toxins in water while yielding inert waste for safe disposal, Laramée is developing a series of prototypes designed for personal, home use in affected areas. These social sculptures, which take the form of tea-bag filters, faucet and shower head filters, and drinking straws, restore an element of control to people whose lives have been compromised by radioactive pollution. They are not a substitute for substantial clean-up operations, but "a way to give power to the people and potentially lower risks of radiation-specific diseases and birth defects."

Laramée is still raising funds for this important, potentially life-saving device. Once the program begins, participants will receive their filters, use them for a specific period of time, and then exchange them for replacements. After these field tests, Laramée's team will make the filters available as open-source designs, and community educational programming will provide filter production training. Such a grassroots approach to the problem has another important benefit, giving people the means to challenge policy decisions made without their input: "Providing people with the capacity to monitor their own landscapes may reveal variances in what have been politically determined as 'safe' and 'sustainable' levels of toxicity." In communities caught up in political wrangling, the filters can serve as first responders, cleaning polluted water immediately and for however long it takes government agencies to move from acknowledging the problem to resolving responsibility, to finally mobilizing the appropriate resources.

Like all of Laramée's work, this model social sculpture project shares information, innovation, and ideas across disciplines and with the public to initiate positive social change. The collaborative approach is essential: not only do artists have to incorporate what they learn from science, but scientists also have to open their work up to artistic interpretation. Together, "art/science collaborations can energize action to change consciousness and promote awareness of environmental and health issues by directly involving communities." To anyone who doubts the relevance of artists and their contributions, Laramée offers an insight from Newton Harrison, "Artists outsee other people."[3]

Notes

1 See the interview with Laramée at <www.wavehill.org/arts/laramee_interview.html>.

2 See Laramée's background paper for *Water Filter Social Sculptures*.

3 Laramée, <www.wavehill.org/arts/laramee_interview.html>.

Making the Invisible Visible:
A Conversation with Andrea Polli

by Polly Ullrich

Andrea Polli, an artist and associate professor in fine arts and engineering and the Mesa Del Sol Endowed Chair of Digital Media at the University of New Mexico, works collaboratively with atmospheric scientists to develop systems for understanding weather, pollution, and climate through sound and visualization. Many of her works rely on "sonification," a process that directly translates raw data (about everything from sulfur dioxide, carbon monoxide, and ozone pollution to lightning, wave, and wind trends) into compelling and understandable forms. In 2007–08, Polli spent seven weeks in Antarctica on a National Science Foundation-sponsored project that resulted in the sound work *Sonic Antarctica* (2008), now on CD. Her work with science, media, and technology has led to more than 100 presentations, exhibitions, and performances. Recently, she has been working with her collaborator Chuck Varga and technical designer Markus Maurette on *E-oculus* (2011), a large-scale, permanent LED installation for the University of Utah that visualizes real-time business data (from the Dow Jones, Nikkei, Hang Seng, and other market indices) in a constantly changing skyscape. Other 2011 projects include a residency with Varga at the South Rim of the Grand Canyon, sponsored by the National Park Service, and a book, *Far Field: Digital Culture, Climate Change and the Poles*, in collaboration with Jane Marsching, published by Intellect Press.

Polly Ullrich: *It is fascinating how your work operates across many different realms. You have used the term "sonification" as a way of showing how scientific or technical facts and data can be translated into aesthetic forms, frequently into sound art. What is "sonification," exactly?*

Andrea Polli: I define sonification as the translation of numerical data or information into sound. This is generally seen as a subset of audification, which is the translation of non-aural signals into sound, although not necessarily numerical information (pitch-shifting seismic signals into the audible range would be an example of audification but not sonification).

PU: *Particle Falls (2010), which you created in collaboration with Chuck Varga, projects an enormous electronic "waterfall" on the side of a building in San Jose, California. The imagery provides a moment-to-moment graphic rendering of airborne particulate pollution levels in the city. Modern sensors, combined with the latest projection technology, give shape to every change in air quality, triggered by even the smallest particles. People can look at the work or use a mobile phone app to monitor the air that they breathe. What is your goal for a work like this?*

AP: Our goal with *Particle Falls* is to make the invisible visible and to raise awareness of air quality among the general public. Another goal we had was to encourage agencies that control data like particulate pollution to be more open about sharing that data with the public.

In terms of general goals, I would say I'm interested in exploring and giving shape or form (even if that is through sound) to forces of our environment that are difficult or impossible to perceive. On the flip side, I would like people to start to consider their perceptual faculties and pay more attention to things in their environment like wind, temperature, and pressure—to pay as much attention to these things as they do to the barrage of visual and aural signals we receive through the media landscape.

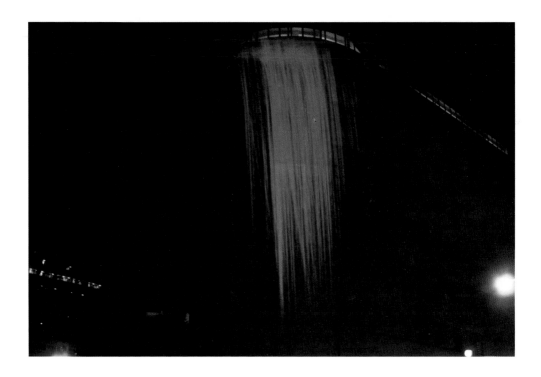

Andrea Polli with Chuck Varga, *Particle Falls*, 2010. Computers, air monitoring system, and projection, dimensions variable. View of project in San Jose, California.

PU: *Does it matter that you are making the invisible "real" with electronic technology that itself seems to be dematerialized?*

AP: Well, I'm not convinced that it is correct or useful to refer to electronic technology as dematerialized. I often give an assignment to my students to investigate the ecological footprint of everyday objects, and inevitably someone chooses a computer, cell phone, or other piece of electronic technology. Their results show a magnitude of impact from these devices that is frightening. There is also increasing evidence that staring at a screen all day long and carrying a cell phone attached to your body can have damaging effects. So, there is a materiality to electronic technology that we should acknowledge.

PU: *Is it important what your work looks like? Do "formal" qualities have any place in your art? Is it important that the data and scientific research be "aestheticized" in some way?*

AP: Yes, what it looks like and what it sounds like are important considerations, and I try to eliminate extraneous material from the work. It's not exactly a Minimalist aesthetic, but an attempt to focus the viewer or listener on the relevant details. This can be challenging because, in many cases, I am dealing with complex systems, and the relevant details are not easily found. In those situations, I try to build a design that involves one or a small number of "shapes" to be created out of the data.

For example, I created a 16-channel sonification of a hurricane for Engine 27 in New York City, titled *Atmospheric Weather Works* (2001). My scientific collaborator and I were curious about what the sonification models of the hurricane would sound like, to help listeners gain insight into the structure of the storm. The work was located in a former firehouse in Tribeca—Engine 27—that had been turned into an art center focusing on sound work. I liked the association with "emergency" because of the location's original use.

Each of the 16 speakers there was set to sonify nine different data variables, from temperature to wind to atmospheric pressure. I originally wanted to model the work after Ligeti's *Requiem*, which I had just heard performed at the amazing Symphony Hall in Berlin. I recorded a series of voices and mapped each variable to the pitch of a distinct drone. However, the results were completely static: all those voices created a wash that didn't allow the listener to hear the changes that were happening in the data streams during the storm. So, I decided to link the variables, using just one or two source sounds in each speaker with various parameters of the sound as it was affected by the storm. Wind speed, for example, controlled volume, temperature controlled pitch, and precipitation opened or closed a band-pass filter. Although the results were still very complex, I was satisfied because the listener could hear changes in the storm over time.

PU: *Your ongoing project* Heat and the Heartbeat of the City, *a Web-based sound installation that is monitoring summer temperatures in New York's Central Park through the year 2080 <www.turbulence.org/works/heat>, is meant to illustrate—through sonification—dramatic climate change and warming. How important is it for art to advocate or critique, to be involved in the social, political sphere of human life?*

AP: Before 2004, I thought that art should be neutral or open-ended (or at least that was the kind of art that I was creating), but in 2004, I started collaborating with the Center for Climate Systems Research at Columbia University's Earth Institute headed by Dr. Cynthia Rosenzweig, who also leads NASA's Climate Impacts Group. We were working on sonifications of projected climate in New York City, and this was the first time that I started to realize the magnitude of climate change. I started investigating more, interviewed several scientists about their research, and I came to believe that the problem of climate change is so large that everyone's help is needed in addressing it: scientists, artists, journalists, everyone.

Heat and the Heartbeat of the City, 2004–ongoing. On-line project documenting rising heat in Central Park, New York.

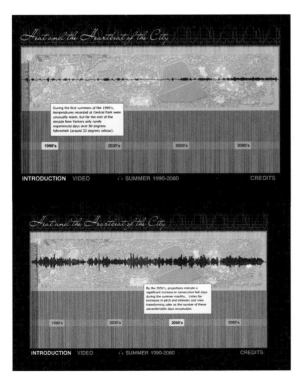

This problem is even more pressing to me because of the media crisis in this country (and many others). There is large corporate control over more and more media, and less and less support available for investigative and science reporting. Not only that, but as the science is becoming more complex, education funding is being cut; so there are fewer people who can understand the science, and on and on. I interviewed one climate scientist in 2007 who called this and other political policies a "war on science." So, although I would not call myself an "activist" because I have too much respect for the dedication that real activists have, I would say that I am an advocate for greater communication and greater understanding between disciplines.

PU: *Is there an ethics behind art-making, or should there be?*

AP: This is a very interesting question, because artists are, of course, subject to the same laws as anyone else. However, in many ways, artists have played a role in changing unjust or ill-

advised laws. Right now, for example, a lot of artists are involved in challenging copyright laws. So, there definitely is an ethical dimension to art-making. In terms of why, I would say that any human activity has to have an ethical dimension. In terms of what the ethical dimension of art-making is, I would have to say that answering that question requires a discourse over time, which I think is happening and will hopefully happen more in the future. These ethics have to be constantly developing and evolving based on interactions between artists, governments, corporations, scholars, and the public.

PU: *What is the artist's role in ethically guiding the public?*

AP: Artists can have a great amount of power, and they need to recognize that. In our current era of media saturation, one role that artists can play is to keep important images and ideas in front of decision-makers and the public. Another role can be to try to reveal hidden truths. A third role might be to challenge prevailing beliefs by creating critical dialogue. I think this is what scholar Chantal Mouffe calls creating "critical space." However, artists also need the freedom to act outside of established roles or norms in order to experiment and express ideas that might not be pleasant or easy.

PU: Hello Weather! *(2008–ongoing), another ambitious collaboration with Varga, set up five permanent public weather stations in Asia, Europe, and the U.S., as well as temporary stations, to allow the public to access information about their local weather and to demystify the collection and use of climate data. The stations sponsor workshops and scientific presentations, and the data is also available via a Twitter feed and Weather Underground. How would you characterize your lineage of art-making? Do you also see yourself within a lineage of scientific research?*

AP: With *Hello, Weather!*, I was inspired by the "citizen science" movement, or what I prefer to call "community science," where non-scientists participate in searching for and gathering data. There is a long history of community science — the Cornell Ornithology project and SETI@home are two good recent examples that use the Internet as a tool to assist community science. *Hello, Weather!* places weather stations in art and community centers around the world and puts the data on-line for anyone to use. Its goals are similar to what I talked about with *Particle Falls* — to make more data

Andrea Polli with Chuck Varga, *Breather,* 2010. Car, plastic, and effects system. View of project in New Delhi, India.

Andrea Polli with Chuck Varga, *Hello Weather!*, 2008–ongoing. Weather station and computers, dimensions variable. Left: View of installation at the Goldwell Open Air Museum, Beatty, Nevada. Right: View of installation at the KHOJ International Artists' Association, New Delhi.

freely available and to encourage more open data access. It was surprising to learn through the course of doing *Hello, Weather!* that the U.S. has several very large, open networks for weather station data, but that other countries do not.

PU: *Could you name some artists, as well as scientists, who have been important to your work?*

AP: There are a lot to mention, but I have been inspired by the scale of community-engaged artworks by Joseph Beuys, Agnes Denes, and Mierle Laderman Ukeles. I have directly used Murray Schafer and Hildegard Westerkamp's work on soundscape and sound walking in my projects. And I have learned a lot from the scientists with whom I have collaborated, especially the lead scientists (and 2008 Nobel Prize winners) Andreas Fischlin and Cynthia Rosenzweig at the Intergovernmental Panel on Climate Change, who despite their great accomplishments as scientists (or perhaps because of them) are incredibly open and respecting of the role of artists in the scientific community.

The Living: Responsive Structures for Dynamic Environments

by Elizabeth Lynch

David Benjamin and Soo-in Yang, who trained as architects, work as The Living and teach at Columbia University, where they direct the Living Architecture Lab. In their work, they envision intelligent "building envelopes" in urban environments that "communicate with citizens about important social, cultural, and environmental issues." They muse about ways that the built environment can be dynamic: their ideas include flexible buildings constructed of materials that appear and disappear when necessary, shift form based on political movements, and respond to changes in the quality of air and water. As a matter of principle, they publish their plans, diagrams, and codes for all projects, so that others, working in any field, can build on their ideas.

Living Light, Benjamin and Yang's futuristic shelter in a Seoul park, "glows and blinks according to data about air quality and collective interest in the environment." Permanently sited in Peace Park, adjacent to the World Cup Stadium, *Living Light* shelters walkers, joggers, and soccer fans. Its pavilion mimics the outline of Seoul in an irregular, gently curved acrylic dome. The elevated structure is partitioned into 27 LED-illuminated segments corresponding to city neighborhoods and supported by a series of vertical steel beams that Benjamin and Yang designed for maximum support and unexpected asymmetry.

Living Light, 2009. Stainless steel, acrylic, LED lighting, air-quality sensors (particulate matter), and SMS text-messaging system, 6 x 6 x 3 meters.

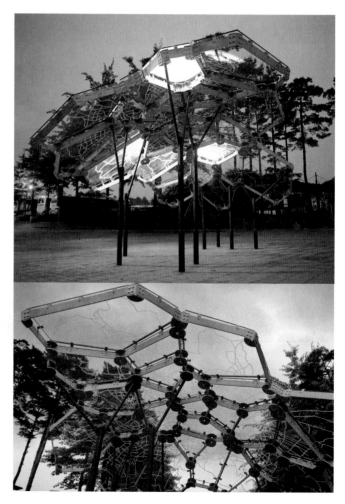

Living Light flashes according to up-to-the-minute data produced by Seoul's air-quality sensors, which measure the "levels of PM-10, particulate matter smaller than 10 micrometers that can settle in the lungs." Each segment of the dome is connected to the sensor closest to its corresponding neighborhood, and the program compares individual neighborhood particulate levels to each other as well as to data from the previous year. As the artists explain, there are two programs every night: "Each neighborhood illuminates…if its current air quality is better than its air quality last year. In addition, every 15 minutes, the panels go dark and then illuminate in order of current best air quality to worst." Another program initiates when "a citizen texts a zip code to the *Living Light* hotline…within three seconds, [they receive] a text message…[with] the current level of PM-10 and whether this level is higher or lower than last year…[Simultaneously], the corresponding panel…blinks to let other[s] know about the collective interest in air quality."

Collaboration and community involvement are integral to Benjamin and Yang's work—they believe that people respond to the immediate feedback from works like *Living Light*, as well as to the sense that they are participating in a collective work. *River Glow*, a prototype that allows water to broadcast its own quality, communicates with glowing light that signals safety levels for swimming and drinking. A similar project, *Amphibious Architecture*, was commissioned by the Architectural League of New York for "Toward the Sentient City," a 2009 exhibition that envisioned computers woven into the social and decision-making fabric of daily life, framed as the "near-future urban environment."

Amphibious Architecture, which Benjamin and Yang created in collaboration with Natalie Jeremijenko and New York University's Environmental Health Clinic, engaged the waters surrounding New York. Two sets of connected, interactive tubes floated in the East and the Bronx Rivers. Below the surface, sensors constantly monitored the water quality and presence of fish; above the surface, blue lights flashed in response to changes in measurements and text messages. As with *Living Light*, people could send text messages directly to the work; in return, they received responses

Amphibious Architecture, 2009. Acrylic, LED lighting, water-quality sensors (dissolved oxygen level), fish-finder sensor, and SMS text-messaging system, dimensions variable.

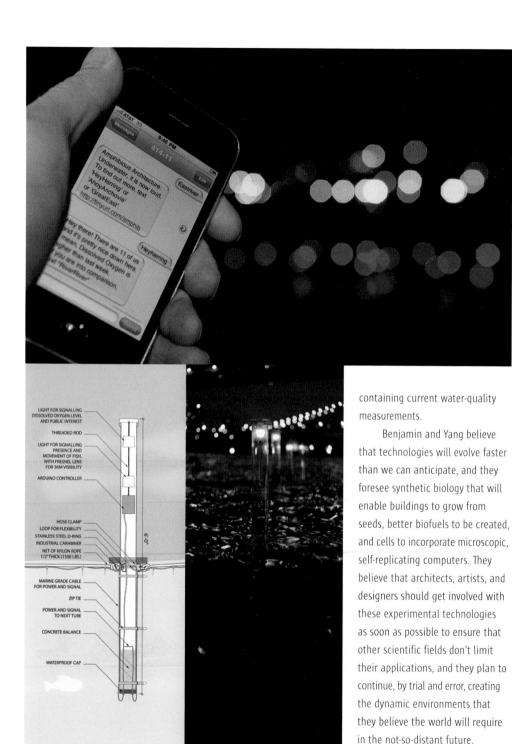

containing current water-quality measurements.

Benjamin and Yang believe that technologies will evolve faster than we can anticipate, and they foresee synthetic biology that will enable buildings to grow from seeds, better biofuels to be created, and cells to incorporate microscopic, self-replicating computers. They believe that architects, artists, and designers should get involved with these experimental technologies as soon as possible to ensure that other scientific fields don't limit their applications, and they plan to continue, by trial and error, creating the dynamic environments that they believe the world will require in the not-so-distant future.

Amphibious Architecture, 2009. Acrylic, LED lighting, water-quality sensors (dissolved oxygen level), fish-finder sensor, and SMS text-messaging system, dimensions variable.

Marjetica Potrč: The Art of Sustainable Self-Sufficiency

by Twylene Moyer

Marjetica Potrč takes the maxim that art can change the world and acts on it. Her interdisciplinary, community-driven interventions in urban and rural areas throughout the world put people first. Though conservation and environmental sensitivity ground all of her projects, Potrč shifts the focus from ideas to implementation—finding sustainable water and energy solutions that improve the lives of real individuals. Unique in their open-ended, grass-roots realization, her adaptable structures and systems turn the architectural priorities of capitalism upside down.[1] Rather than imposing a top-down social engineering that dictates—and enforces—how people should live (and conform), Potrč's projects acknowledge, and accommodate, differences in lifestyle—whether those differences arise by choice or necessity—and enable small groups to improve their situation. After more than 15 years of intensive research and fieldwork around the world, she puts an unexpected face on the enemy of social and environmental justice. Far worse than the acts of any given corporation are the governments—of all persuasions, including bloated, byzantine democracies—that enable and benefit from those acts while failing to meet the needs of all, not just some, of their citizens.

At its core, Potrč's work is about nothing less than empowerment, a concerted effort to restore "democracy built from below" by providing self-help solutions that enable marginalized groups to live with dignity and independence while protecting their local environments.[2] As she has astutely observed, "There are two urban forms in the global city that I consider to be most successful—after all, they are the fastest growing—namely gated communities and shanty-towns."[3] A direct consequence of unfettered inequality, this polarizing oppositional relationship has infected the world,

A Rooftop Rice Field at Byuri School, 2010. Building materials, energy- and water-supply infrastructure, and rice field, dimensions variable. View of project in Anyang, South Korea.

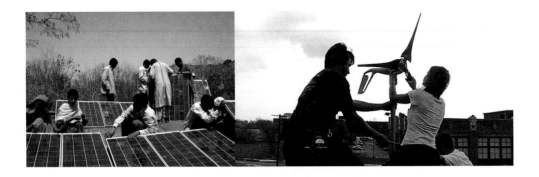

Power from Nature, 2005. Energy infrastructure, dimensions variable.

spreading beyond so-called third world cities to outlying suburbs and into the countryside, surfacing wherever privilege siphons resources and treats basic infrastructure as its exclusive preserve. From New Orleans, West Palm Beach, and Detroit to Shenzhen and Caracas, Potrč has intervened in the battle between the haves and the have nots, proving that imaginative eco-activism can measurably assist even the most disenfranchised, giving them low-cost tools to reinvent themselves and their communities. When government fails, those on the fringe have no choice but self-sufficiency; coupled with limited means and scarce resources, self-sufficiency demands sustainability. Residents in Caracas's La Vega barrio, for instance, are cut off from the municipal water supply. Without sanitation facilities, they face pressing water supply and sewage contamination problems. Potrč's *Dry Toilet* (2003), created in collaboration with the La Vega neighborhood association and Israeli architect Liyat Esakov, bypassed unresponsive city government and its wasteful water system with an ecologically safe, conservation-minded, and economically viable solution adapted to the conditions of the "informal city."

A similar strategy applies in the case of *A Rooftop Rice Field at Byuri School* (2010), located at an alternative school in Anyang, one of Seoul's satellite cities. Here, a tank collects rainwater from the roof of a pavilion at the top of the building and uses it to irrigate a rooftop rice field and serve upper-floor flush toilets. Students cultivate the rice, which is a major ingredient in their meals. Though growing one's own food is an important part of traditional life in Korea, Anyang's municipal planning authorities do not recognize the practice. Part of a citizens' effort to persuade the municipality to provide free, organically grown food for all students, Potrč's project, which underscores the importance of relocalizing food networks to foster self-sufficiency, demonstrates that an intelligent, creative approach to development can also be sustainable and beneficial.

While many of Potrč's field projects concentrate on the interdependence of water and community, others turn to energy infrastructure, supplying groups with clean, dependable power (some for the first time). *Power from Nature* (2005) provided self-sustaining technologies for the alternative rural community of Barefoot College in Rajasthan, India, and the Catherine Ferguson Academy, a high school for teenage mothers in Detroit.[4] Potrč, working with the Nobel Peace Center, created a solar-powered system for Barefoot College and a hybrid wind turbine/solar system for the academy—renewable power sources that reinforce the message of self-sufficiency taught at both institutions.[5] *A Schoolyard in Knivsta: Fruit and Energy Farms* (2008, commissioned by the Swedish National Public Art Council and the Municipality of Knivsta) transformed Thunmanskolen High School in Knivsta, Sweden, into a high-tech, energy-efficient orchard. The hybrid wind and solar system feeds energy into the existing electrical grid, sharing it with the larger community, while the orchard, which doubles as a public park, strikes a new balance between the urban and the rural. These sustainable values reflect the empowerment of the Knivsta community, which recently gained independence from the larger Uppsala Municipality.

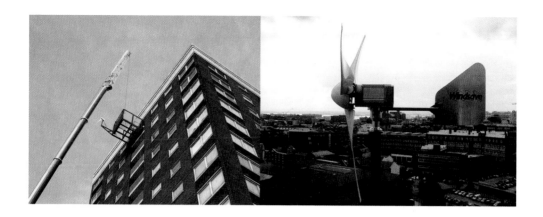

Above: *Balcony Wind Turbine*, 2004. Building materials and energy infrastructure, dimensions variable. View of project in Liverpool.

Below: *A Farm in Murcia: Rainwater Harvesting*, 2007. Water-supply infrastructure, dimensions variable. View of project in Murcia, Spain.

Some large-scale projects bridge the two faces of Potrč's practice—in the field and in the gallery. In 2007, under the auspices of the Sharjah Biennial, she created a solar-powered desalination device that supplies fresh drinking water for students at a public school in Al Dhaid. Though Sharjah City's main plant is supposed to provide potable water to all residents, in some parts of the city, taps deliver only salty water. To power its operation, *A School in Sharjah: Solar-Powered Desalination Device* harnesses the sun, a resource even more plentiful in the United Arab Emirates than oil, pointing the way to a future beyond fossil fuels. *Lookout with Wind Turbine* (2008), a collaboration with the Amsterdam artists' collective Vriza, created an addition to the loggia of the group's apartment in the Piraeus Building. This intervention enabled Potrč to divert the social regulation implicit in the building's Modernist design and replace it with a functional apparatus that draws connections between power (electricity) and Vriza's work of empowerment (the group opens its space for public events) while demonstrating that culture can be a powerful tool for reinventing the city.

Potrč's gallery works—sculptural case studies, drawings, and an ongoing series of experimental prototypes and utilitarian objects called "power tools"—articulate the conceptual framework behind her solutions in the field.[6] While the on-site projects focus on immediate, individual needs and may not be readily translatable to other situations and locations, the gallery works take a more generalized approach to the human and environmental damage wrought by unfettered growth, using elite art world institutions as a means of disseminating radical egalitarianism. Turning galleries and museums into educational centers promoting alternative ways of thinking, she brings her creative solutions into mainstream consciousness. *Dry Toilet*, for instance, went through a half-dozen reincarnations over the course

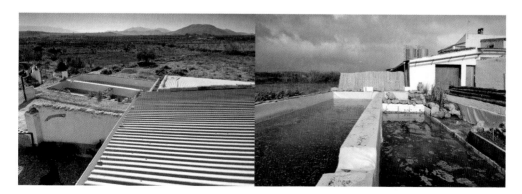

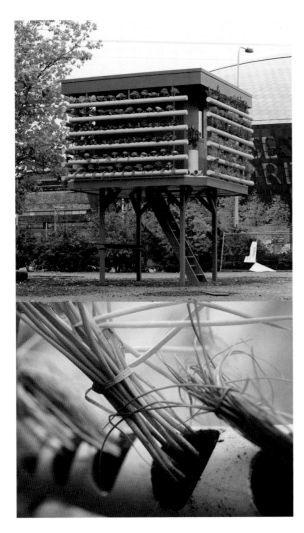

Urban Farm, 2006. Building materials and utilities infrastructure, 3.5 x 3.5 x 4.6 meters. View of project in Roath Basin, Cardiff, Wales.

of several exhibitions, as Potrč reworked the original design intended for Caracas.

Urban Farm, (2006) a self-contained unit housing a hydroponic vegetable garden, living quarters, and vending space now located on the Roath Basin in Wales, was originally commissioned by CBAT The Arts and Regeneration Agency for its "Urban Legacies II—Another New Babylon?" conference. Perched on red stilts, with a ladder connecting a ground-floor public space to the second-level garden and living space (complete with bed, water systems, and a toilet), *Urban Farm* allows its occupants to conjoin life and work. Mobile and adaptable to any location, the design revives the concept of the traditional shopkeeper's house. Using ingenuity to expand a tiny footprint, it encourages sustainable rural trade within the heart of the city, balancing urban and rural lifestyles as well as public and private use of space.

Other sculptural constructions, ranging from the early *Core Unit* (Skulptur Projekte Münster, 1997) to *New Orleans: Shotgun House with Rainwater Harvesting Tank* (2008), *Primitive Hut* (2010), and *Tirana House* (2010), propose self-help building strategies that throw off the constraints of contemporary architectural practice. Based on extensive research that may or may not connect to on-site work, these projects offer free-ranging, experimental spurs to imagination that liberate people from the services that fail them. Accompanying drawings provide intellectual blueprints for new ways of thinking about community, justice, and resources. In the case of New Orleans, Potrč's environmentally committed, DIY shotgun house appeared in conjunction with fluidly rendered and notated drawings sounding the call for residents to take back their "Great Republic of New Orleans" and build their own local democracy based on an organic synthesis of city and wetlands reconceived as a single organism.

By providing sustainable, low-cost, self-contained designs and infrastructures, Potrč's projects allow people to engage with the larger world on their own terms—another guiding principle of her practice. Much of her recent work learns from the example of Brazil's new territories, particularly the Croa River community in Acre, which consists of about 400 families living in the Amazonian rain forest. A 2006 residency there reinforced Potrč's belief that small, self-organized communities represent the only truly democratic, viable, and sustainable political systems, the only way to respect people and the planet. In Acre, she witnessed an interconnected web of bottom-up initiatives directed at individual empowerment and environmental protection—practicing good stewardship of forest-based resources, develop-

ing a small-scale, locally controlled economy, and most importantly, blending local experience and high-tech knowledge through the University of the Forest, which brings rubber tappers and Indians (caretakers of the forest) together with researchers to marry local experience and Western science.[7] This experience has led Potrč to refine the questions that she has been asking for years: What does it mean to live a dignified and responsible life today? Just how far is it possible to "downscale" the world community/economy? Built on localized community partnerships, her ingenious field solutions support the age-old wisdom that when individuals take responsibility for building their own lives, they also build their communities, respecting and protecting an environment that in turn sustains them.

Notes

1 Like Samuel Mockbee and the Rural Studio, as well as Rick Lowe and Project Row Houses, Potrč practices a community-based, equal-opportunity art for all. Many of the principles behind her theoretically rigorous work come from Yona Friedman, a pioneering architect who challenged the Modernist hegemony of the 1950s and '60s with his "mobile architecture." Friedman advocated a people-first architecture of integrated, flexible infrastructure and housing capable of adapting to the constant changes produced by social mobility. Planning rules, as well as building technologies, could be created and re-created according to the needs of residents, based on self-construction and local materials. Housing is decided by the occupant, by means of "infrastructures that are neither determined nor determining." Such mobile architecture is light on the land, capable of being dismantled and moved, alterable as required by the individual occupant, and integrated with means of food production. With an Eastern European background not unlike Potrč's, Friedman based his humanizing vision on direct experience of homeless refugees, first in World War II Europe, and later in Israel. A fierce critic of growing globalization, he also argued for a genuine democracy based on small divisions of people, as opposed to rules determined by what he called the "state mafia" and the "media mafia."

2 Marjetica Potrč, "Frontier Power: Human Bodies, Building Façades, and Fragmented Territories," in *Islands + Ghettos*, exhibition catalogue, (Heidelberg: Heidelberger Kunstverein, 2008), pp. 50–67.

3 Marjetica Potrč, "Five Ways to Urban Independence," in Lívia Páldi, ed., *Next Stop, Kiosk* (Ljubljana: Moderna galerija, 2003), p. 77.

4 Founded in 1972, Barefoot College is an NGO that provides basic services and solutions to problems in rural communities, with the objective of making them self-sufficient and sustainable. Its "Barefoot solutions" address solar energy, water issues, education, health care, grassroots action, women's empowerment, and wasteland development. All of these initiatives are village-based, managed and owned by local residents. <www.barefootcollege.org>.

5 On her Web site, Potrč notes that the hybrid system at the Catherine Ferguson Academy was made possible after historic preservation authorities in Oslo refused to authorize her earlier wind turbine project for the Nobel Peace Center. See <www.potrc.org>.

6 The Power Tools include a hand-powered lamp, mobile phone recharger, micro air vehicle, and a series designed for "urban explorers." See <www.potrc.org>.

7 The new territories in Acre, like many other rain forest communities, have been targets of bio-piracy; for this reason, responsible, locally controlled extraction of forest resources is essential to self-protection and community survival. For Potrč's analysis of the new territories, see "New Territories in Acre and Why They Matter," available at <http://e-flux.com/journal/view/10>.

Modest Actions and Big Impacts:
A Conversation with Mary Miss

by Harriet F. Senie

Mary Miss is about to launch what is undoubtedly the most ambitious and far-reaching work of public art in her already distinguished career. Some years ago, she began to think of public art as an instrument for raising awareness of critical issues in our environment, suggesting that daily behaviors have a long-term impact and that everyone can contribute to ecological change. In fall 2011, she begins a test run of *Broadway: 1000 Steps* in New York City, one of a number of projects that constitute her precedent-setting enterprise, The City as Living Laboratory: Sustainability Made Tangible through the Arts (CaLL). At the time of this writing, her proposal, which has been endorsed by Manhattan Borough President Scott Springer, has been approved by the New York City Department of Transportation (DOT). Miss will use the traffic triangle at 137th Street and Broadway for the first phase of a project that she hopes eventually will run the length of Broadway from Bowling Green to Van Cortlandt Park, turning it into a "green corridor" intended to make New York City's sustainability initiatives readily apparent and personally relevant. By wrapping existing poles already used for lighting and signage in green, strategically placing mirrors to direct the viewer's glance toward important ecological elements (water, waste, air quality) while reflecting their faces, and installing graphically arresting signage and labels, Miss hopes to engage the public in linking environmental, social, and economic sustainability. She will be collaborating with several environmental scientists, the writer Tony Hiss, and a team of assistants, as well as working with several city agencies, community groups, and professors and students at adjacent City College. With her goal of building an engaged citizenry, Miss has defined a new role (and form) for public art, going beyond relational aesthetics and temporary social interactions or interventions to become an integral part of a city planning process that continues to expand through the actions of its viewers and participants.

Harriet F. Senie: *In* FLOW (Can You See the River?), *which is a series of site-specific installations that opens at the Indianapolis Museum of Art (IMA) in September 2011, you take a remarkably organic approach to public art.*
Mary Miss: *FLOW* is a precedent project for The City as Living Laboratory: Sustainability Made Tangible through the Arts (CaLL), a framework that I developed with Marda Kirn of EcoArts Connections in Boulder. The idea is to make cities realize that artists can help with sustainability—social, environmental, and economic. *Broadway: 1000 Steps* is another precedent project. In Indianapolis, it is really working. We're doing modest installations, working on engaging people within the community. In recent months, Marda has been getting people from museums, universities, and other organizations to come together for a series of events around the 10-day opening period.

 FLOW is a collaboration with IMA and other museums, as well as the City of Indianapolis; the U.S. Geological Survey; Indiana University/Purdue University, Indianapolis Center for Earth and Environmental Science; Butler University Center for Urban Ecology; Marian University EcoLab; White River State Park; Indianapolis Zoo; HARMONI (residents, business owners, and public/private leadership interested in rejuvenating Midtown); and several neighborhood associations. This kind of project has the potential to become a catalyst. We're looking at a six-mile stretch of the White River, and we're trying to engage a city. It's not about one spot in one neighborhood. Multiple stopping

FLOW (Can You See the River?), 2011. Renderings for project at the Indianapolis Museum of Art, Indianapolis, Indiana.

points will draw attention to focal points of the water system, using carefully placed mirror markers and oversized map pins to focus attention and create a series of reflections—engaging viewers and portraying them as an integral part of the watershed. These modest interventions in the landscape point out key aspects of the system such as wetlands, floodplains, and pollution. The reverse of each mirror is inscribed with the words, "All Property is Riverfront Property. The River Starts at Your Front Door." There will also be rain gardens, green roof samples, porous pavement samples, and historical images—all initiating a conversation about sustainability and environmental issues and suggesting individual involvement and impact. I've been interested in collaborating with individuals within a community, in bringing together a larger group that will carry on river engagement and awareness in Indianapolis and other communities. It's very exciting, but I think the hard thing is getting people to understand. For instance, with the Broadway project, people ask, "What is it, what are you doing?" They want to see *The Gates*, they want to see Eliasson's waterfalls.

HS: *You first developed The Park as Living Laboratory in 2006. That seems like a kick-off. Is this part of your larger thinking?*

MM: It has its roots in *Moving Perimeter: A Wreath for Ground Zero* (2002), the project that I did after 9/11. I wanted to step outside the percent-for-art framework and find a different way to function, a way that would allow me to look at issues that I felt strongly about, instead of always trying to see how I could fit my work into the particular shoe that I was handed. It's not that I'm against these commissions—I've been able to live by them all these years—but there are other ways to operate. The Indianapolis project is supported by a $200,000 grant from the NEA and funding from the National Oceanic Atmospheric Administration (NOAA), so we've shown that cross-funding between art and science can work.

HS: *I remember* Moving Perimeter *very well. Was that the first time you were thinking about addressing environmental/ ecological issues directly as opposed to the more abstract approach taken by some of your earlier work?*

MM: *Greenwood Pond: Double Site* (1989–96), at the Des Moines Art Center, really begins to explore multiple functions and ways of seeing a site, leading viewers along and giving them the experience of a wetland in the middle of the city so that they can appreciate its role. Toward the end of that project, which consists of walkways and a pavilion, I was becoming more interested in the physical experience of getting down to the water, walking a path through grasses, and getting up to look out. I really wanted a way to convey more contact, and I began to do that in the 14th Street Union Square Subway Station project (1992–2000), which I see as an important precedent for this idea of multiple and modest interventions. I let the archaeological and architectural complexities of the station do the work. In other words, I wasn't trying to take over the station, I was allowing viewers to come across these slowly revealed places.

HS: *Enabling a different kind of visibility?*

MM: Yes. By 2008, a number of my projects were canceled, and I was frustrated. I spent years on the Water Pollution Control Plant in Arlington, Virginia, but it didn't happen. There would have been pathways lined with oyster shells, rooftop gardens, trellises, interpretive kiosks, and an observation turret. The transformed plant could have become a "gateway" to the community, as well as an educational tool. These things cost millions of dollars to implement, and when they don't happen, it's the money. *Broadway: 1000 Steps* may cost $2 or $3 million, but it's trying to engage

Connect the Dots, 2007. View of project in Boulder, Colorado.

Broadway: 1000 Steps, 2010–ongoing. Views of possible project elements in New York.

the full length of Broadway with modest installations. I'm trying to come up with ways that allow you to have an impact, directly engaging people in a visceral way that's doable.

HS: *This is the approach that you took in* Connect the Dots *(2007), a temporary project in Boulder. What prompted that piece?*

MM: I spent part of my teenage years in Colorado, and I knew that Boulder, which is at the mouth of a canyon, is susceptible to damaging flashfloods—which could be made worse by climate change. I talked to Sheila Murphy, a U.S. Geological Survey scientist, who said that Boulder is considered (to many people's surprise) one of the highest hazard zones in the western U.S. There are about 140 rainstorms every summer. FEMA uses a 100-year floor to regulate flood plain management, but many experts believe it would be prudent for communities to be prepared for a 500-year flood. Scientists have been trying to get people to think about this, but there hasn't been a flood like that before. The 100-year flood was in 1894, when the city was inundated. Some evidence of that event remains, but when something hasn't happened within your lifetime or within your experience, how do you take it seriously? Nobody did. My idea was to very simply map the predicted depth of the 500-year floodwaters, placing several hundred blue disks on the infrastructure, trees, and buildings of downtown Boulder so that people could see this constant line. The water was sometimes just against your legs and, at other times, 18 feet over your head. Bodily measurement gave people a visceral sense of an ephemeral event outside of memory and made it real.

HS: *Do you think it led to any kind of change?*

MM: I can't say. In *FLOW* and *Broadway*, we're really interested in how to evaluate effectiveness. Do we talk to people ahead of time, talk to them afterwards? As artists, we're not used to reviewing.

HS: *How do you get at the kind of awareness that comes from the visceral engagement that you're talking about? Just looking at the Boulder project, I can feel it—"Oh my god, that water's over my head." The question is whether people remain aware the next time they're voting on a bill for flood prevention.*

MM: Going back to my earliest work, I have always wanted that kind of visceral engagement—emotional, physical, and psychological. I depend on the body's relationship to space. And this is my point—you have to get people interested in these issues. The old-style approach to the environment says, "You better do this, you better recycle." It lectured people, tried to scare them, and that doesn't work. People have too many problems. You can't give them a big problem to deal with: they feel ineffectual and think the situation is totally hopeless. I think that it's really about getting people interested and engaged, so that if they have warnings signs in Boulder, they know what they mean and what to do.

HS: *Are there any specific environmental concerns that you've been engaged with in recent years?*

MM: Water has been a longstanding interest in my work, since about 1960 or so. After IMA canceled my big project [a 1,200-foot walkway through a tree canopy, across a canal, over a wetland, and into the Art and Nature Park] in 2008, it took me a while to decide whether I wanted to go back. But I talked to curator Lisa Freiman and determined that I'd really like to do a test project. Since the White River is so much a part of that institution—it goes right by the park and floods it—I wanted to look at the river between the museum and the center of town, which is about six miles. What struck me was that it wasn't built up like the waterfront in Milwaukee or Chicago. It's kind of invisible, and even in the nature preserve, you feel like you're out in the country. It's not navigable, though the founders thought it was when they built the city. Downtown, the river serves industrial functions, but it also supplies 70 percent of the drinking water, despite the fact that it's highly polluted and has to be processed. As I found out more, it became like the Boulder project—I thought something was dangerous. In Indianapolis, I had a great team of scientists to work with. In a sense, I feel like a bridge-maker between different fields. So, in *FLOW*, you've got physical models on site, along with webcam projections, and a grant from NOAA is funding a Raindrop app that allows you to follow the hydro-logical cycle from a specific location, like your address, to see what happens when a raindrop falls there, how that water gets to the river.

The subtext of the whole project concerns property, so that you can see and claim the effects on the river. Red map pins draw your attention to different aspects of the landscape and what happens to the water. Does it go through pipes, through streams? What happens if it rains, how does it move differently? What are the pollutants? What is the combined sewer overflow (CSO)? The bright red markers have an 18-inch diameter, which calls out what it is you're looking at. But when you look into the mirrors, you see yourself with the river in the background. There's also a guide that provides more information. Then there's a Web site <www.flowcanyouseetheriver.org>, as well as site-specific, cell-phone-accessible commentary such as a zoologist talking about the best place to watch river turtles and a scientist discussing storm surge dynamics.

HS: *It seems as if it would be great for school groups, especially with all the new technology.*

MM: I wanted to reveal all of the pieces so that people could understand the many parts. I'm also going to give out decals that people can attach to their cars or houses. You can get a little red enamel marker to put on your front door or your mailbox, just to say that yes, you're part of this river awareness. The idea is that these physical markers will expand out through the city—at least on a map—because everyone enters their address on the app. The information then appears on the Web site. My goal is to bridge the virtual, physical, and conceptual.

HS: *How has your thinking evolved since you started in this new direction? Your notion of prototypes and segments might be applied in different ways.*

MM: I started from the larger conceptual framework of the City as Living Laboratory and the basic idea that artists are a great resource. I say artists in the broadest sense, including performers, poets, writers, and landscape architects. We have something to offer that cities really need—we can serve as a bridge between their high-level policies and programs and the people at street level, who don't necessarily get what is going on. What's happened with DOT offers an interesting example, because I think that Commissioner Janette Sadik Khan's changes in New York's traffic functions are lost on the person on the street. We see that there's a bicycle lane where the bus stop used to be and that Times Square shouldn't be like

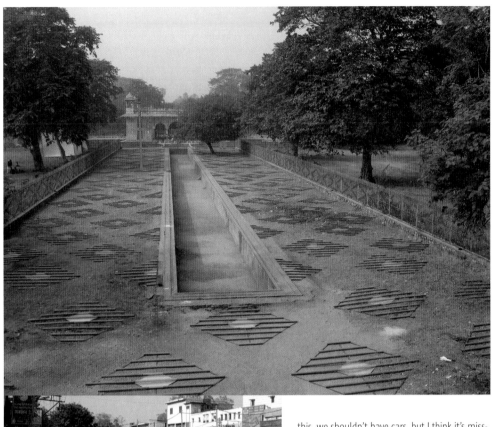

Roshanara's Net, 2008. Mixed-media installation in New Delhi.

this, we shouldn't have cars, but I think it's missing the context. How can we begin to understand the ground level of what these issues are about? It took such a long time to clean up the air; experts said 30 years. But what can you do on a smaller scale, in five years? How can you get people to understand the nature of a city and the city as nature?

HS: *Do you see* Roshanara's Net *(2008), a temporary project in India, as part of this overall focus? How did that come about?*

MM: It's absolutely part of my larger project. I had been in India and met Pooja Sood, who directs the KHOJ International Artists' Association, an artist's space in New Delhi. She asked me to participate in "48°C Public.Art.Ecology." I went out to look at possible sites and found a derelict archaeological site—a beautiful, 17th-century Mughal pavilion in a city park that people were using for garbage. I kept thinking about what we could do. The neighborhood adjacent to the park has suffered as a result of modernization and public policy decisions to create cleaner air. The city went into this well-established, working-class neighborhood and closed down the textile plants, markets, and other industries, all in a very short period of time, without considering what this would do. The local community was ruined by these things that are supposed to make a better city. So, I wanted to look at what is really

involved in sustainability, to consider issues ranging from the micro- to the macro-scale. *Roshanara's Net* is a kind of ayurvedic garden. I first thought of planting things, but it wasn't possible to disturb the archaeological site. Then I had the idea of a conceptual garden, like a fabric, a textile that could stretch across the site.

There are 100 diamond-shaped units made up of orange pipes. I really loved that each one had a tin nameplate in the middle containing the name of a medicinal plant, with text in Hindi and English describing its use. You could get all this detail up close, but when you stood at a distance, the individual elements blurred into threads, and you saw them form a pattern. There were about 2,000 plants around the perimeter of the pavilion so people could see what they looked like. We also had speakers who came to the installation and talked about what you could grow in a limited space. I think of *Roshanara's Net* as casting a net over the neighborhood, trying to engage people with this heritage site and encouraging them to see it as an amenity. Women and children don't go into the parks very much, so the idea was to radically transform the site for a short period of time, giving it a new use and meaning, with the intention of choreographing a different pattern of urban space, a place where people would want to come.

HS: *Were there any lingering effects?*

MM: There were, and I think that if I lived in Delhi, there could be more. Although we weren't able to plant on the site, there was interest in having the garden outside the archaeological zone. There was also the possibility of the pocket gardens and parks. Urban designers were very interested in this project as a precedent for repurposing archaeological sites. There are neglected ruins all over Delhi, just sitting there. What if they could be re-imagined for different purposes? How could they become something else?

HS: *These projects obviously involve different kinds of collaboration with many kinds of people. Is there one in which you think the process was especially important or that resonates for you as a model?*

MM: What's happening in New York is pretty amazing. *Broadway: 1000 Steps* grew out of a conversation with Amanda Burden, the chair of the City Planning Commission and director of the Department of City Planning. She had heard about CaLL and asked me to bring the ideas that I was working with in Indianapolis to New York. I started thinking about it and wondered what would happen if you could transform this iconic corridor into a place where the city's initiatives become apparent and what would happen if you could do it from Lower Manhattan to the top of the Bronx, going through all kinds of neighborhoods and situations. And then I started thinking about *Broadway: 1000 Steps*. The name comes from a scientist in Indianapolis who was talking about the river and how it could be brought back to life, or to a healthier life. She said, "It's a thousand small steps to degrade an environment and a thousand small steps to upgrade it." I'm trying to think of this in terms of individual engagement, trying to present things in a way so that people can understand how single actions in aggregate can rebuild and re-create our surroundings—this way, it doesn't seem overwhelming and people don't have the "oh god, I can't do anything" reaction.

Last winter, I went to a conference organized by Columbia University's Earth Institute, the CUNY Institute for Sustainable Cities (CISC), and Tipping Point [a British organization that explores connections between cultural life and the challenge of global climate change]. Its goal was to bring artists and scientists together. When I started with the idea of turning Broadway into the city's new green spine, I didn't know how to meet scientists. At the Tipping Point conference, I met many wonderful people, especially from CISC, who contacted me and said, "Look, we'd really like to work with you." And that, in turn, led to a series of relationships with CISC, the Earth Institute, the NYC Department of City Planning, and the Mayor's office. I've been working with this group of people for the past year. Since the scope of the project encompasses land, water, transportation, energy, air, and climate change, we started by surveying, locating green markets, schools, LEED-certified buildings, and other anchors to use as starting points for our "hubs," which are points designed to engage individuals, neighborhoods, and communities.

Of course, there's the process of finding funding, and we've spent a lot of time writing grants with our science partners. We had people from Columbia's Center for Research on Environmental Decisions, the Earth Institute, and

NYU's environmental education school assisting with cross-disciplinary grants. There's a Lower Manhattan Development Corporation grant for everything below Houston Street, and we applied for that. We were also invited to apply for National Science Foundation (NSF) programs.

HS: *These cross-disciplinary grants sound promising. They could open new avenues of work with the potential to inspire new kinds of public art, new models of civic life.*

MM: But you know, there is a complication that's been thrown into this. There's a New York-based investigative theater group called The Civilians who got $700,000 from the NSF for a new show on climate change. Apparently Congress is questioning why the NSF is giving money to a theater group. Everyone in the scientific world realizes that communication is everything, and that they are not doing a good job with it themselves. So they're really interested in collaborative efforts, but I'm a bit worried by this new development.

HS: *Where is* Broadway: 1000 Steps *now?*

MM: Well, there's the process of identifying the sites. We're also doing a test hub at 137th Street, at City College, which will open in mid-September in conjunction with Urban Design Week. This test site is a partnership with the Institute for Learning Innovation. Tony Hiss, who wrote *The Experience of Place*, is interested in looking at a place in detail in the same way that I am, so I called him up, and he's going to be working with this too, putting a narrative together for the different elements. At this point, we're beginning to become more specific.

HS: *What is the goal?*

MM: We're not trying to take over Broadway; we're going to repurpose what's there, creating a sense of incremental transformation as people travel the length of the integrated installations. We'll be using the infrastructure that's already there. We're taking this step by step, and now, we have to articulate what we're going to do at these hubs.

Platforms for Participation:
A Conversation with Natalie Jeremijenko

by Jennifer McGregor

Natalie Jeremijenko, named a top young innovator by MIT's *Technology Review*, is an associate professor of visual art, computer science, and environmental studies at New York University. She has also taught at the Royal College of Art in London, the University of California, San Diego, and Yale University. In 2010, the Neuberger Museum of Art in Purchase, New York, presented her work in the survey exhibition "Connected Environments"; it also appeared in "Remediate/Revision: Public Artists Engaging the Environment" at Wave Hill in the Bronx. She has participated in the 2010 San Jose Biennial, the 1997 and 2006 Whitney Biennials, and the 2006 National Design Triennial at the Cooper-Hewitt National Design Museum in New York.

Jeremijenko created and directs the Environmental Health Clinic (or xClinic) at NYU, which approaches health from an understanding of its dependence on external environments. "Impatients"—those too impatient to wait for traditional legislative measures to address environmental problems—can make appointments at the clinic to discuss their particular concerns; they leave with prescriptions that enable them to take positive action. Jeremijenko describes her lifestyle and public experiments as xDesign, experimental design that focuses on creating new technologies for social change. More information can be found at <http://environmentalhealthclinic.net>.

Jennifer McGregor: *You're often positioned in the art/science/technology trajectory. Could you talk about the difference between the laboratory and the studio in your practice?*

Natalie Jeremijenko: I use neither the lab nor the studio model. The clinic offers a widely familiar script; there is a waiting room, a consulting room, and we also have a wet lab that can be set up on the East River. It operates through an on-line scheduling system that combines the tropes and schematic of the health clinic with academic office hours and the idea of a studio visit. There is something that I find difficult about the consumptive gaze of the patron class, the studio visit to get a privileged view of the work's production. That idea is very different from participatory research into the collective problem of how we imagine and redesign our relationship to natural systems. The clinic gives me a framework to structure participation in a way that makes sense to me; people come to let go and discuss their personal environmental concerns. These "impatients" get to do something and step outside definitions. The clinic is driven by the idea that the studio doesn't engage people—they can see but rarely participate meaningfully in the process. In this case, I am very interested in how we can combine collective sense-making and the interpretative intelligence and concerns that people bring and make those explicit.

JM: *Would you call the impatients a curious public?*

NJ: I think that the climate crisis has produced, or revealed, what I call the "crisis of agency." There is a dissatisfaction with small steps, like driving the speed limit, changing light bulbs—formulas that no one really thinks are going to save the world. But what to do? That's the kind of representational challenge that this space addresses. The clinic offers a different structure for participation and a very specific engagement. It's like going to a health clinic. Impatients come with a vague or specific concern that they elaborate, and we draw on resources to put language around it in

order to understand and figure out what to do. It's a very active participant structure. If this project performs the institutional function of a clinic in a very earnest way, then it has also exploded the idea of the lab—the experiments are going on in public, there is public experimentation. I have two main ideas—the lifestyle experiment and the public experiment. *One Trees*, for instance, where 1,000 cloned, genetically identical trees are planted at different sites, is a public experiment. It's taking place where we can watch. The spectacle of the differences that emerge in those trees is something that we can all intelligently interpret. I learn much more from it that way.

JM: *You did this in San Francisco?*

NJ: Yes, the project was originally commissioned by the Yerba Buena Center for the Arts. The idea of *One Trees* was to plant pairs of genetically identical clones in various micro-climates so that we could see how the twins would react. The trees are Paradox trees, hybrids of the Northern California native black walnut and the English walnut. They were planted in various locations in 2003. Making sense of why these identical trees look different and develop differently is the question behind all of this. For instance, there are trees planted at 22nd and Valencia, about 10 feet from each other.

JM: *They're very different in size.*

NJ: I've been watching the divergence between these two to figure out if it was the light conditions, wind, or something else, thinking that one of them had penetrated the main water pipe. But it turns out that San Francisco has terracotta water pipes, and they're cracked and leaking everywhere. Then, a construction guy pointed something out that I hadn't noticed before, demonstrating the importance of drawing on collective intelligence, how you need diverse people. I had seen the houses there, but I hadn't really looked. One's a Victorian and the other, a very plain structure, was probably built in the '50s. Between these two buildings was the 1906 earthquake, which changed building codes. So the foundations might be very different. In another example, we were looking for song sparrows and which trees they preferred. There are ways of looking at it that give a robustness of understanding and a whole set of theories to approach the complex problem of an urban ecosystem. The only way to figure things out is with collective intelligence— that's the advantage of doing it in public with public science, and over the long term, we can aggregate the interpretative search.

JM: *How do you collect the data?*

NJ: Structuring the experiment properly is part of the work. It's challenging at every step of the way. Initially each tree

NoPark, 2008–present. Soil, plants, paint, and mixed media, detail of thumb tattoo.

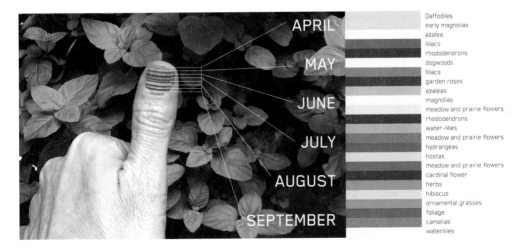

was set up with its own blog, and the stewards could blog on behalf of the trees. We also started tree tweets, but you have to make it a compelling event for the audience. Ideally I have structured a kind of biennial conference in the form of a bike tour to all the trees, and we talk about each one with various biologists and chemists. It's a public event in public space. This becomes one way to bring people into it temporally.

JM: *Does the Environmental Health Clinic have anything to do with analyzing?*

NJ: There is a need to detox, but the problem with the pharmaceutical approach to environmental health is that, like the body, you take all these supplements and you might get everything out, but the next time you walk out on the street, it's going to go right back in unless you couple that with treating behavior. I've been doing a series of sets that couple personal training, which is all about improving your health, with improvements in environmental health. One project pairs core body strength training with seed dispersal. When you go back along your route, you can see how much you planted last time. I have an impatient on the track team who planted carrots, and this made it more interesting for him to continue his training, to see how things were going.

JM: *The clinic also addresses how to reduce mercury-loading in fish, which you've researched in the past. When an impatient comes with a question that you have experience of, do you draw on things you've already started?*

NJ: I have a lot of research connections and resources in the academic community, people looking at the whole mercury cycle. That's what you get with an academic affiliation, and I can bring those resources to bear, but it's not a passive situation of me, as the expert, acting on the patient. It's participatory research to the extent that I've developed a repertoire of projects, monitoring protocols, and lifestyle experiments, but I'm not diffusing accountability and saying, "Oh, it's his research." The interesting thing about the expert model is that if I'm going to make a claim that we can reduce the mercury level then I've got to be able to stand behind that. Accountability is part of the academic model, it's a reputation-based system. At the clinic, it's not about diffusing that responsibility, it's about drawing on the resources and setting things up so that we produce believable, measurable, and legible research.

JM: *Do you start by considering what can be learned about a problem and how it can be approached, as opposed to solving it?*

NJ: *xAirport*, the project I did at the 2010 San Jose Biennial, looked at the analysis of life systems, the future of urban mobility, and "biodiverCity." We need to license more radically diverse ideas, we need to expand what's possible, and we're not going to do that by reducing the negative effects of the existing system. The FAA created a specific opportunity in 2004 by approving a new class of light sport aircraft that can be flown after just 20 hours of flight training with a light sport license. So, we do an analysis of the flight system and see areas where we can intervene and have the most impact, not just to reduce negative effects, but also to use the opportunity to design a flight system for urban mobility that regenerates environmental health and promotes biodiversity. It's a strategy of making sense of what we can do.

JM: xAirport *revolves around the notion of "wetlanding"—creating a freshwater urban wetland that also functions as a landing strip for personal, amphibious planes. It re-presents complex natural processes and celebrates them as collaborators in a possible "high-tech" 21st century. When you see pictures of people flying the training devices, they seem to be having a great deal of fun.*

NJ: We came up with a system of hand-flyers with wings that people can put on, and then they fly down a Wetlanding Zipline. The San Jose models have a 16-foot wingspan. It really was fun. Playfulness is an important part of the strategy. We've also done a proposal for a Modular Zipline in Manhattan that follows the San Jose prototype.

JM: *Who do you work with on a project like this?*

NJ: For the amphibious planes, I'm working closely with two companies, particularly Icon Aircraft. I went to engineering school with these guys, so I know them well. We have a corporate research relationship where we share ideas, but they're not funding me and don't share all of my concerns. They're doing a leisure sport vehicle that they advertise with girls in bikinis (they know their market). My charge is, how do we re-imagine urban mobility to get greater benefit?

We design the planes with different air foils, but the landing strip is where we have the most effect. It's a chance to restore existing water areas and preserve biodiversity hotspots while increasing the recreational use of otherwise degraded areas. It looks like we're going to be able to build a wetlanding at Westchester Airport as part of the expansion efforts there.

JM: *If you work with a high level of public engagement, the experience that people have, and take away, becomes very important.*

NJ: At San Jose, the first thing people said was, "Oh, I want to ride on that." Of course, in order to ride, they have to join the Imaginary Airforce flight training. They have to understand the wing types, what a wetlanding is, understand this opportunity for flight. This is engaging enough for them to learn other things as well.

JM: *So this project again draws connections between personal lifestyle and environmental concerns?*

NJ: There's a serious claim in all of the projects. In this case, the real flight training, the experience of the angle of attack and maneuverability, is much more transferable to piloting skills than a computer-based flight simulator. In the public experiment here, we're using a portable wind tunnel, with four different wing types of approximately the same surface area but different air foil features. This allows us to explore the question that every kid has asked at least once: Why do plane wings and bird wings look different? There's also an iPhone app that you can attach to the strap-on flight simulator wings and access acceleration changes. It's really a public experiment for people to have an opinion about their airport. To increase environmental performance, we need to open up radically new designs. Once they've done the pilot training and have their license then they can do the zipline, which is not about height and speed, but about experiencing the gentle phenomenon of lift and controlling the wings. It is a real flight experience that gives you confidence about flying.

JM: *And the landings took place in a wetland?*

NJ: Yes, we built a 300-foot wetland in downtown San Jose. This is the other cultural difficulty that we have—we don't build wetlands downtown; instead, we build toxic front lawns with loads of chrysanthemums. It was intended to be permanent and then at the last moment they said it was too difficult, too expensive. It was a huge disappointment, because the whole issue turns on the idea of being able to reposition the environmental experience culturally, creating different ways to inhabit and urbanize the wetlands, which have been in the swamps of the cultural imagination, always on the periphery where you don't go to hang out. We've explored different ways of working in and positioning your body in that environment. In another project, we take the normal example of the fish tank and invert that relationship. Taking organisms out of their environment produces visibility.

JM: *What are the conditions in which you would be able to make a permanent wetland?*

NJ: I learned a lot from San Jose, and now there are different kits for wetlands. I'm thinking about how to scale different wetlanding projects. There are the wetlanding strips, but there is also the act of creating many small wetland vegetable plots. There are all sorts of ways to explore how we can reintegrate these critical systems into an urban infrastructure. It's the best technology we have in the 21st century, even though it's wet and slimy. We can sit back and wonder if we are spectators to the biggest species extinction crisis since the dinosaurs, or we can act and effect change. This whole repertoire of wetlandings drawing on the wonder of flight—including the hand-flying, the ziplining—licenses people to have an opinion about flight. They can imagine themselves as flying, they can pilot their own future. Most people don't realize that you can get a pilot's license in a week and that these new planes cost about the same as a luxury Prius. This could mean a radical shift. It's not about the hand-wringing of "don't travel," it's about whether we can take to heart the redesign of our relationship to natural systems and the improvement of our mental health.

JM: *Could the wetlands part exist without the planes?*

NJ: The project is very much about using these sexy new planes. There is legislation up the wazoo about wetland loss, but the problem is still ongoing. This idea couples fascination with new technology and the FAA-enabled cultural

✖ AIRPORT
WETLANDINGS ARE THE NEW BLACK

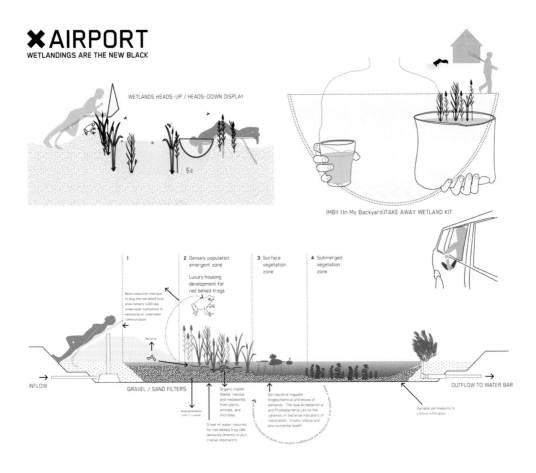

Sit Different, from *xAirport*, 2010–present. Display renderings of new interfaces and perspectives on the swamp.

opportunity that we have right now with the creation of a new infrastructure of distributive wetlands that can provide habitat, recharge aquifers, improve water quality, and treat urban wastewater.

JM: *So what's next?*

NJ: The next thing is to partner with Westchester Airport, which caters to private planes and our target audience. The airport was built in a great swamp, and it neighbors a reservoir that provides drinking water to Manhattan. We are working with already organized community and environmental groups battling the airport expansion, which they seem to have won. But it's in the airport's interest to be able to service this constituency. It's very easy for environmentalists to be corporate bashers. The example of BP demonstrates the preservation/conservation logic: "Bad BP" and "Good Us." A friend of mine gave the example of a drunk who leaves the bar after drinking too much, drives his car, has a fatal accident, and kills someone. Do you blame the bartender? Do you blame the driver? The same kind of logic works here: Do we blame BP for the oily demands of society when we fail to imagine alternatives?

JM: *So it's a given that Westchester Airport is going to want this new class of planes and this new way to expand. Your environmental project and their operations are not at cross-purposes.*

NJ: Exactly. If we can design systems and projects and prescriptions that enable them to improve their environmental performance and demonstrate that they have less runoff into their reservoirs and precious resources, they don't oppose it, they know it's in their interest as well. That's structuring participation.

xAirport, 2010–present. Diagrammatic rendering of flight safety procedures.

JM: *Did the Neuberger open the door to this project?*

NJ: Cultural legitimation of the context is a very important part of being able to stage these projects. While many of them happen outside, the forum provided by the museum, the arts organization, enlists interest and support. The people who came to the opening are the people who live near and use the Westchester airport. There's a way to operate effectively at those different levels.

And now San Jose wants to build the wetlands; they see the value, that it can be a spectacular public resource, a destination that also fulfills legal requirements for stormwater infiltration. Regulatory compliance is much less fun than doing the same thing via our new wetlanding with flyovers. The spectacular part, I think, comes from the strategy of the artist. The legitimation of the arts organization is critical, as critical as drawing on the scientific resources of academia. There are very few spaces for this kind of generative critical thinking, thinking that's playful and spectacular. You're expanding the possibilities and radically improving, changing, and transforming our relationship to natural systems. We don't have the instant answer; it takes real work—creative work, critical work, and a lot of social and cultural work as well. Arts organizations and the institutional framework of the Environmental Health Clinic help create the space for it to happen.

JM: *Do you consider any of your projects complete? Let's take the example of the robotic geese, which act as an interface between people and the birds themselves, allowing "goosers" to "talk" to the geese through pre-recorded words and sounds. Do you reach a point where you say, "We've learned what we can from that?"*

NJ: No. And I'm working on a whole new set of algorithms now [for the communication]. There's a group that has applied some of the same strategies that I've been using to music. Instead of having corporate control (iTunes telling you what categories you can search and how to buy), this system uses people's descriptions of music as the search terms. In these irreducibly complex socio-ecological systems, we're trying to figure out what works, what doesn't work, what might work later, what works with whom.

JM: *It also becomes a tool to investigate more.*

NJ: Exactly. I've been using the term "thing" because things help you make sense of things. The object is not just an object in a museum, it's a thing to think with. And the other concept that's been recently articulated is to describe the social movement that this represents. The relationship with impatients, instead of being a collector/artist relationship or a teacher/apprentice relationship, facilitates what I call lifestyle experiments, which I think is a whole class much wider than what I'm doing in the clinic. For instance, there's a woman who only makes art out of garbage, and a student who said he would only drink beer from people he shook hands with. How do these little experiments work for me, in my context? How can I reinvent? It's not a lifestyle choice in which you're committed to something, or a subscription, or a deprivation experiment—what can I go without?—it's a creative exploration, a creative experiment.

JM: *How can I reconfigure my relationship to the world in a positive way?*

NJ: Right, using life as art, your own lifestyle as a medium. This realm of lifestyle experiment is how we characterize an incredibly diverse set of projects created by artists and non-artists and people who are driven by knowing. To really re-imagine and redesign our relationship to natural systems requires thinking of things, really creating, grabbing the material from experience.

JM: *It is very important that this is not just something you watch or hear about, you're physically tasting it.*

NoPark, 2008–present. Soil, plants, paint, and mixed media, 2 views of installation in New York.

NJ: The challenge is to find the platform for participation. Some are individual lifestyle experiments facilitated by the clinic to amplify and network different people, different forms of events. Some are bigger systems analyses of the urban mobility system or the urban agricultural system. Some, like feeding the lures to the fish to reduce mercury-loading, are structuring participation collectively. There are different ways for us to participate. If we only look at market relationships and exchange relationships as the responsible consumer idea of buying our way out of this, without tapping into collective creative and analytical power, then we are limiting ourselves. Agency is not located in purchasing power—our creative agency, our creative thinking, that's where we have extraordinary resources to address these very challenging representational issues.

JM: NoPark *transforms no-parking zones into low-growth gardens, creating micro-engineered green spaces that still provide emergency parking while stabilizing the soil, preventing oily stormwater runoff, and maintaining essential moisture for street trees. Could people have done this project without you?*

NJ: To an extent. Parking Day, the global extension, has propagated extremely successfully, with people defying cars and concrete. And certainly people are invited to do it. Designing the *NoParks* to optimize them for habitat provisioning, infiltration, and air quality while maximizing their cultural impact isn't as easy as it looks. Lots of people are interested, but what we've learned from all the design charrettes and community participation is that not everyone is a great designer, and not everyone has to be; they can appreciate a good idea, recognizing something rather then developing it themselves. The artist's role is to open up the ideas and dialogue.

JM: NoPark *and Matthew Mazzotta's* Park Spark, *which digests dog waste and converts methane gas into a useable form of energy, are very different projects, but they both have something that people recognize as doable. It's scaled so that people ask, "Why don't we have these everywhere? Why doesn't every park have lights powered by recycled dog waste?" They recognize that these aren't boutique ideas and that we should find ways to install them everywhere.*

NJ: People can recognize that this is participatory democracy as opposed to the traditional, top-down way that things are done. The work at the Petaluma water treatment facility is brilliantly produced and conceived, and measured by the same measures that I would use. It's a great project in all respects, people can go there and learn, but it's at a scale doesn't inspire them to think, "Oh I can do that."

JM: *Exactly, people from other public art programs look at it and say, "I have to show this to our engineers." But that's not the same as public rallying.*

NJ: There are different levels at which to act. The capacity that many of us have to want to do something is really urgent and real and very big. The capacity that we have to convince every water treatment facility in the country to do a massive, expensive and political, arts-driven project is limited. The traditional actors in environmental remediation have been environmental lawyers, environmental engineers, and conservationists, but there is new work to be done. For instance, with the water treatment issue, the biggest pollution burden on the New York/New Jersey estuary system is no longer the big polluters like GE—regulation has been successful. Now it's storm sewers, every one of us. Different problems require different scales of action. And that's what the Environmental Health Clinic is really—a platform for participation that individuals and small groups can recognize and do.

Acknowledgements

We would like to thank all of the writers and artists featured here for their contributions to *The New Earthwork: Art, Action, Agency*. Many of the articles that originally appeared in *Sculpture* required extensive updating, so special thanks to the numerous artists who generously shared their recent work and developing projects with us. Eileen Schramm, the designer of this volume and of *Sculpture*, deserves credit for her commitment to making this a good-looking and inspiring book. We also thank Beth Wilson and Elizabeth Lynch (former editorial assistants for *Sculpture*) and Husna Kazmir (former editorial intern), Pat Soden and the University of Washington Press, Johannah Hutchison (Executive Director of the International Sculpture Center) and the ISC Board of Trustees, and the National Endowment for the Arts (for their generous funding of this publication and the ISC), and the ISC staff (past and present) who have made both this book and the magazine possible.

Cover Images

1 FoRM Associates, *Northala Fields* (aerial view), 2003–09. Clean demolition spoil, plantings, and water, approximately 2000 x 1500 x 105 ft.

2 Stacy Levy with Biohabitats Inc., *Dendritic Decay Garden at Washington Avenue Green* (detail), 2010. Removal of concrete and asphalt, addition of spoil and native plants, porous asphalt, recycled concrete, and glass, 1100 x 400 ft. Project in Philadelphia.

3 Jason deCaires Taylor, *The Silent Evolution*, 2009–10. Cement, sand, microsilica, fiberglass, and live coral, 400 life-size figures. View of installation in the National Marine Park of Cancún, Isla Mujeres, and Punta Nizuc, Mexico.

4 Tattfoo Tan, *S.O.S. Mobile Garden*, ongoing. Mixed media, dimensions variable.

5 Buster Simpson, *When the Tide is Out, the Table is Set*, 1978–present. Plates, 12 x 10 in. each.

6 The Yes Men, *Gilda the Golden Skeleton* lounges in a field of rape, 2005. View of project in Scotland.

7 Brandon Ballengée, *DFA 18, Triton*, 2001/07. Unique chromogenic print on watercolor paper, 46.5 x 34.5 in.

8 Vaughn Bell, *Garment for Flora-Fauna Relationship*, 2006. Performance with sewn cotton carrier, soil, baby hemlock tree, and water, dimensions variable.

9 Agnes Denes, *Tree Mountain—A Living Time Capsule—11,000 Trees, 11,000 People, 400 Years*, 1992–96. Project located in Ylöjärvi, Finland, 420 x 270 x 28 meters.

10 Amy Franceschini, *Victory Gardens*, 2007–10. View of mixed-media project.

11 Andy Goldsworthy, *Hand hit site dust, Presidio Spire*, 2008 Unique Ilfachrome print, 15.5 x 15.5 in.

Photo Credits

315